Curating Opera

Curation as a concept and a catchword in modern parlance has, over recent decades, become deeply ingrained in modern culture. The purpose of this study is to explore the curatorial forces at work within the modern opera house and to examine the functionaries and processes that guide them. In turn, comparisons are made with the workings of the traditional art museum, where artworks are studied, preserved, restored, displayed and contextualised – processes which are also present in the opera house. Curatorial roles in each institution are identified and described, and the role of the celebrity art curator is compared with that of the modern stage director, who has acquired previously undreamt-of licence to interrogate operatic works, overlaying them with new concepts and levels of meaning in order to reinvent and redefine the operatic repertoire for contemporary needs. A point of coalescence between the opera house and the art museum is identified, with the transformation, towards the end of the nineteenth century, of the opera house into the operatic museum. Curatorial practices in the opera house are examined, and further communalities and synergies in the way that 'works' are defined in each institution are explored.

This study also considers the so-called 'birth' of opera around the start of the seventeenth century, with reference to the near-contemporary rise of the modern art museum, outlining operatic practice and performance history over the last 400 years in order to identify the curatorial practices that have historically been employed in the maintenance and development of the repertoire. This examination of the forces of curation within the modern opera house will highlight aspects of authenticity, authorial intent, preservation, restoration and historically informed performance practice.

Stephen Mould studied music in Sydney and London, subsequently pursuing a career in opera houses, where he has been employed as a coach, musical assistant, conductor and senior administrator in Germany, Belgium, Australia and the USA. For thirteen years he was a member of the staff of Opera Australia, as a musical assistant, conductor and Head of Music. He is currently senior lecturer in conducting and operatic studies at the Sydney Conservatorium of Music, The University of Sydney.

Ashgate Interdisciplinary Studies in Opera

Series Editor: Roberta Montemorra Marvin, University of Massachusetts, USA

The *Ashgate Interdisciplinary Studies in Opera* series provides a centralized and prominent forum for the presentation of cutting-edge scholarship that draws on numerous disciplinary approaches to a wide range of subjects associated with the creation, performance and reception of opera (and related genres) in various historical and social contexts. There is great need for a broader approach to scholarship about opera. In recent years, the course of study has developed significantly, going beyond traditional musicological approaches to reflect new perspectives from literary criticism and comparative literature, cultural history, philosophy, art history, theatre history, gender studies, film studies, political science, philology, psychoanalysis and medicine. The new brands of scholarship have allowed a more comprehensive interrogation of the complex nexus of means of artistic expression operative in opera, one that has meaningfully challenged prevalent historicist and formalist musical approaches. This series continues to move this important trend forward by including essay collections and monographs that reflect the ever-increasing interest in opera in non-musical contexts. Books in the series are linked by their emphasis on the study of a single genre – opera – yet are distinguished by their individualized and novel approaches by scholars from various disciplines/fields of inquiry. The remit of the series welcomes studies of seventeenth-century to contemporary opera from all geographical locations, including non-Western topics.

Performing Homer
The Voyage of Ulysses from Epic to Opera
Edited by Wendy Heller and Eleanora Stoppino

The Operatic Archive
American Opera as History
Colleen Renihan

Contextualizing Melodrama in the Czech Lands
In Concert and on Stage
Judith A. Mabary

Curating Opera
Reinventing the Past Through Museums of Opera and Art
Stephen Mould

For more information about this series, please visit: www.routledge.com/music/series/AISO

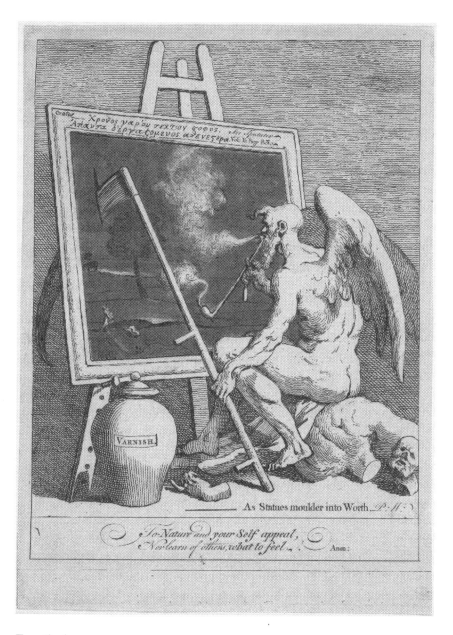

Frontispiece:
Time Smoking a Picture (c1761) by William Hogarth (1697–1764)
Etching and aquatint; third state of three (not recorded by Paulson)
Dimensions: image: 23.5 × 18.4 cm
Photograph: © Metropolitan Museum of Art

Curating Opera
Reinventing the Past Through Museums of Opera and Art

Stephen Mould

First published 2021
by Routledge
2 Park Square, Milton Park, Abingdon, Oxon OX14 4RN

and by Routledge
52 Vanderbilt Avenue, New York, NY 10017

Routledge is an imprint of the Taylor & Francis Group, an informa business

© 2021 Stephen Mould

The right of Stephen Mould to be identified as author of this work has been asserted by him in accordance with sections 77 and 78 of the Copyright, Designs and Patents Act 1988.

All rights reserved. No part of this book may be reprinted or reproduced or utilised in any form or by any electronic, mechanical, or other means, now known or hereafter invented, including photocopying and recording, or in any information storage or retrieval system, without permission in writing from the publishers.

Trademark notice: Product or corporate names may be trademarks or registered trademarks, and are used only for identification and explanation without intent to infringe.

British Library Cataloguing-in-Publication Data
A catalogue record for this book is available from the British Library

Library of Congress Cataloging-in-Publication Data
A catalog record has been requested for this book

ISBN: 978-0-367-46781-4 (hbk)
ISBN: 978-1-003-03101-7 (ebk)

Typeset in Times New Roman
by Deanta Global Publishing Services, Chennai, India

Contents

Frontispiece iii
List of tables ix
List of musical examples x
Acknowledgements xi

Introduction 1

PART I

1. 'Curationism' 11
2. Towards the curation of opera 23
3. The rise and fall of the public art museum 33

PART II

4. The invention of opera 51
5. Operatic transformations 61
6. From marketplace to museum 70
7. Mozart's operas during the long nineteenth century (1) 88
8. Mozart's operas during the long nineteenth century (2) 100
9. Boom and bust in the nineteenth century 113

PART III

10 The sociology of the opera house – insiders 129

11 The operatic work and the concept of *Werktreue* 145

12 Rossini, Rembrandt and the *Werktreue* debate 161

13 Dramaturgy and the dramaturge in the opera house 173

14 The dramaturgy of murder and madness 184

15 'Deeds of music made visible' 192

16 Conclusion 203

Bibliography 211
Index 218

Tables

4.1	The operas of Lully, showing the number of years in the repertoire	56
6.1	Versions of the Mozart operatic canon, taken from a number of disparate, twentieth-century sources	81
6.2	The seven 'canonised' Mozart operas, as marketed in a Bärenreiter Verlag pamphlet	82
6.3	The earlier Mozart operas, with details of premières and modern revivals	83
9.1	The most performed operas in Germany, 1947–75 (Konold)	122
9.2	Operatic full scores advertised for sale by Ricordi during the twentieth century	123

Musical examples

6.1	Mozart, *Il Flauto Magico,* no. 6, Trio, bars 68–71. London, Boosey and Co., 1871.	71
6.2	Mozart, *Die Zauberflöte*, no. 6, Trio, bars 68–71.	72
6.3	Gluck, *Orfeo* (1762), 'Che faro', bars 455–63.	75
6.4	Gluck, *Orphée* (1774), 'J'ai perdu mon Eurydice', bars 433–9.	75
11.1	Verdi, *La traviata*: 'Brindisi' as traditionally printed and performed, bars 321–8.	147
11.2	Verdi, *La traviata*: 'Brindisi' as printed in the Ricordi Critical Edition, bars 321–7.	148

Acknowledgements

This book is the result of a lifetime's interest in opera and the visual arts. In particular, my interest stems from having been an operatic practitioner, during which time I have often questioned why operatic works are presented, preserved and adapted in in the ways that they are. My curiosity has also extended to the art museum, and how works are conserved and placed in new contexts. In terms of the operatic side of the book, much of what is presented here is the result of nearly 30 years of experience as an 'insider', working in opera houses and festivals around the world in a variety of roles. I am therefore indebted to the countless colleagues – conductors, directors, singers, dramaturges and administrators – with whom I have worked, along with the operatic institutions themselves.

It would not have been possible to assemble the variety of material I have accessed without the tireless assistance, expertise and generosity of the staff of the Sydney Conservatorium of Music Library, led by Ludwig Sugiri. In addition, I am grateful for the friendly and prompt assistance I have received from staff of the British Library, United Kingdom, the Music Department of the Bayerische Staatsbibliotek, Munich, and Ian Coss of Clear Music, Australia.

I am grateful for financial assistance in the completion of this project, provided by the University of Sydney, and for the ongoing support of my Dean, Professor Anna Reid, who was my original thesis supervisor. Sincere thanks are also due to Jacqui Smith for her assistance with editing and Kieren Brandt-Sawdy for the formatting of the musical examples. I would also like to express my gratitude to Peter Quantrill for the indexing, and for general editorial advice in the final stages of production.

On a personal note, I would like to dedicate this book to my daughter Alice, who has been a constant support to me throughout the process of research and writing. I would further like to dedicate the book to my beloved partner of the last seven years, Natalia Raspopova (Наташа, 10 November 2013–5 April 2020).

Introduction

Synergies between the art museum and the opera house may not be immediately obvious to the visitor who frequents those institutions. In the later nineteenth century, however, the opera house began to be considered an 'operatic museum', and in Paris, the Opéra was often referred to as an 'operatic Louvre'. If a visitor to the Louvre today were to stand in front of one of the monumental historical paintings that are displayed in that institution, they would be confronted by a tableau on a scale that might easily fill the stage of an opera house. If that visitor were to allow their mind to wander, half-closing their eyes, they might imagine the painting before them animating, coming to life. With the addition of music, the figures portrayed could begin to sing, and this reverie might cause the visitor to imagine that they are at a performance of the nearby Opéra, witnessing a work by Meyerbeer or Halévy. A frozen moment in history (a painting) has been brought to life in the imagination, through the agency of music, in order to create a dramatic setting that unfolds in time.

This is a fanciful game, but perhaps hardly more so than the many games that are played both by visitors and also by those who create and guide the museum (of art or opera) experience from behind the scenes. These 'games' may be benign; they may be ethically, scientifically and museologically sound; they may be necessary to allow the visitor to position themselves within the continuum of history. But they are games, which are devised by curators. Curators work with artefacts – restoring, preserving and animating them, bringing them to life, through performance or, in the case of plastic artworks, placing them in specific contexts, such as exhibitions. The works presented in institutionalised museums have generally been created by people who are long dead. The older the work, the more challenges facing the curator, in terms of preservation, display and contextualisation, in order to present the work, to enrich it with context and animate it in the imagination of the visitor. Visitors to art galleries view works in environments which are far removed from those for which the works were intended. Modern environments are climate-controlled and iluminated in order to maximise accessibility for the viewer while minimising damage to the work. A work painted for display in a seventeenth-century cathedral or palace may well be displayed today in a

sterile white cube. In an attempt to compensate for the effluxion of time between the creation of works and the attentions of the visitor, written contextualisation is generally provided for study. Works are curated, enclosed in a bubble that enables preservation, display and study, but there is a cost to this process. Could that cost be calculated in terms of diminishing authenticity?

For just over 400 years, public art museums have been developing methodologies and practices for the preservation and display of artworks. During that time, notions of what is appropriate to display in a museum of art have shifted considerably, along with the methods of display that are considered appropriate. Similarly, for just over 400 years, operas have been performed in a variety of venues, from rooms in aristocratic palaces to purpose-built theatres. Operas have been produced under the most diverse circumstances, and as the opera house developed the characteristics of a museum-like environment, a defined opera repertoire gradually formed, effectively representing the 'permanent collection' of the museum. The modern opera house is, no less than the art museum, a carefully curated environment, where many games are played to maintain the repertoire in a performative state. Operas may be subject to cuts, which shorten them and alter their inherent structure and balance; modern orchestras exhibit vastly differing characteristics from those of even 100 years ago; the plots and even the sung text of an opera can be radically reworked, evoking visual worlds and elements that draw upon technologies far removed from those envisaged by the creators of the original works.

These outlines of the museums of art and opera already raise a number of questions about the experience of the visitor, or audience, who frequent each institution. Among the most pressing questions to consider relate to the veracity or authenticity of the experience that is presented. For a painting that may be 200 years old, how close is what the viewer perceives to what the artist saw as they declared the work completed? The familiar, bleached statues from ancient Greece were, in many cases, originally painted in gaudy, bright colours. Why are they not restored to that state in the modern museum? What kind of posturing and selective historicism occurs in the opera house, where old works are reinvented, given new guises, while musically, a scrupulous, authentically focused eye is kept trained on the composer's score? How certain can we be of the veracity of what is seen and heard in the museum?

Consider the case of an art lover who regularly visits a favourite museum, always ensuring that they view *Rembrandt by Himself*,[1] a painting which, according to the description provided, is a self-portrait painted by Rembrandt Harmenszoon van Rijn in 1665. These visits are a regular pastime, and the art lover considers themselves fortunate to have the opportunity to spend time in the presence of a masterpiece. On one such visit, the art lover discovers that the Rembrandt has been removed from view, and that its authorship is under dispute. The art lover finds themselves alienated by the removal of both the work and its attribution, which robs them of a number of certainties, making them aware of the tacit agreements that they had entered into with unseen curatorial forces within the museum as well as the wider art world. Those certainties have evaporated,

leaving a void. As time passes, the dis-attribution causes the art lover to reflect upon notions of authenticity and attribution, to question their perceptions and former beliefs regarding the identity of the 'Rembrandt'. Without the authorial attribution and the brand name of 'Rembrandt', what has the painting become?

Many questions about the status and shifting identity of the painting remain unanswered. Is it a copy of a self-portrait by Rembrandt that is no longer extant (in which case it might be considered the 'next-best to original')? If it is not a copy, what were the circumstances and motivations behind its creation? Is it a forgery, created with the intention to deceive, to derive financial profit? The art lover slowly learns that their experience was the result of the activities of the so-called Rembrandt Research Project, which involved a group of leading art experts, who systematically examined the authenticity of the nearly 700 Rembrandt paintings that were at that time considered to be the authenticated oeuvre of the artist. As a result of the findings of the Project, the number of 'authentic' works was halved, resulting in enormous controversies and noisy repercussions throughout the art world, which eventually caused the enterprise to reconsider a number of its attributions. What can be the position of the art lover when confronted with such curatorial confusions – how does this affect the perceptions of the viewer who looks to experts for guidance and certainty, about the provenance of works that are hung in the museum?

A Rembrandt painting that has been thus 'shamed' faces a difficult afterlife. It will most likely be quietly consigned to storage in order to conceal the considerable embarrassment of the dis-attribution. For the painting itself, there remains an unfortunate ambiguity of status: a portrait of Rembrandt – not by Rembrandt – which may or may not have some tenuous thread of connection to its subject. Perhaps the best that the work can ever hope for is to be raised to the status of a copy. Robbed of its identity, the painting becomes invisible, while 'genuine fakes', such as the Vermeer pastiches by the notorious forger Han van Meegeren (1889–1947), today find a place on the walls of art museums, secure in their forged status (authorial intent is very clear), offering lessons about the gullibility of the art industry. As van Meegeren said at his trial:

> Yesterday, this painting was worth millions of guilders and experts and art lovers would come from all over the world and pay money to see it. Today, it is worth nothing and nobody would cross the street to see it for free. But the picture has not changed. What has?[2]

It may be that no one has ever forged an opera, and it is often considered that music manuscripts are less susceptible to forgery than art works, commanding as they do a considerably lower market value, but from time to time, musical compositions are forged for a variety of reasons – they are generally known as musical hoaxes.[3] One prolific exponent was the violinist, Fritz Kreisler (1875–1962), for whom this activity seems to have been a playful pastime, in effect he created pastiches with a deceptive twist. In 1993, however, the musicologist and Haydn specialist H.C. Robbins Landon announced the discovery of a set of

hitherto unpublished Haydn keyboard sonatas that had lain dormant for 200 years. At a press conference, Landon noted that the works were 'extremely original, though strong influences of C.P.E. Bach and, curiously, Domenico Scarlatti could be observed'.[4] The discovery was hailed in the *BBC Music Magazine* as 'The Haydn Scoop of the Century'.[5] Later, however, these works were revealed to be 'modern forgeries deliberately constructed to deceive scholars and listeners',[6] composed by a musical equivalent of Han van Meegeren. Aside from forgeries, there are works that are considered to be somehow less than completely authentic, for example pastiche operas (*pasticci*), of which two examples by Rossini will be discussed, that contain the composer's music and were authorised by him; nevertheless, until recently, when it now seems the world cannot get enough Rossini, they were regarded as lesser, 'bastard' works and listed separately in catalogues of the composer's oeuvre. Similarly, the concert arias of Mozart include a number of pieces which were written as insertions into the operas of other composers. It is somehow unfashionable today to be reminded of Mozart's status as a professional composer who undertook tasks for money in the world of opera, perhaps mercenary tasks where divine inspiration did not play a large part. For these status-related reasons, the insertion arias of Mozart are not often performed. During the course of this book, the alternative arias which Mozart composed for *Le nozze di Figaro*, and a scandal that was ignited by their performance, will be discussed.

Institutionalised art museums traditionally exude an air of respectability and authority, leading many visitors to be trusting and often uncritical of what is 'dished up' to them. Nowadays, however, curatorial processes in the museum are being increasingly demystified, with techniques and concepts being shared with museum visitors, allowing them to grasp the forces that are at work behind the scenes in the gallery. This helps to market the art museum and enhance the museum experience, attracting new, younger audiences. The notion of the role of the visitor in the museum has become an important element in curation and the development of exhibitions – in fact, today, the 'imagined visitor' is an important component of museology.[7] Today's visitor is likely to be more thoughtful, more informed and more active in questioning what they see and experience.

Operatic works are very different from plastic artworks; they can be slippery creatures, and defining the essence of an operatic work from its many constituent parts is no easy task. The history of an opera is inseparable from the history of the many adaptations that it has undergone during its performance history: changes which often call into question the very identity of the work. It may be argued that many modern operatic productions present their audiences with a 'fake' experience, but this notion is dependent upon arriving at an understanding of what the original creators of the work – librettist and composer – had in mind. Did they consider their creation to be a 'work' at all, and did they consider that somewhere within it there resided a sense of 'artist's intent', a central concept in the art museum, based on the notion that 'the goal of art conservation should be to present the artwork as the artist originally intended it to be seen [and heard]'.[8] The conundrum of how much a composer considered their operatic creation to constitute a discrete 'work' (with all the trappings that the word implies) raises

an assumption that lies at the heart of much operatic (work-based) thinking and informs the creation of the many critical scholarly editions of operas which have appeared in recent decades. But what would happen if we discovered that the composer did not think in these terms? Suppose that an opera could exist in a fluid state, in a theoretically infinite number of guises, adapting for different singers, theatres and performance conditions, with every one of them potentially 'authentic'? In such a circumstance, an operatic 'work' (it is hard to avoid the term) may be said to exhibit 'multiple authenticities'. Not that such a concept is likely to cut much ice with the familiar kind of well-heeled operatic audience for whom a performance is most valued as a predictable, defined and reassuring experience. The opera lover is content to discuss the merits of a particular singer in, for example, *Don Giovanni*; they are often more uncomfortable when challenged over what actually constitutes the contents of that work. In operation here are certain tacit expectations about the plot, who will appear on stage and what musical numbers they will expect to hear. These all conjoin, somehow, to form the identity of '*Don Giovanni*' in the eyes and ears of the public. Opera, for many of its avid consumers, is a nostalgia industry, founded upon a sense of longing for an idealised past, often invoking the 'lost age of *bel canto*'. In the minds of most opera lovers, that idealised past leads back to a magical moment when a composer, long dead, lays down their pen and declares their work 'complete'. This is a convenient fiction, upon which much operatic misinformation but also many of the practices of the opera industry are based.

What exactly is an 'operatic work', and how might we recognise it? For the moment, let us assume that it is a printed volume: a score, perhaps a critical, scholarly edition. Often, such scores are expensive and beautifully bound – they appear authoritative and canonic, they contain the work of the librettist, which has then been set to music by the composer. The libretto would seem fundamental to the enterprise – so why is *Don Giovanni* popularly considered to be an opera by Mozart? If the libretto has been written in verse, placing it in the context of a musical score will distort the structure and flow of the text – the composer has extended the natural length of certain syllables, shortened others and often repeated some lines of text a number of times. The musical score may be said to contain a distortion of the librettist's original work.

What happens to the operatic score when a new production is created of *Don Giovanni*? The work of the composer is approached with great care – Mozart still inspires such respect. In this case, we are dealing with not just an operatic work but an operatic 'masterpiece'; for such iconic works, special conditions often apply. Valiant efforts are made to condense *Don Giovanni* into a single, 'authentic' form for performance. Constructs such as *Werktreue*[9] are used to ensure that the interpreters remain faithful to the spirit of the 'work'. In the modern opera house, however, the concept of historically informed performance (HIP) has more recently become a regular visitor, and the accepted convention today is to strive for a sense of authenticity that may often be selective but which at least anchors the parameters of interpretation broadly within conventions of performance that relate to the work's era of composition. This is a particularly important concern

as that era inexorably slips away, leaving performers with 'music of the past' or 'ancient music' to contend with. Today, 'authenticity' is an important trope in musical performance, and the opera house does its best to ensure that the work of the author who appears most prominently on billboards and programmes (i.e. the composer) has been correctly represented.

And what of the hapless librettist? The sung text that they have penned will be treated with some degree of respect – assuming that the opera is sung in the original language. A time-travelling librettist from an earlier era might be shocked to discover that today, operas are regularly performed by singers with a less than fluent grasp of the libretto's original language, while audiences largely rely on surtitles. But what of the stage directions provided by the librettist? The plot? The period in which the work is deemed to take place? All of that is negotiable today, a process that involves a living stage director and a long-dead librettist. Most opera goers are not particularly interested in how early performances looked onstage – that aspect of authenticity is generally ignored today. There is, however, much information and evidence available, and in recent times, academic interest in early production books and related source material has experienced a renaissance. Nevertheless, opera is generally recognised to be an artform that requires a facelift at regular intervals. The operatic industry and economy is dependent on its most bankable assets receiving regular updates which bring modern technologies and concepts to bear on the works, so that their production incorporates the visual languages prevalent in film, television, musical theatre, contemporary art and architecture.

During the early twentieth century, the art museum experienced a crisis, which resulted in the partitioning of traditional and avant-garde art often into entirely separate buildings. The traditional museum was held to be an outmoded institution, and many artists were concerned to critique and deconstruct it. The opera house was also transformed during the late nineteenth century by a somewhat different turn of events, when it began to develop a museum-like culture, whereby primarily canonic works of the past were performed. A decline in new works saw the opera repertoire turning in on itself. While new operas continue to be written today, few find a place in the repertoire, and performances are generally rare. The repertoire continues to simulate renewal by looking back into the past, unearthing and reviving works that have become extinct, in order to access a supply of 'new' works, which also carry the allure of being discoveries from the deep past, like treasure raised from a shipwreck. Such works can be a gift to the interventionist style of director, who acquires an opera without performance traditions that may be radically adapted according to their tastes and beliefs. In a relatively recent development, the director has come to dominate the operatic hierarchy, playing an active, quasi-authorial role in the presentation of opera; one that may be usefully compared with that of the celebrity-style curator of contemporary art. It has become common practice to interrogate the work of the opera librettist: to examine the text, analyse it and identify wider themes that can be grafted onto the original story, on occasion even completely reinventing the original story, using the tool of dramaturgy, to update the original work for modern sensibilities.

This outline has hardly skimmed the surface of the complexities of modern operatic practice, and for all that the catch-cry of 'the death of opera' continues to be evoked, opera survives and even thrives as a financially draining artform that is propped up, in central Europe, for example, by significant government funding, and elsewhere by private sponsorship. In Northern America, opera continues to be a glamorous commodity for the wealthy and a cultural link for various waves of emigrants from Europe. Like those emigrants, European opera has been assimilated into American culture. Opera has, in effect, become a modern *Wunderkammer* – a cabinet of curiosities, combining sublime and diverse music, colourful and compelling stories, along with a blank onstage canvas, which may be filled with visual elements from any period, animated by new media and technologies, a repository for directorial obsessions, creating something new, exotic and not infrequently controversial from an eclectic array of elements.

Opera today is deftly curated by a number of functionaries whose curatorial roles have only in recent years been recognised as such. Who are these curators? The conductor and the stage director may be the obvious candidates, but there are many more hidden in the behind-the-scenes recesses of the opera house. Today, the curator plays the role of priest, magician, intellectual, cultural apologist and architect – one who designs and builds a bridge to the past. The following chapters examine the world of opera through the lens of curation in order to encourage an enriched understanding of the art form. Operatic works have been constantly 'reinvented' ever since the genre took shape at the dawn of the seventeenth century; that characteristic seems to be an almost overriding part of their identity. There is nothing new about this except that today such processes need to be justified, ensuring that they conform to notions of authenticity in the musical domain of the operatic enterprise, and create a curatorial platform that legitimises the results that play out onstage.

This study examines the rise of opera and the development of the commercial opera house, tracing it through to its metamorphosis into the 'operatic museum' during the later nineteenth century; a period that happens to be broadly contemporaneous with the rise of the public art museum. Comparisons are drawn between the curatorial practices of the operatic and art museums, allowing similarities to be charted and synergies to emerge. Just as collections were formed in art museums, so, too, did the opera repertoire develop, though in a rather more gradual process. During the spread of opera through Europe (and beyond), certain works proved persistent, surviving in a market which was largely based upon a constant supply of new works with little regard for the fate of older ones. The development of the operatic repertoire was a complex phenomenon, but central driving forces were the operatic works and Romantic myth of Mozart, as his posthumous reputation developed as a canonised, deified figure in the culture of the nineteenth century.

Curatorial roles within the opera house are explored, and the chief musical functionaries operating within the central-European opera house system are outlined, along with the very structured hierarchies that seed complex power struggles within working environments. It is proposed that the operatic works of

Richard Wagner, along with the legacy that he created in his early productions at Bayreuth (particularly the 1876 *Ring* cycle production and the première of *Parsifal* in 1882), were the direct precursors of many developments in the production of opera during the following century. Wagner's work exercised a huge influence on the development of operatic dramaturgy and associated curatorial practices in the opera houses of the world. Having created both the text and the music of his music–dramas, Wagner finally also became the stage director and dramaturge (the *Gesamtschauspieler*) of his self-styled temple to his art, Bayreuth. It is Wagner's concept of musical dramaturgy, explored through his own music–dramas, that has had a defining impact on twentieth-century opera, freeing the workings of the stage from a literal approach to the libretto, and during the post-war era, spawning the rise of *Regieoper*.[10] Today, Wagner would be celebrated (and just as likely deplored) as a celebrity curator, and it is with an examination of curation that we begin this study.

Notes

1. In the National Gallery of Victoria, Australia.
2. Hugh Moss, *The Art of Understanding Art* (London: Profile Books Ltd, 2015), 117.
3. www.google.com/search?q=musical+hoaxes&oq=musical+hoaxes&aqs=chrome.69i57.3752j0j1&sourceid=chrome&ie=UTF-8, accessed 20 July 2020.
4. Frederick Reece, 'Composing Authority in Six Forged "Haydn" Sonatas', *The Journal of Musicology* 35, no. 1: 104–43.
5. Ibid., 105.
6. Ibid., 143.
7. See: Christopher Whitehead, *Museums and the Construction of Disciplines* (London: Gerald Duckworth & Co. Ltd., 2009), 32.
8. Steven W. Dykstra, 'The Artist's Intentions and the Intentional Fallacy in Fine Arts Conservation', *Journal of the American Institute for Conservation* 35, no. 3 (1996): 197.
9. The concept of fidelity to the work or 'masterpiece'.
10. Literally, 'director's opera'.

Part I

1 'Curationism'

Curating the world

We live in an age of 'curationism': one of many offshoots of the verb 'to curate' that have proliferated in recent decades in response to the growing perception of the act of curation as a process that is central to the way we chart and navigate our civilised world. The word 'curate' continues to transform in ways that indicate a rapid shift in meaning and usage – 'curate as a verb ... the adjective curatorial and the noun curation'[1] – not to mention 'curationism'. A recent book bearing that title claims to show 'how curating took over the art world and everything else'.[2] Alex Farquharson, director of Tate Britain, has noted that 'the recent appearance of the verb "to curate", where once there was just a noun, indicates the growth and vitality of the discussion ... new words, after all, especially ones as grammatically bastardised as the verb "to curate" (worse still the adjective "curatorial") emerge from a linguistic community's persistent need to identify a point of discussion'.[3]

A century ago, the term 'curator' evoked a shadowy figure, working behind the scenes in musty, unventilated rooms, pulling invisible strings that animated the inner workings of the museum. Today, our world is widely and visibly curated, with the new wave of curators enjoying, in many cases, almost the status of pop stars. The author has, in recent memory, taken part in both a curated cheese and a curated wine tasting, as well as being invited to a curated exhibition featuring the newly released models of a luxury car manufacturer. Our world is increasingly populated by content curators, biocurators, data curators and digital curators, to name but a few of the types emerging in recent years.

Within the art world, the term 'curator' has substantially altered in meaning, the result of a division whereby the same word can signify quite different functionaries. Public art museums still employ curators who perform the same background roles as in the past, albeit in a slightly more visible way. In recent times museums have begun to interface more actively with their visitors, marketing the experiences that are offered, and demystifying the practices that they employ in maintaining and presenting their collections. The figure of the traditional curator has become more visible to the public as institutions seek to promote the value of the museum experience within today's society. The new generation of modern art curators are cut of very different cloth from the traditional curator type, being

typically glamorous, charismatic or quirky: figures such as Hans Ulrich Obrist, Harald Szeeman, Carolyn Christov-Bakargiev and Rose Lee Goldberg embody the post-war phenomenon of the self-styled, celebrity curator who dominates the contemporary art world of today, being often referred to as an *Ausstellungsmacher*.[4] These high-flying figures have transformed the art world, and in so doing, have redefined the relationship between the curator and the artist, with the former not infrequently emerging as the dominant force.

In light of the emergence of curation as a driving force in our culture, this book interrogates the world of opera in order to discover what curatorial forces drive and define the art form. Both the history of opera and the workings of the modern opera house are explored, revealing curatorial processes that have been gradually taking shape since opera's rise in the early seventeenth century. By the second half of the nineteenth century, the opera house had assumed an identity as an 'operatic museum',[5] and opera companies increasingly occupied buildings whose façades resembled those of the traditional art museum. As the production of new operatic works began to atrophy, a fixed repertory gradually defined itself, effectively becoming the 'core collection' of the operatic museum. As the creation of new operas continued to decline, works from the existing repertory began to assume canonic status, forming a collection of operatic classics, which today is curated according to established principles, ensuring the survival of a genre that is generally recognised today as being a 'museum culture'. Who are the opera curators of today? Who makes the decisions that lead to new productions and repertoire selections? How have operatic works survived over time, and what curatorial practices have facilitated their survival? Are there synergies of approach that emerge when the processes of the opera house are compared with those of the traditional, public art museum? Does a consideration of how artworks and operatic works are curated within their respective institutions shed light upon both institutions, revealing the games that are played within modern museums to 'dish up' the past to audiences or visitors? Having established a division in the meaning of 'curator' in the art world, is a similar division discernible in the world of opera? Is operatic practice also governed by a combination of shadowy custodians and more visible personalities, the modern powerbrokers in the business of opera?

The inner workings of museums have traditionally remained closed to the general public, a circumstance that has often been perceived as a lack of transparency and has, at times, led to a crisis of faith in museum processes, causing controversies to erupt. Such cases often play out dramatically in the press, affording the public a glimpse into a hidden world that they barely grasp, and bringing the realisation that this world subtly influences their experience of the museum and its collections. Artefacts are restored and prepared for display; information relating to works is organised and disseminated in the form of catalogues, gallery labels and audio guides. The opinions, knowledge and even personal aversions or enthusiasms of curators are transmitted in their choices and decisions when planning exhibitions. In the operatic museum, the musical score is the basis of the work's identity when creating productions. The 'support' of

the operatic work (the libretto) is critically examined and frequently altered in a variety of ways to render it accessible and relevant to modern audiences. Both institutions make their works/collections available for public consumption, a transaction that may, or may not, include an admission fee on the part of the visitor to gain admittance. Is it possible to guarantee that curation will remain an altruistic process when the presentation of works for the public also involves attracting a paying audience to the hosting institution that may be (partly) dependent upon such takings to fund its operations? The experience of visiting an art exhibition or an operatic performance involves entering a complex environment and taking part in a 'staged' experience, guided, in many of its aspects, by unseen hands. The assumption is that such museums employ established methodologies and underlying philosophies when engaging with works and preparing them for performance/exhibition. At the heart of these processes lies the guiding principle of authenticity (*Werktreue*), which involves consideration of the circumstances under which the work was created, the period in history from which it originates and at what point the work may have been considered by its creator to be complete – raising complex questions of authorial intent which, in turn, begs the question of the exact identity of a 'work', posing potential dilemmas for its preservation or restoration.

A seventeenth-century painting created for a predetermined position in a sombre, dimly lit church will acquire a different aura when hung in a brightly lit, modern gallery. Objectively speaking, the painting remains the same, but the context of its surroundings redefines the viewer's perceptions. How does the viewer begin to contextualise this experience? What kind of 'authenticity' is being offered by the curatorial team? While defining 'authenticity' is already a complex matter in the context of the art museum, the complexities multiply exponentially when considering works as multi-faceted as operas.

How is it possible to convince an opera goer that they are attending a performance of, for example, Mozart's *Così fan tutte* when, as the curtain rises, instead of a café in eighteenth-century Naples (as specified by the librettist), they are confronted with a contemporary diner in a north-eastern beach town in America? Does the familiar sound of the music override visual perceptions, providing audiences with the reassurance that this is Mozart's music, so it must be *Così*? What is the essence of the opera *Così fan tutte*? Does it reside equally in the music of Mozart and the text of Lorenzo Da Ponte, or has the balance shifted today? Why is the music generally performed according to prevailing notions of 'authenticity', whereas the plot and the text have become negotiable fields? These are complex questions to ponder, and although the posturing of radical stage directors has weathered its fair share of criticism over the years, transpositions of place and time in operatic plots have become almost *de rigueur* today. A visitor to a modern opera house will probably find that the staging of most productions bears little resemblance to the instructions contained in the libretto. The musical elements of the production will most likely have been prepared with some reference to 'authenticity', for example working with a scholarly critical edition of the score, giving due consideration to stylistic matters, and undertaking preparation

according to current understandings of historically informed performance practice (HIP). In spite of these efforts to engage with notions of musical authenticity, it can be safely assumed that what is heard in such a performance does not resemble that which was heard at the work's première in 1790. The search for authenticity that pervades so many aspects of contemporary life and culture remains disturbingly elusive, and we discover that 'the past is a foreign country'.[6] Foreign it may be, but our culture inclines heavily towards it, longingly. Our next task is to enter this foreign realm, the past as presented in a modern museum. When a visitor enters a museum to engage with works and objects, how exactly does their experience unfold?

Visiting the art museum

On approaching an art museum, the visitor may well pass beneath a classically referenced façade through which they enter an outer foyer that, by its design, suggests a hallowed Temple of Art. What is the intention of the visitor? Perhaps to view works by a favourite artist, or from a particular period, or school of painting? To wander randomly, flaneur-like, drawn to works that catch the roving eye? Or else to engage in a more structured experience, viewing a complex agglomeration of works, perhaps arranged as a themed exhibition? Moving through the gallery, how is the visitor's interaction with an individual work influenced by others displayed nearby? Is there some constructed narrative thread that influences the sequence in which the works are hung, designed to add depth to the visitor's experience? How does the architecture of the gallery relate to the style of the artworks, and how does this influence the perceptions of the 'imagined visitor'?[7] Is the viewer made aware of the history of the painting they are studying, and, in the case of a work of considerable age, what information is imparted to them about its condition? Has the painting been restored, and if so, how extensively – how much of the artist's original work is in evidence; has it been significantly retouched, and how have areas of paint loss been resolved? What lies beneath the shiny surface of the painting – does the gilded frame conceal evidence of the work having been cut down from its original size, and are the supports of the painting original? Is the handsome, ornately carved frame original, and if not, does it broadly reflect a style that the artist might have chosen? Is the provenance clear and the attribution fully resolved, or might the work occupy the shadowy borders of art attribution where many worthy pictures languish in a twilight world of 'school of', 'in the manner of', 'after' or 'studio of'? In short, how aware is the viewer of the unseen curatorial hands that conserve, restore, authenticate and display artworks? How cognisant is the viewer of the forces that animate their museum experience? There is nothing new about these questions, but there is a growing awareness of an element of subtle manipulation being brought to bear upon the viewer when visiting a traditional art museum, a transaction that has become an important element in the theory and practice of modern museology. Most viewers are willing to be led by trusted experts regarding areas in which they are but enthusiastic novices.

In the art museum, signs are typically placed adjacent to works, providing context and offering information for the education of the visitor.[8] The impact of these signs is far from straightforward. It has been suggested that:

> The imagined visitor him or herself is actually curatorially authored. The imagined visitor is the moving, seeing, reading, learning, intellectualising, behaving and feeling element in curators' visions of display spaces.[9]

The signs can become intrusive as the viewer moves forward to read the small print, thereby losing contact with the work itself – a situation that is mirrored in the use of surtitles[10] in the opera house, where an audience member may be more inclined to follow the translation than to experience the visual and musical spectacle before them. A phenomenon regularly occurs at exhibitions whereby some viewers move backwards in order to engage with an artwork from a distance, while others move forwards in order to study the explanatory text. A shuffle ensues that often renders the process alienating and unsatisfying for all concerned.

Today, visiting an art gallery has become an event that involves the viewer in an active, collaborative role. Rather than being invited to surrender to a staid, almost religious ritual, as was the case in the past, visitors to art museums today are invited to actively question what they see and to consider how the objects with which they interact have come to be part of the museum's collection.

The art museum's operatic counterpart

When visiting an opera house, the opera goer may also pass beneath a classically referenced portico, to experience a single work, selected from the company's current 'opera season', which is defined by a group of works that have been programmed for performance in rotation, offering a carefully chosen selection from the repertoire to provide subscribers with a varied and satisfying operatic diet. The operatic repertoire consists of approximately 100–150 core works[11] (regional variations account in part for the margin), and from this list, the artistic management of an opera house will make their selection. The repertoire, by its nature, will consist largely of works by long-dead composers, which is not to say that new works are not introduced from time to time, but they tend to be the exception. This almost prurient interest in works of the past is the outcome of two aspects of operatic history – first, the significant decline in operatic production that took place during the course of the later nineteenth century, and secondly, an almost concurrent rift that developed between composers and their audiences that widened as the twentieth century progressed. Today, operas are marketed in ways that convey a primarily composer-based perception of the works on offer – Verdi's *Il trovatore*, Puccini's *La bohème* etc. – the name of the librettist will generally not be included in marketing material and will be harder to recall, even by an enthusiastic opera lover; a curious situation in view of the fact that no opera could exist without its libretto. There have been many distinguished operatic collaborations involving great, complementary literary and musical minds: Lully/Quinault,

Gluck/Calzabigi, Mozart/Da Ponte, Meyerbeer/Scribe, Verdi/Boito, Strauss/Hofmannsthal and Wagner/Wagner, to name but a few. Nevertheless, the librettist is generally marginalised today in the marketing of operas, becoming a silent partner to the composer. This is also reflected in the means by which opera plots are reworked, manipulated or seemingly ignored by the current practices imposed by the stage director, which leaves the librettist one of the operatic casualties of the present day.

Prior to the performance commencing, the audience may be seated in a Rococo-style auditorium glittering with sumptuous embellishments, gold highlights and sparkling chandeliers. The dimming of the lights prior to the performance commencing effectively cancels out that space, and the audience is drawn into another world that will shortly emerge from the darkness of the stage. The conductor (*maestro*) enters the orchestral pit, wearing formal evening attire and thus setting the tone for the evening. Lights are dimmed and at a predetermined moment the curtain(s) will rise, or part. The orchestra will begin playing the score, producing a sound that is of a recognisably 'modern' orchestra, one that would not necessarily be familiar to the composer of the work being performed. Over the last 200 years, orchestral instruments have developed in a variety of ways: stringed instruments now play on steel, rather than gut; wind and brass instruments have been refined to produce sounds that the modern music industry deems to be more pleasing to the modern ear; timpani are now quickly and chromatically tuned using pedals. When performing music from the more distant past (prior to the nineteenth century), some concessions to authenticity may be made by creating a hybrid configuration of the orchestra. An opera by Mozart, for example, may employ an orchestra with natural horns and trumpets substituting for their modern cousins, along with Baroque-style timpani, while the remainder of the orchestra will play on modern instruments. The work will typically be played by what is termed a 'Mozart orchestra',[12] a modern construct of the orchestra considered to have been at the composer's disposal. In even earlier works, from the seventeenth century for example, a specialist ensemble may be hired in to provide instruments that are not found in the modern orchestra – harpsichords, theorboes, lutes, portative organs etc.; a string section playing on gut strings and making selective use of vibrato; and earlier prototypes of wind and brass instruments including natural horns, all of which may be tuned to a so-called 'Baroque pitch'.[13]

As the stage is revealed, the opera goer may be perplexed to see a white or black cube space emerge, similar to that of a modern art gallery, or else a set design that bears little resemblance to the period or location of the opera's plot as described in the libretto. The sung text may also have been altered, aligning it with the transpositions of time and place that have been dictated by the librettist's modern apologist, the stage director. Beneath the stage, the orchestra produces sounds that are recognisable and familiar, while onstage, operas are transformed in ways that no librettist from the eighteenth or nineteenth century could have imagined, let alone condoned. The librettist in earlier times was not only responsible for composing the text and describing the scenic elements of the opera in detail; they were also engaged to attend the rehearsals for the première and ensure that their

instructions were followed to the letter. The scale of the transformation that has taken place in operatic production values during the twentieth century, particularly during the post-war years in Germany, can be gauged by examining photographs of some of Wagner's original designs[14] for his own productions at Bayreuth[15] (where he sought to realise his own staging instructions in a literal fashion) in comparison with images of the post-war festivals at Bayreuth, which revealed a radical new aesthetic that was introduced by the composer's grandson, Wieland Wagner (1917–66).[16] Just a few minutes after the commencement of a notional opera performance, the opera goer is already swamped by curatorial conventions that will significantly influence their perceptions of the work whose performance they are attending. The seasoned opera goer may be content to accept much of what they experience without question. They may, for example be oblivious to the fact that for much of the nineteenth century, the conductor had a different function from that undertaken in a modern performance. Conductors did not stand against the wall that divides the pit from the audience, as is the custom today; rather, they would stand in the middle of the pit, or even directly in front of the stage, where they could exercise greater influence over the singers, though with proportionally less control over the orchestra, many of whom faced backwards (from the audience perspective) towards the stage in an attempt to see the conductor, causing a corresponding change to the sound and balance as experienced by the audience. In Italy, during the same period, performances were more likely to be led by the principal first violinist, who, in addition to playing, effectively had charge of the whole orchestra, although sometimes the load was shared between the leader and the conductor, who also assumed many of the duties of the modern prompter.[17] In considering the role of the conductor in a modern performance, we are presented with a dynamic that is far removed from that which pertained in earlier times. If each individual element of our notional opera performance were examined in this way, it would become clear that today's performance conditions vary markedly from those of earlier times. This may not be a 'bad' thing – many opera lovers find themselves nonplussed upon hearing early recordings by some of the legendary singers of the past, as they listen in vain to discern the qualities that built the reputations of those artists. A modern performance of an opera raises a number of complex issues of authenticity: in an attempt to create the best of both worlds, certain traditions of the past have been retained, while many others have been ignored, with selective historicism an ever present feature of the modern operatic museum.

The central-European operatic and art museums are broadly comparable in a number of their characteristics. The traditional opera house performs works selected from an established repertory, a 'permanent collection' mostly assembled prior to the early twentieth century. The 'core collection' of an opera company comprises the active productions that it maintains in its repertoire, which can be revived at any time for performance, from which a 'current exhibition' or opera season is chosen. Entering the operatic museum for the first time may be more confronting than entering the art museum. The opera house adopts a different social code than the museum, and the predominance of evening opera

performances raises questions of apparel, demeanour and applause conventions, which are more relaxed today than in earlier times but can nevertheless be daunting for a novice opera goer. Attending opera performances can be an expensive pastime. In the central-European model, where theatres are still highly subsidised, seats are available at a wide range of prices; for students or others on a limited budget there are *Stehplätze* (standing room), *Hörplätze* (from these seats you can hear, but not see the performance) or seats with a limited view that are hardly more expensive than the cost of a special exhibition in an art museum. In other parts of the world, opera funding is more precarious, and the more dependent the opera house is upon subscriptions and single ticket sales, the higher the ticket prices will be. In contrast to the art museum, which will usually have a stable funding model, the opera house outside central Europe is frequently a quixotic enterprise, often hovering on the brink of financial crisis. The mandate is always to maintain the highest musical standards and production values, but when a management focuses upon its balance sheets, the danger emerges that the identity of operatic works may become compromised when realised on the stage.

Crisis in the museum

During the late nineteenth century, the traditional art museum came under the scrutiny of artists themselves, who began to critique the hallowed environments where their works were exhibited. The museum was perceived by members of the avant-garde as an obsolete institution, ill-equipped to meet the needs and aspirations of modern society and hence the modern artist, a sentiment neatly summed up by Marcel Duchamp's comment that museums were 'morgues of art'.[18] The ensuing crisis of identity that occurred within the art museum played out over the greater part of the twentieth century, and from the end of World War II, a clear-cut division is evident within the art world. The results can be observed in larger cities that boast a traditional art museum (generally housed within a temple-like, classically referenced building) along with a museum for modern art (which may be a new wing added to the older museum, or, to make the split even more obvious, a completely separate building). The new wing or building will typically be of a contemporary design, perhaps with a Miesian-inspired exterior (in effect, a modern temple) with a white cube interior. A thick, though nervous, fuzzy line came to be drawn between art of the 'past' and that of the twentieth century, leading to new methodologies by which art was presented to the viewer, who also became carefully positioned in the overall experience.[19] As the century progressed, avant-garde artists continued to pour scorn upon the established art museum, occasionally depositing a decaying animal or a pile of bricks within its confines to stage a post-modernist protest. In this wide-reaching shake-up of how museums, artworks and visitors interact, the role of the curator acquired new definitions and meanings, while the art museum's relationship to its audience and their expectations and social makeup also began to shift. Terminology was redefined to describe those who work in museums and undertake curatorial functions. In relation to exhibition and display, art could be experienced in

a museum, an *Ausstellung* (exhibition) or a *Sammlung* (collection) – each with slightly different shades of meaning and significance.[20] A museum may host an *Ausstellung*, though a museum does not necessarily possess its own *Sammlung*. A *Sammlung* is not necessarily a museum. Visitors to art institutions were categorised as either *Konsument* (consumers), *Besucher* (visitors) or *Kenner* (experts). Traditional curators were known as *Aufseher* (overseer, attendant), *Kustos* (custodian) or *Kurator* (curator), while the new wave of contemporary art curators were referred to as *Ausstellungsmacher* (makers of exhibitions).[21] Contemporary artists have applied their practice to critique the traditional role of the curator as conservator, as when, for example, the corpse of a shark, imperfectly preserved in formaldehyde and decomposing, became an insoluble curatorial conundrum ('if refurbished or replaced the shark became a different artwork'),[22] or when Robert Rauschenberg (1925–2008) created an artwork by erasing a drawing by Willem de Kooning (1904–97),[23] leaving a ghostly shadow that a traditional curator would read as a damaged artwork in need of restoration.

During the final decades of the nineteenth century, the operatic museum also faced a crisis of identity, although this did not play out as an avant-garde revolution: it was simply the case that the creation of new operas declined sharply as the century wore on. In Italy, which had led the production of operatic works during the nineteenth century, the business of opera went into decline and the industry shrank.[24] By the turn of the century in Paris, the repertoire had begun to retreat into the past, with revivals of works by Mozart and Gluck becoming more sought-after fare for opera goers than new works.[25] The repertoire of the opera house increasingly turned towards a small selection of older works, as the performance of new works declined and opera atrophied into a shrinking nostalgia industry. During the latter part of the nineteenth century, Gioachino Rossini (1792–1868), the celebrated composer of nearly 40 operas, was remembered for just one opera, *Il barbiere di Siviglia* (1813), which alone survived the century in the active repertoire. Recent histories of opera attempt to define a work that represents the last 'great' opera that was composed,[26] usually alighting upon either Puccini's *Turandot* (1926), or Alban Berg's *Lulu* (1937), significantly both works that were left incomplete and unresolved by their respective composers. Study of the active repertoires of most opera houses today will reveal institutions that are largely disconnected from music of the present, instead continuing to programme offerings of old works by long-dead composers. If it is felt that the repertoire model is limited (such concerns generally arise during periods where funding models come under review) by the regurgitation of a staple diet of *La traviata*, *Madama Butterfly* and *Die Zauberflöte* pushed for all they're worth, it is likely that managements will prefer to turn their attentions to works of the even-more-distant past (rather like resurrecting a dodo), trawling around for long-extinct masterpieces from the Baroque or pre-classical period. On rare occasions, new works are introduced, after which they then face the considerable challenge of securing performances beyond their première, treading the long road that needs to be travelled for a work to establish a footing in the repertoire – the true test of its viability.

During the twentieth century, the institutionalised opera house became a prohibitively expensive model, widely perceived as a plaything for the wealthy, or the upwardly mobile, who turned to the art form for social, as much as artistic, nourishment. The trope of the 'death of opera' has been much rehearsed throughout the twentieth century, sometimes with murderous intent, for example when Pierre Boulez (1968)[27] suggested that opera houses should be blown up, thereafter accepting lucrative conducting engagements in some of the most iconic examples. The state of almost total destruction of Germany at the close of World War II precipitated a cultural crisis that demanded nothing less than a wide-ranging reconsideration of the position and significance of culture in post-war European society, causing much deep reflection about the relevance of the operatic canon in the new cultural landscape. This in turn gave rise to a new aesthetic of opera production, which has come to be known as *Regieoper* (the term is used both to define a category and also on occasion as a pejorative condemnation), which remains influential today, particularly in central Europe. This new direction was driven in part by a determination to establish relevance for the traditional opera repertoire in post-war society. In effect, operatic works became 'open works',[28] 'negotiable works' – with the opera libretto becoming the main point of discussion. The concept of the libretto as a negotiable tool may be compared with the curatorial challenge that faced contemporary art curation, which became, in the words of Swiss curator Harald Szeeman (1933–2005), 'the great balancing act' between illustrating the curatorial concept and 'preserving the autonomy of the artworks'.[29] Opera has also had to contend with issues stemming from what must be considered an ageing repertoire – the sheer length and scale of many works, which to modern audiences are ungainly, as well as the rise of new genres such as film and the musical.[30] The general public who attend an opera performance today will expect to have a visual experience that is in some way comparable with these competing artforms. All of these issues have conjoined to define the current crisis in the world of opera.

With works of the past providing the main fare of the opera house, contemporary dramaturgical and visual techniques and concepts have increasingly been grafted onto them in order to maintain their relevance in modern times. Post-war developments in the visual arts and spoken theatre have acted as a trigger that ignited a more 'contemporary' aesthetic in opera productions.[31] It was clear that opera was not about to renew itself by presenting seasons of brand-new works, which would have alienated audiences. Rather, influenced by the visual worlds of Broadway, the Hollywood film and even modern architecture, works of the past were revitalised by the acquisition of new visual and production techniques. This has also involved importing practitioners from these areas as designers and directors, with notable film directors (Werner Herzog[32] and Michael Haneke[33]) making forays into the world of opera production, along with choreographers and visual artists (David Hockney[34] and William Kentridge[35]), who took production values in new directions. One of the high priests of the contemporary artworld, Hans Ulrich Obrist, has even created (curated?) an opera[36] that has infiltrated (with some notoriety) the Vienna Staatsoper and other operatic venues.

Notes

1 David Balzer, *Curationism* (Toronto: Coach House Books, 2014), 8.
2 Ibid.
3 Judith Rugg and Michele Sedgwick, *Issues in Curating Contemporary Art and Performance* (Bristol: Intellect Books, 2007), 15.
4 Anke te Heesen, *Theorien des Museums* (Hamburg: Junius Verlag, 2012), 24.
5 There is an overlap of meaning between the descriptors opera house, operatic museum and institutionalized opera house – with some interchangeability. Opera house is a generic term that refers to a building where mainly opera performances take place. The opera museum refers to the phenomenon that arose during the nineteenth century of certain operas acquiring canonic status and being given under conditions that aligned in some way with notions of a museum-like environment. Such an institution in modern times is generally referred to as an institutionalized opera house. These terms have been used as deemed most appropriate to the context.
6 The title of David Lowenthal, *The Past is a Foreign Country* (Cambridge: Cambridge University Press, 1985).
7 The notion of the 'imagined visitor' is discussed in Christopher Whitehead, *Museums and the Construction of Disciplines* (London: Gerald Duckworth & Co. Ltd., 2009), 32.
8 Ibid., 32–3.
9 Ibid., 32.
10 Surtitles, or supertitles, are a trademark of the Canadian Opera Company, who first used them in 1983. They are now used fairly universally for providing translations in a variety of languages for opera productions.
11 Whitehead discusses the hierarchy of the canon in Whitehead, *Museums and the Construction of Disciplines*, 29.
12 A 'Mozart Orchestra' indicates primarily the number of strings to each part that could be considered 'normal' in Mozart's time (10, 8, 6, 4, 2). The term further eschews the doubling of winds, which became usual during the later nineteenth century and much of the twentieth.
13 A construct that was developed during the first half of the twentieth century, taking the very general notion that pitch was lower during the Baroque period, and standardizing it at around a half tone lower than modern pitch.
14 A selection can be found by searching 'Richard Wagner, *The Ring* cycle, Bayreuth, 1876' on Google Images, accessed 27 February 2019.
15 Wagner directed the 1876 *Ring* cycle at Bayreuth. While he had experts to specifically assist him with stage movement and scenery, he was heavily involved in all aspects of the preparations for the performances.
16 Wieland Wagner's life and career are discussed in Geoffrey Skelton, *Wieland Wagner: The Positive Sceptic* (London: Victor Gollancz Ltd., 1971).
17 An engraving of Verdi conducting suggests the dynamic: https://sfopera.com/contentassets/424e9df65a7f476d8a2e4c71b44615e6/aida-images--giuseppe-verdi-conducting-the-1880-paris-opera-premiere.pdf, accessed 20 February 2019.
18 Sarah Walden, *The Ravished Image or, How to Ruin a Masterpiece by Restoration* (London: Weidenfeld and Nicolson, 1985), 71.
19 As in Marcel Duchamp's 'Mile of string', which was created for the 'First Papers of Surrealism' exhibition of Surrealist art in New York, 1942.
20 Lines have become blurred – 'an exhibition must not necessarily take place in a museum, and a collection is not necessarily a museum'. Heesen, *Theorien des Museums*, 19.
21 Ibid.
22 Don Thompson, *The Curious Economics of Contemporary Art* (London: Aurum Press Ltd., 2008), 2–3.
23 An image can be seen at: www.sfmoma.org/artwork/98.298/, accessed 16 February 2019.

24 John Rosselli, *The Opera Industry in Italy from Cimarosa to Verdi* (Cambridge: Cambridge University Press, 1984), 165–77.
25 William Gibbons, *Building the Operatic Museum: Eighteenth-Century Opera in Fin-De-Siècle Paris* (Rochester, NY: University of Rochester Press; Woodbridge: Boydell and Brewer Limited, 2013), 19.
26 Carolyn Abbate and Roger Parker, *A History of Opera: The Last Four Hundred Years* (London: Allen Lane, 2012) – this book discusses the death of Puccini (1924) as the 'terminus' of the repertory, 527. Daniel Snowman, *The Gilded Stage: The Social History of Opera* (London: Atlantic, 2009) – this book discusses the 'staple operatic diet' as spanning from 1782 (Mozart, *Die Entführung aus dem Serail*) to 1926 (Puccini, *Turandot*).
27 Boulez, interview in *Der Spiegel*, 1968, discussed in: Ruth Bereson, *The Operatic State, Cultural Policy and the Opera House* (London: Routledge, 2002), 53.
28 A reference to Umberto Eco, trans., *The Open Work* (London: Hutchinson Radius, 1989).
29 Paul O'Neill, *The Culture of Curating and the Curating of Culture(s)* (Cambridge, MA: MIT Press, 2012), 22.
30 This matter is discussed in Christopher Lynch, 'Die Zauberflöte at the Metropolitan Opera House in 1941: The Mozart Revival, Broadway and Exile', *Music Quarterly* 100 (2017): 33–84.
31 Ibid.
32 See: www.wernerherzog.com/complete-works-opera.html, accessed 23 January 2019.
33 His opera debut was in 2006 (*Don Giovanni*, Paris) and more recently 2013 (*Così fan Tutte*, Madrid). See also: www.youtube.com/watch?v=aGnvwL88EnY, accessed 23 January 2019.
34 Hockney's opera productions include: Stravinsky, *The Rake's Progress*, Glyndebourne Festival Opera (1975); Mozart, *Die Zauberflöte*, Glyndebourne Festival Opera (1978); Wagner, *Tristan und Isolde*, Los Angeles Opera (1987); Puccini, *Turandot*, Chicago Lyric Opera (1991); and Strauss, *Die Frau ohne Schatten*, ROH London (1987).
35 See: www.opera-online.com/en/items/personnalities/william-kentridge, accessed 23 January 2019.
36 A performance can be found on: https://vimeo.com/68004608, accessed 24 February 2019.

2 Towards the curation of opera

Defining the museums

Now that we have briefly described each museum from the perspective of the visitor, the internal structure of a notional, traditional art museum will be defined. This museum will comprise a core collection, consisting primarily of Western painting and sculpture that may date from antiquity (in the case of sculpture) until approximately the end of the nineteenth century. The permanent display, derived from this collection, will form a survey of Western art, represented by the best examples that the gallery has the resources and opportunity to collect. Such a museum will also contain a dedicated space for hosting travelling exhibitions. More recent works from later periods will be partitioned, displayed in a separate wing or perhaps in a completely new building dedicated to 'modern art'. The notional museum will also hold works on paper in its collection – watercolours, pastels, drawings, sketches, prints of all types, etc. These works will be less often displayed; rather, they will be stored in a separate cabinet or collection (for example, the *Kupferstichkabinett* of German museums) for study by connoisseurs, while a rotating selection may be displayed in vitrines in the main galleries. A central point of similarity between the notional art and operatic museums is the display of a core collection of works, while others remain in storage.

In defining the operatic equivalent, the notional opera house, the German repertoire theatre has been selected as the model, examples of which exist throughout Germany in cities such as Mannheim, Wuppertal, Augsburg or Darmstadt. Virtually all of the sizeable opera theatres in the world are broadly based upon this institution, where a significant repertoire of 'live' operatic productions is maintained in the 'core collection' that can be quickly and effectively revived and performed, embracing the breadth of the repertoire from the lighter *Spielopern* and operettas to the music–dramas of Wagner. Over the course of a week, such a theatre may present a programme as varied as Wagner's *Lohengrin*, Lortzing's *Zar und Zimmerman*, Mozart's *Le nozze di Figaro* and Puccini's *La bohème* as well as one of the many operettas, such as Millöcker's *Gasparone*. The strength of such a system lies in its ability to maintain a wide and varied repertoire (a large, core collection) that is kept 'live' by having salaried soloists, chorus and orchestra at the management's disposal, whose collective memory and experience allow

productions to be revived with a minimum of rehearsal, not infrequently with just a single run-through. Solo roles are performed by the ensemble singers, or on occasion a guest who is hired in to substitute in the case of illness or indisposition. The substituting guest artist will typically arrive at the theatre on the day of the performance and learn the production in the space of a couple of hours, with the help of a resident director who is responsible for maintaining the integrity of the production. Costumes will be speedily altered, and the guest singer may have a short rehearsal with the conductor, or else they may simply 'meet' when the singer walks onstage for the first time during the actual performance – a not infrequent occurrence.[1] The conductor may be leading the opera for the first time: the concept of 'jumping in' (*einspringen*) is another curious characteristic of the German system and the means by which a conductor assimilates a large repertoire, while developing nerves of steel for the many unknowns that lie in wait in a live performance under such potentially perilous conditions. In this way, an opera that may have remained dormant for a number of months can be revived quickly (like an artwork hibernating in storage, in a state of suspended animation), ready to be revivified upon demand. This so-called 'repertoire system' is the typical working model of central-European opera houses, and the largest theatres maintain an impressive variety of productions that can be programmed in this way. This institution, as it has become, of repertoire opera is the cornerstone of the German opera house tradition.

The alternate opera house model is exemplified by the *stagione* system, where a single work is prepared for performance, in a lengthy and exacting rehearsal process, and then receives a limited number of performances. This approach to opera is usual in Italy (examples include La Scala, Milan; Teatro Regio, Parma; but also, the Paris Opéra and the Theater an der Wien, Vienna) and equates with the *Ausstellung*, or the visiting exhibition, in the artworld of today. An event is imported, carefully prepared and runs for a limited amount of time. This is exactly how public opera began in Italy, as a 'pop-up' event, when an impresario would hire a space, assemble an opera troupe and run a season of opera, after which the troupe generally disbanded or perhaps toured to another town. These two modes of opera presentation – repertoire and *stagione* – are subject to many local variations; nevertheless, they remain today the fundamental structural models of opera houses. *Stagione* is best considered as an idea rather than a specific practice that is too prescriptive. A number of opera houses today increasingly exhibit a hybrid structure, maintaining a fixed repertoire while also creating specialised productions (often of niche or more obscure repertoire that demands considerable rehearsal but will have only a limited number of performances) in the *stagione* manner. The practices of such houses are reminiscent of the art museum model that contains a permanent collection as well as dedicated spaces where travelling exhibitions can be accommodated. Examples of such hybrid (semi-*stagione*) houses are the Metropolitan Opera, New York; Bayerische Staatsoper, Munich; Vienna Staatsoper and the Komische Oper, Berlin.

With the notional opera house defined, mention should also be made of the opera festival, which typically takes place during the warmer months of the year

in Europe. Most festivals are of a 'pop-up' nature, with all the resources required being transported to the performance venue and removed at the conclusion of the season, along the lines of an *Ausstellung*. Two European opera festivals of a more permanent nature are noteworthy here, because although they give performances for only a small part of the year, they are far from 'pop-up' events; rather, they are institutions dedicated to the works of two iconic composers who feature in this study: the Salzburg Festival, founded around the works of Mozart in 1920, and the Bayreuth Festival, Richard Wagner's temple to his music–dramas. Bayreuth presents the case of an exclusive, rarefied event, essentially dedicated to the performance of seven operatic works.[2] Apart from the Wagner repertory, only Beethoven's Ninth Symphony is ever performed at Bayreuth, a stipulation that was made not by the composer himself but rather his heirs. The monumental scale of the Bayreuth Festival aside, it may be compared to a specialised niche art collection, perhaps a private *Sammlung*, that focuses solely upon a very particular subject, period or artist.

Having defined museums of both types and examined some of the processes that are employed to render and maintain the opera repertoire in a performative state, we now begin to consider the concept of opera curation, and how it manifests within the opera house. In articulating this practice, the following key concepts are central to the observations that are presented in the remainder of this book.

The notion of the operatic work

Consider the following positions (however unlikely):

a) a musicologist who has never attended an opera performance, and whose only experience of operatic works comes from reading the scores of these works, in silence at their desk, with the result that their sole experience of operas is a score-based one[3]
b) an opera lover who has attended countless operatic performances in theatres around the world, in a variety of productions. The opera lover does not read music, has never looked inside an operatic score, but does possess several comprehensive opera guides, outlining the plots of the established repertoire, which are sometimes consulted when preparing for a performance of an unfamiliar work
c) a devotee of the works of Wagner, who has decided to limit their listening experience of the composer's works to the most authentic examples possible. The enthusiast discovers a single recording of the Prelude to Act III of *Parsifal* that was made in the Festspielhaus at Bayreuth, conducted by the composer's son Siegfried, during the 1920s. This single recording comes to embody, in the enthusiast's mind, the most 'authentic' experience of the composer's work that could exist – recorded in the theatre that Wagner conceived *Parsifal* to be performed in, conducted by the composer's musical and consaguinous heir, at a period when the original production of the work,

created under the supervision of the composer, was still being presented in the theatre. The Wagner devotee eschews listening to anything other than this single recording: although it represents a mere fragment of the composer's oeuvre, it signifies for the listener the essence, the Holy Grail of Wagnerian authenticity

These three positions represent a range of possibilities as to where the identity of an operatic work resides. For the musicologist (a), it lies within the pages of the score, a document untouched by the work's performance history, a repository that is unsullied by ornamenting sopranos, tenors with interpolated high notes, and interventionist conductors. If the musicologist in question were to make a practice of only studying scores of the most recent scholarly editions, this may be considered to offer an 'authentic' experience that surpasses any performance in any opera house of a given work. The musicologist's experience of the operatic work would remain an abstracted notation-based view of a work which was, in reality, designed for performance, for the process of 'socialisation', which a work undergoes as it travels to different centres and theatres, rather than remaining house-bound, as though preserved in aspic.

In the case of (b), the opera goer, their understanding of a particular opera, for example *Così fan tutte*, will be based upon a blend of experiences – the collective memories of recordings listened to and performances attended. While the enthusiast possesses a wider experience of that work, including its performance history, they may never have seen a performance of *Così* that is set in its designated location – eighteenth-century Naples, with the tell-tale outline of Mount Vesuvius in the background. They will likely not be too worried by this circumstance, as their experience of opera going will have prepared them to expect that an opera can be subject to reinvention, not least of time and place. The opera goer is generally someone who seeks a reassuring blend of the known and the unknown. A subscription to an opera season will generally ensure that the works on offer are dominated by perennial favourites. The typical opera audience likes to be reassured by the familiar – this is the basic premise of the fixed repertory. Such an audience does, however, from time to time like to be confronted by some novelty – a new singer, a new production, nothing too radical, but the right mixture of the familiar and the unknown. Authenticity for the opera goer has little relation to the music score but is based on a blended series of recollections over time.

The third position (c) is the strangest – although it basically represents the position at Bayreuth in the years following Wagner's death, which was characterised by the tendency to idealise the past, and maintain the posthumous presence of the composer by ensuring that his pronouncements, wishes and productions were literally preserved, with the result that Bayreuth during this period regressed into an ossified museum culture. In identifying the most authentic Wagnerian experience possible, the devotee has paid a considerable price, one that does not allow the works of the past to be mutable, or re-imaginable.

The relationship between an operatic score and a realised performance identifies a point of tension that is one of the main themes of this book. When realising

the score, what kind of negotiations occur between the musical text and libretto? That question has greatly influenced the history of opera performance during the course of the twentieth century and continues to play a crucial role in how an operatic 'work' is currently defined. In considering the operatic work, it is proposed that the term refers to the musical score created by the composer,[4] which incorporates the text of the librettist. It may seem strange to define an operatic work in this manner; after all, the libretto was usually written before the music and has determined important elements of the work's structure. The theoretical structure for defining the drama within the operatic work is known as musical dramaturgy.

Musical dramaturgy

The basic premise of musical dramaturgy is that 'the primary constituent of an opera *as a drama* is the music'.[5] In the original conception of dramaturgy, a text became a 'drama' when it was realised as theatre (i.e. in performance); however, in modern usage, there is a confusion as to whether or not the 'text' itself (words and music) already embodies a 'drama'.[6] In other words, does the music of the composer effectively 'stage' the work? The *Leitmotif* technique developed by Wagner might strongly suggest that it does. In Wagner's own productions of his later music–dramas at Bayreuth, he was insistent that what was seen onstage and what was heard from the orchestra should align rather than occur in counterpoint. Today, however, it is generally accepted that the Wagnerian orchestra functions as a kind of Jungian collective unconscious, adding layers of meaning and depth to the stage action, but not slavishly illustrating it, as was implied by the old quip about *Leitmotif*s functioning as 'calling-cards'. How a stage director interprets and works with the musical tissue supplied by the composer is the basis of musical dramaturgy, which realises the essence of the drama from the score. A large element of this involves interpreting how the composer's score has articulated the drama in time, which may include real time (as in the case of *secco* recitative), slowed-down time, or time sped up. Instructive examples are found in the many operatic mad scenes, the most famous of which is found in *Lucia di Lammermoor* (1835). During this scene the orchestra articulates a state of madness, through artificially slowed-down time, against which the protagonist delivers the text in broken, fragmentary vocal delivery, alternating with sudden contrasts of unnaturally fast music, suggesting the onset of a sudden manic state of mind. Donizetti specified the glass harmonica to accompany the protagonist in her madness,[7] providing an unusual instrumental *tinta* to establish the uncanny atmosphere of the scene. Nellie Melba[8] – one of the role's great exponents – firmly established a tradition of the flute substituting for the glass harmonica as Lucia's companion-in-madness, and this popularly accepted expression of her affliction has been embodied in a series of voice and flute embellishments, culminating in a virtuosic and haunting cadenza, all of which were created long after Donizetti's death. Today these accretions are still regularly performed and have become an integral part of the opera in the mind of the public. Does one favour the original sound world

specified by Donizetti, or does one accept that somewhere in the later part of the nineteenth century a 'new' conception of Lucia's madness was established, which has bestowed upon the flute version a type of posthumous authenticity?

Other examples of musical dramaturgy at work can be found in the depiction of offstage events. In Benjamin Britten's *Billy Budd* (1951), for example, a conversation, central to the core of the drama, becomes abstracted into music when, on the night before Billy is to be hung for killing Claggart, Captain Vere enters the condemned man's cabin for a final conversation, leaving the stage empty. The audience is not privy to the conversation; instead, Britten composed a sequence of 34 chords in contrasting orchestral configurations spread over a wide dynamic range, creating a suggestive blank canvas upon which the spectator is free to imagine the conversation that is taking place.[9] Britten also employed an orchestral instrument, the French horn, as a substitute for the human voice in *Owen Wingrave* (1970),[10] where the title character leaves the stage and has a conversation with his grandfather. The grandfather's voice is heard clearly, while Owen's voice is reduced to a wordless recitative-like response by the offstage French horn,[11] from which the listener can only intuit the likely text.

Anyone familiar with Shakespeare's *Othello* (1604), hearing Verdi's *Otello* (1887) for the first time, would be surprised to hear the 'Credo' that is sung by Iago towards the beginning of Act 2. The listener might be forgiven for concluding that Verdi had complied with a demand from a leading singer for a suitable aria to fill out his role. The 'Credo' is, in fact, an invention of the librettist Arrigo Boito (1842–1918), a musical–dramatic masterstroke that is not to be found in Shakespeare, but was enthusiastically accepted by Verdi, allowing the composer to embody the nihilism of Iago within a musical framework, personifying in sound the force of evil that is central to the drama of the opera. In a collaboration such as that of Verdi/Boito, involving a meeting of extraordinary minds, the dramaturgy of opera becomes a finely honed tool. These examples form a brief introduction to musical dramaturgy, demonstrating how the composer (in conjunction with the librettist) is able to generate and embody the drama onstage through the agency of the musical score.

Boundaries within the opera museum

While scandals within the art museum erupt into the public space from time to time, nothing has ever emerged from those quarters quite like the television series 'The House' in 1996. This is the kind of curatorial scandal that the public love, as the Royal Opera House, Covent Garden saw its behind-the-scenes dramas erupt into the homes of television viewers in the United Kingdom and beyond. The series revealed a world of conflicts, scandals (both large and small), personality clashes and fragile egos, which seemed to distract the distinguished operatic museum from its core business – the curation of the opera repertoire. Did the series capture a 'normal' day behind the scenes? Was the BBC merely lucky to be filming at a particularly challenging time for the staff of the theatre? Or did the protagonists, true to operatic form, decide to 'put on a show', allowing dramas

to roll out and fester for the camera? Those who work with cultural artefacts of any type are all subject to the human frailties of greed and ambition – fed by museum structures, which are generally based on a culture of hiring staff in junior positions, from where they may rise as they prove their worth and adapt to the particular characteristics of the organisation. Thus, it can be seen that individual agendas and ambitions exist alongside higher imperatives – the preservation and contextualisation of cultural artefacts. Here follows a summary of the sociological aspects of curatorial practices within the operatic museum, which are explored in detail in Chapter 10.

In the academic literature, the inner processes of opera houses have received less attention than those of the art museum, although in recent years a number of studies have appeared, including that of Bereson, who explores 'the cultural, financial and political investments that have gone into the maintenance of opera and opera houses'.[12] A number of ethnographies have taken the reader into the opera rehearsal room, describing details of the production process. Paul Atkinson,[13] for example, delves behind the scenes to examine how 'collective social action', along with 'social organisation',[14] facilitates the creation of opera performances. Similar attention has been turned upon the art museum, where, in relation to internal social dynamics, the theories of Pierre Bourdieu (1930–2002) have been influential.[15] Bourdieu was concerned with the dynamics of power that operate within society and structures, as well as the (often subtle) ways in which power is disseminated and a prevailing social (workplace) order maintained. Bourdieu assigned descriptors to articulate his theories, for example *capital*, *habitus* and *field*. Christopher Whitehead, in his *Museums and the Construction of Disciplines,* applies the theories of Bourdieu to the museum,[16] introducing the philosopher's notion of *field*, defining it thus:

> a network, or configuration, of objective relations between positions. These positions are objectively defined, in their existence and in the determinations they impose upon their occupants, agents or institutions, by their present and potential situation (situs) in the structure of the distribution of power (or capital) whose possession commands access to the specific profits that are at stake in the field, as well as by their objective relation to other positions (domination, subordination, homology etc.).[17]

Whitehead also draws upon the idea of 'art worlds' (coined by Danto, 1964),[18] defining this as 'a network of people whose cooperative activity, organised via their joint knowledge of conventional means of doing things, produces the kind of representations that the art world is noted for'.[19] This collaborative process is presented as a positive activity with a positive outcome. There is more competitive tension around the concept of 'boundary work', which Whitehead defines as 'the development of arguments, practices and strategies to justify particular divisions of knowledge and the strategies used to construct, maintain and push boundaries'.[20] This description reflects the characteristics of the curatorial interfaces that take place when developing a concept for an operatic production. Whitehead

30 Part I

further states that boundary work can be competitive and territorialising or can involve the conferral upon others of certain territorial rights: it can be expansive – in seeking to enlarge disciplinary territories – or reductive, in seeking to delimit or down-scale them.[21]

Inherent in boundary work is the existence of tensions that arise from the presence of competitive hierarchies which, in addition to playing a role in the structure of the art museum, are present among the functionaries (including coaches, musical assistants and conductors) in any theatre. One of the characteristics of the processes of the opera house is the level of potential conflict implicit in the realisation of its many (often competing) elements, where perfect integration of the musical, textual and scenic elements of opera proves to be more difficult to achieve in practice than the theory might suggest.

The whimsical side of opera curation

There is also a whimsical aspect to exploring the curatorial threads that bind the world of opera together. Richard Strauss, in his role as a leading operatic composer and conductor of his day, was no stranger to the behind-the-scenes travails that accompany an opera production. The Prologue to *Ariadne auf Naxos* (1916) is based upon Strauss's experiences in the opera house, full of humour, insider jokes and great operatic truths. In his final opera, *Capriccio* (1942),[22] perhaps in a gesture of farewell to the operatic stage, the composer took the unprecedented step of bringing one of the most self-effacing and unseen functionaries of opera performance onto the stage, in the guise of Monsieur Taupe, the prompter (*Souffleuse*).[23]

Monsieur Taupe, a spectral presence, embodies the old-style museum curator type. He effectively holds the performance together, as though animating a *Wunderkammer*; indeed, Taupe describes himself as the 'invisible master of a magical world'.[24] Monsieur Taupe's natural domain is not quite 'behind the scenes'; rather, he is installed (almost interred) in the small prompt box at the very front of the stage, where he fulfils a crucial function, to which most audiences attending a performance are oblivious. Monsieur Taupe exemplifies the unseen *curator* who quietly influences, even 'stages' the experience of a museum visit for the viewer.

When one begins to scour the operatic repertoire for potential curator types, examples soon begin to emerge: Leporello is preoccupied with curating Don Giovanni; Don Alfonso curates the pairs of lovers in *Così*, with the help of his co-curator, Despina; Wotan may be the nominal CEO of the museum, but he too is also carefully curated by Brünnhilde (though at a certain point he consigns her to storage). Having identified a traditional, musty curator type in Monsieur Taupe, this chapter concludes with an example of the newer type of celebrity curator. In Igor Stravinsky's *The Rake's Progress* (1951),[25] we encounter Baba the Turk, an exotic and ambiguous character, who performs an aria[26] (probably unique in the literature, though it may belong to the genre of 'catalogue' aria) in which she recites the contents of her personal Cabinet of Curiosities. She discusses the provenance of her collection and reveals her curatorial position with respect to

her small museum, noting that she must tell her maid not to touch the objects, revealing an awareness of the vulnerability of her collection to the passing of time and the inevitability of decay in the private world she has created ('But the moths will get in them'). Upon completing this catalogue of precarious exhibits, Baba discovers that she herself has been part of a collection – an exotic (and very dispensable) curiosity for her husband, who has lost all interest in her, leaving her de-accessioned. In a later scene,[27] the auctioneer (Sellem) disposes of the remains of Baba's collection, finally putting the owner herself under the hammer, as her ex-husband chants a street-cry – 'Old wives for sale' – in the distance. Baba, in certain ways, resembles the new wave of curators of the 1990s: flamboyant, articulate, very visible and not averse to creating an occasional drama.

In this exploration of curatorial practices, 'curation' is recognised to be 'any arrangement of things, usually cultural',[28] along with a nod to Claude Lévi-Strauss, whose use of the term *bricolage* is applied to the curatorial context: 'The *bricoleur* is anyone attempting to plan, solve or create.'[29] We now turn to the rise of the public art museum.

Notes

1. It has been said that many Marschallins have met their Octavian for the first time in bed as the curtain has risen on the first act of *Rosenkavalier*.
2. The count of seven works is arrived at by beginning chronologically from *Der Fliegende Holländer* and counting the four operas of the *Ring* Cycle as one work.
3. Basically, 'a composition does not require a performance in order to exist ... The reading of the score is sufficient'. Heinrich Schenker, in Nicholas Cook, *Beyond the Score: Music as Performance*, Oxford Scholarship Online, accessed April 2014.
4. Philip Gossett, 'Writing the History of Opera', Chapter 47 in *The Oxford Handbook of Opera*, ed. Helen M. Greenwald (Oxford: Oxford University Press, 2014), 1034.
5. Carl Dalhaus, 'The Dramaturgy of Italian Opera', Chapter 2 in *Opera in Theory and Practice, Image and Myth*, ed. Lorenzo Bianconi and Giorgio Pestelli (London: The University of Chicago Press, 2003), 73.
6. Ibid., 74.
7. The instrument consists of a series of glass bowls, which are graduated in size to produce a musical scale. The instrument was first described around 1740, and among the early exponents were C. W. Gluck. Both Mozart and Beethoven wrote works for the instrument.
8. Nellie Melba (1861–1931) was an Australian soprano; the role of Lucia was a staple of her repertoire.
9. Benjamin Britten, *Billy Budd*, Boosey & Hawkes Full Score, 1985. Act 2, Scene 2, Fig. 103, 477–80.
10. Benjamin Britten, *Owen Wingrave* (television opera), Faber Music, Full Score, 1995. Act 2, Fig. 216, 207–14.
11. The French horn symbolises Owen's responses.
12. Ruth Bereson, *The Operatic State, Cultural Policy and the Opera House* (London: Routledge, 2002), Abstract.
13. Paul Atkinson, *Everyday Arias, An Operatic Ethnography* (Lanham: AltaMira Press, 2006).
14. Ibid., 199.
15. Pierre Bourdieu (1930–2002), French sociologist, anthropologist and philosopher.

16 See, for example: Malcolm Quinn, David Beech, Michael Lehnert, Carol Tulloch and Stephen Wilson, eds., *The Persistence of Taste: Art, Museums and Everyday Life after Bourdieu* (London: Routledge, 2018).
17 Christopher Whitehead, *Museums and the Construction of Disciplines* (London: Gerald Duckworth & Co. Ltd., 2009), 29.
18 Arthur Danto, 'The Artworld', *Journal of Philosophy* 62, no. 19 (1964): 571–84.
19 Whitehead, *Museums and the Construction of Disciplines*, 47.
20 Ibid., 61.
21 Ibid.
22 Richard Strauss, *Capriccio: A Conversation Piece for Music*, Full Score (London: Boosey and Hawkes, 1942).
23 Ibid., Scene 12, 315–25.
24 'Ich bin der unsichtbare Herrscher einer magischen Welt.' Ibid., 316–17, Fig. 249–50.
25 Igor Stravinsky, *The Rake's Progress: An Opera in Three Acts* (Full Score) (London: Boosey and Hawkes, 1962).
26 Ibid., 209–14.
27 Ibid., 270–99.
28 Balzer, *Curationism*, 29.
29 Ibid.

3 The rise and fall of the public art museum

The northern-European *Wunderkammer* succumbs to a craze from the south

It is generally accepted that opera is an Italian art, originally disseminated throughout Europe and beyond by peripatetic singers and composers. Germany, on the other hand has been characterised as the business centre of opera, a position that it retains today, as evinced by its highly organised system of well-funded opera houses. While the rise of opera is based upon a process of exportation, the development of public art museums in northern Europe was seeded by the availability of collections to travellers who visited Italy, making the 'Grand Tour'. It was in Italy that the practice of opening aristocratic collections to visitors originated, a process that led to the transformation of private collections within the Hapsburg Empire and England, where, in turn, methodologies of museology and curatorial practice were developed. We now consider the development of the art museum, which emerged out of the era of the *Wunderkammer*, their dispersal giving rise to public art museums, just as the Renaissance *intermedi* gave rise to public opera. The notion of the *Wunderkammer* has persisted through later times, a phenomenon that can be observed in the spectacle of Baroque theatre, whose 'microcosm of the world' is a reflection of it. That idea also carries through to Richard Wagner, who, in directing his 1876 production of the *Ring* cycle at Bayreuth, sought to create a nineteenth-century 'theatre of illusion'. The *Wunderkammer* has latterly also been evoked by contemporary art curators, led by Hans Ulrich Obrist, who relate it to their own practice.

During the Renaissance, the *Wunderkammer* was typically a room given over to aristocratic and princely collections of objects of all kinds, which evolved from the earlier medieval reliquaries that were housed by the Church. A sub-category of the *Wunderkammer* was the *Kunstkammer*, which specifically housed paintings and other artworks. Older historical accounts of the *Wunderkammer* have emphasised the eccentric nature of many of these collections, dismissing them from serious consideration as prototypes of the modern museum. They were characterised as haphazard collections of bizarre, exotic and unique objects, 'confused assemblages of oddities and rarities',[1] the obsessions and playthings of kings, nobles and the well-to-do.

Undoubtedly, many collections conformed to this type: an outward expression of the preoccupations of their equally eccentric owners, as was the case with the collection of Habsburg Emperor Rudolf II (1552–1612), which boasted at least five lions that roamed the castle moat in Prague, a camel that arrived in 1591, two leopards brought from Venice in 1596, parakeets from Spain, a cassowary and even a dodo.[2] The collection was catalogued in 1607, at a time when Rudolf's supremacy as the ruler of the Holy Roman Empire was under threat. Eventually challenged and defeated by his brother Matthias, he locked himself in his cabinet surrounded by his fantastical collection. The demise of a lion in the castle moat in Prague in January 1612 was the harbinger of Rudolf's own death, three days later.[3] It was not until 1782 that an auction was held at Prague Castle, where 300 lots comprising the remains of Rudolph's collection went under the hammer. There was, apparently, no interest in the dodo, which was thrown into the castle moat.[4]

More recent scholarship has revealed that the culture of the *Wunderkammer* in many cases incorporated ingeniously organised resources, creating laboratories of learning and advancement,[5] used by their owners for studying and engaging with the world from both a scientific and an aesthetic point of view; a direct forerunner of and palimpsest for the modern museum. In showcasing their owner's 'panoramic education and broad humanist learning',[6] the collection would include '*naturalia* (products of nature), *arteficialia* (or *artefacta*, the products of man) and *scientifica* (the testaments of man's ability to dominate nature, such as astrolabes, clocks, automatons and scientific instruments)'.[7] Along with artworks, the cabinets may have included religious artefacts, jewels, pieces crafted in precious metals, natural curiosities and exotic relics from distant lands. Religious objects were transferred from the older reliquaries and included items believed to be associated with Christ or his apostles and disciples; skeletons and objects associated with the saints were also assimilated. The more bizarre objects that characterised these collections might include Christ's toenails, a vial of the Virgin's milk, or even Moses' rod.[8] Such items were held to possess, through their sanctity, divine powers of healing, notions that were developed in some later *Wunderkammern* in the form of a preoccupation – at times bordering upon an obsession – with alchemy, magic and the occult.

The *Wunderkammern* may be seen as 'the crucible of the scientific revolution'. Many of the objects they contained 'were collected to measure the heavens'; others were 'to try the human mind and hand', while natural marvels were 'to archive the earth'.[9] Thus, their significance extended beyond that of mere collections of exotic or valuable objects, or expressions of the private interests and obsessions of their owners. In some cases, they were cultivated as 'a microcosm or theater of the world and a memory theater'.[10]

The transition from the era of the *Wunderkammer* to the rise of the public art museum occurred through a confluence of factors that unfolded regionally across Europe. The *Wunderkammern* were influential in the rise of the museum insofar as many of their collections were subsumed and re-organised into new structures. This was due to the decline and dispersal of the northern-European collections,

caused by a period of internal strife in central Europe, the resultant demise of royal dynasties and the subsequent lack of interest in their collections. The process was also influenced by the phenomenon of the Grand Tour, with returning travellers sharing accounts of the rich collections of art in Italy, which were accessible to a far wider public than was then the case in Northern Europe. The collections available to the traveller to the south included ancient Greek and Roman statuary, along with painting, particularly Italian works from the thirteenth century onwards. In Venice, the Statuario Pubblico (containing antiquities) opened to the public as early as 1596. The Capitoline Museums in Rome followed suit in 1734, while Florence's Uffizi Gallery, which had been opening its doors upon request since the sixteenth century, formally became a public museum in 1765.

This period of transformation of the *Wunderkammer* may be seen to form a parallel with the transformation of the Italian *intermedi*, which have been described as 'a spectacular diversion of myth, mime, dance, song and machine of Baroque excess – a pantomime *sul gusto antico*'.[11] An underlying connection with the exotic and fantastical nature of many *Wunderkammern* and the excesses of the *intermedi* may be discerned in such descriptions. In addition, it has been stated that the structure of the *intermedi* – a series of separate entertainments that were played during a day of celebration, bookending a larger work – gradually became 'more dramatically and musically unified',[12] leading to speculations that as they became more popular than the main work that was being performed, *intermedi* began to develop conceptually towards the notion of a unified work of art, an assertion that has not, however, gone unchallenged.[13] This will be dealt with in more detail in Chapter 4, but in both cases the transition, from *Wunderkammer* to art museum and *intermedi* to opera, is best seen as a fluid one, occurring over a number of years with many regional variations.

It is during the period of the *Wunderkammer* that the term 'curator' begins to gain currency in relation to the custodianship and organisation of collections. The term can be traced back at least as far as Ancient Rome, where the *curatore* was in charge of 'overseeing the Empire's aqueducts, bathhouses and sewers'.[14] By the fourteenth century, the term referred to a parish priest, while a century later it described someone who looked after minors and lunatics. The specific definition of the curator as 'a superintendent, especially of a museum'[15] dates in English-speaking sources from around 1660.[16] In German museology, however, the first curator (*Custos*) is considered to be Samuel Quiccheberg, who, in 1559, was engaged in the service of Albrecht V, Duke of Bavaria to order the objects of his *Kunstkammer*. As a result of this undertaking, Quiccheberg articulated the first *Museumstheorie*,[17] thus qualifying as the first museum curator in the modern sense.

Travellers returning from their sojourns in Italy, brought stories of the cultural splendours they had visited, spreading the idea that royal and aristocratic collections could be displayed to a wider audience and in so doing become a tool for exhibiting a public expression of power and wealth, securing for a family or dynasty status and ongoing kudos in the pages of cultural history. This was an important factor in the opening of the collections, which in many cases meant

opening the doors of royal palaces to the public. Jürgen Habermas[18] has proposed that the great achievement of the Enlightenment was the development of the notion of the public sphere,[19] a process that can be discerned in the gradual shift towards private aristocratic art collections opening their doors to a wider public.

The opening of aristocratic collections

The curatorial developments that occurred as collections were opened in Northern Europe are summarised here, with mention of some specific institutions that were particularly influential in the process of establishing the art museum in the form in which it is recognised today. The **Düsseldorf picture gallery** *(Gemäldegalerie Düsseldorf)* is an early example of a widely dispersed collection that was gathered together from around 1704 to allow its owner, Johann William II von Pfaltz, to construct, in an unprecedented move, a separate, designated space to house his widely praised collection of paintings and sculpture.[20] The original hanging of the works is preserved in a catalogue by Joseph Karsch, which describes hangings 'in axially symmetric pairs among the five rooms' in a move away from the Baroque arrangement of hanging as many works together as possible. The effect of the new arrangement was aesthetically based rather than instructive, and in spite of the innovatory nature of the arrangement, the works were hung in a far greater density than is the practice today.

In 1756, the painter Wilhelm Lambert Krahe (1712–90) was appointed director of the Düsseldorf gallery, and under his leadership it opened fully to the public. Krahe's professional background was as a painter, collector, restorer and art dealer; this background was typical of the gallery director type of the period. Krahe provided visionary leadership that transformed the display of the collection, instigating innovations that were significant for future museum development, including the hanging of paintings in schools rather than in an aesthetic arrangement and dedicating specific rooms for individual schools and artists.[21] A slightly later catalogue of the collection[22] shows how the methods of display had evolved by around 1778.[23] The pictures are apparently grouped according to size and shape, retaining an aesthetically pleasing design within the architecture of the building, and the aim seems to have been to gather works in dense groups rather than defining space for individual works to be appreciated.

The **Royal Gallery, Dresden** (Gemäldegalerie Alte Meister) opened its doors to the public in 1745 and two years later appointed co-directors to oversee the collection, one of whom was Pietro Maria Guarienti, who also typified the curator of the time, being 'a painter, restorer, dealer and writer all in one'.[24] In this he resembles an operatic impresario, with a wide overview of the skills and requirements of their field, along with business acumen and the ability to market their product. In his role as co-director, Guarienti was responsible for the Interior Gallery,[25] and following the Düsseldorf model, attempted to 'separate national schools and to devote the Interior Gallery exclusively to the Italian school as the aesthetic heart of the collection'.[26] The hanging conditions of the gallery were far from ideal, as depicted in an engraving from 1830 showing the cavernous Interior Gallery walls

(30 feet high and 121 feet long) covered in paintings,[27] apparently hung so as to use every inch of wall space, some 'hung so high that visitors could study them only with the aid of opera glasses'.[28]

From *Kunstkammer* to public museum

In Vienna, during the 1760s, Empress Maria Theresa and her son Joseph II contrived to gather together all of the Habsburg collections that were scattered around various palaces and castles in Europe, assemble them in Vienna and install them in the **Belvedere Palace**. This undertaking was an inspired act of enlightened absolutism, through which the Habsburg private collections were to be transferred 'institutionally into a public entity',[29] a watershed moment in the historical process of transferring royal collections to allow unlimited access for the benefit of the rising bourgeoisie.

With the establishment of the gallery in the Belvedere Palace, the question of the arrangement of the collection, along with measures to cater for the education of the bourgeoisie, led to the engagement of Christian von Mechel (1737–1813) as curator.[30] Mechel's work cataloguing and describing the enormous collection was firmly grounded in the notion of *Bildung*, ensuring that the public would be educated and enlightened as to its significance. Mechel developed an ingenious system of organisation inspired by the architecture of the palace, by which he achieved an overall sense of harmony and aesthetic logic between the works on display, their arrangement and the building that housed them. Mechel organised the collection by artist, chronology and school, a system that was pioneering and subsequently adopted in other leading European art museums. The Imperial Picture Gallery (today the **Kunsthistorischesmuseum**) opened to the public in 1781.

Mechel organised the collection into three basic national divisions: Italian, Netherlandish and German, displaying works of individual artists together, in order to facilitate their study within the context of the artists' oeuvre. In the German galleries, paintings were arranged according to the reigns of successive Habsburg monarchs, a curatorial practice that was a political imperative, expressing Maria Theresa's determination to create a lasting monument to Habsburg taste and discernment.[31] Picture frames were standardised as an aesthetic measure to prevent them distracting from the works themselves. Mechel created a catalogue that could be used in conjunction with a numbering system that he devised for each painting, in order that 'the museum's visitors not only judge paintings by their intrinsic qualities but also understand, through the systematic ordering of the paintings, the historical development of art'.[32] Mechel regarded the Belvedere as a *Lehrmittelsammlung* – a collection with an educative purpose, as well as a *'sichtbare Geschichte der Kunst'*[33] – a visible history of art. It has been claimed that the gallery was 'a near perfect parallel to the palace's interior arrangement – a *Gesamtkunstwerk*',[34] and that the Belvedere as configured by Mechel was the 'first modern museum,' where 'practices later taken as museological standards were first employed'.[35]

Recent research has examined Mechel's methodology, proposing that it may be an early example of a 'taxonomic practice with natural history collections'

finding its way 'into the world of fine art'.[36] Historian Debora Meijers describes the Belvedere collections as arranged according to 'a taxonomy of sorts':

> one which sought to apply a visual art history to the gallery walls, structured through categorical titles printed over the entrances to rooms and finer grained captions placed next to the paintings: the specimens. For ... Mechel, the path to true knowledge – as witnessed by advances in the natural sciences – could only be achieved through observation, analysis and comparison. Not yet based on the modern idea of chronology ... his aesthetic history was instead carved up into natural epochs in which schools and periods were posited as parallel units – a scheme that almost resembles a post-modern relativistic taxonomy. From this time on, it was the periodic ... event of rehanging a collection that enabled curators ... to usher in new ideas about the rules and principles underlying a new system of order.[37]

Mechel's vision did not go uncriticised. A very different means of arrangement was adopted in 1799 when Johann Christian von Mannlich (1741–1822), the director of the **Hofgartengalerie** in Munich, radically rehung his gallery in order to 'show the aesthetic progress of art, not the historical schools'.[38] In a gesture reminiscent of a Rossinian finale, Mannlich used 'the technique of a qualitative crescendo all the way to the last, climactic hall'.[39] The issue of whether a museum should fulfil a primarily didactic function or, rather, create an environment where viewers can connect emotionally with the finest works of art was already an ongoing conundrum, raising questions which are still the subject of debate.

In Paris, the opening of the **Musée du Louvre** in 1793 was a milestone in the evolution of museums, housing a collection that functioned as an important propaganda tool for the French State, highlighting the strong connection between political exigencies and the public display of art. Not long after the Louvre's inception, its collections were subject to a series of wide-ranging curatorial revisions, as the *Ancien Régime* crumbled in the wake of the French Revolution, closely followed by the Terror and the rise of Napoleon. During this turbulent period, the Louvre was renamed several times,[40] and its collections were revised to render them acceptable to each successive government, always with reference to their function as an expression of the power and taste of the state. Works depicting royalist associations were destroyed, while a huge influx of 'acquisitions' arrived as aristocrats of the *Ancien Régime* were stripped of their possessions. These holdings were further bolstered by the booty of war appropriated during the Napoleonic campaigns by 'French commissioners [who] followed the army with "wish lists" drawn up in Paris'.[41] The history of the acquisition of the collections of the Louvre is one of at-times blood-thirsty determination, by successive regimes, to turn artworks to the service of nationalistic political propaganda.

The **Altes Museum**, Berlin, completed in 1830, is one of the most significant museum buildings to be constructed during the nineteenth century, an expression of the philosophy that works displayed should be studied by artists and scholars while equally being enjoyed by the general public, whom the collections could

'first delight, then instruct'.[42] The originator of the project, the German art historian and archaeologist Aloys Hirt (1759–1837),[43] established enlightened curatorial practices, which included engaging scholars, rather than visual artists, for the curatorial staff of the museum, his view being that 'expert knowledge of paintings is a discipline in its own right, just like art itself'.[44]

In 1829, as the Altes Museum neared completion, key curatorial issues remained unresolved, necessitating the formation of a committee to organise the collections, the membership including an architect, an art historian, a sculptor, two painters and a restorer. The committee arrived at the innovative conclusion that the 'purpose of the museum was to serve the general public. This was to take precedence over its role as an institution for artists and art lovers.'[45] The committee disagreed over methods of display, it being considered that 'the arrangement of the works of art should not only awaken the viewer's aesthetic perception but also illuminate historical context',[46] while others felt that the museum should be 'a centre for aesthetic edification … to turn the spotlight on those works of art that would have the most powerful emotional effect on the visitor'.[47] A compromise was eventually reached, and a detailed scholarly catalogue paved the way for recognition of the museum as a leading scholarly institution.[48] The architect of the Altes Museum, Heinrich Schinkel (1781–1841), summed up the spiritual aims of the enterprise: 'The fine arts affect a person's morals … [without them] in every respect of his life he will never be anything but a lowly being and will never partake of a higher, happier existence.'[49]

The institutionalisation of the museum during the nineteenth century

The European museums discussed here exemplify the main themes and stages of museum development through the eighteenth and into the nineteenth centuries. Collections begin to acquire an identity independent of their owners as separate, dedicated buildings (or wings of buildings) are constructed or renovated, resulting in a sense of a new kind of communal ownership among art lovers from the middle ranks of society. Artworks become separated from their traditional surroundings as part of the décor of royal and aristocratic palaces and are organised according to specific methodologies, while the new museum buildings reinforce through their architecture, the notion of the museum as a temple to the fine arts. It is a transformation akin to the developments in public opera performances during the same period, where conversation, eating and other activities are gradually subdued to establish an environment that encourages a full engagement with the operatic work being presented.

The effective partitioning of art objects from scientific and natural history materials, which had been in process for decades, allowed consideration of new methods of display. No longer part of an assorted collection of objects, but re-housed in a spacious museum, the hanging of galleries began to take into account the concept of a target audience, or 'imagined visitor': an awareness arose of the particular journey a viewer might make through the art museum.[50] A merchant with an enquiring

mind and an interest in art may wish to understand what they see within a historical context. A painter, or art expert, may want to study the works of a particular artist across the span of their career, while another may wish to contextualise the works of an individual artist within a wider school of painting. Museums develop policies in line with the character of the collections that they hold, the buildings they inhabit and their need to attract visitors. Current policies have come far from the days when a lofty curatorial committee decided what was good for the bourgeoisie: today, museum managements must engage directly with the public and act upon the feedback they receive. Steven Lubar comments on the way museums chart their work:

> Some put collections at the centre, and around them, rings for conservation and preservation, curatorial expertise and research, then visitor learning and community engagement. Other museums reverse this. They make a point of putting visitor experience or community engagement at the centre, and of proposing a different set of rings: engagement, the museum building, objects and information about them. Yet others might list the audiences they focus on first and build the museum's resources around them.[51]

Since the 1830s art museums, mostly based upon central-European models, have proliferated worldwide, developing local variations to meet specific requirements. The English museum model, for example, generally developed along the lines of museums of natural history (notably the Ashmolean (est. 1683) and the British Museum (founded 1753)), but these institutions also collected ancient art of non-European cultures, whose significance became gradually recognised by other art museums, broadening the rather narrow, European-focused nature of their collections. These innovations are often attributed to Napoleon's campaigns, but they also developed out of the World Fairs of the nineteenth century that introduced the exoticism of distant cultures and of antiquity – themes that were enthusiastically incorporated not only into art museums but also into the opera house. The division of art and natural history collections occurred somewhat later in Great Britain; for example, the National Gallery in London, was not founded until 1824.[52] American museums, bolstered by huge endowments, have created correspondingly sized art collections,[53] that rival and often exceed those of the largest European museums. The United States has also succumbed to the culture of 'over collecting'; creating museums that hold a hitherto inconceivable array of objects (notably the Smithsonian)[54] – of natural history as well as collections of numismatics, ancient art and artefacts of widely diverse cultures, along with domestic items that traditionally were consigned to the area of 'arts and crafts', long considered to be of inferior museological value when compared with an oil painting or a sculpture. Today, these distinctions have become blurred, as designer Bruno Munari noted:

> In art exhibitions we see less and less of oil paintings on canvas and pieces of sculpture in marble or bronze. Instead we see a growing number of objects made in all sorts of ways of all sorts of materials, things that have no connection with the old-fashioned categories of the visual arts. In the old days of

painting these materials and techniques were very much looked down on as inhuman and unworthy of being the vehicles of a Work of Art.[55]

Notions of what a museum might collect, from which cultures those objects might originate and what actually belongs in a museum of art (raising questions of the distinction between a work of art and a mere object) are ongoing conversations that continue to influence acquisitions and outcomes. The construct of the typical art museum that was proposed in Chapter 2 may seem limited and prescriptive in the categories of collectible works that it outlines. In fact, most major art museums are unashamedly selective and hierarchical in both their collecting choices and their methods of display. Works considered to be the most prestigious, valuable, important and beautiful are all prominently visible. Works on paper are much less accessible (although there are considerations of preservation that influence these decisions), and other genres of object, for example furnishings and arts and crafts, have only been incorporated into displays in relatively recent times.

The art museum in crisis – 'morgues of art'

By the beginning of the twentieth century, a major rift can be discerned, when many leading artists began to interrogate the culture of the established museum in their works, with a strongly polemical stance being adopted by the Dadaists, Surrealists and Constructivists, all of whom sought to 'subvert the conventional form of art exhibitions'.[56] The Surrealists notably incorporated the culture of 'found objects' into their practice, combining this with an interest in the temporality of art, the impermanence of materials and the implications of these practices for the afterlife of their creations. Artists began to articulate an awareness of the division that had developed between art and life, targeting the museum, which in their eyes had become an outmoded, bourgeois institution, disconnected from contemporary society. Artists of the early avant-garde began to relinquish 'a measure of their authorial control' and inspire spectators 'to move from passive recipients of art objects to more active participants engaging directly with art'.[57] Lazar Markovich (El) Lissitzky's *Kabinett der Abstrakten* (1927–8, Landesmuseum, Hannover) and Marcel Duchamp's *Mile of String* (1942, 'First Papers of Surrealism') are important pioneering examples of works that demonstrated 'where the corporeality of the spectator' became an element of the exhibition. Lissitzky was concerned with challenging the ways in which people experienced art 'at a time when modernist urban design was being used to provoke greater levels of separation between people'.[58]

Along with such experiments came a reshuffling of roles in the art world, which saw the curator, or the artist-curator, growing ever more visible and influential. Leading figures who were central in articulating new relationships between artist, exhibition and viewer include:

- Frederick Kiesler – Exhibition of New Theater Technique, Kunsthaus, Vienna, 1924

- Alexander Dorner – director of the Landesmuseum, Hanover during the 1920s
- Willem Sandberg – director of the Stedelijk Museum, Amsterdam, 1945–62
- Lawrence Alloway – assistant director, Institute of Contemporary Arts, London, 1955
- Pontus Hultén – founding director of Moderna Museet, Stockholm in the 1950s and curator of the 1968 exhibition *She-A Cathedral*[59]

New forms of installation art that were influential in leading to new concepts in curating during the 1960s include:

- Lucio Fontana's *Ambiente Nero* (1949)
- Richard Hamilton's *An Exhibit* (1957)
- Yves Klein's *Le Vide* (1958)
- Allan Kaprow's happenings and environments (1959–late 1960s)
- Hélio Oiticica's *Grande Núcleo* (1960–66)
- Claes Oldenburg's *The Store* (1962)[60]

These artists created works that interrogated or delivered a critique of art institutions, which in turn 'began to call into question the curatorial act and the ways in which it was affecting the boundaries of art's production, as well as responsibility for its authorship and its mediation'.[61]

By the 1960s, a loosening of the designations of artist, curator and critic becomes evident, resulting in an interrogation of how such roles had been traditionally enacted in art institutions. Gallerist Seth Siegelaub, a significant protagonist in this process, has said of this time:

> We thought that we could demystify the role of the museum, the role of the collector and the production of the artwork; ... In that sense we tried to demystify the hidden structures of the art world.[62]

Curator Paul O'Neill adds that this process demonstrated that 'there were many actors and actions at play in the construction of art and its exhibition value'. He notes that the curator's sudden visibility made 'differentiation between the author of the work and the independent curator increasingly complicated'.[63] The traditional role of the curator as 'a caretaker of collections – a behind-the-scenes organiser and arbiter of taste'[64] had given way to that of 'an independently motivated practitioner' who occupied a more central position within 'the contemporary art world and its parallel commentaries'. During the late 1960s, 'art and its primary experience became re-centred around the temporality of the event of the exhibition rather than the artworks on display'.[65] It was not for nothing that the new curator type was dubbed an *Ausstellungsmacher* or a *faiseur d'expositions*. Between the 1960s and the 1990s, further wide-reaching developments took place that redefined the landscape of the art world. While the earlier part of the twentieth century can be seen to have promoted the curator to a far more central role,

the final decades leading to the new century see that figure emerging as an ever more public, independent figure, the spokesperson for the artist: this is the 'curator's moment'.

The 'curator's moment' – articulating art

Author and art critic Michael Brenson defined the 'curator's moment', in which he saw curators as taking on the roles of 'aestheticians, diplomats, economists, critics, historians, politicians, audience developers and promoters'. Curators acted as mediators between 'community leaders, business executives and heads of state'; thus, they needed to be capable of articulating 'the ability of art to touch and mobilize people and encourage debates about spirituality, creativity, identity and the nation'.[66] Celebrity-curator Hans Ulrich Obrist supports this claim: 'There are curators, artists, critics, gallerists and collectors, all of whom are forces. The art world, in the best case, is a polyphony of these different voices.'[67]

Obrist refers to artworks as 'scores', noting that 'the instruction [that is, the score], not the object, is the work'.[68] This formulation of the 'score' as the work will assume considerable significance when the dramaturgy of opera is considered in later chapters. Obrist sees 'art history as a history of the object' and asks: 'What could be the scores, the instructions?' He explains that a number of his projects 'are not crated or put in boxes; they consist of ideas. So, besides the physical exhibitions that I do, I have this parallel reality: my dematerialized exhibitions.'[69] This echoes the position of a specific production of an opera in relation to the composer's score. Such concepts are symptomatic of a period where the very meaning of the word 'art' was in flux, as described by artist Robert Barry in 1969: 'The word "art" is becoming less of a noun and more of a verb. ... [The concern is] not so much about the objects themselves as what possibilities are inherent in them and what the ideas are in them.'[70] Substituting the word 'operas' for 'objects' in Barry's quote describes exactly the processes of opera production today. The modern stage director has come to function in a similar way to the curator of the 1990s, as someone who interrogates and explores operatic works, recasting the ideas inherent in them in order to reinvest works of the past with new meanings that resonate in present-day society. While Obrist posits that 'curating produces ephemeral constellations',[71] French art theorist André Malraux found that 'by incorporating an object into a museum, it becomes divorced from its original context and function, it transforms into an abstract item in the imaginary museum of art history'.[72]

Today, the term 'curator' is invoked with a casualness that calls its meaning into question; in current parlance there exist at least four distinct shades of meaning to the term, which still describes the behind-the-scenes curator of traditional art museums that we have already encountered, who organises exhibitions and cares for collections. It may also be used to describe the more radical curator (often an artist who absorbs a curatorial role into their practice) of the first half of the twentieth century who creates a platform from which to deliver a critique upon the institutionalised art museum. In the latter part of the twentieth century,

the term has also come to refer to a freelance functionary, the celebrity curator, the *Ausstellungsmacher*, alluding to their preoccupation with art fairs, Biennales and similar events, usually high-profile in nature, that further the cause of contemporary art. The term *curator* in the current millennium has shifted even further, away from the art museum and even the art fair to describe anybody

> from the celebrity programmer of a pop festival to a fashion stylist who puts together a 'capsule collection' from a department store's fall/winter stock. A curator, here is essentially a paid selector of stuff for sale, whether it be concert tickets or cuff links.[73]

The great balancing act – reshuffling roles

In the post-war period, the visual arts underwent a fundamental questioning and redefining of the elements of artistic production, curation and exhibition processes. The shifting of roles, influence and power between the protagonists of the art world created a new landscape that continues to be negotiated in the current century. Comparable processes were at work in the world of opera, as the definition of what might be considered to be an 'opera' expanded to include hybrid works, such as Gershwin's *Porgy and Bess* (1935, an opera that played with success on Broadway); Sondheim's *Sweeney Todd* (1979, a musical that has enjoyed success in the opera house); Glass's *Einstein on the Beach* (1976, a 'five-hour abstraction with no plot, no characters, no arias, no trained singers, no orchestra and no intermissions' – an 'opera in name only' that premiered at the Metropolitan Opera)[74] along with new genres facilitated by emerging technologies such as the 'television opera' (Menotti – *Amahl and the night visitors* (1951), Britten – *Owen Wingrave* (1970)). In the arts generally, the very definition of what comprised an 'artwork' was widely deconstructed, and a blurring of the boundaries of disciplines created new possibilities and blended genres. Indeed, Obrist has co-curated an operatic project *Il Tempo del Postino*,[75] which has been dubbed 'the world's first visual arts opera'.[76] Reviews of this operatic foray identify elements at least as bizarre and arcane as those found in the *Wunderkammern* of earlier times:

> There was a burned-out car, with a sacrificial woman on top. Another naked woman stood still while a gungy X-ray plate contraption was pulled down over her head. There was a team of paramilitaries in balaclavas playing trombones. A sort of high priest with a big coat and a real dog for a head performed pointless rites that seemed to last hours. Two more women came on, naked, did backbends into crab positions and peed copiously on the stage. A large bull was led out and coaxed to mate with a fake cow. It is possible that had the bull been roused a whole chain of events might have been set in motion involving the peeing women still in the by now excruciating crab positions and the silly dog man. As it was, however, quite properly, the bull took one look at performance art and postman time and decided he would rather be anywhere but here. Who could blame him?[77]

This work has appeared in the hallowed halls of, among others, the Vienna Staatsoper and Theater Basel,[78] with controversial results. Many lines have become blurred, with an art curator creating an opera, opera directors impersonating a new wave art curator, all amid cries of '*Gesamtkunstwerk!*' and '*Wunderkammer!*' We now consider the rise of the opera house and trace its development into the opera museum.

Notes

1 Tristan Weddigen, 'The Picture Galleries of Dresden, Düsseldorf and Kassel: Princely Collections in Eighteenth-Century Germany', in *The First Modern Museums of Art*, ed. Carole Paul (Los Angeles: The J. Paul Getty Museum, 2012), 145.
2 Edward Hollis, *The Memory Palace: A Book of Lost Interiors* (London: Portobello Books, 2013), 154–5.
3 Ibid., 154.
4 Ibid., 126.
5 R. Impey and Arthur MacGregor, *The Origins of Museums: The Cabinet of Curiosities in Sixteenth and Seventeenth-Century Europe* (Oxford: Clarendon Press, Oxford University, 1985), 1–4.
6 www.metmuseum.org/toah/hd/kuns/hd_kuns.htm, accessed 11 January 2019.
7 Ibid.
8 Patrick Mauriès, *Cabinets of Curiosities* (London: Thames and Hudson, 2002), 7.
9 Edward Hollis, *The Memory Palace: A Book of Lost Interiors* (London: Portobello Books, 2013), 119.
10 Francesca Fiorani, reviewing Bredecamp (1995) in *Renaissance Quarterly* 51, no. 1 (Spring 1998): 268–70, 268.
11 Lydia Goehr, 'The Concept of Opera', Chapter 5 in *The Oxford Handbook of Opera*, ed. Helen M. Greenwald (Oxford: Oxford University Press, 2014), 120.
12 Ibid.
13 Ibid.
14 https://au.phaidon.com/agenda/art/articles/2011/september/09/a-brief-history-of-the-word-curator/, accessed 20 January 2019.
15 William Geddie, ed., *Chambers' Twentieth Century Dictionary* (Edinburgh: W. & R. Chambers, Ltd., 1959), 258.
16 www.etymonline.com/search?q=Curator, accessed 23 February 2019.
17 It can be found in Anke te Heesen, *Theorien des Museums* (Hamburg: Junius Verlag, 2012), 32.
18 Jürgen Habermas (b.1929), German philosopher and sociologist.
19 Carole Paul, *The First Modern Museums of Art: The Birth of an Institution in 18th- and Early-19th-Century Europe*, xi. Quoted from Jurgen Habermas, *The Structural Transformation of the Public Sphere: An Enquiry into a Category of Bourgeois Society*, trans. Thomas Burger (Cambridge, MA, 1989).
20 Weddigen, 'The Picture Galleries of Dresden, Düsseldorf and Kassel: Princely Collections in Eighteenth-Century Germany'.
21 Ibid., 155–7.
22 Published by Christian von Mechel with engravings by Nicholas de Pigage. www.getty.edu/research/exhibitions_events/exhibitions/display_arthistory/dusseldorf_catalogue.html, accessed 24 January 2020.
23 Weddigen, in Paul, *The First Modern Museums of Art: The Birth of an Institution in 18th- and Early-19th-Century Europe*, 157, Fig. 5–4.
24 Ibid., 148.
25 Ibid., 149.

26 Ibid.
27 Ibid., Fig. 5–2. (The image can be found at https://en.wikipedia.org/wiki/Gem%C3%A4ldegalerie_Alte_Meister.)
28 Ibid., 150. Opera glasses can be dated from 1738 and seem to have served on occasion in art museums as well. Stanley Sadie, *The New Grove Dictionary of Opera* (London: Macmillan, 1992), iii, 696–7.
29 Yonan, in Paul, *The First Modern Museums of Art: The Birth of an Institution in 18th- and Early-19th-Century Europe*, 171. Also see: www.khm.at/en/visit/collections/picture-gallery/history-of-the-collection/, accessed 24 February 2019.
30 Ibid., 173.
31 Ibid., 171.
32 Ibid., 177.
33 Ibid., 178.
34 Ibid.
35 Ibid.
36 Ken Arnold, *Cabinets for the Curious* (Aldershot: Ashgate Publishing Limited, 2006), 237.
37 Ibid. Arnold paraphrases Debora Meijers, 'Art History as a Form of Natural History: The Transformation of the Kaiserlich-Königliche Bildergalerie in Vienna into a "Visible History of Art" (1772–1781)'. This is discussed in Note 5, 237.
38 Adrian von Buttlar and Bénédict Savoy, 'Glypothek and Alte Pinakothek, Munich: Museums as Public Monuments', in Paul, *The First Modern Museums of Art: The Birth of an Institution in 18th- and Early-19th-Century Europe*, 320.
39 Ibid.
40 Andrew McClellan, 'Musée du Louvre, Paris: Palace of the People, Art for All', in Paul, *The First Modern Museums of Art: The Birth of an Institution in 18th- and Early-19th-Century Europe*, 230.
41 Ibid., 226.
42 Thomas W. Gaehtgens, 'Altes Museum, Berlin: Building Prussia's First Modern Museum', in Paul, *The First Modern Museums of Art: The Birth of an Institution in 18th- and Early-19th Century Europe*, 297.
43 Professor of Fine Art at the Academy of Art in Berlin.
44 Gaehtgens, in Paul, *The First Modern Museums of Art: The Birth of an Institution in 18th- and Early-19th-Century Europe*, 288.
45 Ibid., 297.
46 Ibid.
47 Ibid., 297–8.
48 Ibid., 298.
49 Ibid., 300.
50 Whitehead, *Museums and the Construction of Disciplines*, 32.
51 Steven Lubar, *Inside the Lost Museum* (Cambridge, MA: Harvard University Press, 2017), 5.
52 www.britannica.com/topic/National-Gallery-museum-London, accessed 25 February 2019.
53 For example, The Metropolitan Museum of Art and MoMA, New York; The Art Institute of Chicago; The National Gallery of Art, Washington DC; Museum of Fine Arts, Boston; J. Paul Getty Museum, Los Angeles; San Francisco Museum of Modern Art; Philadelphia Museum of Art; High Museum of Art, Atlanta; Seattle Art Museum, etc.
54 www.si.edu/, accessed 12 March 2020.
55 Bruno Munari, *Design as Art* (London: Penguin Books, 1971), 11.
56 Paul O'Neill, *The Culture of Curating and the Curating of Culture(s)* (Cambridge, MA: MIT Press, 2012), 10.
57 Ibid.

58 Ibid., 11.
59 Ibid., 13.
60 Ibid.
61 Ibid., 14.
62 Ibid., 19.
63 Ibid.
64 Ibid., 1.
65 Ibid., 1–2.
66 Michael Brenson, 'The Curator's Moment: Trends in the Field of International Contemporary Art Exhibitions', *Art Journal* 57, no. 4 (Winter 1998): 16.
67 Hans Ulrich Obrist, *Everything You Always Wanted to Know About Curating*: *But Were Afraid to Ask*, ed. April Elizabeth Lamm (Berlin: Sternberg Press, 2007), 113.
68 Ibid., 25.
69 Ibid.
70 O'Neill, *The Culture of Curating and the Curating of Culture(s)*, 18.
71 Obrist, *Everything You Always Wanted to Know About Curating*, 51.
72 www.andremalraux.com/wpcontent/uploads/2013/10/Grebe_Malraux_Article.pdf, accessed 20 November 2014.
73 https://au.phaidon.com/agenda/art/articles/2011/september/09/a-brief-history-of-the-word-curator/, accessed 20 January 2019.
74 Robert Fink, 'After the Canon', Chapter 49 in *The Oxford Book of Opera*, ed. Helen M. Greenwald (Oxford: Oxford University Press, 2014), 1068.
75 With Philippe Parreno.
76 www.e-flux.com/announcements/38054/il-tempo-del-postino/, accessed 28 February 2019.
77 www.theguardian.com/music/2007/jul/15/manchesterfestival2007.manchesterfestival, accessed 14 November 2014.
78 It has also been described as a 'group show' or an 'exhibition-cum-performance' – the work is usually given in opera house environments. The work has an official website at http://iltempodelpostino.com/, where it can be viewed in its three-hour entirety.

Part II

4 The invention of opera

The myth of the 400-year history of opera

Historical accounts of the origins of opera are generally concerned to identify a moment of 'birth', with one recent publication alluding to a 'Virgin Birth', an 'Italianate miracle'.[1] More prosaic descriptions have deconstructed such a notion, with Ellen Rosand describing 'the aesthetic soul-searching involved in trying to define a bastard genre seeking to combine music and drama'.[2] Most accounts highlight the activities of the Florentine *Camerata* in the late sixteenth century, which produced works that we now describe as the first operas, as defining the period of operatic gestation. In the literature, this period is characterised variously as *The Rise of Opera*,[3] 'the Invention of Opera'[4] or *The Birth of Opera*.[5] There is a clear consensus that around this time a decisive operatic event occurred, although exactly what that was is still being discussed. Lydia Goehr, for example, refers to a 'conceptual birth', occurring when the Renaissance *intermedi* 'began to surpass the main theatre piece, becoming itself the main event'.[6] Working back from the present day, scholars retrospectively construct a 400-year history of opera, creating a line of demarcation that excludes medieval mystery plays and passions, early street theatre (*commedia dell'arte*), Renaissance *intermedi* and other courtly entertainments that flourished in earlier times. Recent surveys continue to perpetuate the 400-year myth,[7] although Carolyn Abbate and Roger Parker concede that the Florentine *Camerata* was the continuation of a long line of activity, operatic in all but name, noting that the 'combining [of] drama, dance, song and instrumental music was a huge, centuries-old series of experiments'.[8] They suggest that the issue could be turned on its head to 'ask whether, worldwide, there were many theatrical genres before 1600 that did not feature music in some important way'.[9] The focus upon 1600 is largely a phenomenon of repertoire-based thinking that separates 'opera' from the continuum of its own history, indicative of ingrained perceptions that 'opera' is something that is performed under particular circumstances in an 'opera house'. Many of the earlier genres mentioned (particularly the *intermedi*) are all but impossible to recreate in a modern opera house context with any degree of verisimilitude. There also exists an imperative to identify an early operatic masterpiece that defines the genre and also has some presence in what we today recognise as the operatic repertoire.

The official, 400-year position identifies the first opera as Jacopo Peri's (1561–1633) *Dafne* (1597–8), which survives only as a fragment and can hold no place in the modern repertoire. A slightly later work by Peri that has survived – *Euridice* (1600)[10] – has also failed to join the modern repertoire; although on historical grounds it can be considered the founding, surviving work of the 'operatic canon'. The historical significance of these works as the first operas has been contested (or ignored) at various times in operatic history, with Christoph Willibald Gluck (1714–87), for example, asserting that it was first in his own works that a unity 'in word, action and music is demonstrated',[11] and other historical accounts tending to 'treat opera up to the point of Gluck and Mozart as a long and naïve pregnancy'.[12] Unity emerges as a prerequisite in distinguishing an 'opera' from a mere entertainment, which might contain similar elements but in a less structured form. In spite of holding the official position as the first extant opera, it is unlikely that Peri's *Euridice* would be programmed by any modern opera house today (though perhaps by a specialist, niche company). What historians seem unable to quite articulate is that these works are not considered to be particularly interesting to today's opera-going public and would be unlikely to be commercially viable in the modern opera house context. Here, the commercial/social and the historical/philosophical rub shoulders in an awkward way, and a distinction emerges between the operatic canon (the defining works and achievements of the genre) and the operatic repertoire (the fare that is regularly programmed by an opera house). The reforms that Gluck apparently instituted[13] assure him a distinguished place in operatic history, where his works are regarded as masterpieces of the genre. He figures prominently in operatic tomes, though his works are rarely programmed in opera seasons, having acquired a reputation as being 'bad for box office'. While scholars would question whether works such as Bizet's *Les pêcheurs des perles* or Delibes' *Lakmé* hold a place in the operatic canon, opera house managements would be more likely to programme these works than a Gluck opera.[14]

Another contender as the first official opera is Claudio Monteverdi's *L'Orfeo* (1607), although recently Emilio de' Cavalieri's *Rappresentazione di Anima e di Corpo* (Rome, 1600)[15] has challenged that position. Monteverdi's work firmly positions opera's origins within the context of the lofty experiments of the *Camerata*, embedding it in a world of aristocratic philosophising, thus establishing a 'noble' birth, avoiding a potentially 'bastard' birth as a public entertainment in the more salacious environment of Venice. Although not technically the first opera, *L'Orfeo* has been posited as the major work that sprang from the operatic experiments of the *Camerata* and is often dubbed the first operatic masterpiece (a word rich in canonic associations), the 'earliest major example of what came to be known as *opera seria*'.[16] Monteverdi's *L'Orfeo* affords operatic history an acknowledged masterpiece, one that holds a niche position in the canon today, for while it is a relative rarity within the opera house, it is widely known through recordings, which allow works to acquire a significance in the public imagination that belies their peripheral place in the repertory of the opera house. *L'Orfeo* was created without reference to an opera house environment; it was composed before any operatic infrastructure was conceived of. The work was

never revived for future performances, it did not travel to other centres, no revisions exist for new singers, nor were 'hit' numbers published. *L'Orfeo* was a niche experiment, designed to please a select group of aristocrats, performed only twice, then remaining silent for 300 years until its revival in the early twentieth century. Interestingly, a score of the work was published in 1609, though not in order to promote and facilitate performance[17]; rather, the publication functioned as a kind of commemorative programme, a lasting souvenir of a great occasion, evoking the power of the Gonzagas who ruled the court of Mantua.

From the rarefied world of the Mantuan court, Monteverdi went on to become the *maestro della musica* at the Basilica of San Marco in Venice. It is not known whether he took part in the early commercial operatic ventures in that city, though members of his choir did, and one of his students, Francesco Cavalli (1602–76), became the leading Venetian opera composer of the period. By 1640, Monteverdi had joined forces with commercial opera and revised his *Arianna* (1608, rev. 1640) for performances in the Teatro San Moisè. The music of *Arianna* is now lost, with the exception of the *Lamento*, which was extensively copied and published at the time, becoming a prototype operatic hit, in which form it remained extremely popular throughout the seventeenth century. Monteverdi's final opera, *L'incoronazione di Poppea* (1643), exists in two main versions that pose an almost insoluble puzzle for modern scholars,[18] highlighting the fact that the work travelled and was revived elsewhere, and that when this occurred, it was open to adaption, reconstruction and reconfiguration at each revival, and perhaps at every performance. In the case of *Poppea,* it remains uncertain that Monteverdi was the composer; in fact, it is established that he was not the sole author, highlighting the development in thinking over 400 years that the identity of a 'work' is bound up with its attribution to a specific creator. Today, it is customary to speak of Monteverdi's last opera, *L'incoronazione di Poppea* as the crowning masterpiece of the composer's old age, while it remains unclear just how much of the music he actually produced. Would *Poppea* be appreciated in quite the same way today if Monteverdi's name were not attached to it? The attribution of Monteverdi brings to the early years of operatic history an established musical pedigree of one of the most significant ('greatest') composers of the day.

The notion of unity (of text, music and action) has been identified as a recurring theme in operatic history, a concern that dates back to its origins when the Florentine *Camerata* were emulating similar values under the influence of the ancient Greeks. The achievement of the *Camerata* has been articulated as having created 'a staged drama unfolding integrally in words and music', producing the conditions whereby opera as a concept crystallised, combining three essential ingredients – philosophical, poetical and musical[19] – thus creating a 'totality of staged words and music'.[20] This unified, philosophical concept, articulated by scholar Robert Donington, is a lofty one that sets the bar high for what may qualify as an 'opera', and many works in the current repertory would not pass the test. Perhaps for this reason, Abbate and Parker are less proscriptive, defining opera simply as 'a type of theatre in which most or all of the characters sing most or all of the time'.[21] One wonders if Donington might not be falling prey to selective

historicism in his stipulation of a harmonious balance of opera's elements that achieve a totality of 'staged words and music'. This is not unlike Wagner's 1849 formulation of the *Gesamtkunstwerk*, which defines a harmony of parts that exist between what is sung, what is played by the orchestra and the visual elements that appear onstage. The combination of these elements is often reduced to a binary, expressed by the well-known formulation '*Prima la musica, dopo le parole*',[22] and today we can only consider the text and music that were created by the *Camerata*, for example, as we have no idea how their work was staged. The many operatic reforms that have subsequently taken place have sought to restore order to this notional sense of unity, usually during times when vocal excesses are perceived as having clouded the balance between text and word, implying a notional sense of unity that in reality, shifts according to circumstance. Nevertheless, the concept of *Gesamtkunstwerk* persists and may be considered to reside in works as diverse as Monteverdi's *L'Orfeo*, Gluck's reform operas and the music–dramas of Wagner. These represent decisive moments in operatic history where forces have conjoined in a particular way to create a unified artistic and aesthetic experience, unusual in an art form that has otherwise been preoccupied with the world of business and theatrical routine.

Opera goes public: Venice

It was the unique setting of Venice that provided the conditions for the operatic developments which metamorphosed into a burgeoning industry. Opera caught on quickly in Venice, thriving within the city's unique social structure, appealing particularly to the 'self-ennobled merchant class'.[23] In 1637, the first public theatre, the Teatro San Cassiano, opened in Venice when the Tron family paid to have their palace renovated, thereafter throwing it open to the public. This trend spread to Rome and Naples, as well as smaller towns, opening the way for commercial opera to migrate through the Italian peninsula, facilitated by its 'carriers', the travelling theatrical troupes. Opera became a novelty, a fad in a society with fluid social boundaries, supported by patrician families who fed the new craze by financing the renovation or construction of theatres, endowing a public artform that attracted a variety of social classes, who paid to attend the performances.[24] Venice offered certain unique conditions to support the rise of public opera: 'regular demand, dependable financial backing and a broad and predictable audience', to which may be added the sense that Venice was uniquely suited for 'the elaboration of others' inventions'.[25] This accounts for the speed with which opera developed: 150 operas being performed in nine theatres in Venice during the years 1637 and 1678, indicating a popular craze.[26]

While Monteverdi's stage works are undoubted masterpieces, they are not typical examples of the period, and their impact upon contemporary composers remains uncertain, though it is considered that his works 'did not produce models for the future'.[27] The composer responsible for shaping Venetian opera as a genre and defining its form was Francesco Cavalli (1602–76), in close collaboration with librettist Giovanni Faustini (1615–51). While others, such as Giovanni

Antonio Boretti (1640–72) and Antonio Sartorio (1630–80), composed works that enjoyed popularity, it was Cavalli who dominated the market, producing a total of two dozen operas between the years 1639 and 1669.[28] His works disappeared, like all operas of this period, being rediscovered in the later part of the twentieth century. The difficulties encountered in reconstructing these works highlight some of the characteristics of the emerging opera industry at this time: in particular, a hungry market always demanding novelties in the form of new works, which resulted in what might be described as 'pop-up' opera – where a space that may be a chamber in a patrician palazzo is hired for the performances, and an impresario commissions the composer and librettist, hires the singers and makes all other arrangements. At the end of the season, the troupe disperses, leaving little trace, echoing the improvised and ephemeral qualities of the Venetian street entertainments from which opera, in part, derived.

A further characteristic of this period is the attitude to the musical score – in physical terms, this is all that remained of an opera after a season of performances. Although works were occasionally revived and produced in other cities, there was no organised means to publish scores or disseminate performing material, practices that were generally not developed until the following century. Effectively, Italian Baroque operas, after their initial seasons, became extinct, victims of the emphasis upon novelty (as will be discussed, the French model developed somewhat differently). As the operas of this period lay dormant and forgotten in musty libraries, many composers' names (such as Cavalli) survived only as occasional mentions in the academic literature until the great revival of Baroque opera during the twentieth century awoke a dormant repertoire, previously considered to have become extinct.

Opera goes forth to France

While the concept of a developing repertoire was slow to take hold in Italy, the situation in France, where opera came to flourish under Louis XIV, progressed somewhat differently. Opera had already spread northwards by the mid-seventeenth century, where it was met by competing entertainments: spoken drama (generally given with musical interludes) and ballet were already well established. Ballet was to remain an essential ingredient in the development of the form in France (*opéra–ballet*), and the creation of French opera (the *tragédie en musique*, or *tragédie lyrique*) was masterminded by Jean-Baptiste Lully (1632–87), a shrewd and astute composer who was also a fine dancer.[29] Lully, who hailed from Florence, divined the mood and taste of the French (in much the same way as Gluck was to do a century later), and developed a form of recitative that was related to the manner of declamation used in the spoken plays of the *Comédie Française*. He also incorporated the sumptuous style of the court ballet into his works and created the form that became known as the 'French Overture'. It could be said that Lully created his own kind of commercial *Gesamtkunstwerk*, combining the predilections of the French with the Italian operatic style. Lully, a master politician, found favour with Louis XIV, and from 1672, he successfully

dominated the opera market in France, a genre he had effectively created. The composer was eventually adopted as an honorary Frenchman, becoming for the purposes of French history a national composer who was the mastermind of this new development, a necessary prerequisite in a country where everything of a cultural nature also functioned as a political tool, under the control of the state, with opera being 'a monopoly that was licensed by the king'.[30]

Under these circumstances, the operas of Lully became indispensable entertainments, regularly performed, that developed into what can be recognised as the earliest opera repertoire. This is reflected in the publication of Lully's *Oeuvres Complètes* (1679–87), the first complete edition of the works of an opera composer that cemented the concepts of repertoire and canonicity. The longevity of Lully's operas is notable, with *Thésée* (1675), for example, remaining in the repertory for over 100 years. The table of his works (Table 4.1) summarises the phenomenon.[31]

In the face of this unprecedented period of popularity and persistence, it is notable that Lully's music is more written about than played today. His significance remains largely historical, and his works are only occasionally revived, usually under festival or specialist conditions, such as the performances of *Atys* by Les Arts Florissants in 2011.[32] Following Lully's unfortunate death, the works of his successor Jean-Phillipe Rameau (1683–1764), gradually eclipsed those of his predecessor, a situation that persists today, when Rameau's operas are revived with some frequency. This is partly accounted for by the fact that Rameau was progressive in terms of employing an expanded harmonic palate and far-reaching modulations, as well as his treatment of the orchestra, which in his hands, developed into a virtuosic entity. Rameau's orchestra thus becomes

Table 4.1 The operas of Lully, showing the number of years in the repertoire[33]

Opera	Year of première	Year of final performance	Number of years in repertoire
Thésée	1675	1779	104
Amadis	1684	1771	87
Alceste	1674	1757	83
Armide	1686	1764	78
Prosperine	1680	1758	78
Acis	1686	1762	76
Atys	1676	1747	71
Roland	1685	1755	70
Festes de l'Amour	1672	1738	66
Persée	1682	1746	64
Cadmus	1673	1737	64
Phaeton	1683	1742	59
Isis	1677	1732	55
Bellérophon	1679	1728	49
Psyché	1678	1713	35

an active commentator upon the onstage drama, and the composer introduced important innovations, notably the introduction of clarinets and horns, as well as techniques such as *pizzicato* (1744) and the *glissando* (1745).[34] Rameau's operas also achieved longevity, with his *Castor et Pollux*, for example, being performed at the Paris Opéra 254 times over a period of 48 years.[35]

Baroque opera as 'mirror of the world' – the *Wunderkammer*

One of the major characteristics of opera as it developed during the seventeenth century was the element of spectacle and visual richness that dominated the stage, due to sophisticated machinery that, to audiences of the day, would have been as overwhelming as a Cecil B. de Mille epic was to early twentieth-century filmgoers. Venetian opera of the period generally employed limited instrumental forces, resulting in a fairly monochrome palette, consisting mostly of continuo instruments and a small string contingent. The stage, however, was a different matter, with storm, flood, fire and hail being evoked by the most ingenious technologies of the day. Visual spectacle, depicting the wildness and perversity of nature was an inherent part of the attraction of opera, which leads to the notion of Baroque opera as a 'mirror of the world'. Ellen Rosand writes of Venetian opera of this period that 'the spectacle of opera mirrored the spectacle of miraculous Venice herself',[36] a staged representation of the world in all of its diversity and strangeness: a performative reflection of the world, a *Wunderkabinett*. Such tendencies are present as early as Monteverdi's *L'Orfeo*, which achieves a fusion of ancient Greek myth and sixteenth-century theatrical conventions with the vocal and instrumental characteristics of the *intermedi*, the madrigal style, and the recitative style developed by the *Camerata*. The composer portrays the disparate worlds of the drama by the use of contrasting musical styles, along with vocal and instrumental combinations which reference the known musical forms of the day. The operatic model developed in Venice drew upon a similarly eclectic variety of traditions and embraced a rich multiplicity of influences, reminiscent of the diversity, exoticism and fantastical nature of the *Wunderkammer*, mirroring *La Serenissima* herself.

While the *Wunderkammer* has been regarded in some accounts as a repository for 'things devoid of life',[37] its creators and owners seem to have perceived those 'things' as existing in a state of suspended animation, waiting to be released, to emerge 'from the arcane recesses of history to form a shadowy procession, wreathed in mists'.[38] The often complex rituals that surrounded the opening of the Cabinet, the examination of its contents and – where scientific investigations were involved – working with the artefacts, were held to be a process that could lead to mimesis.[39] Research has revealed how the collections of Sir Hans Sloane (1660–1753)[40] were stored, displayed, catalogued and regarded by their owner and those who visited his home-cum-museum.[41] In working with his collections, describing them, ordering them and creating contexts for the grouping of objects, Sloane became the animator of his collection, an actor (or perhaps a director) upon a stage of his own devising.

Consider a Baroque opera performance, where myths from antiquity are being conjured through the mists of time. Visually, the audience is presented with an array of the exotic, the fantastical and the perverse. Natural phenomena, evoking the violence of nature, are imitated in a constructed environment. All is unveiled with expert precision and timing; diverse groups of musical instruments, some of an exotic nature, are seen and heard; painstakingly constructed sets reveal lavish architectural forms, both antique and fantastical; 'shadowy processions' are brought to life by the latest scientific and technological resources of the day, visiting storm, fire and flood upon the stage. Ever present is a morbid interest in the unnatural, particularly the castrato, conjuring up notions of sexual ambiguity and gender fluidity. Connoisseurship is exercised through an appreciation of the unique timbral qualities of the castrato voice, along with the ability to produce stratospheric *fioratura*, a legacy of the unprecedented rise in virtuoso singing that reached a peak of specialisation around this time.[42] The whole staged spectacle would have provided a rarefied, complex, rich, potentially salacious experience bordering on the unreal – a *Wunderkammer* animated into performance mode. In the final scene of the Paris production of Rameau's *Dardanus* (1739, rev. 1744), Venus appeared, 'descending in a cloud machine [which] consisted of six pairs of wings, borders and a painted backdrop'.[43] The effect was overwhelming in its life-like nature, and the production remained a mainstay for over a decade at the Paris Opéra.

A growing preoccupation with the scientific basis of the world was also reflected onto the operatic stage from time to time, opera having long been a platform on which to critique contemporary issues – political and philosophical – within society. An interesting example from this period is found in Cavalli's *La Calisto* (1651), where the character Endimione is something of an intellectual and, as we learn during the opera, 'the first to study the moon'.[44] It is hard not to see a parallel here with the astronomer Galileo Galilei (1564–1642), who, in 1609, had built the first astronomical telescope, becoming 'the first person to map the lunar surface'.[45] In addition, following the publication of his *Dialogue Concerning the Two Chief World Systems* (1632), Galileo was 'hauled before the Holy Inquisition in Rome and charged with heresy … he was threatened with torture, forced to renounce his … findings and imprisoned in his home for the remainder of his life'.[46] In *La Calisto*, Endimione is captured by Pane (Pan), threatened with life imprisonment, to be followed by death if he does not renounce his beliefs.[47] Some lines of Endimione's – for example, 'If indeed my mouth, that betrayer of the heart's affections, were actually … to deny the goddess, … don't believe it'[48] – would have been interpreted by contemporary audiences in relation to the fate of Galileo, who had been dead only a few years. Venetian opera was not confined to the representation of elevated planes of thought and enquiry but embraced the high and low in fairly equal measure. There is no shortage of perversity, or celebrations of the unnatural in *La Calisto*, with Giove (Jupiter) disguising himself as the goddess Diane (Diana), effectively appearing onstage from time to time as a drag queen, and while it is not certain how this transformation was made explicit in the seventeenth century, in many modern productions Giove, in his Diane guise, sings in a full-on, parodic falsetto.

The invention of opera 59

This chapter has traced the establishment of opera in Italy, and its migration to the court of France, in the hands of the Italian Lully. The following chapter outlines the establishment of opera in England and Germany, as national boundaries start to become blurred, and then returns to Italy, to the city of Naples, where eighteenth-century operatic developments, in the hands of Scarlatti, facilitated the production of operas, and the major librettist of the eighteenth century, Pietro Metastasio, is discussed.

Notes

1. Carolyn Abbate and Roger Parker, *A History of Opera: The Last Four Hundred Years* (London: Allen Lane, 2012), 37 – referencing Richard Wagner in *Oper und Drama*.
2. Ellen Rosand, *Opera in Seventeenth-Century Venice, The Creation of a Genre* (Berkeley: University of California Press, 1991), 4–5.
3. Robert Donington, *The Rise of Opera* (London: Faber, 1981).
4. Fred Kersten, *Galileo and the 'Invention' of Opera: A Study in the Phenomenology of Consciousness* (Dordrecht: Kluwer Academic, 1997).
5. Frederick Wilhelm Sternfeld, *The Birth of Opera* (Oxford: Clarendon Press, 1993).
6. Lydia Goehr, 'The Concept of Opera', Chapter 5 in *The Oxford Handbook of Opera*, ed. Helen M. Greenwald (Oxford: Oxford University Press, 2014), 120.
7. Daniel Snowman, *The Gilded Stage: The Social History of Opera* (London: Atlantic, 2009).
8. Abbate and Parker, *A History of Opera: The Last Four Hundred Years*, 39.
9. Ibid.
10. Alfred Loewenberg, *Annals of Opera, 1597–1940*, 3rd ed. (Totowa, NJ: Rowman and Littlefield, 1978), 3.
11. Goehr, 'The Concept of Opera', 100. This is in turn a reference from E.T.A. Hoffmann in 1814.
12. Ibid., 103.
13. The question of whether it was Gluck, or his librettist Calzabigi, who was the driver of the operatic reform is discussed in more detail in later chapters.
14. This division between the worlds of scholarship and operatic practice is highlighted in the by now classic 'Opera as Drama' (1956, rev. 1988) by Joseph Kerman, who has articulated his own Pantheon of operatic works that fulfil the criterion of having 'taken opera's dramatic potential seriously'. The works discussed by Kerman amount to a stab at what defines the operatic canon, outside of the commercial world of the opera house. His view is that '[d]rama is or entails the revelation of the quality of human response to actions and events, in the direct context of those actions and events. Opera is drama when it furthers such revelations.' Joseph Kerman, *Opera as Drama*, rev. ed. (Berkeley: University of California Press, 1988), ix, xiv.
15. Warren Kirkendale, 'The Myth of the "Birth of Opera" in the Florentine Camera Debunked by Emilio de' Cavalieri: A Commemorative Lecture', *The Opera Quarterly* 19, no. 4 (Autumn 2003): 631–43 (Oxford University Press).
16. Snowman, *The Gilded Stage: The Social History of Opera*, 27.
17. Ibid., 23–24.
18. Claudio Monteverdi and Alan Curtis, eds., *L'incoronazione di Poppea* (London: Novello, 1989), v–viii.
19. Donington, *The Rise of Opera*, 7.
20. Ibid., 19.
21. Abbate and Parker, *A History of Opera: The Last Four Hundred Years*, 1.

22 The title of the 1786 *Singspiel* by Antonio Salieri and Giovanni Battista Casti. It has been much quoted and is the theme of Richard Strauss and Clemens Krauss's *Capriccio* (1942).
23 Rosand, *Opera in Seventeenth-Century Venice, The Creation of a Genre*, 1.
24 Ibid.
25 Ibid.
26 Ibid., 3.
27 Ibid., 4.
28 Stanley Sadie, *The New Grove Dictionary of Opera*, 4 vols (London: Macmillan, 1992), i, 787–8.
29 Ibid., iii, 82–8.
30 Evan Baker, *From the Score to the Stage: An Illustrated History of Continental Opera Production and Staging* (Chicago: University of Chicago Press, Ltd., 2013), 33.
31 Loewenberg, *Annals of Opera, 1597–1940*, 56.
32 www.nytimes.com/2011/09/11/arts/music/atys-french-baroque-opera-by-lully-at-bam.html, accessed 12 March 2020.
33 Loewenberg, *Annals of Opera, 1597–1940*, 56.
34 Sadie, *New Grove Dictionary of Opera*, iii, 1228.
35 Loewenberg, *Annals of Opera, 1597–1940*, 191.
36 Rosand, *Opera in Seventeenth-Century Venice, The Creation of a Genre*, 2.
37 Patrick Mauriès, *Cabinets of Curiosities* (London: Thames and Hudson, 2002), 7.
38 Ibid.
39 Ibid., 68–127.
40 Sloane (1660–1753) bequeathed his collection to the British nation, providing the core of the collection of the British Museum.
41 Michael Cyril William Hunter, Alison Walker and Arthur MacGregor, *From Books to Bezoars: Sir Hans Sloane and His Collections* (London: British Library, 2012).
42 Abbate and Parker, *A History of Opera: The Last Four Hundred Years*, 51.
43 Baker, *From the Score to the Stage: An Illustrated History of Continental Opera Production and Staging*, 56.
44 Francesco Cavalli and Jennifer Williams Brown, eds., *La Calisto* (Wisconsin: A-R Editions, Inc., 2007), xvii.
45 Ibid.
46 Ibid.
47 Ibid.
48 Francesco Cavalli, ed. Álvaro Torrente and Nicola Badolato, *La Calisto* (Kassel: Bärenreiter Verlag, 2013), xxxi. Brackets in the libretto indicate that this passage was later cut by the composer.

5 Operatic transformations

Opera in England

Crossing the Channel

In the period that preceded the arrival of opera on its shores, England cultivated its own aristocratic entertainments that in many respects prefigured the burgeoning novelty that was spreading throughout mainland Europe. During the seventeenth century, the *masque* was the official entertainment of the Royal court: a concoction of spoken text, vocal music, ballet or dance, and acting which drew largely upon mythical and allegorical subjects. During the late seventeenth century, opera, the craze thriving on the mainland of Europe, became regarded as a desirable commodity as well as a useful political tool for rulers, as exemplified in France, where it had been successfully fashioned by Lully into an expression of royal supremacy. King Charles II (ruled 1660–85) was eager to partake in this novelty, not only for the entertainment of his court, but more generally to display his taste, discernment and power on the world stage. In 1683, the King commissioned an English impresario, Thomas Betterton, to travel to France 'to endeavour to carry over the Opera'[1] – i.e. members of the Académie Royal – in order to 'represent … something at least like an Opera in England for his Majesty's diversion'.[2] Betterton's journey had all of the flavour of a covert diplomatic mission, which ultimately failed, and when he eventually returned to London, it was without an opera company, although he did bring a composer, Luis Grabu (?–after 1693), a Spaniard rather than a Frenchman, who then set about creating the opera *Albion and Albanius* (1684–5) with the English court poet John Dryden. It is in this rather diluted form that Lully's operatic idea was introduced to England, and while the ensuing opera is stylistically indebted to the *tragédie en musique*, it is officially the first surviving full-length opera in English.[3] The choice of Grabu as the court composer[4] ruffled local British feathers, and it was presumably from a sense of chagrin at the foreigner's success that John Blow (1649–1708) composed his *Venus and Adonis* (c1684),[5] the first opera by an English composer.

Henry Purcell and the Englishness of opera

It is against this background that Henry Purcell (1659–95) produced four works, so-called 'semi-operas', a term that evokes the mixing of genres prevalent at the

time. Operatically, Purcell's reputation is built upon his masterpiece, the (full) opera *Dido and Aeneas* (1689),[6] which is the only work of the period to hold a place in the operatic repertoire today. *Dido and Aeneas* is a masterly combination of most of the known musical styles of the day – Italian, English and French. It is ironic, then, that the work is considered to define a sense of 'Englishness', which comes from 'an original synthesis of French and Italian ingredients that is more attributable to Purcell's individuality than to his nationality as such'.[7] It also presents the unique case of a 'very late, atypical, and geographically peripheral seventeenth-century opera, from a country where opera was practically unknown, [managing] to become the twentieth-century "classic" of the genre'.[8] That process began after the opera's publication in 1841, followed by its return to the stage after a silence of 195 years.[9] This reflects the complexity and, at times, the apparent randomness of the development of repertoire formation, which will be discussed further in the following chapter. The synthesis that Purcell produced – an amalgam of disparate elements that also had their origins in the *masque* – is perhaps also a key ingredient of the English musical sensibility, finding outward expression in the practice of *pasticcio*,[10] which became inextricably linked with opera production in England until the end of the nineteenth century. The slightly later 'ballad opera' – of which John Gay's *The Beggars Opera* (1728) is the best-known example – also exhibits this 'mash-up' style. The British aristocracy were enthusiastic to import to their own shores the phenomenon of opera that they encountered on the Grand Tour. A notable coup was the appearance in London (in 1708) of Nicolo Grimaldi (known as Nicolini), a Neapolitan castrato who led the subsequent wave of Italian singers and composers who travelled to London. The Grand Tour can thus be seen as being highly influential upon the development of both public opera houses and museums outside of Italy. Operatic migration northwards throughout Europe disseminated a fundamentally Italian art, performed by Italian singers, singing in their native tongue.

Händel in London

A further decisive event in English musical history took place when, in 1710, Georg Friedrich Händel (1685–1759) arrived in London. Handel (as he became known) was international by inclination; a German who undertook an apprenticeship in Italy, where he was schooled in the Neapolitan style of *opera seria*. Handel's career led him from Halle to Hamburg, Florence, Rome, Naples, Venice, Hanover and Düsseldorf before arriving in the English capital. This odyssey, which covered thousands of kilometres, highlights opera as a peripatetic artform that is transportable across borders and forms a notable contrast with the composer's contemporary, J.S. Bach, whose life and work encompassed five German towns, all situated within a total distance of about 200 kilometres. Handel exercised an inestimable impact upon the operatic life of London, reigning for many years supreme as the purveyor of the 'international style', able to provide virtuosic vocal challenges to the many foreign singers who travelled to London, among whom the above-mentioned Nicolini can be numbered, who created the title role in *Rinaldo* in 1711. Handel was not only a major composer but also an impresario,

and an adept and astute businessman. His operas enjoyed enormous popularity during his lifetime, but they soon faded from memory,[11] with not one being staged between 1754 and 1920,[12] when they were rediscovered and revived in Germany by the Göttingen International Handel Festival, led by its founder, Oskar Hagen. In the same way that the French adopted the Italian Lully, the English claimed Handel as their own, in order to remedy a lack, it being generally conceded that since Purcell, there had been no great English opera composer. England became one of the great centres of musical performance, particularly of opera, a position it has held since the eighteenth century. London boasted several rival opera houses that produced a flurry of works, but, from its native composers – operatically speaking – there remains little but arrangements, rewritings and pastiches of the works of foreign composers, working practices that have been subsequently vilified in the operatic literature. It was not until Benjamin Britten (1913–76) that England produced a composer worthy to succeed Purcell, and his operatic compositions have provided a unique contribution – a corpus of works from the second half of the twentieth century that can be said to have become part of the international operatic repertoire, and that have redefined English opera as well as opera composed to English-language texts.

Opera in Germany

The operatic idea quickly migrated north to Germany, where ambitious rulers sought to import and copy the Italian style. Italian architects or technicians were often engaged to construct opera houses separate from their own palaces, with dedicated spaces for lavish stage machinery and large audiences who flocked to the new theatres. German-language operas appeared fairly soon after the first operas in Italy, for example *Dafne* (1627, lost), composed by Heinrich Schütz (1585–1672).[13] Nevertheless, during much of the seventeenth and early eighteenth centuries, opera in the vernacular would struggle to emerge from the shadow of its Italian-language rivals. Impressive operatic edifices were constructed, such as the Opernhaus am Salvatorplatz in Munich, which was completed in 1657; the Komödienhaus in Dresden, one of the largest theatres in Europe with 2000 seats, which was built between 1664 and 1667 by Johann Georg II, Elector of Saxony. The works performed during this period have not found a place in the modern repertoire, with composers such as Johann Caspar Kerll[14] and his successor Giuseppe Antonio Bernabei[15] in Munich, as well as the creators of the first extant German opera, *Dafne* (1762) – Marco Giuseppe Peranda[16] and Giovanni Andrea Bontempi[17] – being today little more than names in opera histories, though they do highlight the northward migration of Italian composers who found lucrative posts in German-speaking lands and were able to cash in on the demand for opera.

Singspiel and other genres

In Hamburg, the Theater am Gänsemarkt – the first public theatre outside Italy – opened in 1678,[18] and operas by a number of German composers were given,

notably Reinhard Keiser (1674–1739, composer of over 100 operas), Georg Philipp Telemann (1681–1767, composer of at least 35 operas), Georg Friederich Handel (three operas composed specifically for Hamburg), Carl Heinrich Graun (1704–59, composer of at least 35 operas) and Johann Adolph Hasse (1699–1783, composer of over 60 operas). These composers were German by name, but wrote music in the Italian style and language. While opera remained an imported, Italian art, there were attempts to create a specifically German operatic style, particularly through the incorporation of national idioms. While France developed the *opéra comique* and England had the *ballad opera*, Germany devised the *Singspiel*. In fact, it was a *Singspiel* that opened the Hamburg opera house – *Adam und Eva* (1678), by Johann Theile (1646–1724).[19] The *Singspiel* can be regarded as 'opera for the people' and aimed to be popular, humorous, tuneful and ultimately musically unchallenging. This notion of a popular sub-genre of opera survived into the nineteenth century in the works of Albert Lortzing (1801–51), for example, which by then were known as *Spieloper*. The *Singspiel* is sung in the vernacular and contains spoken dialogue that is punctuated by ensembles and arias that are generally strophic and popular (folk-like) in character. The *Singspiel* was considered a light entertainment for the bourgeoisie and often contains elements of *Kasperltheater* (a loosely northern version of the *Commedia dell'arte*), populated by magical and fantastical creatures who inhabit plots constructed around the polarities of good and evil. They were usually performed by travelling troupes, as was the case for *commedia dell'arte* in Italy. Mozart's *Die Entführung aus dem Serail* is an example of the form taken to a level of musical sophistication and vocal virtuosity that is unique. *Die Zauberflöte*, a work that defies a single genre, has strong elements of *Singspiel* running through it and gathers together a wide variety of musical styles under the banner of '*Deutscher Oper*'.[20] Mozart's great achievement was to incorporate several styles and genres of music and produce a work that has been endlessly redefined and reconfigured in productions, presented as either an *opera seria*, a Grand Opera, a *Singspiel*, a *Kasperltheater* or a *Zauberoper*, depending upon the particular needs of audiences, censors and latterly the individual obsessions of stage directors.

Operatic developments in Naples

As opera slowly made its way through Italy during the seventeenth century, it developed a number of regional variations, notably in the distinctive style that was cultivated in Naples. This is summed up in the achievement of Alessandro Scarlatti (1660–1725), composer of well over 100 operatic works. Scarlatti was not particularly innovative or revolutionary; rather, he reshaped what he inherited, developing structural operatic formulae that became the standard and facilitated such a large production of works. The innovations that Scarlatti incorporated within his operas include the development of the 'da capo aria' (which quickly became a classic formal model); the incorporation of the *siciliana* style into the operatic vocabulary; and a new type of three-part overture – a fast, fanfare-like opening, a slow section and a concluding dance. Scarlatti's prolific output attests

to the growing popularity of opera and the demand for new works. His articulation of operatic formulae created an almost production-line template that allowed him to become an enormously successful composer in his day.

It would be wrong, however, to consider Scarlatti as merely a routined composer who was concerned to produce as many operas as possible within a given time frame. During a period spent in Rome, the composer was elected to a musical and literary association known as the Arcadian Academy. For all their philosophising, such associations can best be understood as a kind of reformist watchdog, self-appointed to guard the purity of the operatic product. There has always existed a tension in opera between aesthetes and philosophers, who wish to maintain the classical purity of the artform's lofty antiquarian origins, and the marketplace, where the philosophical integrity of opera can be breached, where word and music might run up against each other in an unseemly way, where vocal display and pyrotechnics may threaten to 'steal the show' (devaluing the primacy of the text), and where the comic and the tragic may come into too close a juxtaposition. The history of opera can be read as a series of reforms – perhaps in reaction to opera lovers having too much fun and threatening to bring down the theoretical and philosophical scaffolding upon which the artform relies which have been enacted in order to maintain a semblance of opera as something more than a mere entertainment. Monteverdi's work in Mantua, and later in Venice, sums up these two positions, and it was the early Venetian opera that exercised a penchant for combining the serious and the comic in a Shakespearian-like juxtaposition, allowing a variety of musical styles (popular, courtly and even religious) to co-exist in a single work. The Arcadian Academy was specifically reacting to this Venetian habit of 'comic and bawdy scenes with their conniving servants and ageing wet nurses'[21] and sought to replace the comic with pastoral scenes and heroic, historical figures. The reformists were attempting to turn back the clock 100 years in order to purify opera in the spirit of the Florentine *Camerata*, reforms that were also initiated in Venice by the poet, librettist and man of letters Apostolo Zeno (1669–1750). Scarlatti set at least one of Zeno's operatic texts,[22] and it is reasonable to assume that the composer was, on the one hand, able to produce popular operatic works for the marketplace while, on the other, maintaining a philosophical position as regards the lofty aims of the Arcadians.

Metastasio – the librettist's monopoly

The subsequent reform of opera culminated in the work of the librettist Pietro Antonio Trapassi (1698–1782) – better known by his pen name Metastasio – who was very close to the Arcadian Academy. Metastasio is a significant figure in the development of opera for many reasons, most notably because of how he crafted his librettos in order to define and dominate the genre. He was a key figure in the development of *opera seria* and influential in defining its structure and content, more so than any composer of the time. Metastasio's innovations included assigning arias according to the significance of the character, with the main couple given around half the total number of arias to sing – often as many as six

each. The secondary couple would have three to four arias, and lesser characters would receive correspondingly fewer. The arias were delineated quite rigorously according to type in the libretto structure, so that two *bravura* arias, for example, never ran in succession. The system that Metastasio developed was rigorous and ingenious, and this brief outline hardly does it justice. Perhaps the poet's greatest achievement was in defining the parameters and division between recitative, which furthers the action and unfolds in real time, and the world of the aria, in which time could be stretched, allowing self-examination and psychological reflection to be portrayed.[23]

Over a period of 50 years, Metastasio produced a corpus of around 60 librettos, half of which were in the *seria* genre; over the ensuing century his texts were set by more than 100 composers producing over 800 separate works. Many were settings by Johann Adolf Hasse – who enjoyed a considerable reputation and was reportedly Metastasio's favourite composer – which led the librettist to allow Hasse to set a text that he held dear, *Attilio Regolo* (1750), for performance at the court of King Frederick Augustus II of Saxony.[24] This was an important and historic collaboration that reveals a very different power balance between the creators, with Metastasio calling the shots and the composer obediently complying. Metastasio's codification of the opera libretto directly influenced the productivity of composers during this period. His texts were widely published and assumed the status of classics, enjoying a life of over a century, exceeding that of many of the operas that they spawned, which barely survived their infancy. Today, the exact opposite is the case; it is the composer's name that is associated with an opera as its primary creator, while the librettist may go unacknowledged, his name remaining unknown to many opera lovers. Metastasio's librettos became a comprehensive corpus (repertoire) of opera texts, functioning in part as compositional manuals. The lack of revivals of the works of Hasse and Graun, for example, is less related to the quality of their music than to a consequence of the fact that the Metastasian conception of *opera seria* is unsuited to the expectations and tastes of modern audiences. Over time, the Metastasian libretto began to show signs of wear, as did the *seria* genre generally. The structure of the libretto began to crumble under its own weight: faced with developments in the (ever-lengthening) aria form, parts of the original structure began to be cut due to time constraints. It remains noteworthy, however, just how strong and adaptable Metastasio's framework remained, and how long the *opera seria* genre persisted.

As Metastasio's *seria* structure wore thin, there were small troupes in the wings who provided comic diversions in the form of *intermezzi*, which probably originated in Venice, reaching London around 1737 and Paris by 1752.[25] These entertainments proved to be subversive creatures, harbingers of a revolution that saw small-scale works, based upon popular forms, usurp the old *seria* form. An example of this can be seen in two works by the Neapolitan Giovanni Battista Pergolesi (1710–36). Few opera lovers today know Pergolesi's *opera seria*, *Il prigioniero superbo* (1733); however, his *intermezzo*, *La serva padrona* (1733), quickly became a hit throughout Europe and uniquely survived into the modern repertoire, suffering only a brief period of oblivion during the first

half of the nineteenth century.²⁶ *La serva padrona* was originally a 'filler' for the larger work, *Il prigioniero superbo*, in performance. Today, it is regarded by musicologist Richard Taruskin as 'the great masterwork of the intermezzo genre', describing the decisive role the comic work played in supplanting the old *seria* style. *La serva padrona* was performed by an Italian troupe (*buffoni*) in Paris in 1752, sparking a *querelle* that was led by the philosopher Jean-Jacques Rousseau (1712–78), who published his philosophical platform in November 1753. At that time, Rameau was the leading French opera composer and musical theorist, but by the time of the *querelle* he was nearly 70, and his production of operas had declined significantly. While he remained a popular figure, he was an obvious target for the *Querelle des Bouffons*, which became a pamphlet war conducted by Rousseau, and later Jacques Diderot (1713–84), who favoured the Italian *opera buffa* style over the French *tragedies lyriques*. Rousseau even composed an opera in the 'new' style,²⁷ thus combining his philosophical platform with his hobby of composing. This 'new' style replaced the old French style with the more 'natural' Italian. The *Querelle des Bouffons* has been identified as a musical prefiguring of the French Revolution, 'striking the beginning of a blow from which not only the *tragédie lyriques* but the absolutist monarchy itself never fully recovered'.²⁸ French opera increasingly embraced the new style, until another reform was enacted by Gluck, when he arrived in Paris, importing a Viennese model of reform opera to enliven the Parisian stage.

This brief sketch of developments during the seventeenth and eighteenth centuries establishes themes that determine the subsequent path of opera, including the gradual development of an operatic repertoire, due to the unusual longevity and persistence of individual works. A growing sense of the operatic canon is also evident alongside markets that seemed to regard operatic works as throw-away commodities – for example, in the publication of the *Oeuvres Complètes* of Lully, as well as the librettos of Metastasio. *Seria* and *buffo* characterise the two faces of opera, frequently placed in opposition to one another, though ultimately interdependent; this plays itself out in both the popular successes of travelling *buffo* opera-troupes and in the lofty musings and pronouncements of men of letters, eager to maintain a philosophical scaffolding around this 'bastard' artform. Opera thus presents a complex identity – an entertainment for the public, a diversion for aristocrats, a display of power and status for royalty, and a plaything for intellectuals and philosophers. Opera has, until this point, remained a primarily Italian art – in terms of language, musical style and the singers who undertook its export from the Italian peninsula to the rest of Europe (and eventually beyond). Perhaps the most successful attempt to establish a new style for opera is exemplified in the French model of Lully, which was inherited by Rameau. However, even after a long period of success and stability, the genre could be brought undone by a short, comic *intermezzo*, written in a popular style, and performed by a travelling troupe of *Bouffons*.

The following chapter discusses the afterlives of specific operas (following their premières): how they survived, travelled and were adapted to local circumstances, with far-reaching implications for how the 'authenticity' of these works

is quantified and articulated today. The modern operatic repertoire is often considered to date from around the period that we have reached, with 1782 and the première of Mozart's *Die Entführung aus dem Serail* being a convenient, often quoted watershed moment. Beginning with *Entführung*, the operatic works of Mozart began, subsequent to his death, to generate what developed into the opera repertoire during the nineteenth century. The notion of canon, a body of works exemplifying higher aspirations and ideals above the purely commercial, is also a characteristic of the later works of Gluck. His *Orfeo ed Euridice* (Vienna, 1762) is a work known to all opera lovers, even if only through the enduringly popular aria 'Che faro senza Euridice?' that has survived through countless adaptations and reworkings (some by Gluck himself). In the case of many performances during the eighteenth century, 'Che faro' was the only piece to survive the *pasticcio* practice that dramatically reconfigured (almost beyond recognition) Gluck's opera with the interpolation of the works of numerous other composers. This aria represents to many listeners Gluck's opera '*Orfeo*', although it is not generally heard in its original version. Gluck created no fewer than three versions of the opera, with other adapters taking over in the nineteenth century, including Hector Berlioz. Editions have proliferated, the libretto has been regularly mutilated, and it is only in recent decades that the work has been performed and recorded in versions that might be considered 'authentic' – though that judgement remains conjectural. Gluck's *Orfeo* may be an example of the 'survival of the fittest' category of opera, and the following chapter explores its influence, along with that of Mozart's later operas, on the development of an operatic repertoire.

Notes

1 Stanley Sadie, *The New Grove Dictionary of Opera*, 4 vols (London: Macmillan, 1992), ii, 505.
2 Louise K. Stein, 'How Opera Travelled', Chapter 38 in *The Oxford Handbook of Opera*, ed. Helen M. Greenwald (Oxford: Oxford University Press, 2014), 851.
3 Sadie, *The New Grove Dictionary of Opera*, i, 505.
4 Ibid.
5 Alfred Loewenberg, *Annals of Opera, 1597–1940* (New Jersey: Rowman and Littlefield, 1978), 75–76.
6 Ibid., 85–87.
7 Richard Taruskin, *Music in the Seventeenth and Eighteenth Centuries* (Oxford: Oxford University Press, 2010), 134.
8 Ibid., 137.
9 Loewenberg, *Annals of Opera, 1597–1940*, 86.
10 Literally 'a pie' – the gathering together of disparate musical numbers (often by different composers) to create a new operatic work, or to refashion an existing one.
11 *Messiah* (1741) was one of the few works from this period to have been more or less continuously performed up until the twentieth century.
12 Christopher Headington, Roy Westbrook and Terry Barfoot, *Opera: A History* (London: Arrow Books, 1991), 61.
13 Loewenberg, *Annals of Opera, 1597–1940*, 12–13.
14 Sadie, *The New Grove Dictionary of Opera*, ii, 977–8.
15 Ibid., i, 440.

16 Ibid., iii, 949.
17 Ibid., i, 544.
18 Evan Baker, *From the Score to the Stage: An Illustrated History of Continental Opera Production and Staging* (Chicago: University of Chicago Press, Ltd., 2013), 29–30.
19 Sadie, *The New Grove Dictionary of Opera*, iv, 723.
20 It is described thus in Mozart's own catalogue of his works.
21 Taruskin, *Music in the Seventeenth and Eighteenth Centuries*, 151. Much of this section is loosely derived from 141–54.
22 *Scipione nelle Spagne*.
23 Taruskin, *Music in the Seventeenth and Eighteenth Centuries*, section on Metastasio – 153–7.
24 Ibid., 157.
25 Ibid., 435.
26 Loewenberg, *Annals of Opera, 1597–1940*, 177.
27 *Le devin du village* (1752).
28 Taruskin, *Music in the Seventeenth and Eighteenth Centuries*, 443.

6 From marketplace to museum

'Misreadings'

The typical eighteenth-century opera composer was intimately involved in the rehearsals of their new works, but their degree of authorial control was limited by their standing within the operatic hierarchy, there being more powerful forces to whom they had to defer – librettists, singers and impresarios being only the most obvious. The composer's place was well down the pecking order, and this was typical of the opera industry of this period: even Mozart had no illusions as to his lowly status. The composer would lead the première of their new work from the keyboard, as well as the two subsequent performances, where they could further establish a sense of their musical intentions. Thereafter, the performances were taken over by an assistant. The composer's written intentions would be left behind in the several (usually two) scores that were created during the rehearsal period, which were used as the basis for copying material for singers and orchestra. If the work became popular, it could be revived again in the same theatre, or travel to other theatres in other towns. The opera was usually circulated in manuscript copies, and a lucrative trade developed in producing scores that were then reworked for performance conditions specific to other operatic centres. This was a widespread practice, and in a period where copyright did not exist, composers had little hope of exercising wider authorial control over their progeny.

The practice of 'pirating' scores of popular operas became a lucrative trade. In a period when there was no alternative to making handwritten copies, quality control was an ever-present issue, as mistakes and 'misreadings'[1] would inevitably creep into scores, which were then reproduced by other copyists, who would, in turn, create further mistakes of their own. The resulting confusion of materials, often of uncertain origins, eventually provided the basis for printed editions of scores, meaning that existing errors were easily carried over into widely disseminated print copies. The industry which developed in arranging, copying and also publishing operas was a volatile one, in most cases lacking the fundamental resource which would have clarified the many confusions that were propagated: a reliable exemplar of the composer's manuscript, although in this period, such an artefact held challenges of its own. In such a complex environment, works could easily 'go out of focus'. In the following chapters, large-scale arrangements and

adaptation of operas will be explored, but it is important to note that at the micro-level, in the finer details of musical notation, the world of opera was vulnerable to many distortions of the works that it marketed, meaning that operas, as they travelled were frequently performed with an increasing agglomeration of alterations and errors, both intentional and unintentional. Some became generally accepted, transmitted through widely disseminated popular editions, and performed for many years until the advent of more reliable editions allowed the composer's original intentions to be reestablished.

An example of the process at work can be seen in the Trio (no. 6) from Mozart's *Die Zauberflöte*, which was often performed with a chord omitted during the nineteenth century. Example 6.1 shows the final bars of the Trio, as given in a popular, widely disseminated edition of the opera published in 1871.[2] In the final bar, there are three chords, followed by a rest.

The correct version, given in all modern editions (including the *Neue Mozart-Ausgabe*), is as shown in Example 6.2, with an additional chord replacing the rest.

The 1871 reading might seem logical, if there was no composer's autograph to confirm the error, but in fact, Mozart had created a quirky, comic effect, with a series of repeated chords that suddenly disappear into mid-air. This misreading apparently was accepted as authentic for many years, having also been published in an earlier English edition of 1850,[3] which was established to provide accurate editions of 'standard operas', and to displace the many spurious editions that were in circulation at that time. More surprisingly, this misreading also appears in an arrangement of the opera for piano duet by Alexander von Zemlinsky,[4] which appeared around 1904. Zemlinsky was a noted composer and also a well-known operatic conductor, who was acquainted with Gustav Mahler. As Zemlinsky lived in Vienna, it was very likely he would have heard Mahler's performances of *Zauberflöte* at the Hofoper. Could it be that even in Vienna, the work was performed with this misprint as late as the turn of the century, under Mahler's direction?

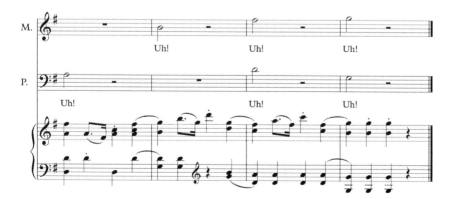

Example 6.1 Mozart, *Il Flauto Magico*, no. 6, Trio, bars 68–71. London, Boosey and Co., 1871.

72 Part II

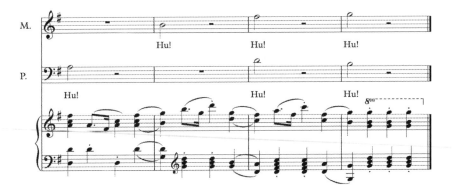

Example 6.2 Mozart, *Die Zauberflöte*, no. 6, Trio, bars 68–71.

Operatic works would gradually 'go out of focus', falling victim to such small-scale misreadings while also being subject to large-scale adaptations and other structural alterations in order to render them performable under a variety of circumstances in different theatres. This was the case with nearly all popular works during the eighteenth century and continued into the nineteenth. Having been created under very specific conditions for performance at the Habsburg court, one might think that Gluck's *Orfeo ed Euridice* (1762) would have escaped such a fate. However, Gluck's *Orfeo* presents a work that was subjected to the most far-reaching adaptations and rewritings in its subsequent performance history, both by the composer (who created three distinct versions) as well as a string of arrangers, resulting in the work being not infrequently adapted beyond recognition. In spite of this, *Orfeo* has been described as being 'more enduringly successful than any other stage work of the period',[5] a success that seems to have been aided by regular adaptation, indicating that a survival strategy for works of this period was for them to be malleable, mutable - able to be presented in numerous guises and adapted to a variety of performance conditions. The extraordinary success of *Orfeo* resulted in a crisis of identity for the work, which presents a particularly interesting and rich case of what occurred in the progress of an opera through the commercial world, and examines what methodological processes and tools were developed during the nineteenth century (musicological research, *Werktreue*) for unravelling the many complications created by misreadings and adaptations in an attempt to re-establish the author's original intent.

Survival of the fittest: C. W. Gluck's *Orfeo*

The première of Gluck's *Orfeo* in Vienna in 1762[6] is recognised as a landmark event in the history of operatic reform, for which an extraordinary curatorial team was assembled, led by the librettist Ranier de'Calzabigi; the Director of Vienna's Imperial Theatres, Count Giacomo Durazzo; choreographer Gasparo Angiolini;

set designer Giovanni Maria Quaglio; the creator of the opera's title role, the castrato Gaetano Guadagni; and of course the composer, Christoph Willibald Gluck. The exact degree of influence of each protagonist is impossible to determine with certainty today, although a review of the première[7] acknowledged primarily the contribution of Calzabigi, glossed over Gluck's music, and emphasised the contributions of both Angiolini and Quaglio. Although *Orfeo* went on to become an extremely popular work in the commercial market, it was not composed for popular consumption; rather, it presented a carefully considered aesthetic and philosophical experiment, painstakingly curated, composed specifically for performance in a court theatre, embodying a message of impending operatic reform, with the target of that reform being the operatic methodology developed by Metastasio, discussed in the previous chapter. Alfred Einstein has noted that

> Gluck hated those meek, political, philosophical and moral views of Metastasio's, his metaphors, his garrulous little passions, his geometrically devised word-plays. Gluck liked emotions captured from simple nature, mighty passions at boiling-point and at the climax of their outbreak, loud theatrical tumults.[8]

Orfeo has earned Gluck a significant place in operatic history, and its reception has identified him as a leading protagonist in the reformist platform of the work. It seems curious, then, that a few years after the work's carefully considered première, Gluck adapted it into a festive wedding entertainment (*Le feste d'Apollo*, 1769, Parma). Moreover, the reformist stance that the composer adopted in composing *Orfeo* represents something of a mid-career switch, revealing a sudden interest in a vision of opera beyond the purely commercial, which had been the composer's preoccupation until that point. The driving force behind this quest to articulate an alternative to the Metastasian operatic ideal was clearly the librettist, Calzabigi, in spite of published declarations that bore Gluck's signature. Gluck's exact position regarding the philosophical background to the work's composition remains unclear; it may have simply been the case that he had the good fortune to be in the right place at the right time and the *Zeitgeist* played to his strengths as a composer. He found in Calzabigi's libretto a perfect opportunity to pare back his style, cultivating melodic simplicity ('bella simplicità')[9] and eschewing the excesses of singers, creating 'a startling new musico–dramatic vision'[10] which offered a strong challenge to 'the moribund conventions of Italian opera seria'.[11] According to Gluck's contemporary Charles Burney (1726–1814): 'The chevalier Gluck is simplifying music … he tries all he can to keep his music chaste and sober', noting that Gluck's works 'contain few difficulties of execution, though many of expression'.[12]

Over a decade later, Gluck visited Paris, where the Opéra was suffering a crisis of direction following the *Querelles des Bouffons* some years before and the more recent death of Rameau. On his arrival, the composer met his former singing pupil, the Dauphine Marie Antoinette, who had lived in Paris since June 1772. The disarray into which the Opéra had fallen gave Gluck an opportunity to stake his claim,

taking advantage of Royal support to create something new and refreshing for the Parisian taste, thereby forging a new path for French opera. The composer chose to revise *Orfeo* after the positive reception of his *Iphigénie en Aulide* in Paris in April 1774, in order to produce a further operatic success in that city. In so doing, Gluck was not expressing dissatisfaction with the original score he had created in Vienna; rather he was undertaking the usual work of an opera composer of that period – adapting a successful work according to the local taste of other markets, although in this case local taste was being moulded by Gluck's aspirations for operatic reform; the opera's adaption represented 'a move in a carefully planned campaign to conquer the French operatic world'.[13] Once again, time and opportunity were propitious – in reworking *Orfeo*, Gluck succeeded in defining the new, Parisian style, and, along with five other operas,[14] he eventually created a corpus of work that enabled him to establish himself as the worthy successor of Rameau.[15]

That position seems likely to remain historically secure: 'Gluck is the master who liberated the opera from the conventions of contemporary Italian *opera seria* and created a new operatic style based on truly dramatic expression.'[16] His exact achievement, however, has more recently come under increased scrutiny, producing the view that, following *Orfeo*, Gluck produced

> six more reform operas and at least seven retrogressions to his earlier style. This is the problem facing any attempted penetration of Gluck's character: in particular – in what light could he view it – to produce such a rich but illogical succession of operas?[17]

While both the Vienna (1762) and Paris (1774) versions are considered to be reform operas, it has been noted that 'of no single achievement of the reform can we say, "Gluck did this." There is always an equal possibility that the credit is due elsewhere.'[18] From this uncertain position, Gluck's Orphic opera effectively exists today in two quite separate versions, written in distinct styles, for different circumstances: one a short, chamber-like work (1762), the other a full-length opera (1774) that draws on the grander tradition of the French *tragédie lyrique*.[19]

In spite of the rarefied circumstances of the première of *Orfeo* in Vienna, it was soon performed in many other centres, achieving great popularity in the world of commercial opera, not least because it became a staple in the repertoire of Guadagni, who had created the title role,[20] and whose performances of the work in London during the 1770s made the work an enduring favourite in that city. What is not known is exactly which version of the opera Guadagni performed in London. Johann Christian Bach (1735–82) had lived in that city since 1762, and in 1770 he created an adaptation of Gluck's *Orfeo*, incorporating new text,[21] for which he composed additional music.[22] Due to the fairly short duration of the original opera, it was an obvious candidate for such treatment; however, after Bach's additions were made, only seven numbers of Gluck's original remained. In spite of the scale of Bach's excisions, this version (or versions of this version: it too was endlessly adapted) has been described by Gluck scholar Patricia Howard as 'the serious J.C. Bach version',[23] perhaps implying that the stature of

From marketplace to museum 75

the adapter somehow lent this version a sense of authority. Audiences in Dublin in 1784 and New York in 1863[24] first heard *Orfeo* in J.C. Bach's version, which became widely identified simply as Gluck's *Orfeo*. In terms of the scale of such adaptations, the nadir of the work's performance history may have occurred in 1792, at Covent Garden, London, when *Orfeo* was given in a version by 'Gluck, Handel, Bach, Sacchini and Weichsel with additional new music by William Reeve'. Virtually nothing of Gluck's original remained, save 'Che faro', and the first line of the English translation used on that occasion well sums up the dilemma: 'What, alas shall Orpheus do?'[25]

'Che faro' has remained the enduring 'hit' of Gluck's *Orpheus*, readily recognised by music lovers who may not know any other part of the opera. The melodic outline at the climactic point of this iconic number differs in a number of important ways between the composer's two versions. The original Vienna version is given in Example 6.3.

The version created for Paris has become famous through numerous recordings, notably that of Kathleen Ferrier in the mid-twentieth century, and it is often considered superior in its heightened intensity to that of Vienna (Example 6.4).

Consideration of the vocal close of 'Che faro' in these two versions highlights the conundrum that the two versions of *Orpheus* pose in terms of performance choice. During the twentieth century, Gluck's opera has most often been performed in a version which is a conflation of both versions. From a scholarly point of view, the original Vienna version would seem to be the most correct to perform, as it represents Gluck's original vision of reform and is the one upon which his historical position is built. A number of performers, notably conductor John Eliot Gardiner,[26] have adopted this position, finding that 'accommodating *Orfeo* to Parisian tastes was damaging to it … [the composer] capitulated to French

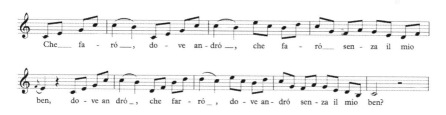

Example 6.3 Gluck, *Orfeo* (1762), 'Che faro', bars 455–63.

Example 6.4 Gluck, *Orphée* (1774), 'J'ai perdu mon Eurydice', bars 433–9.

conservatism in transforming *Orfeo* to *Orphée*.[27] Nevertheless, many modern performances attempt to create the 'best of all possible worlds', adding elements of both versions to create a composite *Orpheus*; for example retaining the two orchestral numbers that were composed for Paris – the 'Dance of the Furies'[28] and the 'Dance of the Blessed Spirits'[29] – which are indispensable to the notion of the work in the opera-lovers' imagination. Another major issue when performing the work today is that the three versions Gluck produced were all written for different voice types that are scarce or extinct today (1762 – alto castrato, 1769 – soprano castrato, 1774 – *haute-contre*), meaning that transpositions are often required when casting the title role. The possibilities for Orpheus's vocal identity were widened further when, in 1813, a female singer assumed the title role in a production in Milan.[30] In addition, the Vienna version is scored for certain instruments that today are obsolete, meaning that from the current perspective, *Orfeo*, for all that it is admired, falls between two musical worlds that are difficult to recreate, and his music can easily seem fragile and distant. Today, performers and scholars are at pains to retrieve an authentic version of *Orfeo* from a distant past that may not be fully accessible, to somehow restore a work that was so widely performed and so often reinvented that it is no simple matter to create a single version today that may be regarded as completely authentic or definitive.

Orphée remained popular in Paris, being performed in that city well into the nineteenth century in a virtually unbroken line of performances. The popularity of the work can be gauged by the appearance of parodies, the earliest of which appeared as early as 1775, Paisiello's *Socrate immaginario*, which transformed the title role into a comic character. Over 80 years later, Jacques Offenbach's (1819–80) *Orphée aux enfers* opened on 21 October 1858 at the Bouffes-Parisiens theatre in Paris, eventually becoming one of the most popular of all operettas, with a net of satire that was spread wide and not too much being spared: the government of the day, antiquity, social issues and Gluck's *Orphée* itself – in particular 'Che faro', which it cheekily quoted.[31] Acclaim for the work was such that Offenbach extensively revised and expanded it into a four-act *opéra féerie* (a 'grand operetta'!), in which form it was presented at the Théâtre de la Gaîté, Paris, on 7 February 1874. The 1858 presentation of *Orphée aux Enfers* created a huge *succés de scandale*, to the chagrin of Hector Berlioz (1803–69), an avid admirer of Gluck, who wrote that the popularity of Offenbach's parody 'demands an exemplary act of reparation'.[32] The depiction of a melancholy *Orpheus*, playing Gluck's 'Che faro' mournfully on a violin, highlighted the ongoing status of that aria as an iconic, operatic 'hit'. Ironically, the operetta in its *opéra féerie* guise became a staple in Vienna, where Gluck's chaste reform opera had first seen the light of day.

In 1859, Léon Carvalho, the director of the Théâtre-Lyrique, engaged a curatorial team to revive Gluck's opera and remove the accretions which had long distorted the work. Berlioz was offered the job of restoring Gluck's original score, allowing him an opportunity to exact revenge upon the *Bouffes-Parisiens*. He was joined by the celebrated mezzo-soprano Pauline Viardot (1821–1910), who also sang the role of *Orphée*, and the composer Camille Saint-Saëns (1835–1921), thus creating a meeting of sophisticated musical minds and cultural sensibilities,

all of whom shared an interest in what was at that time considered 'early music'. In the hands of these protagonists, the work of reviving *Orphée* unfolded according to quite different criteria from those employed during that period in reviving the operas of Mozart, for example. While Berlioz was not above engaging in work for the commercial market (the recitatives he provided for Weber's *Der Freischütz* may be considered to fall into this category), this team of co-curators saw themselves as performing a reverential act of revivification of a great work from the past. As will be discussed, such reverence did not preclude the occasional forgery, or playing to the gallery by providing inauthentic vocal *melismas* in order to market Gluck to the public, but in terms of the practices of the day, this team adopted very different methodologies to those of the many adapters who reworked operas in order to suit Parisian tastes. Berlioz described his work as that of a 'mosaicist' who was undertaking what became the process of 'reproducing' *Orphée*.[33] This involved working with the 1774 French version as the main text and reconfiguring it in line with the key structures of the Vienna version. Berlioz noted that the instrumentation had only been 'retouched for the present revival so far as was necessary in order to restore it to its original condition',[34] which is not quite true – in a number of respects, Berlioz's efforts exceeded restoration and extended to correcting perceived errors and miscalculations of Gluck. Such corrections included the revision of the orchestral parts and the correction of incorrectly accented French text settings ('uncorrected prosodic howlers').[35] Berlioz also substituted music from other works by Gluck[36] to replace passages he found banal (such as the finale), and in so doing somewhat overstepped curatorial boundaries by today's standards.

Berlioz wrongly believed that Fernando Bertoni, rather than Gluck, had composed the aria that ends Act 1 ('Quel est l'audacieux'). In his book *A travers chants*,[37] the Frenchman refers to this 'audacious plagiarism', which he used as a subterfuge, suggesting to Viardot that she compose her own cadenza for the number:[38]

> I forgot to tell you that in your 'air à roulades' that concludes the first act, it is absolutely essential to sing an astounding cadenza at the last fermata. Gluck calls for it.[39] So compose a lively mixture of vocalises for this moment and you will bring down the house as you leave the stage.[40]

Berlioz then hit upon the idea of using the previously heard theme 'just as instrumental virtuosos do in their concertos'.[41] Rather than omitting a number that Gluck had apparently not composed, Berlioz seized upon the uncertain authorship in order to create a vocal display that ultimately negates the spirit of unadorned simplicity central to the original concept of *Orfeo*. Allowing his 'restorative' labours to extend to forgery,[42] Berlioz wrote: 'We will say, if we have to, that this is the cadenza sung by Legros ... The Parisians will surely swallow it whole.'[43] Berlioz walked a thin line between restoration and forgery in making what he perceived to be improvements that produced, in his mind, a superior artistic result. In 1901, Reynaldo Hahn visited Viardot and discussed the role she played when

she 'revised and reconstituted' the opera, which provided some insight into the dynamic between the curatorial team:[44]

> 'But I didn't do anything,' she said 'that didn't have the absolute approval of Berlioz and Saint-Saëns. Even that famous cadenza – I had the honour of taking the blame for it – which I sang in the great bravura aria was decided by the three of us!' She went to the piano... she played the fermata slowly, stopping to explain to me each one's contribution. The first part (by Berlioz) is fine; the second (by Saint-Saëns) goes a bit overboard; the little run written by the singer is too 'singer-esc' and the last part, by Berlioz, could just as well have been written by the concierge.[45]

Saint-Saëns, who was also convinced that the aria was the work of Bertoni, later wrote: 'We took up the task [of writing the cadenza] with even greater enthusiasm as we were convinced we were fooling about with a piece whose composer merited no fidelity.'[46] The curatorial team colluded in the creation of a forged, though highly successful, cadenza. With the aria's authorship attributed to Bertoni rather than Gluck, it was clearly felt that they had licence to 'gild the lily'. While a master such as Gluck warranted the greatest respect in the accurate preservation of their legacy, other conditions clearly applied to composers of a lesser rank.

Berlioz, Saint-Saëns and Viardot brought together a trove of musical knowledge and expertise, working together to achieve a particular sense of authenticity and fidelity to Gluck's operatic masterpiece:

> Gluck, to Berlioz's way of thinking, was a musician of the present who deserved to be liberated from the bonds of a now superseded past. ... In his efforts to produce the works of Gluck in an ideal fashion, Berlioz was actually under the influence of a grand idea that was in fact the credo of Second Empire society – that progress was possible in the arts as it was in all human endeavour. Such an idea resulted from two convictions: first, that modern copies, given their technical excellence, were superior to their ancient models; and second, that all forms of expression tended constantly to evolve towards perfection. ... Berlioz demonstrated his conviction that perceiving a work in purely aesthetic terms could give access to what time had rent obscure and could place that work in a kind of eternal present.[47]

The 'Berlioz edition' of *Orphée*,[48] in the decades following its publication, became the standard text of Gluck's opera until well into the twentieth century. However, Berlioz's text has been distorted over many reprints, with new transpositions and other alterations made by shadowy editors, making it difficult to establish exactly what Berlioz and his team had originally written. Furthermore, in several multilingual singing translations, the Italian text was back-translated from the French, needlessly distorting Calzabigi's original libretto thus further distancing the work from Gluck's 1762 original. The Peters edition[49] has erroneously been accepted as, and dubbed, the 'Berlioz version', though it is often confused with Gluck's own

Paris version of 1774, leading one scholar to note: 'One might even go as far as to say that Gluck's *Orphée* and Berlioz's *Orphée* have, by assimilation, become one.'[50]

Scholarly editions of Gluck's scores appeared during the course of the twentieth century, though with little impact upon performance practice. The 1762 Vienna *Orfeo* appeared in a reliable score in 1914, but no accompanying performance material was published, making it largely inaccessible to performers. The same problem emerged when Bärenreiter Verlag published the same (1762) Vienna *Orfeo* in its complete edition of the works of Gluck,[51] with John Eliot Gardiner, as late as 1980, lamenting the fact that although a full score had been published in 1963, no corresponding orchestral material was for hire or sale,[52] making performance of the edition practically impossible.[53] Aside from the question of available performance editions, the decision of which version to perform remains a vexed one, and performers have proven to be inconsistent in justifying their choices. Regarding the preferred version, Gardiner has said: 'With this opera, first is best: … no-one, neither Gluck himself nor Berlioz nor any of the well-meaning arrangers … has ever improved upon the inspired, perfectly proportioned "Baroque" *Orfeo* of 1762.'[54] It is therefore hard to fathom why Gardiner's first recording of Gluck's opera presented the Berlioz version of 1859. In justifying his choice on that occasion, Gardiner purported to be 'offering a fascinating and plausible alternative version of the opera ["secondary authenticity" (!)] for those occasions when the title-role is required to be sung by a female mezzo in preference to – or in the absence of – a castrato … or of a "damnably high" tenor'.[55] Elsewhere, however, Gardiner has written that the Berlioz version 'far from combining the "best of both worlds" involves the use of a female Orpheus and transpositions in key, sex and character which were never sanctioned by Gluck'.[56] In 2008, Gardiner conducted a production of *Orphée et Eurydice* for the reopening of the Théâtre du Châtelet in Paris and again chose the 1859 Berlioz restoration: 'underlining his preference for this version, he performed the opera with the nineteenth-century period instruments of his *Orchestre Revolutionnaire et Romantique*'.[57]

Amid this surfeit of versions, adaptations and complex hierarchies of authenticity, it is the choice of singer for the title role that is the crucial artistic choice in creating a new production of *Orpheus* today and which will necessarily inform the choice of version. The criterion for what constitutes an ideal Orpheus continues to shift with the times, from the otherworldly castrato, to the heroic *haute-contre*, to the ambiguous mezzo-soprano and thence (almost) full circle to the historically acceptable countertenor, via baritones (including Dietrich Fischer-Dieskau), transposed tenors and sopranos. The key to the viability of *Orpheus* in modern operatic practice is in choosing a version that allows the title role to emerge in a guise that is relevant to the spirit of the times, which means that a production based upon such a criterion will likely be several degrees removed from 'authentic'.

Gluck continues to occupy a unique position in the world of opera. His historical position as the co-creator of operatic reform remains secure. During the nineteenth century, major musical figures such as Berlioz, Wagner and Richard Strauss created modern performing editions of Gluck's major operas, assisting his progeny to maintain a place upon the operatic stage rather than falling into a netherworld

of museum storage. The regular presence of Gluck's works in the opera house has further declined with the rise of historically informed performance practice during the second half of the twentieth century, when the difficulties of recreating Gluck's very particular sound world and aesthetic became apparent. Today, Gluck's works hold a distinguished place in the operatic canon, a marginal place in the repertoire of the opera house and an emerging position in recording catalogues. Gluck's works occupy a place between two worlds and styles, the Baroque and the Classical; his last opera was produced in 1781, just a year shy of the historical line identified as the starting point of the modern operatic repertoire (1782, Mozart's *Die Entführung aus dem Serail*). Mozart's works had to wait somewhat longer than Gluck's for the curatorial attentions of major musical minds working in the service of *Werktreue*. This occurred around the turn of the century when Gustav Mahler in Vienna and Richard Strauss in Munich led 'Mozart Revivals'. The development of the Mozartian operatic canon and the place of the composer's operas in the operatic repertoire, are now considered.

Mozart's operas and the operatic canon

It has been remarked that list-making is symptomatic of a sense of imminent loss, in which case the appearance of opera guides in the early part of the twentieth century may well betray a prescient sense of impending change or shortage in the repertoire. Countless opera guides have appeared in countries with strong operatic traditions, providing important snapshots of local versions of the repertoire, indicating trends over time. A selection of data is presented here for Mozart's operas, which is, of necessity, highly selective. In 1908, *Chapters of Opera* appeared in America, written by Henry Krehbiel (1854–1923), an early musicologist whose publications concerning opera dissemination in America created, for waves of immigrants, a sense of American-based ownership of the art form. Another important opera guide from this period was written by Gustav Kobbé (1857–1918), whose *Complete Opera Book* was published in the United States in 1919 and in the United Kingdom in 1922. Subtle differences in the contents of each edition articulate the contrasting make-up of the repertoire on each side of the Atlantic. Kobbe's *Opera Book* (as it is now called) reached its 11th edition in 1997, and a comparison of successive editions indicates shifts in the active repertoire of English-speaking countries during the twentieth century. The *Handbuch der Oper* by Rudolf Kloiber first appeared post-World War II (1st edition, 1951) and lists the operatic repertoire of theatres in German-speaking lands. While at one level the book outlines the plots and performance history of operas, matters of interest to the general public, the publication is fundamentally a business tool, containing specialist information (for example, a detailed account of the *Fach*-system, by which voice types and operatic roles are paired and categorised), which makes it a valuable reference for the managements and administrations of opera houses in central Europe. The two editions of Kloiber cited in Table 6.1 chart the fortunes of Mozart's operas in the German milieu during the second half of the twentieth century, showing the addition of Mozart's youthful works to the repertoire. Richard Strauss's list of the

Table 6.1 Versions of the Mozart operatic canon, taken from a number of disparate, twentieth-century sources

Krehbiel, 1919[a]	Kloiber, 1952[b]	Kloiber, 2002[c]	Richard Strauss, 1945[d]	Kobbé, 1922 (UK)[e]	Kobbé, 1969 (UK)[f]	Kobbé, 1987 (USA)[g]	Kobbé, 1997 (UK)[h]
–	Idomeneo	Idomeneo	Idomeneo (arr. Wallerstein/Strauss)	–	Idomeneo	Idomeneo	Idomeneo
–	Entführung	Entführung	–	Entführung	Entführung	Entführung	Entführung
Figaro	Figaro	Figaro	Figaro	Figaro	Figaro	Figaro	Figaro
Giovanni	Giovanni	Giovanni	Giovanni	Giovanni	Giovanni	Giovanni	Giovanni
–	Così	Così	Così	–	Così	Così	Così
Zauberflöte	Zauberflöte	Zauberflöte	Zauberflöte	Zauberflöte	Zauberflöte	Zauberflöte	Zauberflöte
–	–	Tito	–	–	Tito	Tito	Tito
Bastien und Bastienne; Schauspieldirektor	Bastien und Bastienne; Schauspieldirektor	Bastien und Bastienne; La finta semplice; Mitridate; Ascanio in Alba; Lucio Silla; La finta giardiniera; Il rè pastore; Der Schauspieldirektor			Schauspieldirektor		Mitridate; Lucio Silla; La finta giardiniera; Il rè pastore; Schauspieldirektor

[a] Henry Edward Krehbiel, *More Chapters of Opera: Being Historical and Critical Observations and Records Concerning the Lyric Drama in New York from 1908 to 1918* (New York: Henry Holt and company, 1919).
[b] Rudolf Kloiber, *Handbuch Der Oper* (Regensburg: Gustav Bosse Verlag, 1952).
[c] Rudolf Kloiber, Wulf Konold and Robert Maschka, *Handbuch Der Oper*, 9., erw., neubearbeitete Aufl., gemeinschaftliche Originalausg. ed. (München, Kassel; New York: Deutscher Taschenbuch Verlag; Bärenreiter, 2002).
[d] Letter to Karl Böhm, 27 April 1945. The letter is reproduced in Böhm, *Ich Erinnere Mich Ganz Genau: Autobiographie* (Wien: F. Molden, 1974).
[e] Gustav Kobbé, *The Complete Opera Book* (London: Putnam, 1922).
[f] Gustav Kobbé and George Henry Hubert Lascelles Harewood, *Kobbé's Complete Opera Book*, 8th ed. (London: Putnam, 1969).
[g] Gustav Kobbé, George Henry Hubert Lascelles Harewood and Gustav Kobbé, *The Definitive Kobbé's Opera Book*, 1st American ed. (New York: Putnam, 1987).
[h] Gustav Kobbé, George Henry Hubert Lascelles Harewood, Antony Peattie, *The New Kobbé's Opera Book* (London: Ebury Press, 1997).

Mozart canon is taken from a letter that he wrote to the conductor Karl Böhm, in 1945, after the Vienna Staatsoper had been bombed, a time when the composer was undoubtedly contemplating profound loss. Strauss, a dedicated Mozartian, articulated a notional repertoire – one which he hoped would again be performed in German theatres in the future, in times of peace.

It is significant that only three of the later Mozart operas are mentioned by Krehbiel (United States) – these are the works that survived the nineteenth century, and this is also reflected in Kobbé (United Kingdom, 1922), which also includes *Entführung*. Aside from these two early publications, *Così* appears as a constant presence, whereas *Tito* only appears after 1969. The presence of *Idomeneo* from 1952 indicates the work's central position within the Mozart canon (although it is not often performed, leaving it on the periphery of the active repertoire), and its inclusion may also be due to various adaptations (which generally reduced the scale of the work). that were made of it during the twentieth century. The earlier works of Mozart (pre-*Idomeneo*) are listed last and indicate the growing popularity of his earlier operas during the twentieth century, notably *La finta giardiniera*, *Der Schauspieldirektor* and the early *seria* works.

The data shown here might indicate that the Mozart operatic canon needs to be reconsidered today, to include earlier works that have found a place in the active repertoire in recent decades. Mozart's operatic oeuvre comprises a list of around 20 works,[58] three of which remained unfinished and unperformed in the composer's lifetime. The earliest work listed (*Apollo et Hyacinthus*) was composed by the 11-year-old Mozart in 1767. His final work for the stage, *La clemenza di Tito*, received its première just three months before the composer's death. A dividing line between Mozart's 'juvenile' operas (composed between the ages of 11 and 19) and his mature works is defined by *Idomeneo* (1781, aged 26), a work usually regarded as the first 'great' Mozart opera, in spite of infrequent performances. Of works composed subsequent to *Idomeneo*, two hold no place in the Mozart canon (*L'oca del Cairo*, *Lo sposo deluso*) and one holds a peripheral place (*Der Schauspieldirektor*, composed as part of a double bill with Salieri *Prima la music et poi le parole*). More recently, Bärenreiter Verlag, publishers of the authoritative *Neue Mozart-Ausgabe*, defined a 'Mozart Canon'[59] for the twenty-first century (Table 6.2).

Table 6.2 The seven 'canonised' Mozart operas, as marketed in a Bärenreiter Verlag pamphlet

Opera title	Date of composition
Idomeneo	1781
Die Entführung aus dem Serail	1782
Le nozze di Figaro	1786
Don Giovanni	1787
Così fan tutte	1790
Die Zauberflöte	1791
La clemenza di Tito	1791

Table 6.3 The earlier Mozart operas, with details of premières and modern revivals

Title	Date and location of première	Modern revivals
Apollo et Hyacinthus	Salzburg, 1767	Revived Rostock 1922; Munich 1932; Salzburg 1935. All of these revivals were adapted in some way they were translated into German and the music reworked. The Salzburg production incorporated a puppet theatre.
Bastien und Bastienne	Vienna (Mesmer's house), 1768	Revived Berlin, 1890 and then with a new text by M. Kalbeck, produced in Vienna in 1891; subsequently widely performed internationally. First UK performance: 1894; first US performance: 1916.[a]
La finta semplice	Salzburg, 1769	1769 Salzburg; revived Karlsruhe 1921; Vienna 1925; Breslau 1927; Prague 1928.[b] First UK performance 1907.[c]
Mitridate, re di Ponto	Milan, 1770	No revivals before the twentieth century.[d] First modern performance: Salzburg, 1971.
Ascanio in Alba	Milan, 1771	First modern performance: 1958, Salzburg, in a version by Paumgartner.[e]
Il sogno di Scipone	Salzburg, 1772 (only excerpts perf.) 1979?	First (modern?) performance 1979, Salzburg; first US performance: 2001.[f]
Lucio Silla	Milan, 1772	Revived Prague, 1929; first UK perf. 1967; first US perf. 1968.[g]
La finta giardiniera	Munich, 1775	A German singing translation dates from 1780 (see below), in which form it was performed in Augsburg, Nürnberg, Salzburg, Frankfurt, and Mayence. It was further revived, in 1796–7 following Mozart's death, in Prague 1796 and Silesia 1797, after which it disappeared from the stage until 1891 (Vienna) and was revived in the twentieth century from 1915. First UK perf. 1930; first US perf. 1927.[h]
Il rè pastore	Salzburg, 1775	Revived Salzburg and Munich, 1906;[i] First UK perf. 1954.
Zaide (Das Serail)	[Frankfurt 1866]	Fragment only of a *Singspiel* (probably 1779), unfinished, pub. 1838 (André). First known perf. Frankfurt, 1866.[j]
L'oca del Cairo	[Unperf.] 1860?	1783 – unfinished. Published 1855 (André). Fragments perf. in Frankfurt, 1860. French version (*pasticcio*) by Wilder, Paris 1867, gained wide currency.[k]

Continued

Table 6.3 (Continued)

Title	Date and location of première	Modern revivals
Lo sposo deluso	[Unperf. – only a fragment of Act 1 completed.]	In 1991, the 200th anniversary of Mozart's death, Opera North premièred *The Jewel Box*, a pasticcio opera devised by Paul Griffiths. This used the existing pieces from *Lo sposo deluso* and *L'oca del Cairo* as well as arias written by Mozart for insertion into operas by Anfossi, Piccini and Cimarosa, among others. (The programme was an imagined reconstruction of a 1783 pantomime in which Mozart and Aloysia Weber are said to have taken part.) In 2006, the 250th anniversary of Mozart's birth, the fragment of *Lo sposo deluso* received several performances, including Bampton Classical Opera's revival of *The Jewel Box*. The Salzburg Festival's double bill of *Lo sposo deluso* and *L'oca del Cairo* and other arias written by Mozart in a programme titled *Rex tremendus*, conceived and staged by Joachim Schlöme with the Camerata Salzburg conducted by Michael Hofstetter.[l]
Der Schauspieldirektor	Schönbrunn, 1786	The première was a double bill with Salieri's *Prima la musica e poi le parole*. The dialogue has been continually updated in later times. First UK perf. 1857. First US perf. 1870 (as *Mozart und Schikaneder*).[m]

[a] Loewenberg, *Annals of Opera, 1597–1940*, 300–1, http://opera.stanford.edu/Mozart/Bastien/history.html, accessed 13 November 2014.
[b] Ibid., 307.
[c] http://opera.stanford.edu/Mozart/FintaSemplice/history.html, accessed 13 November 2014.
[d] Loewenberg, *Annals of Opera, 1597–1940*, 316.
[e] http://es.wikipedia.org/wiki/Ascanio_in_Alba, accessed 24 February 2015.
[f] http://en.wikipedia.org/wiki/Il_sogno_di_Scipione, accessed 2 May 2015.
[g] Loewenberg, *Annals of Opera, 1597–1940*, 327, http://en.wikipedia.org/wiki/Lucio_Silla, accessed 2 May 2015.
[h] Ibid., 341–2.
[i] Ibid., 345.
[j] Loewenberg, *Annals of Opera, 1597–1940*, 980.
[k] Ibid., 992–3. The 1867 adaptation by Victor Wilder included *L'Oca del Cairo* and *Lo sposo deluso*, along with inserts that Mozart wrote for Bianchi's *La villanella rapita* to produce a single work. In the twentieth century, numbers from each of the two operas were arranged by Hans Erismann to create *Don Pedros Heimkehr*, which was premièred in 1953 in Zurich.
[l] http://en.wikipedia.org/wiki/Lo_sposo_deluso, accessed 1 May 2015.
[m] Loewenberg, *Annals of Opera, 1597–1940*, 422–3.

This list seems to be created more as a marketing tool than as a serious attempt to define the Mozart operatic canon. The publisher has presented the publication as the 'great Mozart operas in a boxed set',[60] including a (2014) branding that portrays the composer in a 'cool' attitude, complete with leather jacket and sunglasses. Here, a scholarly publication rubs shoulders with commercial imperatives in a way that is awkward. Today, *La finta giardiniera* could lay a claim to being a canonic work, particularly since lost sections of it were discovered during the 1970s, making it now possible to perform the work in its original form. *La finta* is today a rival to *Tito*, a fact not recognised by the Bärenreiter canon, which, by limiting its selection criterion to exclude juvenilia, places it at odds with current performance trends.

Table 6.3 lists the Mozart works that are not included in the Bärenreiter canon and presents a thumbnail sketch of their (often complex) gestation and performance history. In recent times, *Mitridate* and *Lucio Silla* have been revived in influential productions that have led to a reconsideration of their place on the modern operatic stage and hence in the repertoire. For example, a production of *Lucia Silla* conducted by Nikolaus Harnoncourt in 2005 (*Wiener Festwochen*) led the conductor to staunchly defend the importance of the latter work as the '*Höhepunkt der Opera Seria*' (Table 6.3).[61]

As opera houses continue to enrich their repertoire by looking to neglected works from the past, it seems likely that the early operas of Mozart will continue to receive further attention. Today, every composition by Mozart is potentially of interest, and when it comes to incomplete or fragmentary Mozart operas, the practice of *pasticcio* lies in wait, ready to swing into action and facilitate a place in the repertoire for these works – in the case of Mozart, this practice is deemed acceptable in order to maintain his music on the operatic stage. The following chapter examines the progress of the later Mozart operas during the nineteenth century, charting their journey from the operatic marketplace to the operatic museum.

Notes

1 A reference to: Umberto Eco, *Misreadings* (London: Picador, 1994)
2 Wolfgang Amadeus Mozart, J. Pittman and Arthur Sullivan, *Il Flauto Magico. Opera in Two Acts*, with Italian and English words, ed. Arthur Sullivan and J. Pittman (London: Boosey and Co., 1871), 57.
3 Wolfgang Amadeus Mozart, J. Wrey Mould and W.S. Rockstro, *Die Zauberflöte* (London: T. Boosey & Co., 1850).
4 Mozart/Zemlinsky, *Die Zauberflöte*, für Klavier zu 4 Händen, UE708A. (Vienna: Universal Edition, ca. 1906). .
5 Patricia Howard and C.W. von Gluck, *Orfeo* (Cambridge: Cambridge University Press, 1981), 15.
6 In the course of this chapter, '*Orfeo*' denotes the 1762 Vienna version; '*Orphée*' denotes the 1774 Paris version, including the Berlioz version of it; '*Orpheus*' refers loosely to the opera of Gluck, without specifically referring to any one version.
7 *Wienerisches Diarium* of 13 October 1762; the review was anonymous.
8 Alfred Einstein, *Gluck*, 1st ed., reprinted with revisions, ed. Dent (Farrar Straus and Cudahy, 1964), 66–7.

86 Part II

9 Max Loppert, 'The Gluck-Berlioz *Orphée Et Eurydice*', liner note in EMI CDS 7 49834 2 (1989), 14.
10 Ibid.
11 Ibid.
12 Howard and Gluck, *Orfeo*, 57, which in turn is quoted from Burney, *The present state of music in Germany, the Netherlands, and United Province* (London: T. Becket; J Robson; and G Robinson, 1775).
13 Ibid., 65.
14 Four original works – *Iphigénie en Aulide* (1774), *Armide* (1777), *Iphigénie en Tauride* (1779), *Echo et Narcisse* (1779–80), as well as two adaptations – *Orphée et Eurydice* (1774) and *Alceste* (1776).
15 Howard and Gluck, *Orfeo*. She notes (12) that 'The Opéra was suffering the lack of a good serious composer to follow Rameau.'
16 Oliver Strunk, Leo Treitler and Robert P. Morgan., *Source Readings in Music History*, Vol. 5 (London: Faber and Faber, 1952), 99.
17 Patricia Howard, *Gluck and the Birth of Modern Opera* (New York: St. Martin's Press, 1964), 1.
18 Howard and Gluck, *Orfeo*, 26.
19 A comparison may be drawn between Gluck and Kurt Weill, notably the relation between the *Mahagonny Songspiel* (1927) and the larger-scale *Aufstieg und Fall der Stadt Mahagonny* (1930). In addition, Gluck's relationship with his librettist Calzabigi makes an interesting comparison with Weill's relationship with Bertolt Brecht.
20 Stanley Sadie, *The New Grove Dictionary of Opera*, 4 vols (London: Macmillan, 1992), ii, 558.
21 Written by Giovanni Bottarelli.
22 Howard and Gluck, *Orfeo*, 63.
23 Ibid., 65.
24 Ibid., 98.
25 Ibid., 65.
26 Ibid., 112–19.
27 Ibid.
28 '*Air de Furies*' in the Paris Version, Act 2, Scene 1.
29 '*Ballet des Ombres heureuses*' in the Paris version, Act 2, Scene 2.
30 Howard and Gluck, *Orfeo*, 61.
31 Ibid., 95.
32 Fauquet, 'Berlioz's version of Gluck's *Orphée*', in *Berlioz Studies*, ed. Peter Bloom. (Cambridge:, New York: Cambrudge University Press, 1992), 197.
33 Ibid., 205.
34 Hector Berlioz, *Gluck and His Operas; With an Account of Their Relation to Musical Art* (Westport, CO: Greenwood Press, 1973), 13.
35 Loppert, 'The Gluck-Berlioz *Orphée Et Eurydice*', 18.
36 The chorus *Le Dieu de Paphos* from Gluck's final opera *Echo et Narcisse*.
37 Berlioz, *Gluck and His Operas; with an Account of Their Relation to Musical Art*, 30–6.
38 Fauquet, 'Berlioz's version of Gluck's *Orphée*', in *Berlioz Studies*, 211.
39 Although Berlioz believed the aria not to be Gluck's work.
40 Fauquet, 'Berlioz's version of Gluck's *Orphée*', in *Berlioz Studies*, 211.
41 Ibid., 212.
42 The notion of forgery or deception regarding works of the past was regarded perhaps more playfully in those times. Saint-Saëns, in a reminiscence of Viardot, records: 'One day ... Mme Viardot announced her intention of letting them hear a magnificent aria by Mozart that she had discovered; and she sang them a long aria with recitatives, arioso and a final allegro, which was praised to the skies and which she had quite simply written for the occasion.' In evaluating this Mozartian forgery by Viardot, Saint-Saëns

says: 'I have read this aria; even the sharpest critic might have been taken in by it.' Camille Saint-Saëns and Roger Nichols, *Camille Saint-Saëns on Music and Musicians*, (Oxford: Oxford University Press, 2008), 169.
43 Fauquet, 'Berlioz's version of Gluck's *Orphée*', in *Berlioz Studies*, 212.
44 Reynaldo Hahn, 'Notes', *Journal D'un Musicien* (Paris, 1933), 7.
45 Ibid.
46 Camille Saint-Saëns, *Portraits Et Souvenirs, L'art et les Artistes* (Paris: Société d'édition artistique, 1900), 211. Fauquet, 'Berlioz's version of Gluck's *Orphée*', in *Berlioz Studies*, 212, fn. 73.
47 Ibid., 209.
48 As it was popularly known.
49 Christoph Willibald Ritter von Gluck ed. Alfred Dörffel, *Orpheus, Opera in 3 Acts* (in German, French and Italian text), (Leipzig: C. F. Peters, n.d.).
50 Fauquet, 'Berlioz's version of Gluck's *Orphée*', in *Berlioz Studies*, 236.
51 Which publishes three different scores, 1762, 1774 and the Berlioz/Viardot conflation. Gluck, Moline and Calzabigi *Orphée et Euridice*; Christoph Willibald Ritter von Gluck and Hermann Abert, *Orfeo Ed Euridice*. Originalpartitur Der Wiener Fassung Von 1762 (Graz: Akad. Druck- u. Verl., 1960); Gluck, *Fauquet and Berlioz, Arrangements of Works by Other Composers. 1, Gluck*.
52 Material is currently on hire, but not for sale: Howard and Gluck, *Orfeo*, 113.
53 This situation has changed markedly (2020).
54 John Eliot Gardiner, 'Introducing the Gluck-Berlioz *Orphée* of 1859', *Gluck Orphée et Eurydice* Booklet accompanying EMI CD 7 49834 2 (1989): 2.
55 Ibid.
56 Howard and Gluck, *Orfeo*, 116.
57 www.prestoclassical.co.uk/r/EMI/2165779, accessed 10 June 2014.
58 Sadie, *The New Grove Dictionary of Opera*, iii, 496–7.
59 www.baerenreiter.com/nc/en/search/combined-search/?tx_indexedsearch[sword]= Mozart+operas&tx_indexedsearch[submit_button], accessed 15 May 2015.
60 TP 601. www.baerenreiter.com/nc/en/search/combined-search/?tx_indexedsearch [sword]=Mozart+operas&tx_indexedsearch[submit_button], accessed 15 May 2015.
61 Nikolaus Harnoncourt, *Mozart-Dialoge* (Kassel: Bärenreiter-Verlag, 2009), 233–42.

7 Mozart's operas during the long nineteenth century (1)

Die Zauberflöte

Die Zauberflöte was composed for a modest suburban theatre in Vienna, the Freihaus-Theater auf der Wieden, and quickly became a success, leading to what has been dubbed a 'veritable *Zauberflöte* craze', which accelerated following the composer's early death. By 1794, it had been performed widely in many centres, including Leipzig, Frankfurt am Main, Munich, Dresden, Mannheim, Weimar, Berlin and Hamburg.[1] The opera was quickly adapted and parodied – a typical pattern of dissemination for a work of this genre – which was not unlike a modern 'revue', with the fabric of the work being adaptable and able to accommodate local 'in-jokes' etc. It is partly this inbuilt quality of adaptability that led *Die Zauberflöte* to be widely performed and reimagined throughout the nineteenth century, though it was not popular in all operatic centres.

Some of the earliest adaptations of *Die Zauberflöte* retain an authorial voice, having been created by the work's librettist, Emanuel Schikaneder (1751–1812), who in addition created a satire that referenced a botched performance given at the Vienna Court Opera in 1801, enabling the librettist to make a joke in his own theatre at the expense of the larger institution.[2] Other parodies or 'travesties' followed, including '*Die Zauberflöte travestiert in Knittelversen*[3], with most of the Mozartian music kept' from 1803.[4] In this version:

> Tamino climbs a tree to escape from a pursuing bear. The queen's maids kill it with their broom, roasting-spit and poker, then quarrel over the skin. Papageno helps Tamino to hold a huge, framed portrait of Pamina, while he sings an adaptation of the portrait aria – 'Dies Bildnis ist verzweifelt schwer!'[5]

A still later adaptation (1818) by Karl Meisl, '*Die falsche Zauberflöte*', included contemporary novelties such as a kaleidoscope and *Draisine* (a forerunner of the bicycle). Among the new twists to the story, Pamina cannot easily forgive Tamino for taking coffee with the Queen's maids; while in the finale, the Queen, Pamina and Tamino take a ride on the carousel in the Prater amusement park.[6] Such parodies typify the way *Die Zauberflöte* was treated in Vienna – peppered with topical elements and satire, emphasising the comic, pantomimic nature of the work. As

Die Zauberflöte travelled through the provinces, similar adaptions and modifications multiplied: for example in a 1795 production that was staged in Passau, where Tamino became an Arthurian knight whose quest is to rescue Pamina. In the creation of this adaptation, the Queen of Night (here named Karmela, a 'magician through music') loses both of her arias, the first to the First Lady and the second to Pamina, who sings it as if she were repeating the instructions her mother had given her in a dream.[7]

Such adaptations and parodies of the opera seem quaint and misguided to modern sensibilities, and no less so the major reworking of *Die Zauberflöte* that occurred in Paris, where, in 1792, the opera was reconfigured to become an allegory of the French Revolution. In this production, the Queen of Night is associated with the reign of Louis XVI; Pamina becomes 'Freedom as the Daughter of Despotism'; Tamino 'the People'; Sarastro the 'Wisdom of a Better Legislation'; and the priests 'the National Assembly'.[8] This has been identified as a pro-Jacobin version of the work, which included the symbology of 'the flute – freedom; the three ladies (nymphs) – the three social classes; Papageno – the rich; Papagena – equality; Monostatos – the emigrants; the slaves – the servants and supporters of the emigrants; the three boys (genies) – intelligence, justice and patriotism'.[9] Versions of this adaptation persisted until 1817, and over time the cast was supplemented with personifications of Mozart and Schikaneder, who were portrayed as '*grimme Demagogen und Freiheitshelden*' (grim demagogues and heroes of freedom).

Along with such wide-ranging reworkings of the plot, the music was also far from sacrosanct. During the nineteenth century, the Queen of Night's arias were regularly transposed down in pitch, and coloratura passages were simplified. One early Queen of Night, Antonia Campi, was criticised for overwhelming even the recitative of her first aria ('O zittre nicht') with ornamentation.[10] Star singers and their personalities were becoming increasingly fascinating to the public, so the focus of interest was less on a particular opera than on individual singers and how they chose to present their roles, which often included major changes at the expense of the written notation. When a singer faced difficulties with the coloratura passages of the Queen of Night's arias, for example, those parts might be assigned to the flautist in the orchestra.[11] Roles were adapted to particular singers with a freedom that by today's standards suggests an ignorance of matters of voice type, range and tessitura (though transposition and *puntatura* were widespread practices).[12] Roles became adaptable to the musical abilities of a particular singer, often without reference to their sex.[13]

In Paris, a further development in the staging of *Die Zauberflöte* occurred in 1801, when *Les Mystères d'Isis* received its première: a large-scale adaptation, created by Etienne Morel de Chédeville and Ludwig Wenzel Lachnith.[14] This defined the form in which, for the next 26 years and over 134 performances, *Die Zauberflöte* was heard by Parisians, a version that was created to align the work with the operatic expectations that prevailed in that city. The main focus shifted towards the world of Sarastro, and its popularity was partly due to its predelection with things Egyptian, in the wake of Napoléon's recent campaign (1798–1801).[15] The result, however, was strongly criticised among cognoscenti and deemed

to be a stylistic hotchpotch that was locally dubbed '*Les Misères d'ici*'. Music from *Figaro, Don Giovanni, Tito* and Haydn's 'Drum Roll' Symphony was all incorporated into the score. The original music from *Die Zauberflöte* that did survive was cut, recomposed, transposed and brought in line with the needs of the new text. Berlioz, one of the dissenters, quipped that '*Mozart a été assassiné par Lachnith*', making a qualitative distinction between pastiches created in this manner and his own work of restoration in bringing Gluck's *Orphée* to the Parisian stage. Whatever the judgement of connoisseurs, this adaptation achieved enormous popularity, sparking a growing fascination with Mozart's operas in Paris during the 1830s, a stark contrast to the situation in Germany, where interest in his works was beginning to dwindle. These large-scale adaptations reinvented *Die Zauberflöte* in the guise of a Parisian grand opera, a far cry from its humble origins in a suburban theatre.

Die Zauberföte was also staged in London during this period, although the work found less favour in that city. In 1800, William Crotch noted that '*The Zauberflote* [*sic*] is now well known in England having been adapted and also successfully imitated by (Mozart's) pupil Mr [Thomas] Attwood'. Attwood (1765–1838), in spite of his Mozartian pedigree, set to work at the adaptation with no less zeal than his aforementioned French colleagues. As '*Il Flauto magico*', the work was performed in Italian (as was the custom in London) with dialogue substituted for recitative, in line with the English taste. Nevertheless, the production was not a complete success, nor was a further production from 1811 in a version by Giovanni de Gamerra (1742–1803, the librettist of Mozart's *Lucio Silla*), who transposed the *Singspiel* into a '*dramma eroicomico per musica*'. The Queen of Night's Act 1 aria was given to Pamina, and her second aria was moved into Act 1, marginalising her role in Act 2.[16] Substitutions were made in order to bring the work in line with the form of an Italian opera as it was recognised in London, according to which 'by Italian convention, the heroine Pamina was missing the "entrance aria" that would have signalled her importance in the drama and the Queen of Night [as a force of evil] did not merit a second show aria in Act 2'.[17] This version mystified audiences of 1811, who failed to respond to a work so 'saturated with the traditions of popular Viennese theatre' that was further distorted in order to conform to the Italian opera model preferred in London. While the music was appreciated, it was considered that 'Mozart had wasted his talents on an execrable piece of theatre.'[18]

While *Die Zauberflöte* has gone on to become a staple of the repertoire and one of the most frequently performed operas worldwide, the apparent dichotomy between the quality of the libretto and Mozart's music remains an issue in its presentation, with considerable dramaturgical intervention needed to achieve a dramatically credible production. Careful adaptation of the libretto is mandatory for modern circumstances – typically only a small fragment of the original spoken text is performed today, generally considerably abbreviated. Modern productions of *Die Zauberflöte* broadly present the work in one of two guises, emphasising either its *Singspiel* aspect – the popular, folky side – or else the esoteric, rarefied world of Sarastro and his priests. During the later twentieth century there arose

a fascination with the arcane meaning and symbolism thought to reside in the work, particularly with references that related to the composer's Masonic involvement. A publication by Jacques Chailley, *The Magic Flute Unveiled*,[19] exerted considerable influence upon a number of new productions of the work, underlining its ongoing appeal as a vehicle for the overlaying of contemporary readings and directorial concerns.

Don Giovanni

Of the later Mozart operas, *Don Giovanni* and *Die Zauberflöte* retained the strongest presence in the repertoire during the nineteenth century, both finding an underlying affinity with the *Zeitgeist* and an innate adaptability that allowed them to absorb new conventions and concepts without losing a fundamental sense of identity. E.T.A. Hoffmann's *Don Juan* (1813) initiated the process of the Don's character transformation towards an almost Byronic figure, the embodiment of the Romantic ideal, which played out in adaptations and large-scale reworkings of the opera, as well as an expansion of the music, reconfiguring it to embrace changing tastes, according to the emerging Parisian grand opera model. In Paris, the Don developed into a complex, Romantic anti-hero, while in other centres, audiences preferred the popular, puppet-play traditions, which often devolved into parody and pasticcio, such as a production that took place in London in 1817, entitled '*Don Giovanni* or a Spectre on Horseback! A comical-musical-tragical-pantomimical-burlesque-sensational magic farce!'[20] Even in these early interpretations, one can observe the dual nature of the work, a *dramma giocoso*, where differing readings may emphasise the dramatic at the expense of the comic, and vice versa. This choice of emphasis continues today, when *Don Giovanni* may be presented as either a Romantic grand opera or a more historically inclined late eighteenth-century work, with significant differences in vocal casting and orchestral resources required for each of these approaches.

In Paris, *Don Giovanni* was first performed in 1805 in an arrangement by Christian Kalkbrenner (1755–1806), who retained some of Mozart's music while adding much of his own. This adaptation has been described as a 'dreadfully distorted and mutilated version' of the opera,[21] with the trio of maskers being sung by three Gendarmes and the sung text altered to: 'Courage, vigilance, Adresse, defiance, Que l'active prudence Préside à nos desseins', bringing Mozart's opera dangerously close to the world of Offenbach. By 1811, Parisians had an opportunity to experience something resembling Mozart's original conception when it was given by the Théâtre-Italien company with the music largely conforming to the composer's score. In 1827, a new version by F.H.J. Castil-Blaze[22] was introduced to Paris, with the work recast as an *opéra comique* and the spoken dialogue adapted from Molière; the first step towards the Gallicisation of the work that will be discussed in due course.

In 1834, *Don Giovanni* was further adapted into a five-act grand opera, a treatment that responded to the growing canonical status of the work, Mozart having become known in France during these years as 'l'auteur de Don Juan'.[23] The tenor

Adolphe Nourrit was chosen to sing the title role, and a ballet of some 30 minutes[24] was inserted into the middle of Act 1, including various heavily reworked Mozart compositions. This adaptation's scale and aesthetic brought the work in line with the monumental works that were in fashion at the time, such as Auber's *Gustave III* and Halévy's *La Juive*. Despite a hostile reception at its première, this adaptation gradually took hold and was regularly revived throughout the nineteenth century. The creation of this version followed the French theatre practice of writing more music than would likely be necessary, allowing for later cuts, which applied equally to adaptations and new, original works. The practical exigencies of creating a première not infrequently caused important material to be excised from the score, as was the case with this version, and over the half-century it remained in the repertoire, the contents of the score became a fluid negotiation between the original version and subsequent excisions and alterations, meaning that the production 'was in a constant state of flux, adapting to the needs of its cast, the response of the public and the press'.[25]

This evolving version of the opera ultimately reflected the changing characteristics of the Don's character as it developed in the literature of the nineteenth century. Hoffmann's *Don Juan* was an important influence upon the adapter, Castil-Blaze, and he wrote of his intention 'to give this prodigious musical work a performance of the power which has hitherto been denied it, to show this *Don Giovanni* as Mozart conceived it, as Hoffmann dreamt it'.[26] What emerges from his version is a *Don Giovanni* quite distinct from that created by Da Ponte, eschewing any of the popular origins of the Don Juan story; rather, absorbing the influence of *Don Giovanni* upon Romantic nineteenth-century sensibilities. In Hoffmann's conception, Donna Anna loves and desires Giovanni but recognises the sin of her passion and the corresponding shame it brings to her. This causes her suicidal state. 'She feels that only Don Juan's destruction can bring peace to her mortally tortured soul; but this peace demands her own earthly destruction.'[27] In the operatic adaptation, a scene occurs at the beginning of the fifth (!) act, where the Don has a nightmare that prefigures his downfall, a veritable 'dream sequence', in which he reveals to Leporello 'the extent to which his daredevil attitude was a front which concealed his vulnerability'.[28] In this introspective scene, Giovanni is portrayed 'as a broken man, agitated by deathly premonitions'.[29] The libretto became 'a drastic reworking of Da Ponte, transforming the leading protagonist's character into a Romantic hero and Anna's as a quintessential Romantic heroine faced with no "noble" choice but death.'[30] Following Giovanni's death, the *scena ultima* was cut (as was usual during the nineteenth and early twentieth centuries) and replaced by a 'balletic Epilogue' incorporating music from the 'O voto tremendo' from *Idomeneo* and the *Dies Irae* from the *Requiem* K626. During this music, Donna Anna's coffin was brought onstage, the libretto directing that:

> The virgins place their companion's coffin on the ground and while they kneel in prayer, the shroud lifts up and reveals to Don Juan the body of Donna Anna, who half rises out of her tomb, a black veil around her shoulders and a white crown on her temples.[31]

From these examples of how *Don Giovanni* was re-imagined in Paris during the nineteenth century, we see the efforts that went into aligning the work with new methods of staging, expanding operatic technologies, new literary trends, the rise of Romanticism, and new musical developments, most particularly the requirement for an operatic work to be through-composed, rather than a series of numbers separated by *secco* recitative or dialogue.

The wide-ranging scale of these adaptations highlights the shadowy figure of the arranger or adapter: in this case, Castil-Blaze. Assessments of such arrangers differ markedly, though generally they are given a bad press, being often referred to as 'hacks'. Berlioz was highly dismissive of arrangers such as Lachnith and also Castil-Blaze, who enjoyed a busy and distinguished career as a critic, librettist, translator, arranger, composer and music editor praised elsewhere[32] for his operatic arrangements: his 'skilful reworking of German and Italian material for the French stage played an important role in the absorption of foreign opera in Paris and the French provinces'.[33] Was Berlioz's judgement a dispassionate one, or did he sense a rival, given that many of Castile-Blaze's professional activities mirrored his own?[34] The work of the English arranger, Henry Bishop has begun to be reassessed in recent decades, and his adaptation of *Figaro* for Covent Garden in 1819 was published in 2012,[35] allowing a fuller assessment and understanding of his methods. The history of opera is yet to arrive at a fuller understanding of the working processes and achievement of such adapters.

The nineteenth century presents a confusing face, with operas from the past being given radical makeovers in order to bring them in line with the latest fashions. Mozart's operas were part of this trend, being obliged to adapt in order to maintain a position within a commercially based performance environment. With the publication of more reliable editions of the composer's work, men of letters, whose libraries would contain not only handsomely bound volumes of the literary classics but also 'complete' editions of composers such as Bach, Handel and Mozart, gradually became aware of a discrepancy between what was printed in their authoritative editions and what was heard on the operatic stage. In England, this fuelled an early interest in the notion of *Werktreue*, which originated in literary circles, and heavily influenced critical judgments published in reviews at the time. During this period, *Werktreue* meant creating performances within a framework of fidelity, which was defined by the printed musical score. One such critic, J. Wrey Mould wrote that 'all *conscientious* musicians will agree with us when we state that Mozart's "*Il Don Giovanni*" [sic] has *yet* to be properly put on the stage in this country',[36] noting the 'many little falsehoods wherein the recent Covent Garden performances stand convicted'.[37] He implores the conductor of the production, Sir Michael Costa (1808–84), to:

> Give us the Overture without additional Trombones, Ophicleides and Serpentcleides! ... more than all, restore the last Finale; do not bring down the curtain (as at present) upon eighteen-penny-worth of red and blue fire.[38]

Berlioz railed at the same practices – specifically where Costa added an ophicleide solo to the supper music in the Act 2 finale.[39] Operatic works began to occupy two separate realities – either as printed editions which occupied the shelves of a private library, or as commercial entertainments that took place in an opera house. A similar split occurred in Paris, where operatic 'classics' of the past were adapted to fit the conventions of grand opera, by which they entered the developing 'operatic museum'. It subsequently became clear that these 'exhibits' of the operatic museum had been significantly tampered with and required wide-ranging restoration.

Restoring *Don Giovanni* – a conundrum

While it is a fairly straightforward task today to remove the accretions that distorted performances of *Don Giovanni* during the nineteenth and early twentieth centuries, there is a fundamental difficulty that hinders any 'restoration' of the work. Mozart created two versions of the opera: one for its première in Prague, followed by a revision for Vienna. Although it might seem logical to perform one or other of those versions, this almost never happens, as the two versions created by Mozart present an irreconcilable dilemma. If one consults a score of the opera, for example the Bärenreiter critical edition, both versions are clearly set out, making it theoretically possible to perform either, although the edition tacitly assigns scholarly preference to one reading, by having the 'main text' reflect the Prague version and consigning the Vienna variants to an appendix. In the opera house, a 'best of all possible worlds' conflation is the usual solution adopted, which in particular retains the two additional arias composed for Don Ottavio and Donna Elvira as part of the Vienna version. The reasons for this practice are certainly not scholarly, or dramatic (directors often feel they hold up the action); rather, they derive from the wishes of both the public and the singers themselves. Singers generally want to include these additional arias, as they are both extremely popular with audiences and integral to popular expectations of what should be heard in a performance of *Don Giovanni*. The situation is summed up by conductor Erich Leinsdorf, who wrote: 'No help here from singers! ... I have never been able to stay with either the Prague or the Vienna version pure and simple.'[40] In scholarly circles, the original Prague version is notionally considered the 'most authentic', as it represents Mozart's 'first thoughts', and there is some evidence to suggest that Mozart was coerced (by Da Ponte) into making the changes for Vienna. The Prague version is even referred to in some circles as the 'true *Don Giovanni*';[41] an attractive notion that is not supported by the reality of performance practice. An interesting solution to this problem is available to the collector of recordings, who may wish to create their own, ideal performance in the comfort of their own living room. A recording of the opera conducted by Roger Norrington and released in 2004,[42] contains all the music Mozart composed for both versions, enabling the listener to effectively construct their own, preferred version for home listening.

In the opera house, however, a decision has to be made in order to arrive at a performing version of the work and no matter which choice is made, some of Mozart's music will be omitted. A parallel problem occurs in art curation, where an artist has painted over their own varnish, meaning that when it requires removal and replacement (standard practice in art restoration), the only way this can occur is by also removing the artist's overpainting. Claude Lorrain, for example, was observed at work in 1668 by an eyewitness who noted that 'he has already put the varnish on and is in course of retouching the blue and perfecting the final touches.' These final retouches would inevitably be removed in the course of varnish removal and could only be replaced by a restorer's approximate retouches. Delacroix noted the same issue in his diary, writing that it was necessary to 'find some means of preventing the varnish underneath from being attacked when the top coat of varnish is removed at some later date …'.[43] Such cases present particularly difficult challenges for the art restorer, involving a specialist understanding of exactly what constitutes the identity of a painting and how it can be most responsibly maintained.

The deification of Mozart, *musicien Français*

Unlike other Mozart operas, *Don Giovanni* was published in a substantially accurate full score quite early, in 1801.[44] The history of Mozart's autograph score is of considerable significance for the developing perceptions of Mozart, as well as *Don Giovanni*, during the nineteenth century. The autograph was acquired in 1855 by Pauline Viardot (who, with Berlioz and Saint-Saëns, had created the score of Gluck's *Orphée*), marking the beginning of a cult that grew up around the artefact.[45] According to a contemporary account, Viardot became the 'guardian' of the manuscript which, in turn, became a 'precious relic'.[46] A relic requires a reliquary, which was exactly what Viardot had constructed to house the manuscript.[47] It was given a special place in Viardot's home, to where numerous prominent musicians made pilgrimages. For example, on a visit in 1855, Rossini declared: 'I am going to genuflect in front of this holy relic.' Presumably he did. Viardot perpetuated this *Don Giovanni* cult throughout her life and beyond: 'visitors to her homes … behaved as if they were in the presence of a relic at a shrine'.[48] Viardot loaned the manuscript for display at the Exposition Universelle of 1878 and also at the anniversary [centenary] exhibition of *Don Giovanni*'s première in 1887. This effectively transformed the manuscript 'to the status of a national monument'.[49]

In 1869, Viardot elevated the work to an unattainable abstraction: 'Without a perfect performance, one can no longer listen to *Don Giovanni*.'[50] Scholar Mark Everist notes that

> her claims that the opera had, by the late 1860s, transcended performance … complement the sacralising vocabularies of Rossini and Tchaikovsky and the material symbolism with which she surrounded the autograph of the work … she enhances the veneration of *Don Giovanni* by attempting to remove the

96 Part II

opera from the stage and to place it beyond the grasp of those not yet initiated into its secrets.[51]

Everist concludes that 'Pauline Viardot's treatment of a physical document and her manipulations of the material discourses with which it was surrounded were a considerable force in the ongoing project of enshrining Mozart.'[52]

The 1827 French version of *Don Giovanni* (discussed earlier), with its incorporation of part of the text of Molière's *Don Juan* (1665), has been described by William Gibbons[53] as having led 'to a kind of intellectual ownership of the work on behalf of France'.[54] He notes that this association with Molière ('authorial slippage') lingered, so that in the popular as well as the critical imagination *Don Giovanni* 'became an inherently French opera'.[55] In 1861, the critic Paul Bernard created a list of 'French masterworks which included "our *Guillaume Tell*, our *Don Juan*,[56] our *Lucie*,[57] our *Juive* and our *Huguenots*"'[58] – of the five composers, only one was actually French. In the context of the Gallicising of canonic works, their absence from the operatic stage became a matter of concern. Paul Dukas, writing in 1896, lamented the absence of *Don Giovanni* from the stage for several years, and posed the following question:

> Suppose that tomorrow someone put certain canvases by Rembrandt or Velasquez back into the attic at the Louvre. What a furor! But what if one should banish from our opera houses *Der Freischütz*, *Fidelio*, *Alceste*, *Armide*, *Iphigénie*, *Les Troyens*, etc., etc., who would take notice?[59]

In Paris around the turn of the century, the idea began to circulate that those canonical works required not intermittent productions and revivals but, rather, to be maintained 'on a kind of rotating permanent display'.[60]

Following the disaster of the Commune of 1870, the subsequent resurgence of French nationalism maintained a certain blindness to the origins of the acknowledged French canonic works – operas by the Italian Lully; the Bohemian Gluck; and the Austrian Mozart. In effect, *Don Giovanni* had become a French grand opera, occupying a central place in the canon. Alongside this attitude arose a curatorial imperative to ensure that such works were presented in an 'authentic' way, the parameters of which were far from clearly defined, however. There was considerable resistance to the notion that the 'original Italian' version of *Don Giovanni* should be presented at the Opéra.[61] At that time 'authentic' meant playing Mozart's orchestrated numbers, even with the occasional borrowing from another of his works. The *secco* recitatives were regarded as lying outside the criteria of authenticity, and the order of the numbers was far from sacrosanct. In the eyes of the critic Moreno, 'the ever-flexible masterwork had to adapt to the time and place [i.e., French] conditions in which it found itself'.[62]

Around the turn of the century, Reynaldo Hahn organised a series of concert performances of the Mozart operas at the Nouveau Théâtre, a far more intimate venue than the Opéra. These performances were regarded as something of a watershed in the history of Mozart performance in Paris, akin to the revivals by

Levi, Strauss and Possart in Munich. In reviewing Hahn's 1906 Mozart Festival, critic Jean Chantavoine challenged the director (Albert Carré) of the Opéra-Comique to replace his current repertoire: '*Le Domino noir* [by Auber] with *Don Juan, Mignon* [by Thomas] with *Les Noces*,[63] *Mireille* [by Gounod] with *La Flûte enchantée*,[64] *Les Dragons de Villars* [by Maillart] with *La Flûte enchantée* and *Fra Diavolo* [by Auber] with *Così fan tutti* [sic].'[65] The canonisation and Gallicisation of Mozart are so integrated that there is a call for his operas to substitute for the standard repertoire, replacing recently composed works with those from the more distant past.

Die Zauberflöte and *Don Giovanni* have been discussed in some detail, as they were, by and large, the most performed of the Mozart canon during the 'long' nineteenth century, with each undertaking a unique journey through the operatic landscape. The remainder of Mozart's operatic canon exhibits instructive variants in performance practice and dissemination, and its main characteristics are outlined in the following chapter.

Notes

1 Alfred Loewenberg, *Annals of Opera, 1597–1940* (New Jersey: Rowman and Littlefield, 1978), 495–6.
2 Peter Branscombe, *W.A. Mozart, Die Zauberflöte*, Cambridge Opera Handbooks (Cambridge: Cambridge University Press, 1991), 165–6.
3 'Die Zauberflöte satirised in *Knittelvers*', an old Germanic rhymic verse, where the rhymes occur in an AABB form, and each line has four stresses.
4 Ibid., 166.
5 Ibid. Translation: 'This picture is damnably heavy.'
6 Ibid.
7 Ibid., 165.
8 Gernot Gruber, *Mozart and Posterity* (Boston: Northeastern University Press, 1994), 35.
9 Rachel Cowgill, 'New Light and the Man of Might: Revisiting Early Interpretations of *Die Zauberflöte*', in *Art and Ideology in European Opera: Essays in Honour of Julian Rushton*, eds. Rachel Cowgill, David Cooper and Clive Brown. (Woodbridge: Boydell, 2010), 207.
10 Peter Branscombe, *W.A. Mozart, Die Zauberflöte*, Cambridge Opera Handbooks (Cambridge: Cambridge University Press, 1991), 160.
11 Gruber, *Mozart and Posterity*, 109.
12 Ibid. The practice of transposing and also reworking vocal lines to bring them in line with the tessitura of a given singer is one that is generally quite foreign to modern performance practice. The practice was standard procedure throughout the nineteenth century and accounts for the fact that tenors undertook roles written for bass-baritones and vice-versa: the same was true for female roles. The practice of *puntatura*, is noted by Will Crutchfield as deriving 'presumably after the habit of notating it with unstemmed noteheads ("punti") on the same stave as the line being altered'. Crutchfield notes that the purpose of *puntatura* was twofold – either to alter the tessitura of a role or else to substitute alternative ornamental figures in florid passages. See: Gioacchino Rossini and Patricia B. Brauner *Il barbiere Di Siviglia: [Almaviva o sia L'inutile precauzione] Commedia in Due Atti*, vol. Critical Commentary (Kassel: Bärenreiter, 2008), Appendix on Early Vocal Ornamentation, by Will Crutchfield, 361–420. Specifically, 361.

13 Gruber notes that the popular singer Anna Milder-Hauptmann appeared as Tamino: Gruber, *Mozart and Posterity*, 109.
14 Ibid., 111–12.
15 Ibid., 112.
16 Rachel Cowgill, 'Mozart Productions and the Emergence of Werktreue at London's Italian Opera House, 1780–1830', in *Operatic Migrations: Transforming Works and Crossing Boundaries*, eds. Roberta Montemorra Marvin and Downing A. Thomas (Aldershot: Ashgate, 2006), 159.
17 Ibid.
18 Ibid., 160.
19 Jacques Chailley, *The Magic Flute, Masonic Opera: An interpretation of the Libretto and the Music*. (London Gollancz, 1972)'. It first appeared as *La flûte enchantée, opéra maçonnique* (Paris: Robert Laffont, 1968).
20 Gruber, *Mozart and Posterity*, 64.
21 Hermann Abert and Peter Gellhorn, *Mozart's 'Don Giovanni'* (London: Eulenburg Books, 1976), 23.
22 François-Henri-Josef Blaze, known as Castil-Blaze, among other pseudonyms as an author. He was the son of Henri-Sébastien Blaze, a novelist and amateur composer who wrote (under the pseudonym Hans Werner) music and literary criticism for several journals, among them the Revue des deux mondes. In turn, the son of François-Henri, known as Henri Blaze de Bury, worked on the libretto in question.
23 Katharine Ellis, 'Rewriting *Don Giovanni* or "the Thieving Magpies"', *Journal of the Royal Musical Association* 119, no. 2 (1994): 213.
24 Ibid., 214.
25 Ibid., 216.
26 Ellis, 'Rewriting *Don Giovanni* or "the Thieving Magpies"', 222. In a written apologia for the version, the authors justified their actions by saying that all of the added music was by Mozart, some of it from the 'Appendix' – as per the Breitkopf und Härtel edition. The ballet music did at least use themes and melodies by Mozart. A point of separation perceived by the authors between 'musical numbers' and recitatives should be noted. The recitatives were not referenced by the above statement and were significantly rewritten.
27 Ibid., 227, fn. 36.
28 Ibid., 226.
29 Ibid.
30 Ibid., 230.
31 Ibid., 225.
32 For example, Mark Everist in Stanley Sadie, *The New Grove Dictionary of Opera*, 4 vols (London: Macmillan, 1992), i, 759.
33 Ibid.
34 For example, the recitatives that Berlioz composed for performance in France of Weber's *Der Freischütz*.
35 Henry Rowley Bishop, ed. Christina Fuhrmann, *Mozart's The Marriage of Figaro, Adapted for Covent Garden, 1819* (Middleton, WI: A-R Editions, Inc., 2012).
36 *Wolfgang Amadeus Mozart, Jon Juan; or the Libertine Punished. (Il Don Giovanni) Ossia (Il Dissoluto Punito). Founded on the Spanish Tale of L. Tirso de Molina by the Abbé da Ponte and Rendered into English from the Italian by J. Wrey Mould. Revised from the Orchestral Score by W. S. Rockstro* (London: T Boosey and Co., 1850), ix.
37 Ibid.
38 Ibid., x.
39 Julian Rushton, *W.A. Mozart, Don Giovanni, Cambridge Opera Handbooks* (Cambridge Eng.; New York: Cambridge University Press, 1981), 53.
40 Erich Leinsdorf, *Erich Leinsdorf on Music* (Portland, OR: Amadeus Press, 1997), 74.
41 Rushton, *Don Giovanni*, 53.

42 Mozart, *Don Giovanni*, Schmidt, Miles, Halgrimson, Dawson, Ainsley, Yurisich, Argenta, Finley; Schütz Choir of London, London Classical Players/Roger Norrington. EMI, www.allmusic.com/album/mozart-don-giovanni-prague-and-vienna-versions-die-zauberflöte-mw0001848037/credits, accessed 12 December 2014.
43 These quotes and paraphrased material are from Sarah Walden, *The Ravished Image or, How to Ruin a Masterpiece by Restoration* (London: Weidenfeld and Nicolson, 1985), 133.
44 By Breitkopf & Härtel.
45 Mark Everist, *Mozart's Ghosts, Haunting the Halls of Musical Culture* (Oxford: Oxford University Press, 2012), 157–88.
46 Mark Everist, 'Enshrining Mozart: *Don Giovanni* and the Viardot Circle', *19th-Century Music* 24, no. 2–3 (Fall/Spring 2001–02): 168.
47 'Pauline Viardot preserved the document in an artefact that was as close in construction to a reliquary that its nature would allow.' Everist, 'Enshrining Mozart: *Don Giovanni* and the Viardot Circle', 189. The artefact is illustrated in Everist, Plates 2 and 3. Plate 4 reproduces a floor plan of Viardot's house, showing the placement of the *Don Giovanni* autograph.
48 Ibid.
49 Ibid.
50 Ibid., 179.
51 Ibid., 180.
52 Ibid., 189.
53 William Gibbons, *Building the Operatic Museum: Eighteenth-Century Opera in Fin-De-Siècle Paris* (Rochester: University of Rochester Press; Woodbridge: Boydell and Brewer Limited, 2013), 31.
54 Ibid.
55 Ibid.
56 As *Don Giovanni* was known throughout German and France in the nineteenth century, as well as part of the twentieth.
57 Donizetti, *Lucia di Lammermoor*.
58 Gibbons, *Building the Operatic Museum: Eighteenth-Century Opera in Fin-De-Siècle Paris*, 37.
59 Ibid., 36.
60 Ibid.
61 Ibid., 38.
62 Ibid., 39.
63 i.e. Mozart, *Le nozze di Figaro*.
64 i.e. Mozart, *Die Zauberflöte*.
65 Gibbons, *Building the Operatic Museum: Eighteenth-Century Opera in Fin-De-Siècle Paris*, 41.

8 Mozart's operas during the long nineteenth century (2)

Die Entführung aus dem Serail

Like *Die Zauberflöte, Entführung* is performed today with much of its original dialogue cut, or else with completely new dialogue substituted. During the nineteenth century, *Entführung* was typically performed in London in Italian with new recitatives composed to replace the dialogue. This created the irony that the work, set in Turkey and unpopular in Italy, was invariably performed in London in an Italian translation. Mozart composed *Entführung* for The National Singspiel which had been founded in Vienna in 1778, three years before the composer's arrival in that city in 1781.[1] While the National Singspiel maintained an excellent ensemble of singers, a strong repertoire of works failed to materialise, and a great opportunity lay before Mozart to enrich a bland repertory and raise the form to new artistic heights. Mozart created a work far superior to that of any of his contemporaries, displaying a level of virtuosity, sophistication and invention that completely transcended the *Singspiel* genre. The work was an immediate success, and its subsequent popularity throughout Germany was unprecedented. *Entführung* was premiered in 41 cities outside Vienna during Mozart's lifetime, as well as occupying the stages of the three principal Viennese theatres.[2]

By 1800, *Singspiel* as a genre was on the wane, and with it the popularity of *Entführung* also diminished. It remained ahead of *Idomeneo, Così* and *Tito* in frequency of productions but fell behind *Figaro, Don Giovanni* and *Die Zauberflöte*.[3] The slow demise of the *Singspiel* medium resulted in travesties of Mozart's operas, which began to incorporate fantastical biographical scenes, such as Joachim Perinet's '*Jupiter, Mozart and Schikaneder*'[4] or Louis Schneider's 1845 revision of *Der Schauspieldirektor*, which became *Mozart und Schikaneder*, with Stephanie's characters being replaced by Mozart himself, Schikaneder as the *Schauspieldirektor*, and Mozart's sister-in-law Aloysia Lange.[5]

An 1808 Viennese revival of *Entführung* substituted 'Un' aura amorosa' from *Così* in place of Belmonte's 'Ich baue ganz auf deine Stärke', in response to a wide dissatisfaction with the latter aria. The same aria from *Così* served as substitute for Belmonte's Act 2 aria, 'Wenn der Freude Thränen fliessen' in other centres during the nineteenth century. The 1808 Vienna revival also cut three arias from Act 2 – Blonde's 'Durch Zärtlichkeit und Schmeicheln', Constanze's

'Traurigkeit ward mir zum Lose' and Pedrillo's 'Frisch zum Kampfe'. Many of these substitutions and omissions became commonplace, and it also became usual to omit Constanze's 'Martern aller Arten'. Similar alterations persisted throughout the nineteenth century and were witnessed by Berlioz when attending an 1859 performance of the work in Paris. With tongue in cheek about the observance of 'scrupulous fidelity',[6] Berlioz noted that such fidelity reduced the opera from three acts to two, altered the order of the numbers, caused one of Konstanze's arias to be given to Blonde, and included the addition of an *entr'acte* between the (now) two acts of the Turkish March from the Piano Sonata K 331.

Entführung was first staged in London in 1827, where the topical issue of the Greek War of Independence caused the action to take place on a Greek island. The revised plot was as follows:

> Belmonte (posing as a painter) has landed ... [and meets] a happy band of islanders and an elderly Greek landowner, Eudoxius. Belmonte sets about painting the ruins of a temple to Bacchus and Eudoxius praises his respect for their Greek heritage. ... Just then Osmyn arrives with a detail of labourers; he points to a piece of sculpture and gruffly orders them to 'strike down that trumpery', which he intends to use to fill up the ditch behind the Pasha's stables. ...
>
> Blonde, now Pedrillo's sister, openly foments rebellion among the women of the seraglio. She has fallen in love with an Irish doctor who attends the Pasha, named O'Callaghan. Ibrahim himself, 'born of Christian parents; carried into slavery, when a child – and since risen to rank thro' his wonderful valour in the field', keeps and reveres a bracelet bearing his mother's portrait. The discovery of a duplicate in Constanze's possession leads to the revelation that he and she are brother and sister.[7]

Perhaps understandably, the music also underwent adaptation of similar scope. Christian Kramer, 'Master and Conductor of His Majesty's Band', was mainly responsible for the removal of seven musical numbers (from a total of 21): two of Osmin's, all three of Belmonte's, Pedrillo's 'Frisch zum Kampfe' and Blonde's 'Durch Zärtlichkeit und Schmeicheln'. Astonishingly, Kramer saw fit to compose his own musical setting of two numbers, replacing Mozart's original score: these replacements were of Belmonte's 'O wie ängstlich' and 'Ich baue ganz auf deine Stärke'.[8]

It can be conjectured that *Entführung* fundamentally comprises a string of extraordinary musical numbers, which prop up and give dramaturgical definition to the flimsy support provided by the librettist. The *Neue Mozart-Ausgabe* (NMA) presents a reliable musical text to follow, and the original libretto is today largely ignored by stage directors, reinvented according to their whims – the ongoing fascination with this opera is perhaps due not just to the quality of the music but also to the opportunity afforded to the director to intervene in and extend the directorial process to include a reworking of the original material. Many of the more bizarre adaptations of the plot of *Entführung* during the nineteenth century pale

into comparison with the re-imaginings that have been overlaid upon the work following the postwar rise of *Regieoper*. Mozart's *Entführung* exhibits the quality of adaptability of the 'survival of the fittest' vein, which is fuelled by the dilemma of Mozart's extraordinary music created in response to a lacklustre libretto.

Idomeneo

While the Mozart operas are typified by complicated processes of gestation, the early history of *Idomeneo* poses a particularly complex conundrum. Among the difficulties in defining a performing edition of *Idomeneo* are two distinct versions (1781, Munich; 1786, Vienna) along with further variants that do not belong to either. Such issues were thought to have been resolved when the NMA critical edition of the work (1972)[9] established the Munich score as the definitive version (based upon the 'second libretto') while providing some other performance options. That all changed in 1981, when a large quantity of Mozart's autograph material, missing since the end of World War II, came to light in Poland. Another complication arose with a further discovery, made by Robert Münster in the Bayerische Staatsoper archives, of a transcript of Acts 1 and 2, the work of a court copyist, which was identified as the performing score used for the première of 1781.[10] That score incorporates hitherto unknown cuts, transpositions and additions of material originally thought to have been excised. This previously unknown material in turn raises the issue of the reliability of the so-called 'second libretto' as an accurate record of what occurred at the original Munich performances. The complication of sources and versions is such that a bewildering complexity of options exists for conductors and stage directors wishing to revive the work today – *Idomeneo* potentially offers not one but a multiplicity of authentic possibilities.

Shortly after the *Idomeneo* première in Munich, Mozart settled in Vienna and decided to present the work in that city, planning an adaptation that would conform to the Viennese taste. He planned to revise the title role for a bass (in line with the conventions of French opera) and even had a singer in mind – Ludwig Fischer, who later created the role of Osmin. The role of Idamante was to be adapted for a tenor. Plans for public performance did not materialise, but on 13 March 1786, a unique performance took place in the private theatre at the Auersperg Palace. The cast was described as amateur, which indicated their status as highly trained members of the aristocracy.[11] That occasion was the last time that Mozart's opera was heard during his lifetime.

After the composer's death, *Idomeneo* was performed throughout German-speaking lands between 1803 and 1887,[12] but in spite of this, the work failed to establish a presence farther afield, and its performance history can be regarded as one of 'discrete revivals rather than assimilation into the repertory'. During the later nineteenth century the opera began a separate life as an 'object of serious critical attention' among musical connoisseurs by virtue of its publication.[13] Its revival in anything like a 'complete' or 'authentic' form did not occur until the twentieth century, when it was generally given under festival, or festival-like, conditions.

Idomeneo was also subject to a number of wide-ranging reworkings, notably by Richard Strauss (1930) and Ermanno Wolf-Ferrari (1931), which politicised the work, removing it to a post-Wagnerian world beyond any of which Mozart could have conceived.[14] These arrangements have been heavily criticised in the literature, described in terms of 'mutilation' and even 'rape'; however, in more recent times, the Strauss version in particular has been performed and recorded, offering a fascinating insight into the composer's early-twentieth-century view of Mozart. Perhaps, in the recitatives that Strauss composed, we are afforded a glimpse into what the *secco* recitatives under Strauss's musical direction sounded like in the theatre.

Le nozze di Figaro

Along with composers Antonio Soler (1729–83) and Giuseppe Sarti (1729–1802), Mozart referenced himself in *Don Giovanni*, quoting Figaro's aria 'Non più andrai' in the supper music for Act 2, thereby suggesting that it enjoyed the status of a 'hit' in its day. During the nineteenth century, *Figaro* vied with *Don Giovanni* for popularity, frequently losing out to the allure of the demonic, romantic hero. The three Mozart/Da Ponte collaborations continued to shift in terms of their respective popularity and critical assessment as the century drew to a close. A curious early production of *Figaro* took place in Monza in 1787, where Acts 3 and 4 were reset to music by Angelo Tarchi. Of the parts of Mozart's score that did survive in this version, arias were shared among characters; for example, the Count in Act 1 sang Cherubino's 'Voi che sapete' with an altered text.

Mozart's operas were slow to take hold in Italy, where his music was considered too complex, learned and dense, the rich orchestral writing being a particular point of contention. One solution adopted to address this problem was to give *Figaro* over two evenings, as occurred in Florence in 1788. Musical numbers which are today inextricable from the popular conception of the work were substituted with other arias by other composers; for example, Cherubino's 'Non so più' was replaced with an insertion aria by Bartolomeo Cherubini for Susanna to sing.[15] A production in Hanover in 1789 displaced the recitatives with spoken text drawn from the original play by Beaumarchais (1732–99), a practice that continued until Mahler's tenure in Vienna.

In 1793, a production occurred in Paris which has created interest among literary scholars because Beaumarchais was personally involved. A review of the production had criticised the mixture of singing and speech, the amount of dialogue and the overall length of the performance, and it is here that Beaumarchais actively entered the story as a consultant, cutting dialogue and suggesting that instrumental music should be added to facilitate more dances. Of the playwright's changes, which resulted in a five-act version: Cherubino sang an additional aria in Act 2 to the text of the original song that Beaumarchais had written for him to sing, to the tune of 'Malbroug s'en va-t-en guerre'; Act 3 concluded with the Sextet, which was preceded by Basilio's aria ('In quel'anni', No. 26)[16]; Act 4 began with the Countess alone onstage and ended with the Act 3 finale, with the fandango cut

and replaced by a gavotte; Figaro's aria 'Les preuves les plus sûres' was adapted to the music of Don Giovanni's 'Metà di voi' (No. 17); the aria of Marcellina – 'Il capro e la capretta' (No. 25) – was replaced by 'Ces maîtres de nos âmes', set to Dorabella's aria 'È amore un ladroncello' (No. 28) from *Così*.[17] This has been appropriately described as a 'hybrid *Figaro*', and it enjoyed a particular status due to the influence of Beaumarchais.

Two of the original Vienna cast of *Figaro*, Nancy Storace and Michael Kelly, along with two pupils of Mozart, Stephen Storace and Thomas Attwood, had settled in London and began to introduce Mozart's operas to the stage, initially in the form of insertions into other operas. Stephen Storace was one of the leading exponents of this practice, and the following[18] description of Storace's *pasticcio*, *The Siege of Belgrade*, which was based on Soler's *Una cosa rara*, reports:

> I was not a little astonished yesterday evening when I attended a much-loved operetta 'The Siege of Belgrade' and found almost all arias to be from Cosa rara. A certain Signor Storace understands the art of throwing together several Italian operas to create an original English one.[19]

Mozart scholar Gernot Gruber notes a 'tendency to uncouple the music'[20] – an observation that reveals a deeply work-based line of thinking, whereas in most operatic centres in the eighteenth century, an opera was simply a collection of musical numbers, not necessarily by the same composer, having only a partial existence as a single work or entity. The first Mozart operatic excerpt to be heard in London, for example, was the duet between the Count and Susanna that opens Act 3 of *Figaro*: Nancy Storace and Francesco Benucci introduced it to that city as an insertion into another work.[21] Such an occurrence was a compliment to the composer: thanks to the *pasticcio* tradition, a selection from *Figaro* 'popped in' to an operatic performance to stake a claim. In many cases, Mozart's operas were first introduced to towns and centres in the form of domestic arrangements or individual numbers adapted for performance in the home, among a circle of dedicated amateurs.

London's experience of *Figaro* in the opera house in something approaching a complete form began in a half-hearted fashion in 1812, when the Pantheon theatre staged the work but only presented the first two acts, necessitating a conclusion that left Figaro as the villain of the piece, rather than the Count. The rival King's Theatre soon responded with a more lavish (and more complete) production that was described in *The Times* as 'LE MARIAGE DE FIGARO: the music by Mozart'. In addition, a 'favourite popular Scotch ballet of PEGGY'S LOVE' was given at the end of Act 1, while at the conclusion of the Opera 'God save the King' was sung by the tenor Diomiro Tramezzani followed by the finale, a new Ballet 'LA REINE DE GOLCONDE'.[22] During the course of the evening, a poem 'written for this occasion by an English Lady'[23] was recited by a Mr Elliston. In spite of these intrusive additions, the production included all of Mozart's musical numbers, mostly without adaptation: Susanna appropriated Cherubino's arias, and there were some cuts to the Act 4 finale, but that was the extent of the

changes. While commercial imperatives remained ever-present, there was also a new climate and attitude that were being gradually introduced into the operatic arena. In the words of William Weber:

> The English invented the idea of musical classics. Eighteenth-century England was the first place where old musical works were performed regularly and reverentially, where a collective notion of such works – 'ancient music' – first appeared.[24]

Mozart may not have qualified as 'ancient music', but he was increasingly being recognised as a phenomenon from the past and a 'classic'.

Rival theatres in London readily oscillated between the methodologies of *pasticcio* and textual veracity in competing with their rivals to create productions of the same works. In 1819, *Figaro* was presented at Covent Garden in an English adaptation by Henry Bishop.[25] The work was 'translated, altered and arranged ... and the whole adapted to the English stage',[26] which, in practical terms, meant: the work was arranged in three acts; the plot was simplified; the Count became a speaking role, while a new character, Fiorello, was adapted from Rossini's *Barbiere* and sang the Count's music; the Countess sang (Cherubino's) 'Voi che sapete' as 'Love ever leave me, peace to restore'; numbers from other Mozart works, Bishop himself and Rossini were added to the score; the remaining Mozart numbers were further altered; in the finale to Act 1, Figaro's 'Non più andrai' and part of the Act 1 finale of *Così* were dovetailed.

In adaptations such as these, Mozart's ensembles in particular proved troublesome and were generally removed, with dialogue substituted. Furthermore, in tours to provincial cities of this *Figaro* production, Susanna regularly substituted popular songs such as 'Home, Sweet Home' or 'I've Been Roaming', underlining a marked distinction between the conditions pertaining to operatic performance in London and those in the provinces. In undertaking this complex task of adaptation, Bishop admitted that '[t]he obstacles ... that arose in adapting the *Music* were innumerable!' However, his quest remained 'to improve our National taste for Music, by, ... establishing the works of the immortal MOZART on the English stage'. His version remained in the repertory for 20 years, being finally ousted in 1842, when a new version was given at Covent Garden, with an English text by Planché, conducted by Julius Benedict. While this version replaced recitatives with spoken dialogue, it was generally considered that the musical numbers at least were faithful to Mozart's original and that the opera was given 'with great taste and care'.[27]

Figaro remained behind *Don Giovanni* in popularity during the second half of the nineteenth century, though considerably ahead of *Così*, which all but disappeared. According to Rosenthal,[28] *Figaro* disappeared from the repertory of Covent Garden between 1849 and 1866. Carter notes that during this time, *Figaro* found a home in Victorian drawing rooms, where the main arias remained popular. In London at least, *Figaro* did not revive with vigour until the performances at The Old Vic in 1920.[29]

La clemenza di Tito

La clemenza di Tito is often considered in a similar light to *Idomeneo*, as a work for the connoisseur: musician's music, worthy of study, but not really able to hold the stage, an assessment that persisted well into the twentieth century. This judgement is bound up with Mozart's having chosen to create an opera in the old *seria* style, to a libretto adapted from Metastasio, whose aesthetic had begun to pale. A consideration of Mozart's operas beyond the 'canon of seven', including the earlier *seria* masterpieces throws *Tito* into a different light, calling into question the myths that have persisted of Mozart's reluctance to write the work, along with reports of his ill health compromising the finished result. Edward Dent's 1913 assessment was that 'the opera was finished in eighteen days ... by a man in broken health, exhausted by overwork and forced to write in haste against his will',[30] a judgment that was long accepted as unquestioned fact. Mozart scholar Otto Jahn voiced a similar opinion: 'it will scarcely be expected that an unqualified success should follow such a combination of untoward circumstances'.[31] These assessments were derived from Mozart's earlier biographer, Franz Xaver Niemetschek, writing in 1798.[32] Subsequent assessments written under the influence of this account have been questioned, by Einstein (1945)[33] and further by Rice (1991).[34] The première of *Tito*, in contrast to other Prague premières of Mozart's operas, was a failure, causing displeasure to Leopold II (for whose coronation it was commissioned): a judgement that filtered down through the rest of the court. Shortly thereafter, however, *Tito* found favour with the public in Prague, and by early October 1791, Mozart was able to write to his wife that the final performance was a great success. In the years directly following Mozart's death and prior to 1800, the work was considered to be 'sublime', embodying 'simplicity' and 'tranquil sublimity'; it was also considered to emulate the 'heroic sublimity' of *Idomeneo*.[35]

In the immediate wake of Mozart's death, *Tito* became a vehicle for his widow, Constanze to raise funds for herself and her children. She took a special interest in the work and often sang in the performances she mounted, probably because it was Mozart's last opera and his final works had already begun to acquire halos. Following the success of these performances, which took place between about 1794 and 1797, *Tito* was taken up in the repertory of many theatres.[36] Further afield, *Tito* was performed in Naples in 1807 and Paris in 1816, though it failed to achieve lasting popularity outside German-speaking centres. After 1830, the opera began to disappear and failed to regain a foothold in the repertoire for over 100 years.[37]

The concert arrangement (without recitatives) that Constanze had created was found to be not a sound performing version, while the *secco* recitatives (which were not composed by Mozart) remained problematic. In Vienna in 1811, performances at the Hofoper were criticised for their incomprehensible recitatives, in response to which German spoken dialogue was substituted. This practice spread throughout German-speaking countries and became the usual performance practice for *Tito* during the nineteenth century. *Tito* also had its fair share of vocal

substitutions, with the title role often taken by a baritone or even a bass. Sesto was frequently sung by a tenor – a soprano being unsuitable in terms of dramatic realism – but equally, a tenor destroyed the vocal balance created by Mozart in the ensembles. It became acknowledged that the opera had been composed with very specific voices in mind (i.e. the by then endangered castrato), and when strong singing actors were employed, who lacked the prerequisite vocal skills, it was deemed acceptable to substitute arias by other composers.[38]

Tito appeared in London in 1806, the first Mozart opera to be performed in that city, and found great favour due to the prevailing musical conservatism in London that was led by Richard, second Earl of Mount Edgcumbe (1764–1839), a prominent politician and writer on music.[39] Edgcumbe was a hardened musical conservative, whose memoirs, written during the 1820s, criticise the new style of Rossini, and lament the decline of arias and Metastasian recitative in favour of ensembles, the disappearance of the castrati and their replacement with tenors and basses. It was these widely circulated opinions that accounted for the ongoing popularity of *Tito* in London, where the presentation of *opera seria* remained strong. Edgcumbe's main focus in the appreciation of opera was the voices, so that 'whenever it was revived in London during the next two decades, *Tito* served the purpose it served in 1806: as a vehicle for the greatest singers in London at the time'.[40]

The centrality of the singer in the choice of repertoire in London is also emphasised by musicologist Emanuele Senici,[41] who notes that the 1806 London production of *Tito* was very much a singer-driven enterprise, perhaps explaining why London was the only centre outside Germany where *Tito* entered the repertory. Inevitably, a London production would involve a process somewhere between a significant adaptation and a full-scale *pasticcio*, in which only one or two of the original numbers might survive. The 1806 production was announced in *The Morning Post*[42] as being 'a Grand Serious Opera, with Choruses, entitled LA CLEMENZA DI TITO, entirely composed by Mozart, ... To which will be added FAVOURITE BALLETS'. The printed libretto goes a little further: 'Adapted to the modern Stage by new Scenes and Alterations, by S. Buonaiuti. THE MUSIC ENTIRELY BY MOZART, Without any addition whatsoever'.[43]

The claim of 'no additional music' is correct in a sense but needs to be qualified. Some numbers were cut, but their text was printed in the libretto in inverted commas, so that the continuity of the plot would not be lost (this was standard practice). The implication was further that the italicised number might be included in later performances or seasons. Numbers were moved around and re-assigned to different characters. Senici describes the altering of Servilia's aria 'S'altro che lacrime' – which was revised by the adapter, Serafino Buonaiuti – to became 'Se non mi è lecito', a substitution made by including a text not set by Mozart but taken directly from Metastasio's original libretto. Senici evaluates the adaptation as follows: 'Buonaiuti's was a virtuoso performance whose main concern seemed to be to change what Mozart set to music as little as possible',[44] establishing Buonaiuti's adaptation as something quite distinct from a piece of hackwork driven by the market. In addition to cutting recitative, the numbers were 'radically

rearranged', producing a 'highly symmetrical' result, achieved in part by 'the fact that Buonaiuti kept a constant eye on Metastasio's original *Clemenza*'.[45] In spite of the changes made, the emphasis noted in the announcement above on the 'single authorial voice' of Mozart was notable, with such a reassurance to the public being highly unusual in the working practice of the King's Theatre. The announcement that the music would be Mozart's alone suggests the importance of emphasising that Mozart's music would not suffer the fate of the work of other composers, in spite of the fact that the opera was indeed shortened (as were all imported works) to make way for the ballet *entr'acte*.

Tito disappeared from the London stage following its 1806 première, due in part to the changing tastes of the lead singer, Angela Catalani, which highlights the cult of the singer that existed at the time. It was only in 1812 that a cast suitable to perform *Tito* could be engaged, and the revival that year saw the work score a success over *Così*, *Figaro* and *Il flauto magico*. Subsequent revivals from 1816 onwards show *Tito* being further adapted in the wake of the growing popularity of the Mozart/Da Ponte operas, as well as Rossini's *Barbiere*. During the 1820s and 1830s, London was overwhelmed, first by the phenomenon of Rossini, then in his wake, Donizetti and Bellini.[46] This marks the beginning of the fall of *Tito* from the repertory.

Gruber notes that by the 1820s,[47] Mozart's operas (at least *Don Giovanni* and *Figaro*) had achieved a canonical status in London that could not be eroded even by Rossini. After 1841, *Tito* disappeared from the London stage – though it entered 'the *sancta sanctorum* of immortal classics – much venerated, not often played'.[48] Throughout Europe, *Tito* suffered a similar fate. In the second half of the nineteenth century, the opera all but disappeared from the repertory, suffered critical disapprobation and was not revived until well into the twentieth century.[49] The words of Richard Wagner, often abbreviated (to imply an application solely to *Così fan tutte*), are quoted here in full:

> Oh how truly dear and most praiseworthy is Mozart for me, that it was not possible for him to invent music for *Tito* like that of *Don Giovanni*, for *Così fan tutte* like that of *Figaro*! How disgracefully it would have desecrated music![50]

Così fan tutte

Of the Mozart operatic canon, *Così* has undergone the greatest reversal of fortune, entering the repertory of opera companies worldwide during the course of the twentieth century, and today holding a place as one of the indispensable, core works of the repertory. Following its première in Vienna in 1790, *Così* was produced the following year in Prague, Leipzig and Dresden, staged by Domenico Guardasoni. The libretto from Dresden suggests that around one-third of the set pieces were either cut or replaced by recitative. In Italy, *Così* was first heard in Trieste in 1797, with further performances in Varese, Milan, Naples and Turin[51]. However, it was regarded as a particularly difficult work

to produce in Italy, due in part to the richness and complexity of the ensemble writing.

By the early nineteenth century, Mozart's posthumous reputation was beginning to grow. The apparently frivolous nature of the libretto of *Così* proved a potential stumbling block to this process, and the sexual morality which developed in the following decades meant that *Così*, as penned by Da Ponte, was no longer acceptable for performance. The quality of Mozart's music was not in question: the dilemma was how to reconcile the fact that he had created such sublime music for such a sordid plot. With twenty-first-century hindsight, it becomes clear that Da Ponte and Mozart had created a complex, unsettling work,[52] which was antagonistic to the spirit of the early nineteenth century. Repeated efforts to marry the sublime music to a new text failed to produce a generally accepted solution, and the plethora of translations in German-speaking countries, along with persistent attempts to adapt and reconfigure the musical score, resulted in widespread confusion about the original form and structure of the opera. A version by G.F. Treitschke, which was performed in Berlin in 1805, portrayed Alfonso as a magician and Despina as his spirit. Here, magic and morality become fused in the manner of the developing German Romantic opera genre, where Alfonso takes on characteristics of Prospero and Despina those of Ariel in the manner of Shakespeare's *The Tempest*. A later Berlin adaptation (1820) introduced two additional suitors and a second, male servant who took over from Despina. It has been said that 'no other opera, perhaps, has been subjected to so many different versions and attempts to "improve" the libretto'.[53] German-language librettos aimed at providing a more acceptable solution to what was perceived as the miserable text of Da Ponte. On occasion, elements of the plot were adapted to local taste as well as contemporary events: in 1794, the version of C.F. Bretzner (*Weibertreue, oder die Mächen sind von Flandern*) had the two lovers heading off to fight the French. In the sextet (No. 13), the Wallachians and Turks that Despina refers to become Hussars, Poles and *Sansculots*.[54]

In 1811, the soprano Teresa Bertinotti-Radicati (1776–1854) starred in a performance of *Così* in London that demonstrated the practice of *pasticcio* in full swing. It seems that in this case there was a dual (and conflicting) requirement to please both the public and the critics, to somehow maintain Mozart's canonic status even while his opera was being deconstructed. A notice distributed by the *prima donna* seems to be aimed at reassuring the critics who had come to regard Mozart as a 'classic':

> The same reason that forbids the re-touching of a picture of Corregio's [*sic*] or Raphael's or the alteration of a thought of Milton's or Pope's, induces Madame Bertinotti to hold sacred an Opera of Mozart's: how, indeed, would it be possible to retrench a work so celebrated, without the rebuke of the critic and the regret of amateurs of genuine music?[55]

Inside the theatre, the result was very different. A hotchpotch of *Così* was presented, with solo numbers reduced from twelve to seven, and Fiordiligi (sung by Bertinotti) losing both of her arias. The role of Guglielmo was taken by the tenor,

Diomiro Tramezzani, who was originally to sing Dorabella's aria 'È amore un ladroncello' as a substitute aria but eventually settled on Cherubino's 'Voi che sapete', while Bertinotti decided to sing the Dorabella aria (as Fiordiligi).[56]

A full score of the opera was published in 1810 by Breitkopf & Härtel, and although adaptations continued to appear, there was a slowing in the process as the concept of *Werktreue* continued to evolve, and by mid-century seems to have taken a foothold, at least partly in response to the centenary of Mozart's birth.[57] *Così* presented a subtly different case of adaptation to the other Mozart operas, as it was not driven by the need to introduce local or contemporary elements in order to maintain public interest. Rather, the difficulty was to render the work morally acceptable in a period when personal morality had shifted, a matter that became more urgent as Mozart's deification became more established. As the century progressed, *Così* collided with the theories of Richard Wagner, whose music–dramas embodied a seamless musical continuum, establishing a marked contrast to the earlier style of 'number' operas in which set musical numbers were separated by *secco* recitative. The musical landscape was inexorably shifting, and Mozart's operas now seemed to belong to a distant, fragile past, with a critic writing prophetically in 1891: 'It would now seem to be necessary to support a troupe of Mozart singers alongside the Wagner singers, indeed, even a separate Mozart orchestra alongside the Wagner orchestra.'[58] At a rehearsal of Mozart's *Die Zauberflöte* held at the Vienna Hofoper in 1897, Mahler sent home half the assembled orchestra, which was of Wagnerian proportions.[59] The burgeoning Wagnerian aesthetic threatened to cancel out the Mozart operas as they struggled to adapt. In the wake of this process, Mozart retained his canonic status, but his works had by now become 'ancient music', relics of the past, that could be best and perhaps only appreciated on their own terms, in increasingly 'authentic' settings (smaller theatres) and in something approaching the form that the composer and librettist had intended.

The operas that today form the 'Mozart Canon' all survived the nineteenth century by one means or another. In cases where the works disappeared from the stage, they entered a new phase of existence with the publication of full scores, notably when the Mozart Complete Edition (*Alte Mozart Ausgabe*) appeared between 1877 and 1883, securing, in the case of works that had slipped from the repertoire, an afterlife on the library shelves of scholars. *Così* was notably revived around the turn of the twentieth century as part of the Mozart Renaissance that began in Munich under Ernst Possart, Hermann Levi and Richard Strauss in 1897, followed by Gustav Mahler in Vienna in 1900. Their efforts paved the way for the opera in its original form to enter the mainstream repertoire. The unprecedented shift in fortune that *Così* enjoyed during the course of the twentieth century was itself a phenomenon, and today Da Ponte's portrayal of human blindness and cynical self-interest seems starkly real and startlingly modern. Today, it is usual to speak of the 'Mozart–Da Ponte trilogy', which occupies a special place in Mozart's oeuvre as a distinct sub-entity. The following chapter considers the further development of the opera repertoire during the course of the nineteenth century, followed by its atrophy as the twentieth century drew near.

Notes

1 Thomas Bauman, *W.A. Mozart, Die Entführung aus dem Serail, Cambridge Opera Handbooks* (Cambridge: Cambridge University Press, 1987), 3–6.
2 Ibid., 103–4, table 5.
3 Gernot Gruber, *Mozart and Posterity* (Boston: Northeastern University Press, 1994), 38.
4 Ibid., 70.
5 Alfred Loewenberg, *Annals of Opera, 1597–1940* (New Jersey: Rowman and Littlefield, 1978), 422.
6 Hector Berlioz and Elizabeth Csicsery-Rónay, *The Art of Music and Other Essays (a Travers Chants)* (Bloomington: Indiana University Press, 1994), 169.
7 Bauman, *W.A. Mozart, Die Entführung aus dem Serail*, 113.
8 Ibid., 114–15.
9 Wolfgang Amadeus Mozart, Giambattista Varesco, Daniel Heartz and Bruce Alan Brown., *Idomeneo*: [*Dramma Per Musica in Tre Atti*] (Kassel: Bärenreiter, 1972).
10 http://mozartsocietyofamerica.org/publications/newsletter/archive/MSA-JAN-10.pdf, 6, accessed 30 May 2020.
11 Mark Everist, '"Madame Dorothea Wendling is arcicontentissima": The Performers of Idomeneo', in *W.A. Mozart, Idomeneo*, ed. Julian Rushton (Cambridge: Cambridge University Press, 1993), 61.
12 Loewenberg, *Annals of Opera, 1597–1940*, 386.
13 Julian Rushton, *W.A. Mozart, Idomeneo* (Cambridge: Cambridge University Press, 1983), 83, 84. Rushton notes a Paris performance in 1822 with 'words by Caigniez, arranged from the opera by Mozart by J. L. Bertin'.
14 Italian conductor Vittorio Gui produced an edition which abbreviated the work, changed the vocal distribution and had the aim of casting the work in a form that would make it suitable for performance in more modestly resourced theatres (Milano: Edizioni Suvini Zerboni, 1947).
15 Tim Carter, *Mozart's Le nozze di Figaro* (Cambridge: Cambridge University Press, 1987), 129.
16 The numbering aligns with the Bärenreiter score TP 320 (Kassel: Bärenreiter, 1973, 2011).
17 Carter, *W.A. Mozart: Le nozze di Figaro*, 130.
18 *Journal des Luxus und der Moden*, 15 January 1791, in Loewenberg, *Annals of Opera, 1597–1940*, 485.
19 The original reads: 'Ich war gestern nicht wenig verwundert, als ich in der hier sehr beleibten Operette, The Seige of Belgrade fast alle Arien der Cosa rara fand. Ein gewisser Signore Storace versteht die Kunst aus vielen Italiänischen Opern eine Original-Englische zusammenzustoppeln.' English translation by the present author.
20 Gruber, *Mozart and Posterity*, 51.
21 Carter, *W.A. Mozart: Le nozze di Figaro*, 131.
22 Ibid., 132–3.
23 Ibid.
24 William Weber, *The Rise of Musical Classics in Eighteenth-Century England: A Study in Canon, Ritual and Ideology* (Oxford, New York: Clarendon Press, Oxford University Press, 1992), vii.
25 Henry Rowley Bishop, ed. Christina Fuhrmann, *Mozart's the Marriage of Figaro: Adapted for Covent Garden, 1819*.
26 From Bishop's 'Advertisement' to the printed libretto of 1819, [iii], iv. Carter, *W.A. Mozart: Le nozze di Figaro*, 134.
27 Ibid., 135.
28 Harold Rosenthal, *Two Centuries of Opera at Covent Garden* (London: Putnam, 1958), 679–803.

29 Carter, *W.A. Mozart: Le nozze di Figaro*, 137.
30 Edward J. Dent, *Mozart's Operas, a Critical Study*, 2nd ed., Oxford Paperbacks (London: Oxford University Press, 1960), 212–13.
31 John A. Rice, *W.A. Mozart, La clemenza di Tito, Cambridge Opera Handbooks* (Cambridge: Cambridge University Press, 1991), 121.
32 Franz Xaver Niemetschek, *Life of Mozart (Leben Des K.K. Kapellmeisters Wolfgang Gottlieb Mozart)* (1798), Hyperion reprint ed. (Westport, CO: Hyperion Press, 1979).
33 Alfred Einstein, *Mozart: His Character, His Work* (London: Cassell, 1946) 422–6.
34 Rice, *W.A. Mozart, La clemenza di Tito, Cambridge Opera Handbooks*, 118–33.
35 Gruber, *Mozart and Posterity*, 79–81.
36 Rice, *W.A. Mozart, La clemenza di Tito, Cambridge Opera Handbooks*, 105.
37 Ibid., 104.
38 Ibid., 107–10.
39 Emanuele Senici, 'Adapted to the Modern Stage: *La clemenza di Tito* in London', *Cambridge Opera Journal* 7, no. 1 (1995): 1–22.
40 Ibid.
41 Ibid.
42 Ibid.
43 Ibid., 6.
44 Ibid., 7.
45 Although not noted in the printed libretto, Mozart set Mazzolà's adaptation of Metastasio's *Clemenza*, so Buonaiuti is in fact rearranging the work of Mazzolà working from Metastasio's original text.
46 Rice, *W.A. Mozart, La clemenza di Tito, Cambridge Opera Handbooks*, 116–17.
47 Gruber, *Mozart and Posterity*, 117.
48 Senici, 'Adapted to the Modern Stage: *La clemenza Di Tito* in London', 15.
49 Rice, *W.A. Mozart, La clemenza di Tito, Cambridge Opera Handbooks*, 134–48.
50 Wagner, *Oper und Drama*, in Richard Wagner: *Dichtungen und Schriften*, VII, 38. Quoted in Rice, 119.
51 Loewenberg, *Annals of Opera, 1597–1940*, 477–8.
52 See Edward W. Saïd, *On Late Style: Music and Literature Against the Grain* (New York: Pantheon Books, 2006), 48–72.
53 Loewenberg, *Annals of Opera, 1597–1940*, 476.
54 Bruce Alan Brown, *W.A. Mozart, Così fan tutte* (Cambridge: Cambridge University Press, 1995), 168.
55 Rachel Cowgill, 'Mozart Productions and the Emergence of Werktreue at London's Italian Opera House, 1780–1830', in *Operatic Migrations: Transforming Works and Crossing Boundaries*, eds. Roberta Montemorra Marvin and Downing A. Thomas (Aldershot: Ashgate, 2006), 159.
56 Ibid., 153–7.
57 Brown, *W.A. Mozart, Così fan tutte*, 170.
58 Ibid., 172 (*Schwäbische Kronik*, 14 December 1891).
59 Henri-Louis de La Grange, *Gustav Mahler*, Vol. 2 (Oxford: Oxford University Press, 1995), 32.

9 Boom and bust in the nineteenth century

Operatic developments in Italy

The dissemination of Mozart's operas during the nineteenth century has been outlined in some detail, revealing a surprising persistence, demonstrating their adaptability and their resilience against the constant production of new works by later composers. By the end of the nineteenth century, as the thousands of operas that had been produced atrophied into a tiny cluster still in circulation, Mozart's operas endured alongside the best of Rossini, Donizetti and Bellini, armed with the halo of canonicity that his works had acquired during the century. The case of *Don Giovanni* and its venerated manuscript reflects Mozart's deification, which occurred in tandem with the success of his works (generally heavily adapted) in the marketplace. Away from the realities of the opera house, Mozart came to represent musical perfection, accompanied by a certain fragility and unworldliness that was reflected in the growing body of critical writing around his operas in particular.

As the nineteenth century progressed, Mozart provided the opera industry with a mythical past to be longed for: a lost, golden age, weighed down with an underlying nostalgia for the genius whose talent was prematurely snuffed out, much like certain prematurely deceased pop stars in the current time. Mozart was not the first composer to undergo a posthumous process of deification, although the scale of his transformation was unprecedented. Some years before, a similar phenomenon had developed after the early death of Giovanni Battista Pergolesi, who enjoyed a career of about five years, during which he produced 10 operas along with around 30 other works. His death at the age of 26 from consumption caused his status in the eyes of posterity to rise to proto-Mozartian proportions, and his name became attached to other composers' works, particularly operas: at one stage, catalogues of his output numbered up to 148 entries, demonstrating the emergence of a Pergolesi mythology.

It was not only Mozart's extraordinary music but also the posthumous reimagining of him that ensured his ongoing presence in the opera house and the integration of his works into the operatic repertoire. The operatic world of the early nineteenth century was far from a Valhalla; it also required a living figurehead, and in this regard Rossini stood in for a prematurely deceased Mozart. In many

regards, Rossini possessed the requisite attributes of a 'great' composer, although there is something distinctly lacklustre about an icon who retires from the operatic stage at the age of 36 and thereafter devotes much of their energies to cooking. More gilding falls away when we consider Rossini's apparently indiscriminate recycling of his works in order to create new ones. Most composers would be delighted at the prospect of their publisher suggesting the creation of a complete, definitive edition of their works, but Rossini was distinctly uneasy about that proposal when Giovanni Ricordi approached him about it. Rossini responded that 'the edition you are bringing out will lead to much (justified) criticism, for the same pieces of music will be found in several different operas; the time and money allowed me for my compositions were so paltry that I scarcely had the leisure to read the so-called poems I was to set to music'.[1] An image emerges of a composer who did not quite take himself seriously, who was a penitent self-plagiarist, an enterprising businessman who made more money from the introduction of roulette tables to theatres than he did from his own compositions. He was someone whose professional life, in a number of its aspects, reflected the comic operas for which he is popularly remembered. But there was another side to Rossini, the composer of many *opera serie* that were acclaimed throughout Europe, and the first composer of whom it can be said that he cornered the international market with his works.

Operatically speaking, Rossini literally conquered Europe, as reflected in the words of his biographer, Stendhal, who wrote that 'Napoleon is dead; but a new conqueror has shown himself to the world; and from Moscow to Naples, from London to Vienna, from Paris to Calcutta, his name is constantly on every tongue.'[2] Italian audiences had not always been receptive to the harmonic complexity and the richness of texture typical of Mozart's operas. By contrast, they found Rossini's works approachable, tuneful and, for the most part, uncomplicated. Rossini developed a compositional formula which has been termed the 'Code Rossini', parodying the so-called *Code Napoléon*.[3] This formula enabled the composer to recreate what have been dubbed 'proven recipes',[4] which include his structural plan for the overture, the quirkiness of his orchestration, his invention of the 'Rossini crescendo', and his melodic gift as well as the absence of 'any hint of thematic "development"'[5] in his works. It was this last attribute, the shunning of development, that especially grated on German musicians and which caused a sense of competition to develop in critical circles between advocates of Beethoven and Rossini. The juxtaposition was surprising in a number of ways, not least because Beethoven was a composer dedicated to interrogating existing forms and arriving at highly individual results, in so doing reflecting the 'romantic emphasis on individuality and peculiarity'.[6] Rossini, by contrast, was no revolutionary; he was less interested in changing the face of music than in arriving at a suitable formula to attain success as an opera composer – an aspiration that is easy to be cynical of today, and mistakenly so. A large element in the Beethoven–Rossini debate (which was continued into the twentieth century by the musicologist Carl Dalhaus) was fear; Rossini appeared

to shun most things that German music held dear, and received international accolades because of it. Rossini's success had a Napoleonic aspect to it in the eyes of those inimical to his music – that the wrong kind of might may nevertheless prove itself right.

A full critical assessment of Rossini's legacy is still to be written, and such an assessment is inextricably linked to the availability of his works in reliable critical editions.[7] This is no less true of his compatriots Vincenzo Bellini (1801–35) and Gaetano Donizetti (1797–1848), composers who have also long been represented in the repertoire by only a small proportion of their works. While these three composers have often been grouped together as the main exponents of Italian opera during the first part of the nineteenth century, they cultivated quite distinct, highly personal musical styles and working practices. Rossini spent nearly 17 years in fairly consistent operatic production, producing 39 works, during which he was also involved with other associated interests, which resulted in him gaining financial independence. Donizetti spent his working life of 27 years producing nearly 70 operas, a contributing factor to his ill health and eventual confinement to an asylum. Bellini died young, but his production of operas was methodical and considered; he wrote 10 operas over a period of 10 years. Bellini wrote slowly and earned correspondingly large fees for his work, a circumstance that was in part a legacy of Rossini, who had re-established opera as a popular, and hence lucrative, artform. Donizetti was extremely productive and effectively worked himself into an early grave, although other factors contributed to his demise. His industrious approach demonstrates an awareness of the industry that he was writing for, where success was defined by the production of a constant supply of new works. Both Donizetti and Bellini conform to some extent to the Mozartian myth of the composer who dies young, which lends an aura of tragic Romanticism to their lives, and fuelled the popularity of works such as *Lucia di Lammermoor* (1835).

Rossini's life does not conform to the popular trope of the tragic Romantic artist. The bouts of depression that he suffered from at times in his life were experienced in an affluent environment, where his affliction was largely suffered in silence. He wrote an average of two operas a year, which hardly seems egregious, considering his speed of composition. The creation of *Il barbiere di Siviglia* (1816) in just over three weeks has been much discussed, but was hardly exceptional for the times. The fact that it took such a short time to compose what has become recognised as a perennial masterpiece did not help Rossini's posthumous reputation; his talents became perceived as skin deep, leading to a view that he squandered his gifts, taking the easy way with quickly produced operas, created from partially recycled material and a formulaic approach (even though this initially contributed to his unprecedented popularity by establishing a readily identifiable 'product'). Had Rossini died tragically following the première of *Barbiere*, his posthumous reputation might have been greater. The cases of Bizet and Puccini, for example, attest to the fact that an unresolved masterpiece, interrupted by the death of its composer, can considerably enhance a reputation. While Rossini wrote rapidly in his younger years, the production of operas slowed as his success grew.

In performance practice, there is an abiding tendency to look back at music of earlier times through the myopic lens of the present day, as is exemplified in the case of the Italian conductor Tulio Serafin (1878–1968), who in both his writings[8] and his performances is described by Philip Gossett as 'a conductor who never met a repeat he liked, and who believed that Verdi's music could be perfected by making it sound more like Puccini'.[9] This way of viewing Italian music of the past is inextricably bound up in the music-making traditions of that country, and the process of rediscovery and reassessment of the works of these composers involved stripping away many of the 'traditions', to remove the accretions imposed by later generations.

The period in which these composers were working was one of considerable volatility, both within the opera industry and also in European politics generally. In the world of opera, changes in the practice of music publishing were brought about by the developing idea of the opera repertoire, which was also inextricably entwined with the establishment of copyright. The publishing industry was slow to adjust to the developing concept of repertoire and continued to rely upon practices that were carried over from the previous century, with pirated scores remaining the major means of dissemination and operas being routinely cobbled together from material of highly questionable authenticity. Composers had little control over these matters until the years after 1840, when as a result of the Austro–Sardinian copyright treaty, 'publishers were able to gradually suppress piracy'.[10]

The effect of the treaty was not entirely positive, because while it potentially allowed composers to claim continued payments for their new works, it had the undesired consequence of lowering their commission fees.[11] The revolution and subsequent war that occurred in Italy at the end of that decade had a debilitating effect upon the opera industry – it was generally the case that a war or revolution taking place within proximity of a town would have disastrous consequences for the theatre. So, just at a period when the conditions seemed ripe for a more organised and regulated opera industry, particularly for the composer, the place of opera in urban life became threatened, and the old opera industry began to crumble.[12] One might imagine greater authorial control for composers to be a positive thing, but the reality was a slowing in the creation of works. More self-conscious attitudes on the part of composers resulted in the emerging function of the opera house as a repository for older works, which in turn caused the opera industry to become 'less creative'.[13] This decline led to the production of 'more and more performances of fewer and fewer works',[14] resulting in a process of ossification, the institutionalisation of what had, until that time, been a visceral, lively concern.

The concept of 'repertory opera' began to take firm hold from the 1840s, around the time that copyright was established. The term *opera di repertorio* was first used in correspondence in 1845[15] and appeared in official contracts of the Naples royal theatres from 1851.[16] Abbate and Parker identify Rossini – following on from the trends established by the operas of Mozart – as being an essential element in the formation of the opera repertoire, which they define as 'a body of works that have been revived countless times in countless different venues'.

They see Rossini's comic operas as the 'first exhibits' of the emerging repertory. This was followed by 'a favoured few works by Bellini, Donizetti and Verdi ... the international successes of Verdi's middle-period operas and ... Meyerbeer, solidified the process'.[17]

'By the mid-1850s, when the industry had fully recovered from the political upheaval of 1848–49, repertory opera was becoming well established. By the 1870s it was the norm.'[18] Along with the repertory system, there emerged 'a new kind of opera house, large, unsubsidized, bringing opera and ballet at low prices to a wider public'.[19] These developments were the result of opera becoming commercialised 'through private investment on an epic and adventurous scale', which resulted in a 'hardening of models and formulae' and therefore an impoverishment.[20] The most productive period of new works at La Scala was between 1831 and 1840, when 38 new productions were given. By the 1860s, that number had slowed to one or two a year.[21]

As a result of changing copyright laws, a new and influential player entered the field: the music publisher, the most significant figure of this period being Verdi's publisher, Giulio Ricordi (1840–1912).[22] He exercised an unprecedented degree of influence and power over how, where and when Verdi's operas were performed, in a manner that would have been unthinkable 50 years earlier. It was Ricordi's handling of the dissemination and promotion of Verdi's later operas that enabled the composer's increasingly authorial-based concepts to develop. By the end of the nineteenth century, publishers were active in launching the careers of composers such as Amilcare Ponchielli (1834–86), Alfredo Catalani (1854–93) and Giacomo Puccini (1858–1924).

Musicologist John Rosselli notes that publishers decided where operas were to be performed, controlled casting, supplied set and costume designs, and exercised influence over the production, if not in person then through the issue of production books. What brought publishers into opera production was first, the gradual trend towards repertory opera, which meant an increasing demand for the hire of orchestral scores; and second, the establishment of copyright protection, which in the end suppressed piracy and made exclusive rights over a score worth paying for. During the 1850s, 'publishers began to supply designs and sometimes production books. At about the same time publishers started insisting that scores should not be altered without their consent and that any changes should be made by the composer – a break with long-standing Italian practice.'[23]

During this period, the music publisher emerged as the driving curatorial force in opera, and a publisher such as Ricordi would have the leading operatic works of the day in their catalogue, along with the connections to dominate and monopolise the market. A publisher could effectively dictate to theatres the casting of operas, the version of the opera that was to be performed, and even the visual details of production – formalised in the creation of *disposizioni sceniche* (production books), which were included in the performance materials that were sent out to theatres. In 1887, a production book for *Otello* issued by Ricordi stated:

It is absolutely necessary that artists take full notice of the staging [herein] and conform to it ... the Direction and Ownership must not permit any sort of alteration to the costumes: these have been carefully studied and copied from period paintings and there is no reason for any of them to be changed according to the whim of this or that artist.[24]

Ricordi was, by then, in a position to be able to insist on those requirements, and the publishing firm effectively curated the later works of Verdi, along with those of Puccini, rendering them saleable to the international market, and stipulating the musical and production parameters of their dissemination. While modern critical editions have drilled down into the musical texts in order to establish the finer detail of what the composer intended, the production books – which reflected practice that was approved by the composer – have almost completely fallen from view.[25] The modern opera house strives for authenticity on a music level but remains generally uninterested in the historical reconstruction of premières, or early productions of operas, in spite of considerable information and evidence being available. The alternatives to such historical reconstruction offered by the modern opera house are the subject of Chapters 11 and 12.

Inventing the operatic museum in Paris

In 1861, the music critic A. Thurner made the following observation regarding the developing operatic museum in Paris:

The Opéra must be an operatic Louvre, where Classical works – alternating with our great modern productions – would provide the invigorating energy necessary to give shape to a new generation of composers and artists.[26]

Associations between the Opéra and the Louvre continued to proliferate through the nineteenth century,[27] marking a further shift in the functions and significance of the opera house. It has been already stated that the Louvre was not only a repository of great art but also a national propaganda tool, and the Opéra gradually came to imitate this model. Implicit in the creation of the Louvre's collection – beyond establishing 'the taste and power of the Crown through ownership of canonical old-master paintings' and 'manifesting the superiority of native artistic production'[28] – was a pedagogical function that 'necessitated inclusion of historical artists who exercised beneficial influence on aspiring academicians'.[29] The opera house, as it shifted towards its function as a museum, was to take on the role of educating its audiences by presenting 'a documentary history of music, dramatized in living colour'.[30] In this scenario, the Opéra would, along with the Louvre, function as 'the model institution for preserving historical masterpieces'.[31] Works would be canonised, curated and preserved; operatic 'classics' would be treated in a manner akin to a permanent exhibition of the museum.

Because of its implicit ties to the Royal court, French opera had always exhibited a sense of canonicity; as previously noted, the operas of Lully formed the

earliest fixed repertoire, which enjoyed a life of many decades. Opera remained a propaganda tool in France in the years following the French Revolution. As old worlds gave over to new, and as history was rewritten, opera provided a mythologised mirror of the past that also pointed to the future, resembling the enormous historical paintings that adorned the walls of the Louvre. The public could attend the Opéra, witness the historical works of Meyerbeer, Spontini, Berlioz, Halévy etc. and understand themselves to exist within the greater continuum of world history through the medium of grand opera.

The creation of the 'operatic museum' grew out of this background, facilitated by the extraordinary resources of the Opéra, which enabled monumental works to be produced in a sumptuous manner. Full scores of the leading works were published in elegant editions early in the century. Detailed production books (*livrets de mise-en-scène*), particularly of the operas of Meyerbeer, became authoritative adjuncts to the printed score, outlining templates that were preserved onstage for many years. Parisian opera worked according to the structures and processes that Italy lacked and sought to imitate; this was the reason (apart from the possibility of earning enormous fees) why composers such as Rossini, Donizetti, Verdi and Wagner were attracted to present their operas in Paris in order to have them performed under the most advanced conditions of the day.

The Opéra functioned as a French national institution, and the custom of that nation to adopt foreign artists as their own has already been mentioned.[32] The critic Hippolyte Barbedette, for example, questioned whether in terms of art, nationality was dependent upon 'an act of birth'.[33] He saw Gluck as the creator of the *drame lyrique*:, 'with this title, he is French in the same way as Meyerbeer and France should have the right to lay claim to him'.[34] Gluck's operas were incorporated into the French pantheon, with his origins being identified as 'Bohemian' rather than the culturally more dangerous 'German'.[35] Mozart was similarly adopted and became known in France as the 'Raphael of Music' – a double irony, as it invoked someone 'who had for centuries been adopted as a French artist despite his having spent literally no time in France'.[36] Just as the Louvre collected and displayed the standard European schools of painting while expanding its holdings to include objects from more exotic cultures as a result of Napoleon's campaigns, so the French operatic museum adopted leading European composers. As the nineteenth century wore on, works that portrayed, non-European cultures, influenced in part by expositions and World Fairs, brought the exoticism of distant lands to the stage of the Opéra.

Infinite repertoires

The terms 'operatic repertoire' and 'operatic canon' are subtly different, and the works that populate them are subject to geographical variations. For the purposes of this study, 'opera repertoire' or repertory suggests 'a stock of operas',[37] a body of work that forms the core of the performance repertoire of most opera houses of the world, with some regional variations governed by both local taste and the

size and resources of particular theatres. The opera repertoire is a fluid, evolving entity that continues to metamorphose and develop over time. The 'operatic canon' is best considered as a list of works that defines the historical achievement of opera as an artform, and the works that comprise it may or may not also be part of the current opera repertoire. Thus, Gluck's *Orfeo* is an important staple of the operatic canon, though it may occupy only a peripheral place in the current operatic repertoire. Monteverdi's *L'Orfeo* presents a similar case. It might be said that an ongoing conversation takes place between the opera repertoire and the operatic canon, with the opera repertoire adapting over time according to tastes and fashions, whereas the canon tends to adapt at a more glacial rate, in a way similar to the bound books by the 'classical' authors, which very slowly move in and out of fashion, continuing to occupy a place in the Pantheon of words and ideas even when they are no longer widely read and studied. James A. Paraklias, observes that: 'The operatic canon is not so much a list of favoured repertory as a system of cultural upbringing for performers and opera goers (and the public in general).'[38] While a number of recent contemporary operas may join the repertoire, admission to the canon is not such a simple matter. Recent scholarship refers to the 'arthritic canonicity' of opera, noting that 'of the 2449 operas produced professionally worldwide … a total of 106,477 performances, only around 6 percent enjoyed more than 100 performances, while the top 10, all more than a century old, boasted 25,801 between them'.[39] These are symptoms of a lethargy that afflicts current operatic practice, with 'new' works in some cases finding a place in the repertoire but seldom entering the canon.

In *The Infinity of Lists*,[40] Umberto Eco describes the phenomenon of creating encyclopaedic books of 'physical' monstrosities during the sixteenth and seventeenth centuries, which he dubs 'repertories or lists of extraordinary things'.[41] Eco sees these as the forerunners of the *Wunderkammern*, which found expression through the same fascination with 'the world of objects'.[42] He surmises further that 'a culture prefers enclosed, stable forms when it is sure of its own identity, whereas when faced with a jumbled accumulation of ill-defined phenomena, it starts making lists'.[43] One significant attempt to quantify the 'monstrosity' of the repertory is Alfred Loewenberg's *Annals of Opera*, a gargantuan undertaking charting opera production from 1597 until 1940 in a tome running to around 1700 pages.[44] Loewenberg, aware of the magnitude of such a task, cautiously states that he has produced only a 'skeleton history of opera',[45] noting that 'the selection of some three or four thousand operas out of a total number of – I dare not guess, was also chiefly guided by historical principles'. Loewenberg admits that the number of operas included could have easily been doubled.[46]

Loewenberg's encyclopaedia represents the storage vault of a notional, comprehensive operatic museum (perhaps an operatic counterpart of the Smithsonian), an enormous collection, much of which is seldom displayed. From this compendium of works, only a fraction survives in the repertoire today, and of those works, most date from the last 200 years. Writing from a central-European perspective, musicologist Wulf Konold defines the opera repertoire as spanning the years 1782

(Mozart, *Entführung*) to 1911 (Strauss, *Der Rosenkavalier*) – a period of just over 130 years.[47] Despite the burgeoning interest in Baroque opera over recent decades, as recently as 2009, Snowman describes the 'staple operatic diet' as encompassing 'perhaps forty or fifty acknowledged operatic favourites written during the "long" nineteenth century, from Mozart's *Entführung* (1782) to Puccini's *Turandot* (1926)'.[48] In support of Konold and Snowman's starting date, Abbate and Parker suggest that Mozart's *Entführung* marks the dividing line between 'the distant and the accessible past'.[49]

Four hundred years of operatic activity has spawned a seeming infinity of operatic lists (or repertoires, or canons). These take many forms, for example the opera guides for the popular market that began to proliferate during the nineteenth century, which have already been encountered in considering the Mozart canon. Lists of operas can be found in a variety of sources, indicating the sheer diversity that can be discovered when exploring the phenomenon of different repertoires. *Wikipedia* publishes a 'List of Important Operas',[50] while the London *Guardian* has published a list of the 'Top 50 Operas'.[51] All are important snapshots of a specific time, place and social milieu. Visitors to the Glyndebourne Opera are furnished, during the dinner break, with serviettes that depict *Quercus Operatica*, a 'family tree' of operatic composers, interfaced with that of the Christie family. Operatic history is depicted as neatly rising out of the ground around the birth in 1882 of John Christie, who founded Glyndebourne in 1934.

Locality and national focus account for many variations: the works of Albert Lortzing (1801–51) and Carl Maria von Weber (1786–1826) – particularly *Der Freischütz* – remain staples of the German repertoire, although they are hardly performed or even known outside central Europe. Table 9.1 is derived from data assembled by Wulf Konold,[52] indicating the most performed operas in Germany during the post-war period.

During the course of the nineteenth century, a sense of operatic canonicity was further promoted by the publication of opera guides, which quantified the repertoire for opera lovers and cognoscenti and were often organised according to the national schools encountered in many art museums. Such reference works provide valuable data for charting repertoire trends across time and place. Two significant authors of these guides, Gustav Kobbé and Henry Krehbiel, have been discussed in relation to the Mozart Canon. The early editions of Kobbé not only provided opera plots, analyses of themes etc., but also discussed 'insider' matters such as the languages in which operas were sung in New York or London and listed important singers of the time who were associated with particular roles. Such singers were an important influence upon opera goers – during this period it was often the case that audiences attending a performance were more motivated by a chance to hear Enrico Caruso and Louise Homer than an opera by Donizetti. In discussing 'Una furtiva lagrima' from Donizetti's *L'elisir d'amore*, Kobbé (1922) notes that 'it was because of Caruso's admirable rendition of this beautiful romance [made widely available on his 78RPM recording] that the opera was revived at the Metropolitan Opera … in 1904'.[53] Kobbé (1922) also draws attention to a

Table 9.1 The most performed operas in Germany, 1947–75 (Konold)[54]

Composer	Work	Performance count
Mozart	*Die Zauberflöte*	6142
Mozart	*Le nozze di Figaro*	5461
Bizet	*Carmen*	4968
Puccini	*La bohème*	4888
Lortzing	*Zar und Zimmermann*	4828
Puccini	*Madame Butterfly*	4759
Rossini	*Il barbiere di Siviglia*	4479
Mozart	*Il Seraglio*	4454
Weber	*Der Freischütz*	4384
Beethoven	*Fidelio*	4357
Verdi	*Rigoletto*	4252
Puccini	*Tosca*	4177
Verdi	*Il trovatore*	4054
Verdi	*La traviata*	3907
Lortzing	*Der Wildschütz*	3739
Smetana	*The Bartered Bride*	3725
Verdi	*Aïda*	3594
Offenbach	*Tales of Hoffmann*	3582
Mozart	*Così fan tutte*	3488
Mozart	*Don Giovanni*	3439
Leoncavallo	*I Pagliacci*	3418
Wagner	*Der Fliegende Holländer*	3349
Humperdinck	*Hänsel u. Gretel*	3253
Mascagni	*Cavalleria rusticana*	3068
Verdi	*Un ballo in maschera*	2771
Nicolai	*Die lustige Weiber von Windsor*	2732
R. Strauss	*Der Rosenkavalier*	2603
Lortzing	*Waffenschmied*	2571
Flotow	*Martha*	2471
Verdi	*Otello*	2437
Donizetti	*Don Pasquale*	2340

new, alternative repertoire when referring to the aria 'Bel raggio lusinghier' from Rossini's *Semiramide*, noting that it is 'the one piece that has kept the opera in the phonograph repertoire'[55] – an early reference to the influence of the gramophone. Today, such alternative repertoires, made available by new technologies, proliferate, replacing the former alternatives that were provided by popular arrangements for instruments such as piano, flute and even cornet-à-pistons (a once-popular instrument that was parodied by Gilbert and Sullivan in *The Gondoliers*) that were designed for domestic consumption. Music lovers today are able to build their own libraries (create their own domestic repertoires) of CDs and DVDs. Operas that are rarely staged and hardly have a life in the theatre (or the particular theatre regularly available to a particular individual) are now readily accessible, even in the most remote places. Music lovers may even curate their own performances,

re-ordering, omitting or even encoring musical numbers. Today, an opera lover may be someone who has never entered an opera house, but who possesses an authoritative collection of recordings – audio, audio-visual or both.

The repertoire atrophies

As the nineteenth century drew to a close, Italy continued to witness an ever-declining production of operatic works and started 'making lists', publishing full scores of the surviving iconic works that represented what remained of the repertoire of the nineteenth century.[56] By the early twentieth century, the operatic repertoire that survived in Italy was only a fraction of the total of works produced in the previous century. By 1913, of works predating *Rigoletto* (1851), only *Barbiere*, *Norma*, *La sonnambula*, *L'elisir d'amore* and *Lucia di Lammermoor* retained a firm hold. Other works of lesser popularity included *I Puritani*, *Don Pasquale*, *Linda di Chamounix*, *La favorita*, *Ernani* and Auber's *Fra Diavolo*.[57] This is reflected in the catalogue (Table 9.2), which was printed on the back cover of Ricordi's full scores for much of the twentieth century. While many other works remained available from their hire library, this list of works for sale quantifies the core Italian operatic repertoire,[58] showing what had survived of the canon from

Table 9.2 Operatic full scores advertised for sale by Ricordi during the twentieth century[a]

BELLINI	*Norma*
DONIZETTI	*Don Pasquale*
	L'elisir d'amore
	Lucia di Lammermoor
PUCCINI	*La bohème*
	Gianni Schicchi
	Madama Butterfly
	Suor Angelica
	Il Tabarro
	Tosca
	Turandot
ROSSINI	*Il barbiere di Siviglia*
VERDI	*Aïda*
	Un ballo in maschera
	Falstaff
	Messa di Requiem
	Simon Boccanegra
	Otello
	Rigoletto
	La traviata
	Il trovatore
WAGNER	*Parsifal*

[a] With minor variations, these are the staple operas advertised on the back cover of the 'Ricordi Opera Full Score Series' (numbered in the series P.R. = 'Partitura Ricordi') during the second half of the twentieth century.

the opera boom of the nineteenth century. The inclusion of *Parsifal* is curious, but this may be the result of it being wrested from the exclusive clutches of Bayreuth when copyright expired at the end of 1913. The staple repertory had dwindled to a trickle, and few new works had appeared which could hope to revitalise it.

A point has been reached where the progress of the opera repertoire falters. Steady growth over three centuries, from esoteric experiments to popular entertainments for a growing bourgeoisie, the rise of the opera house as an institution, and the acquisition of a repertoire to legitimise it, has culminated in a crisis. Opera, as it was practised during the nineteenth century, is on the point of collapsing under the weight of its own past.

There is a clear sense of operatic boom and bust in Italy during the earlier nineteenth century, where fortunes were made and lost. The repertoire listed in Table 9.2 evokes the experience of visiting a ghost town, previously a gold shanty town that had sprung up virtually overnight. Temporary wooden buildings have disappeared without trace, while dilapidated structures of brick or stone remain (almost all of them pubs). Little survives to suggest the vitality of the town and the society that flourished there. On the actual gold fields of the nineteenth century, 'opera' (or some version of it) became a sought-after commodity. Brothels metamorphosed into musical halls and thence into 'opera houses' – a clear ascending path from a basic existence to one that aspired to embrace culture. Designated 'opera houses' were often buildings that were too small to accommodate more than a piano and a singer (invariably female), along with an audience of upwardly mobile miners, for whom ideas of high culture were confusingly entwined with more fundamental needs. High culture itself was an ill-defined product, and it remains unclear to what extent these operatic establishments actually hosted performances of operatic works. The career of the celebrated Swedish Soprano, Jenny Lind (1820–87), is relevant here; she may not have visited the gold fields, but her tour of North America became 'one of the best-known events in the nation's entire operatic history, even though she never sang in a single opera' – her repertoire seems to have consisted mainly of folksongs.[59] The opera houses of the gold rush later became picture theatres as the riches extracted from the gold fields waned, sharing the fate of many opera houses in the smaller Italian towns after they closed their doors during the early twentieth century. Opera has lost its haphazard, quixotic, Fitzcarraldo-ish[60] sense of boundary-breaking and conquest, but it continues to have appeal for those who harbour a nostalgia for the past and who choose to fetishise a fixed, limited repertory, which becomes the defining feature of operatic practice in the twentieth century.

Notes

1 Christopher Headington, Roy Westbrook and Terry Barfoot, *Opera: A History* (London: Arrow Books, 1991), 156.
2 Quoted in Warren Roberts, *Rossini and Post-Napoleonic Europe* (Rochester, NY: University of Rochester Press, 2015), 152.
3 Richard Taruskin, *Music in the Nineteenth Century* (Oxford: Oxford University Press, 2010), 15.

4 Ibid.
5 Ibid., 21.
6 Ibid., 15.
7 www.press.uchicago.edu/ucp/books/series/WGR-O.html, accessed 8 November 2019.
8 Tulio Serafin, *Stile, tradizione, e convenzioni del melodrama italiano* (Milano: Ricordi, 1958).
9 Philip Gossett, 'Critical Editions and Performances', in *Verdi in Performance*, eds. Alison Latham and Roger Parker (Oxford: Oxford University Press, 2001), 143.
10 John Rosselli, *The Opera Industry in Italy from Cimarosa to Verdi: The Role of the Impresario* (Cambridge: Cambridge University Press, 1984), 58.
11 Ibid., 168–9.
12 Ibid., 169.
13 Ibid.
14 Ibid.
15 Ibid., 170.
16 Ibid.
17 Carolyn Abbate and Roger Parker, *A History of Opera: The Last Four Hundred Years* (London: Allen Lane, 2012), 190.
18 Rosselli, *The Opera Industry in Italy from Cimarosa to Verdi: The Role of the Impresario*, 170.
19 Ibid., 171.
20 Ibid.
21 Ibid., 170.
22 For a brief account of the publishing firm of Ricordi, see Stanley Sadie, *The New Grove Dictionary of Opera*, 4 vols (London: Macmillan, 1992), iii, 1317–19.
23 Rosselli, *The Opera Industry in Italy from Cimarosa to Verdi: The Role of the Impresario*, 173–4.
24 James Hepokowski, 'Staging Verdi's Operas: The Single, "Correct" Performance' in *Verdi In Performance*, eds. Alison Latham and Roger Parker (Oxford: Oxford University Press, 2001),13.
25 Ibid., 11–20.
26 William Gibbons, *Building the Operatic Museum: Eighteenth-Century Opera in Fin-De-Siècle Paris* (Rochester, NY: University of Rochester Press; Woodbridge, Suffolk: Boydell and Brewer Limited, 2013), 8.
27 The writings of Paul Dukas, for example. Ibid., 16–17.
28 Andrew McClellan, 'Musée du Louvre, Paris: Palace of the People, Art for All', in Carole Paul, *The First Modern Museums of Art: The Birth of an Institution in 18th- and Early 19th-Century Europe* (los Angeles, Calif.: J. Paul Getty Museum, 2012), 219.
29 Ibid.
30 Gibbons, *Building the Operatic Museum: Eighteenth-Century Opera in Fin-De-Siècle Paris*, 9.
31 Ibid., 8.
32 For example: the Italian Lully and the Germans Meyerbeer and Offenbach.
33 Gibbons, *Building the Operatic Museum: Eighteenth-Century Opera in Fin-De-Siècle Paris*, 106.
34 Ibid.
35 Ibid.
36 Ibid., 64.
37 Sadie, *The New Grove Dictionary of Opera*, iii, 1292.
38 James A. Paraklias, *The Operatic Canon*, www.oxfordhandbooks.com/view/10.1093/oxfordhb/9780195335538.001.0001/oxfordhb-9780195335538-e-039, accessed 22 January 2020.
39 www.gsmd.ac.uk/about_the_school/research/research_areas/the_operatic_canon/, accessed 15 February 2020, derived from operabase.com.

40 Umberto Eco, *The Infinity of Lists* (London: MacLehose, 2009).
41 Ibid., 202–3.
42 Ibid.
43 Ibid., frontispiece.
44 Loewenberg, *Annals of Opera, 1597–1940*.
45 Ibid., vii.
46 Ibid.
47 Wulf Konold and Inter Nationes, *German Opera, Then and Now: Reflections and Investigations on the History and Present State of the German Musical Theatre* (Basel: Bärenreiter Kassel, 1980), 74.
48 Daniel Snowman, *The Gilded Stage: The Social History of Opera* (London: Atlantic, 2009), 398.
49 Abbate and Parker, *A History of Opera: The Last Four Hundred Years*, 36.
50 https://en.wikipedia.org/?title=List_of_important_operas, accessed 23 June 2015.
51 www.theguardian.com/music/2011/aug/20/top-50-operas, accessed 23 June 2015.
52 Konold and Inter Nationes, *German Opera, Then and Now: Reflections and Investigations on the History and Present State of the German Musical Theatre*, 75.
53 Gustave Kobbé, *The Complete Opera Book* (London: Putnam, 1922), 337.
54 Konold and Inter Nationes, *German Opera, Then and Now: Reflections and Investigations on the History and Present State of the German Musical Theatre*, 75.
55 Gustave Kobbé, *The Complete Opera Book* (London: Putnam, 1922), 310.
56 Eco, *The Infinity of Lists*.
57 John Rosselli, *Music and Musicians in Nineteenth-Century Italy* (London: Batsford, 1991), 142.
58 It does not include *Cavalleria rusticana* or *I Pagliacci*, both published by E. Sonzogno, Milan and rare exceptions to Ricordi's representation of the staple Italian repertoire in his catalogue.
59 John Dizikies, *Opera in America* (New Haven: Yale University Press, 1993), 130.
60 *Fitzcarraldo* (1982) Directed by Werner Herzog with Klaus Kinski, Claudia Cardinale, José Lewgoy and Miguel Ángel Fuentes.

Part III

10 The sociology of the opera house – insiders

Behind-the-scenes roles within the opera house

This chapter takes the reader behind the scenes into the inner workings of the opera house – an environment where the music staff, including conductors, assistant conductors, répétiteurs, language coaches and prompters, work with singers and stage directors in creating productions. While the conductor is a high-profile functionary, who visibly presides over performances, other roles operate very much behind the scenes, although a répétiteur may, from time to time step up into a more public performance mode. Much of the behind-the-scenes work of operatic curation involves detailed, specialised activity, which is collaborative, instinctive, subjective and characterised by grey areas. In addition, the opera house system exhibits a pyramid-like structure, organised in complex hierarchies of people with a variety of skills and knowledge bases attempting to work their way up the ladder. This creates a working environment that can be extremely challenging, and it accounts for some of the scandals that, from time to time, erupt within this world. In considering the curation of operatic works in this environment, issues of hierarchies and power bases will play a significant role.

The following journey into the world behind the opera stage takes as its model the central-European opera house, the notional operatic museum. This model is heavily stratified and organised, making it easy to articulate the steps that facilitate a career path through the opera house, and the power structures that are encountered along the way. While other opera houses are loosely based upon this model, their hierarchies are generally more fluid. The most notable characteristic of the central-European opera house system is the sheer number and diversity of opera houses that it embraces, of all sizes from the smallest theatre in the provinces to the major theatres of Berlin, Vienna, Munich etc. The typical career trajectory has been for artists to begin their careers in smaller houses, gradually working their way up the ladder to attain their career goals. Even today, this is a well-worn path that facilitates the development of an operatic career – and one that seems susceptible to analysis using the cultural theories of Pierre Bourdieu, which have previously been applied to the area of museology.

The theories of Bourdieu

Bourdieu (1930–2002) was one of the most celebrated French thinkers of the twentieth century, a sociologist whose theories of cultural production are outlined in his books *The Rules of Art* (1996)[1] and *The Field of Cultural Production* (1993).[2] Bourdieu was concerned with how the dynamics of power play out in society and how wealth (*capital*) of all types, including *cultural* (competencies, skills, qualifications and aesthetic dispositions), *social* (the value of social networks) and *symbolic* (education, social status, prestige) *capital*, plays out in the social arena.[3] Key concepts in Bourdieu's theories include *habitus*: our predispositions, the deeply wired schemas with which we perceive, process and carry out actions in the social world. Bourdieu saw this as a mixture of rational and intuitive behaviour, though he emphasised the importance of the intuitive side – which he described as having a 'feel for the game' – which expresses itself in taste, vocal intonation, mannerisms and other aspects of physicality. The *game* is enacted in the *field*, the social arena that Bourdieu believes has a tendency to reproduce itself generationally. In this theory, we all carry deeply founded, unconscious beliefs (*doxa*), and as long as these influence our 'feel for the game', we will remain in the same position in the *field* as we continue to struggle for our desired resources. Bourdieu also coined the notion of *symbolic violence*, linked to *symbolic power* and proposes that when a person in posession of *symbolic power* uses that power against someone who holds less, in an attempt to change their actions, they are exercising *symbolic violence*.[4]

The inner structure of the opera house can be regarded as a *field*: a social arena in which the holders of differing amounts and types of *capital* manoeuvre and compete for desired resources or outcomes. Another concept that is applicable to the opera house is the 'charismatic ideology of "creation"', which Bourdieu sees as drawing undue focus onto the main creatives (typically the conductor and the stage director), who are often seen as the representatives of long-dead composers and librettists. Bourdieu proposes that this ideology 'prevents us asking who has created this "creator" and the magic power of transubstantiation with which the "creator" is endowed'.[5] This relates particularly to the hallowed musical traditions of opera, which carry a certain mystique and are often invoked and exploited by individuals and creative teams as a means of convincing other artists, such as singers, of the divine correctness of their artistic decisions. Given the extensive use made of Bourdieu's theories in the area of museology, it is timely to consider their relevance when they are applied to the musical hierarchies of opera companies, or *fields*, where motivated and ambitious people vie for power and influence, maximising their potential (*situs*) while those at the top of the power structure find subtle ways to suppress their efforts (*symbolic violence*). The aspirations of those in less powerful positions are accepted as long as they support the functions and activities of those at the peak of the structure. No one likes to be knocked from the top branch of a tree (*nomos*). An ambitious novice in an opera house faces a challenging swim upstream to attain the goals they seek. In this consideration of ambition and power play, the operatic work may become of secondary

importance, raising the question of whether an opera house is an institution where works are altruistically curated or where they risk devaluation into commodities that are traded in the quest for power and career advancement.

Invisible functionaries

In considering the roles played behind the scenes in the opera house, we begin with the **backstage conductor**, who is typically heard but not seen. The aural contribution of the backstage conductor is often considerable: in addition to coordinating choruses and instrumental (often brass) ensembles that occur offstage, they also coordinate attention-grabbing effects such as cannons (*Tosca, Madama Butterfly*), organs (*Il trovatore, Roméo et Juliette*), knocks (*Tosca*), complex bells (*Tosca*), cuckoos (*Hänsel und Gretel*), screams (*Tosca, Elektra*) etc. Richard Strauss even includes a Chorus of Unborn Children (*Ungeborene Kinder*) in *Die Frau ohne Schatten*,[6] positioned behind and around the stage for the backstage conductor to contend with. When performing *Tosca*, theatres have been known to hire an actor, or anyone who can scream convincingly (annotated on rehearsal schedules as the 'screamer'), to emit one bloodcurdling cry in Act 2 – exactly on cue. In carrying out the backstage conductor function (which is generally not relished by most members of the music staff), the conductor assumes responsibility for instrumentalists who may not appear on time or electric cables that may be tripped on in the darkness, causing monitors, speakers, organs and other crucial electronic equipment to fail. Exemplary backstage work is rarely praised, but failures are usually castigated, the employee becoming a kind of 'whipping boy', assuming responsibility for circumstances that are often beyond their control. The dangers of the role are clear, the margin for error high, and most people appointed to undertake this function use their *cultural capital* and *situs* in order to move to a safer haven, further up the operatic ladder.

The **prompter** is also an invisible, and preferably silent,[7] element in the performance, who sits in an exposed position – rather like the tail gunner who sat at the rear of the aircraft in times of war, the most vulnerable position and the person most likely to die in combat. The prompter is positioned centrally in a small 'prompt box' mounted on the front lip of the stage, visible to those onstage but invisible to everyone else. The great Russian director, Constantin Stanislavsky (1863–1938), had the following to say about the prompter, referring to spoken theatre, but his observations are no less true of the operatic version:

> If you look into the kennel of the prompter you are reminded of medieval inquisition. The prompter in the theatre is sentenced to eternal torture that makes one fear for his life. He has a dirty box lined with dusty felt. Half of his body is beneath the floor of the stage in the dampness of a cellar, the other half, at the bottom level of the stage, is heated by the hundreds of lamps in the footlights on both sides of him. All the dust created at the rising of the curtain or the sweeping of robes across the stage strikes him square in the mouth.

And he is forced to speak without stop during the performance and rehearsal in an unnaturally squeezed and often strained voice so that he may be heard by the actors alone, and not by the spectators.[8]

To the singers onstage, the prompter is visible and audible, employing a rhythmically precise means of giving the first words of text on cue, just before the singer delivers them. In this sense, the text functions as an audible upbeat, like that given visually by the conductor, allowing the singer to enter at just the right moment. The prompter also gives small but precise visual cues, related to the gestures of a conductor, usually with the index finger of each hand, directing the vocal forces on the stage, while the conductor focuses upon the orchestral forces. There is a palpable and complex division of labour in play here, between conductor and prompter, to which the audience is oblivious. In moments of uncertainty, those onstage must decide whether to look to the conductor or the prompter for guidance, a decision that is made in a split second by instinct rather than any rational decision-making process. In a large, complex ensemble work, such as Verdi's *Falstaff* or Puccini's *Gianni Schicchi*, the prompter is the central contact point who holds the vocal ensemble together; in works with extremely large tableaux, involving multiple choral elements (for example *Lohengrin, Meistersinger* etc.), the prompter (with sight lines correctly organised) can cue and hold all the forces onstage together. La Scala, Milan is unique in having a prompt box that can accommodate two prompters for very complex works. The function of the prompter originated in spoken theatre, where they traditionally sit on the side of the stage, giving verbal cues if an actor forgets their lines. The operatic version is a rather more specialised role, working within a musical landscape that is frequently of considerable complexity and minutely shifting temporality (subtle fluctuations of tempo) in order to ensure that not only the correct lines are sung but that they are sung at exactly the right instant. This role has its origins in Italy, where the *suggeritore* is considered important training for potential conductors.

The apparent division of labour between the prompter and conductor should not be taken to imply that the conductor is unfamiliar with the vocal lines. It is, rather, the case that as the repertoire increased in musical complexity, the fundamental responsibility of the conductor focused on shaping and guiding the large-scale musical structure, the architecture of an operatic work. This responsibility may be compromised when the conductor must also look after the singers onstage at a micro-managing level. In that sense, it is sometimes said (not without a hint of disparagement) that the function of the prompter is that of a 'traffic cop'. In recent times, the role of the prompter has declined and altogether ceased in certain theatres, for reasons that include the financial difficulties that faced opera houses following the global financial crisis of 2007–8 (GFC), with the role of the prompter being perceived as being the most expendable (perhaps because the least visible?) person in an opera company. Concurrently, expectations placed upon singers have shifted a great deal during the later twentieth century, and opera lovers are often surprised to learn that many of the great singers of the past could hardly read music and prepared their roles by rote, under the careful guidance

of a coach. The last 50 years have seen a great development in the musical literacy of singers, making them less reliant upon the assistance of the prompter. Nevertheless, the prompter is retained in many theatres, and it remains one of the most intriguing '(not quite) behind-the-scenes' roles in the world of opera. The role attracts a particular type of person – someone with an altruistic temperament, who is prepared to place their *cultural capital* in the service of others, developing *social capital* in return, but there is also something inwardly daredevil about the figure who sits, cramped and confined in a small box, while facing (often) large crowds of singers, who are dependent upon a well-timed word or gesture to fulfil their obligations, at times keeping an entire performance on track, while the audience remains oblivious.

Another invisible role is the **surtitle operator**, who, unseen, exercises a considerable influence upon how a performance is perceived. Based upon the system of subtitles for foreign-language films, surtitles were first used in 1983, when a new verb 'surtitling' was created. The slides display selected parts of the opera libretto, with the intention to make clear to the audience member what is being sung (or said), a process that needs to be contained within a strict format of two lines of text per title, within which a maximum of 40 characters per line can be accommodated. In addition, the speed of the music dictates the duration within which the surtitles are displayed, which cannot be faster than the time a typical audience member requires to read each slide: 'overtitling' is an occupational hazard. The phenomenon of the surtitle recalls the small information cards that accompany artworks in exhibitions, which also potentially remove the focus from the work itself. The use of surtitles is by now fairly universal, and some theatres display them in a number of languages – for example, the Théâtre de la Monnaie in Brussels has surtitles in English, French and Flemish, as well as providing a visual interpreter for the hearing-impaired. 'Same language surtitling' occurs in some theatres; for example, a Britten opera given in an English-speaking country may have English surtitles, which is in some circles considered to be an unfortunate concession to the decline of singers' diction. The surtitle operator is often an emerging singer, or a budding répétiteur, taking whatever job they can obtain in order to infiltrate the world of the opera house. Excellent music reading skills and a precise sense of timing are crucial to the role, as many profound moments in opera have been rendered comical by an operator who becomes distracted. Roger Pines states: 'Surtitles can be satisfactorily timed only by listening carefully to the singer's phrasing, as if one were a conductor.'[9] The role of surtitle operator may seem an unlikely one from which to ascend the operatic ladder; nevertheless, some have managed to do just that. This is indicative of an old (but perhaps correct) perception that the first step into the world of opera is to somehow find a position within a theatre, any position, using whatever *situs* the novice may have to secure a place in *the field*, and from there develop *cultural capital* and cultivate *social capital* in order to rise to the desired position.

The **language coach** is a fairly recent addition to the opera house staff, a product of the convention that developed during the twentieth century of operas being sung in the original language. Today, audiences can be far from certain that the

singers who appear onstage actually speak the languages that they sing in. This is one of the ironies of modern opera performance, and it is where the work of répétiteurs and specialist language coaches becomes crucial in ensuring that foreign languages are sung with the correct pronunciation,[10] that the flow of the language is natural and convincing, that the meaning and structure of the text are properly communicated, and furthermore, that the text is delivered with suitable vocal colour and emphasis. There is, of course, an expectation or hope (but not specifically a mandatory requirement) that the singer will have a deep understanding of the text that they sing.

When a répétiteur and a language coach work together with a singer, a complex dynamic ensues. A répétiteur will usually have a broad familiarity with a number of operatic languages, while the language coach will often specialise in one, which may also be their mother tongue, affording them considerable *symbolic power* within the rehearsal dynamic. For example, to properly 'tune' the intermittent slips into dialect that are made by Baron Ochs in *Der Rosenkavalier* (1911),[11] an ear is required that is attuned to the so-called *Wiener-Dialekt*. Collaborative work between language coach and répétiteur will inevitably come up against 'grey areas' with often no single 'correct' response or solution – each functionary will have an opinion that is informed by their individual *habitus*, their personal position. A language coach will likely prioritise clarity of delivery and expressivity of text derived from a personal, hierarchical *doxa* developed from a lifetime of speaking the language. A répétiteur will hear the text from a slightly different perspective, from within the context of the musical line, and in the case of a *bel canto* opera, they will choose to prioritise beauty of vocal tone at the expense of textual clarity. There is no objective standard that can be applied here, and the répétiteur and the language coach may clash, not only as a result of their individual *doxa* but also with respect to their individual perceptions of their *symbolic capital* within a highly stratified working environment. These often tightly held positions are hotly defended by experts in the area of language, frequently resulting in the use of *symbolic violence*, comparable to what curator Steven Lubar terms 'object-jealousy' in the art museum, where 'object-love' degenerates into a negative, power struggle position.[12] In an unconflicted situation, répétiteurs, language coaches and conductors will work together in a collaborative fashion to obtain the best results from the singers. This aligns with what Christopher Whitehead, writing about the museum, describes as

> a network of people whose cooperative activity, organised via their joint knowledge of conventional means of doing things, produces the kind of representations that the museum is noted for.[13]

A typical language coach brings a wealth of *cultural capital* to their work, as well as a sense of *habitus* – a wider knowledge of the culture that gave rise to a language and its conventions. In some cases, however, the language coach will be someone who has become stuck on the operatic ladder – perhaps a singer who was forced to abandon their career, which may cause them to exercise *symbolic*

violence in an attempt to exorcise professional disappointment. The best language coaches have a 'feel for the game' that enables them to share their skills in the spirit of developing *social capital*. It is an area, however, where the 'charismatic ideology of "creation"' and other *doxa* are more frequently prevalent.

An emergent role – the répétiteur

We have already encountered some of the functions of the répétiteur, in collaboration with the language coach, as well as prompting and conducting backstage. All of these roles are aspects of the multi-faceted responsibilities of the répétiteur in the opera house, allowing them to develop skills and disciplines which may facilitate their path towards conducting. Among the core attributes of the répétiteur, an exhaustive, multi-dimensional knowledge of the repertoire, including operas, operettas and even musicals, is essential. It must be said that the job title, 'répétiteur',[14] is not an inspiring one, with its connotations of repeating the music endlessly, reflecting the origins of the word, of one who endlessly repeated music for the rehearsals of the *corps de ballet* in seventeenth-century France. In English-speaking countries, this role is often referred to as a coach, vocal coach or opera coach.

The German theatre system has a specific terminology for denoting the various career stages of a répétiteur (*Repetitor*) within the opera house. The lowliest position, from which one might commence one's career, is that of a **Korrepetitor**,[15] whose fundamental role is to play for staging rehearsals. A *Korrepetitor* develops their knowledge and skills (*situs*), eventually taking on the role of coaching singers, thus climbing in status to a **Solorepetitor**. Most répétiteurs naturally gravitate by temperament to either one or the other of those roles – some preferring to work in the more social environment of the rehearsal room, helping to create a production with a director and conductor, while others choose to work with individual singers. The task of the *Solorepetitor* is to assist the singer in learning the role(s) that they will be rehearsing or performing in the near future. Their role can extend from the fundamentals of knowing the correct notes, rhythms and tempi to instilling awareness of dynamics and phrasing and establishing how their role fits both with the orchestral texture and also with other singers in ensemble situations.

The répétiteur generally plays from a vocal score, which includes all of the singing parts, as well as a reduction of the orchestral score that can be realised on the piano. The best répétiteurs also make a study of the original orchestral score, learning which instruments play important solo lines, and gaining a deep understanding of how the orchestral texture is organised – in terms of instrumental combinations – which gives them additional information when creating a realisation on the piano that in some way emulates the orchestra. A phrase often used in assessing the skills of a répétiteur is 'to play like an orchestra', a description that underlines the fact that the répétiteur rarely plays exactly what appears in a vocal score; rather they rely upon the sound of the orchestral texture that they have in their inner ear, from their study of scores or recordings, or both. Aside from the limitations of literally transcribing the orchestra score, the répétiteur has to render

a score in many different contexts, presenting it in different ways. They must be able to dissect a score, find and reproduce important accompaniment figures that the singer must lock into, highlight and, where necessary, simplify harmonic structures (particularly in works that border on the atonal, such as Strauss's *Elektra*[16] or Berg's *Wozzeck*[17]) and offer solutions to assist singers to pitch their entries within complex, polyphonic writing. In the hands of the répétiteur, the vocal score of an opera becomes a multi-faceted object, a tool that can be spontaneously modified or improvised around. In one moment, it may have a didactic purpose, as a means of providing basic orientation for the singer, and in the next, it may be employed to simulate the sound world of a full orchestra at a piano dress rehearsal. The vocal score, in the hands of a skilled répétiteur, resembles an interactive artwork, a series of written instructions that can be realised in a variety of ways depending upon the choices of the répétiteur within a given context.

The skills of the répétiteur are highly specialised, and their work is central to maintaining the artistic standards of a professional opera company. While it is nominally an invisible role, on occasion the coach may, in addition to backstage conducting, or prompting, undertake a more public role in performances, playing keyboard instruments, such as celesta or piano in the orchestra, and even virtuosic, featured solos, such as the keyboard glockenspiel in Mozart's *Die Zauberflöte* or the solo piano part in Strauss's *Ariadne auf Naxos*.

The répétiteur in performance mode – continuo

Another area where the répétiteur may undertake a prominent performing role in performance (demonstrating their *situs*) is accompanying recitatives at the harpsichord (or other keyboard instruments), a requirement for many of the operas of Mozart, Rossini and Donizetti. The continuo fulfils a number of functions, with a large choice of styles possible to 'realise' (improvising a full accompaniment from a simple, figured bass instruction) the accompaniment. The most basic function is to play harmonic progressions that assist the singers to stay on pitch. This may sound like an unremarkable role, and in many modern performances and recordings, the harpsichord accompaniment is realised in a skeletal, minimal manner, which was long thought to be an authentic approach. Composers generally considered the working-out of recitatives to be a low priority, and well-known results of this attitude include both Mozart in *La clemenza di Tito* and Rossini in *Il barbiere di Siviglia*, who each delegated the composition of the recitatives to an assistant. A performance of either opera will involve audiences spending around 30–40 per cent of the performance listening to music not composed by Mozart or Rossini.

What exactly did Mozart or Rossini play on the keyboard when they led their premières? There is scant evidence to answer that question, which has further been clouded by the style of continuo playing that developed currency in the early twentieth century. Today, the continuo player may work closely with a like-minded stage director to develop and create links and transitions – scales, arpeggios and runs – to fill in moments on stage where a change in pace is required

(where a singer may walk, make an entrance or exit in a particular way) or to underlay a passage where a particular mood is required; in short, the continuo accompaniment may develop into a kind of musical protagonist, which helps to stage the opera, bringing to life the very bare indications that are in the score.

In Munich around the turn of the twentieth century, a 'Mozart Revival' took place under the guidance of Ernst Possart. Richard Strauss led performances from a *fortepiano*, like a Kapellmeister of old, playing the *secco* recitatives, in renditions that have become legendary. Reports survive of Strauss's extemporisations, and here we find him in an improvised act of composerly communion with his idol, Mozart, with the figure of Wagner also lurking somewhere in the background. Strauss's interpolations became a dramatic commentary in the form of introduced musical *Leitmotif*s, in which he often quoted from his own compositions. Conductor Wolfgang Sawallisch (1923–2013) recalls Strauss's manner of playing later in life:

> What he played on the cembalo [harpsichord] during the recitatives could not be repeated today. From the outset, Strauss's Mozart was a total surprise, but then, after a few moments, I grasped that every theme he charmingly interwove had an exact reference to the action somewhere on the stage. When there was a joke, a witticism or some other form of humour on stage, there suddenly appeared a touch of 'Till Eulenspiegel' or when, between Fiordiligi and Ferrando, there was a romantic exchange a touch of 'Don Juan' would ring out! But one knew exactly that each of the situations was correctly represented. Eventually, one waited for what would come next! So, suddenly, one was confronted with a completely different style which made Mozart live, a topical style of Mozart interpretation, even though Strauss was at least seventy years old.[18]

The continuo practices of Strauss were an anachronism, and the notion of creating *Leitmotif*s to create a dialogue with the stage is clearly a post-Wagnerian construct; nonetheless, it was highly effective and made good theatre. In conducting from the keyboard, Strauss evoked the figure of an eighteenth-century *Kapellmeister*, a role that traditionally attracts some scorn in operatic circles and is often thought of as a half-way station between the coach and the *bona fide* conductor, an apprenticeship role. Nevertheless, even a conductor as renowned as Christian Thielemann[19] speaks in defence of the role of the *Kapellmeister*,[20] which he clearly reveres and which he associates with his own musical practice. We now consider the journey of the répétiteur within the opera house.

Journeyman – from répétiteur to *Kapellmeister*

More structured than within other cultures, the career progression from *Korrepetitor* to *Solorepetitor* then leads to the **Solorepetitor mit Dirigierverpflichtungen**, nominally a répétiteur who may be contractually required to 'jump in' to conduct performances, where minimal rehearsal with the cast and no orchestral rehearsal is the order of the day. Typically, this will involve taking over works that the

répétiteur has been involved with in the rehearsal phase, ensuring that they know the routine of the piece well. At the performance, the aspiring conductor enters the orchestral pit and encounters the orchestra for the first time. These are the typical conditions under which a coach in Germany will begin to conduct, taking over operas and operettas, acquiring a repertoire, and eventually demonstrating that they have the strength of musical personality to create performances of distinction under such circumstances. Having survived this *nomos* and having obtained a 'feel for the game', the journeyman conductor, armed with enhanced *symbolic capital*, is then ready for the next stage of their rise through the opera house system.

The progressing coach–conductor gradually leaves the keyboard-based side of their job behind, often a slow transition, eventually rising to **Zweiter** (second) **Kapellmeister**, and thence to **Erster** (first) **Kapellmeister**[21], with the 'main prize' of *Generalmusikdirektor* (GMD) lying somewhere ahead. The climb is not an easy one – within most répétiteurs there lurks a conductor-in-the-wings, and conductors are single-minded, ambitious creatures, protective of their growing *cultural capital*. There will always be resistance shown towards répétiteurs who wish to rise to greater heights, not only from their répétiteur colleagues but also from the *Kapellmeistern* who have already risen up the ladder and don't wish to be knocked off their perches.

The strong organisational hierarchy (*nomos*) of German-speaking theatres is unique to these central-European institutions. In English-speaking theatres, things are more relaxed, and a member of music staff might be asked if they would 'carve' a rehearsal (just as the man of the house in Victorian and Edwardian times would carve the roast). There is something genteel and civilised about this terminology. In German-speaking theatres, an assistant would likely be asked to *taktieren* (literally mark the *Takte* or bars) rather than *dirigieren* (conduct). The German terminology is overtly hierarchical, and in one large German theatre, a well-known music director stipulated that in deputising at a rehearsal, an assistant may '*taktieren, aber nie dirigieren*' (mark the bars, but never conduct). The rise of musicians through the system often brings with it an artfully concealed sense of insecurity that is seldom absent in the workplace. In climbing the ladder from Second *Kapellmeister* to first, the journeyman will then have their own new productions to prepare and première. They will also take over performances of the major operas in the current repertoire that have been in the hands of the music director (GMD). In attaining a First *Kapellmeister* position in a substantial theatre, the erstwhile répétiteur may be seen to have nearly arrived at their goal – assuming that their intention is to become a GMD. Not everyone in the opera house has such an ambition, however, and not all musicians have the tenacity to fulfil the ambition that they harbour.

Safe havens in the opera house

There was a time in German theatres where most employees, including singers, orchestra and music staff, could potentially attain tenure, the longed-for state of

Unkundbarkeit, which was humorously portrayed in Patrick Süskind's play *Der Kontrabaß* (1981),[22] a one-man play about a double bass player in a municipal German opera orchestra. In Germany, positions in orchestras and opera choruses are usually well protected, but in the rest of the world, they remain precarious, particularly as older musicians face the spectre of diminishing competency. The situation for guest singers is potentially even more critical, with a vocal condition or even a bad case of influenza having the potential to slow or stall a career. There are those who are nonetheless risk takers, whose *habitus* and 'feel for the game' naturally equip them to climb the steep ladder of the opera theatre, sometimes even beyond the level of their own natural abilities. Others are more risk-averse and will prefer to use their *capital* to create a degree of security. Some simply get stuck along the way, or else recognise that their natural vocation is in a job on a lower rung of the ladder. There are a variety of positions within an opera house where a coach, for example, may take a detour from the path heading higher up the ladder.

The position of **chorus director** is such a role, an important and highly responsible one within the opera house, with a cohort of perhaps 40 or more singers in their charge, and the mandate to produce a unified, precise ensemble. Larger houses will employ an **assistant chorus director**, who will accompany rehearsals on the piano, and there may be an administrative assistant to look after the day-to-day issues of this self-governing area, in which the chorus director effectively rules supreme, while within the larger workings of the theatre, they adapt to the wishes of the GMD and guest conductors. A successful chorus director will understand how to obtain a floating *pianissimo* from a large chorus; they will be extremely attuned to vocal colour and internal balance within voice types. They will know, for example, which of their sopranos can be assigned to the top line of the music to obtain a perfectly tuned result, or they may be aware of a shortage of deeper contralto voices, especially where lines are divided, and may discreetly add a couple of high tenors to blend the sound and equalise the balance. These are some of the 'tricks' that the chorus director employs in order to obtain the best sound and ensemble from their chorus – this is their *cultural capital* at work in *the field*. Opera managements are keenly aware of the value of an experienced chorus director who can foresee potential problems in performance and solve them before they occur, and who can give the chorus the tools to be able to produce a unified result, even with an inexpert conductor at the reins of a performance. The role is an ideal one for a personality that likes to have their own fiefdom while functioning within a much larger entity.

Another crucial position for the smooth functioning of the theatre, broadly equal in status to that of the chorus director is that of the **Studienleiter** (Head of Music, or Head of Music Staff), whose task is to ensure that all the solo singers are prepared in their roles and ready for the first day of music rehearsals with the conductor. The *Studienleiter* organises their music staff to undertake coachings, while they may personally coach some of the more important singers themselves. In addition, they schedule preliminary ensemble rehearsals, which they will most likely direct themselves, assembling together quartets, quintets, sextets, finales and other ensemble

numbers that require careful group preparation. Other tasks include producing the rehearsal schedule, ensuring that all rehearsals and performances (staging, ensemble and solo coaching) are adequately staffed, that répétiteurs are able to deputise as assistants when conductors are not available, and that the most suitable member of the staff, with the requisite skills and demeanour, is used to the best advantage in the most appropriate rehearsal. The *Studienleiter* will have accumulated considerable *cultural capital* during their apprenticeship as a répétiteur, which they employ in this role. The *Studienleiter* must be highly attuned to interpersonal issues, having built a strong network of *social capital* within the theatre, in order to avoid scheduling situations where personality or other conflicts could arise.

This may have the ring of a mundane job, and it certainly does have its duller side, involving a great deal of facilitation, planning and administration. It can also offer opportunities to work closely with the GMD or other conductors and directors as a musical assistant. The crucial attribute (*capital*) of the *Studienleiter* is an exhaustive knowledge of the operatic repertoire, specifically an intimate knowledge of the singing roles in each opera – to know their difficulty, the type of singer required and the length of the role, and to be adept at estimating how much coaching time should be assigned to each singer in order to master their role. They also need to have a strong grasp of the capabilities of the ensemble of singers in the opera house, to know their strengths and weaknesses in terms of language, musicianship, speed of learning and memorisation. A similar understanding of the strengths and limitations of their music staff is also crucial to the mix of skills they bring to the job. They need to use their *symbolic capital* within the organisation to achieve positive interpersonal results (*social capital*) rather than *symbolic violence*, and they should exude a strong, but benign, sense of authority.

The *Studienleiter* is likely to be someone who once had the ambition to become a *Kapellmeister* but did not quite arrive at that goal. To maintain a substantive role within the theatre, the *Studienleiter* requires great strength of character in order not to get swamped in administration and to develop their position as an effective musical presence. If the *Studienleiter* possesses these qualities, then the day-to-day functioning of the musical administration of the opera company will progress smoothly. In this sense, the *Studienleiter* can be influential in *the field* without being powerful. Such influence will often allow the *Studienleiter* to use their *capital* to negotiate further rewards, beyond salary and influence, such as conducting: most theatres will enter into an agreement with a *Studienleiter* who clearly possesses the skills to keep the wheels of the enterprise turning smoothly. Managements see the assignment of performances to some of these 'safe haven' functionaries as being sensible business practice.

The music director (GMD)

The ***Generalmusikdirektor*** (GMD) occupies an important and dignified position musically, socially and politically in the life of the city. They fulfil a substantive function, being responsible for making the decisions that in a cultural sense guide the spirit of *Bildung* within their community that even today remains an important

element of the central-European psyche. With that in mind, the GMD formulates and plans the repertoire for the forthcoming season, ensuring that a mix of 'high art', and more popular works, including operettas, and *Spielopern*, are all represented. The GMD is responsible not only for planning the opera seasons, but also the seasons of orchestral concerts, for which the opera orchestra puts on another hat (and usually name), as the town's symphony orchestra on several occasions each season.

As a conductor rises through the ranks of the opera house, they are likely to have opportunities to conduct in a number of genres – operettas, musicals, operas, ballets and even incidental music for plays. This offers the conductor chances to gain a large repertoire in these areas, but the conductor will have fewer opportunities for developing symphonic repertoire, unless they cultivate opportunities available outside the theatre. Therefore, in making the transition from First *Kapellmeister* to GMD, the conductor is likely to arrive opera repertoire heavy and symphonic repertoire light. It is often the symphony concert seasons that will draw a conductor to accept a GMD position, and they will put a great deal of effort into planning the orchestral series, programming key works of the repertoire for themselves to conduct. They will then be in a position to indulge in 'podium exchange' – a career development tactic whereby the GMD, having assigned themselves to a generous number of symphony concerts, will invite guest conductors who are chief conductors of other orchestras and whom the GMD hopes may reciprocate with invitations for them. This is the 'podium exchange' principle in full flight – the GMD uses their *cultural capital* to play *in the field* with another conductor, whose *capital* they enhance and increase in the hope of a reciprocal invitation, also resulting in an increase of *cultural capital* for the GMD.

There are many cases of conductors who, upon being appointed GMD, have little interest left in the day-to-day world of opera. They have acquired their repertoire; they prepare and conduct the few operas they are contractually obliged to undertake, as well as an agreed number of performances following the première, and from there hand over performances to other members of the conducting staff, thereafter devoting their efforts to their symphony concerts. Many GMDs develop their symphonic repertoire methodically – one is likely to see Beethoven, Mahler, Bruckner and Sibelius symphony cycles in their programs as gaps in their repertoire are closed. The administrative responsibilities of the position are considerable, and while the term *Generalmusikdirektor* has a certain ring to it, when the GMD takes on the full load of artistic and business duties, this often becomes an exhausting challenge, involving lengthy and complex negotiations between stakeholders, applications to the governing bodies that fund the theatre's activities, and many moments of playing Solomon, mediating between artistic integrity and cold financial reality. It is more usual to have those responsibilities split into two positions, particularly in larger theatres, but this also brings its own problems – the GMD aspires to create the strongest artistic program, while the *Intendant* (as the CEO is generally known) is focused upon balancing the books. One of the more public controversies of division of power within the opera house occurred at the Bayerische Staatsoper, Munich, in the 1970s and 1980s between GMD Wolfgang

142 Part III

Sawallisch and the flamboyant stage director and *Intendant* August Everding, involving a breakdown of communication and burgeoning brinksmanship regarding the ultimate responsibilities and rights of each these functionaries within a complex history of power structures, causing much confusion. The disagreement was fought out very publicly, ultimately resulting in the departure of Sawallisch.[23] Consider the withering exchanges between the *Haushofmeister* (Major-Domo) and the *Musiklehrer* (Music Master) in the Prologue of *Ariadne auf Naxos*,[24] and imagine such in-fighting continuing day in, day out, in the everyday life of a theatre: two people with quite different agendas speaking past one another, uncomprehending, while a collection of people in various states of undress run around, attempting to stage an opera. Strauss and Hofmannsthal's portrayal, nominally of the house of the 'richest man in Vienna', has become an immortal vignette of the wiles of operatic enterprises the world over.

Negotiating the German theatre system

In spite of a potentially inflexible structure and a 'fly by the seat of your pants' attitude to performance, the German theatre system remains an extraordinary institution, at one level functioning as a training ground for singers, conductors, coaches and stage directors, while at its highest echelons producing performances that are world-class, with all departments of the theatre carefully engaged in the service of the operatic work. In 2014, Germany had 83 publicly funded opera houses (with 67 theatres in Austria),[25] from tiny outposts that generally avoid the heavier repertoire to the largest international opera houses where Wagner, Strauss, Berg and Janáček are daily fare. Cities such as Berlin and Vienna have three full-time working opera houses, each with its own repertoire model. Such a concentration of theatres within one country allows the system to be diverse and self-regulating; one enters the profession at a certain level, and then rises (or occasionally falls) to the level of one's own competency. One of the dangers of the system is its commitment to productivity. The larger theatres in particular have systems in place to ensure that in spite of unforeseen circumstances, performances will inexorably take place. It has been said that day-to-day life in the theatre can on occasion feel a little like working in the German post office, or on the production line of BMW.

This Bourdieu-influenced analysis of the musical functionaries of the opera house offers an outline of the hidden curatorial machinery at work in the modern German opera house. Ambition and the quest for power emerge as strong themes, and in the day-to-day dramas and politics of the opera house, it is very easy for the pursuit of personal artistic fulfilment to get lost. It is tempting to regard many of the employees of opera houses as self-interested functionaries, who allow individual ambition to influence the inner workings of the operatic museum, and who, in the pursuit of their careers, risk losing sight of the works that are entrusted to them to faithfully represent. The positions considered here are not the only ones within the opera house that specifically deal with works and their characteristics/identity. The following chapter examines the significant role of the *Dramaturg* in

the German opera house, along with the broader concept of dramaturgy and its influence over the post-war rise of *Regieoper*.

Notes

1 Pierre Bourdieu, *The Rules of Art: Genesis and Structure of the Literary Field*, trans. Susan Emanuel (Cambridge: Polity Press, 1996).
2 Pierre Bourdieu and Randal Johnson, *The Field of Cultural Production: Essays on Art and Literature* (Cambridge: Polity, 1993).
3 This brief account of Bourdieu's theories is summarised largely from 'Pierre Bourdieu', *New World Encyclopedia*, www.newworldencyclopedia.org/entry/Pierre_Bourdieu, accessed 24 February 2019.
4 Ibid., see under heading 'Symbolic capital and symbolic violence'.
5 Bourdieu, *The Rules of Art*, 167.
6 Richard Strauss and Hugo von Hofmannsthal, *Die Frau ohne Schatten* (Berlin: A. Fürstner, 1919) 601, fig. 179.
7 Sometimes (inadvertently) heard in the theatre (during soft passages) and audible on many live opera recordings.
8 Constantin Stanislavsky, *My Life in Art* (Boston: Little Brown & Co., 1924), 297. Quoted in *Oxford Music Online*, prompter entry, https://doi.org/10.1093/gmo/9781561 592630.article.O007991, accessed 31 August 2011.
9 Roger Pines, 'Surtitles [supertitles]' in Stanley Sadie, *The New Grove Dictionary of Opera*, 4 vols (London: Macmillan, 1992), 606–8.
10 *Bühnenaussprache* – the correct delivery for the language to sound clear and correct to the audience from the stage; applied to the Italian repertoire, it is known as 'Italian lyric diction'.
11 Richard Strauss, Otto Singer and Hugo von Hofmannsthal, *Der Rosenkavalier* (New York: Dover Publications, 1987).
12 Steven Lubar, *Inside the Lost Museum: Curating, Past and Present* (Cambridge, MA: Harvard University Press, 2018), 105.
13 Christopher Whitehead, *Museums and the Construction of Disciplines* (London: Gerald Duckworth & Co. Ltd., 2009), 47.
14 A typical dictionary definition – 'a coach, tutor: one who rehearses opera singers, &c'. – this from William Geddie, ed., *Chambers' Twentieth Century Dictionary* (Edinburgh: London: W. & R. Chambers, Ltd., 1959), 935. Sadie, The *New Grove Dictionary of Opera*, iii, 1292–3, gives a more detailed definition. *Répétiteur* – French [English], *Repetitor* – German, *maestro concertatore*, *repetitore* – Italian.
15 Online sources such as 'Das Deutsche Bühnen-Jahbuch geht Online!', *Genossenschaft Deutscher Bühnen-Angehöriger*, www.buehnengenossenschaft.de/das-deutsche-bue hnen-jahrbuch-geht-online, accessed 18 January 2019, contain information about the different stations of répétiteurship in the German system. Rudolf Hartmann, *Handbuch des Korrepetierens (Zur Psychologie und Methodik des Partienstudiums)* (Berlin: Max Hesses Verlag, 1926), 146–9, discusses the working relationship between the *Kapellmeister* and the *Korrepetitor.*
16 Richard Strauss and Hugo von Hofmannsthal, *Elektra* (Berlin: Fürstner, 1908).
17 Alban Berg, *Georg Büchners Wozzeck. Oper in 3 Akten (15 Szenen) ... Op. 7. Partitur. Nach Den Hinterlassenen Endgültigen Korrekturen Des Komponisten Revidiert von H. E. Apostel (1955). English Translation by Eric Blackall and Vida Harford* (Wien, etc: Universal Edition, 1955).
18 W. Sawallisch, *Im Interesse der Deutlichkeit: Mein Leben mit der Musik* (Hamburg: Hoffmann and Campe, 1988), 29–30.

19 Christian Thielemann, *My Life with Wagner* (Great Britain: Weidenfeld & Nicolson, 2015).
20 Ibid., 102–4.
21 Known colloquially as the '*Erster*'.
22 Patrick Süskind, *Der Kontrabass* (Zürich: Diogenes, 1984).
23 Sawallisch, *Im Interesse der Deutlichkeit: Mein Leben mit der Musik*, 220–7.
24 Richard Strauss, *Ariadne auf Naxos* (Berlin: Adolph Fürstner, 1916).
25 'Theaterstatistik', *Deutscher Bühnenverein*, www.buehnenverein.de/de/publikationen-und-statistiken/statistiken/theaterstatistik.html, accessed 6 February 2019.

11 The operatic work and the concept of *Werktreue*

The fragile identity of operas

Chapters 8 and 9 outlined the journeys undertaken by Mozart's operatic works following their premieres, onto international stages, from which they could secure a place in the repertoire. Such journeys were complex and at times perilous, and involved traversing national boundaries and adapting to new languages and customs. Some of the practices encountered were curious, such as the habit of performing operatic works in London, in Italian, regardless of their origins. The process of adaptation (which resulted in a work 'going out of focus') generally began with modifications to the libretto, and this loosening of the work's fundamental structure preceded more wide-ranging changes that affected the musical structure. These practices included: *retuschen*/re-orchestration – adapting the orchestral elements of the score for smaller/larger forces, or the specific instruments that are available in a particular locality; *puntatura* – the practice of reworking a vocal line to fit the range of a particular singer; improvisation and extemporisation – by singers, usually but not exclusively in their solo numbers; substitution – replacing a particular number in the score with another which may, or may not, have been written by the main composer, which in turn raises the matter of the larger-scale practice of *pasticcio* – where pieces are gathered together from a number of musical sources and a libretto created or adapted to bind the resulting 'mash up' together dramatically.

Two other conventions were also significant in operatic practice, though they are often overlooked in 'work'-focused critical literature. The *opera gala*, or *benefit concert*, usually showcased one main singer and included selections from 'signature' roles as well as other, non-operatic pieces, such as folksongs, which were not infrequently substituted for arias in opera performances. The second area that has also been glossed over in the literature until recently is the operatic *arrangements and transcriptions* made for domestic use, which were an important means of dissemination and familiarisation: such arrangements would frequently travel ahead of a new opera production, allowing opera lovers to familiarise themselves with the 'hit' numbers, which in such arrangements were partitioned from the rest of the work. Publishers produced arrangements of complete operas, from the eighteenth century onwards, with examples for *Harmonie* (wind ensemble)[1]

being particularly sought after. These effectively brought a scaled-down opera performance, with all of the latest popular tunes, into the homes of aristocrats who did not have the means to support their own theatres.[2] Such ensembles can be seen as a means of disseminating operatic fare based upon social standing and budget, and a group of players performing in an adjoining room at a social gathering can be regarded as a forerunner of the player-piano (or reproducing-piano), or even the jukebox of the twentieth century. Operatic works had many outlets for transmission beyond the main stage of the opera house; they were sought-after novelties that would pop into the 'miscellaneous concert',[3] an important feature of concert life in the late eighteenth and nineteenth centuries. An operatic aria or *scena* might occur between the movements of a symphony, for example, highlighting the fact that the notion of a 'work', be it a symphony or an opera, did not exist in the same way as it does today. In that sense, what is today regarded as the 'identity' of an operatic work was not completely formed in those times, meaning that when we speak today of a Mozart opera, for example, as exhibiting a sense of unity, we are probably speaking anachronistically. Mozart *may* have been concerned during the process of composition to achieve musical unity, but the market conditions of performance that he composed for tended to play down and, even undermine such notions.

Therefore, not only did operas not exhibit the semblance of integrated works in their dissemination patterns and performance histories, but they were also struggling in a market that largely relied upon the handwritten copying of scores and other material, creating conditions where much detail was lost, and works might be performed for a number of years with glaring errors. One example of a tiny fleck being chipped off an operatic work has already been given in Chapter 6, when a single chord disappeared from the end of an ensemble in *Die Zauberflöte*, creating a misreading that was circulated widely through several editions of the work. Another example of a misreading that has proved disorientating for listener and performer alike occurs in the iconic 'Brindisi' from Verdi's *La traviata*. The misreading in question involves one bar of music, lasting around a second, seemingly minor, but in performance proving surprisingly disruptive. The 1996 critical edition of the opera surprisingly omits a single bar, creating an effect that is irregular and unexpected to most opera lovers, and which, to ears familiar with the traditional version, simply seems wrong.[4] Until the appearance of the critical edition, this passage was universally performed as shown in Example 11.1.

The version published by the Chicago Verdi edition is shown in Example 11.2. This second reading, truncated by one bar, is, according to the critical edition, the correct one. It is, however, generally met with incredulity when it is performed today and is still not fully accepted into the opera's performance practice. When the new edition is used in performance, the 'missing' bar is more often than not restored. However, if the 1996 edition is accurate, the 'Brindisi' has been (and continues to be) performed incorrectly for nearly 150 years.

Example 11.1 Verdi, *La traviata*: 'Brindisi' as traditionally printed and performed, bars 321–8.

There is an unwritten expectation that cultural artefacts must offer an acceptable, reliable representation of the past. Re-imaginings of the past that uncover errors are found to be unsettling or disquieting.

> Celebrating some of its aspects, expunging others, we reshape the past in line with present needs. How do we alter what we recall, what we chronicle and what we preserve? ... Memory, history and relics of early times shed light on the past. But the past they reveal is not simply what happened; it is in large measure a past of our own creation, moulded by selective erosion, oblivion and invention.[5]

Working with *Werktreue*

Werktreue can be quickly and simply defined: the notion of fidelity to a musical work. Behind that terse definition there are a number of complicating factors.

Example 11.2 Verdi, *La traviata*: 'Brindisi' as printed in the Ricordi Critical Edition, bars 321–7.

The view of *Werktreue* during the late nineteenth and early twentieth centuries was primarily based around the musical score (that was considered synonymous with the musical work), which was deemed to be immutable. If one could access an authentic score, based upon the composer's autograph, *Werktreue* was certainly within one's grasp. Today, even armed with a reliable edition of a work, achieving fidelity in its performance remains an elusive goal. It is not difficult to obtain a score of a work by Mozart the authenticity of which is accepted by both academics and performers (excepting occasional minor quibbles among experts). However, in the empty spaces between the notation, there still lurk many uncertainties. Mozart's score is not enough. We may look back at old treatises concerning performance and musical execution, including that of the composer's father, Leopold Mozart, but even armed with such a resource, grey areas remain. During the course of the nineteenth century, it became clear that an accurate score

was not enough to realise a work of the past. Increasing value was attached to a detailed knowledge of performance conventions of earlier times, which sometimes emerge in operatic practice as 'traditions'. During the last two decades, the works of nineteenth-century composers have become subject to closer scrutiny. It is said that the score of a middle-period opera of Verdi specifies at best 70 per cent of what the composer intended; the remainder he left to a shared knowledge of the conventions of his time. Performances of Mozart's music require a sense of the 'Mozart style': an elusive concept, the investigation of which has identified a multiplicity of Mozart styles in current performance practice. The further we look back beyond Mozart's time, the more confusing the landscape becomes. Today, it is possible to accurately reproduce a musical score from 400 years ago, but place that score in the hands of modern performers and uncertainties abound: almost everything around the score has changed, including the original musical and performance styles, and the conventions within which the instincts of performers are developed and nurtured.

A more modern means of exploring authenticity in performance would be to incorporate a historically informed approach to performance (HIP), which brings known scholarship to bear as a central resource in interpreting what the composer has notated. Today, most of the music currently in the repertoires and canons of 'classical music' requires such an approach. Authenticity would seem to have become a key that can potentially unlock *Treue* – the slightly moralistic notion of 'fidelity' in performance. The origins of *Werktreue* in nineteenth-century thinking have led to the term being invoked with a sense of religious zeal, particularly when applied to canonic masterpieces that are considered to embody great cosmic truths, the essence of which the performer has a duty to reveal to the audience. *Werktreue* becomes an even more complex matter in operatic works, where establishing parameters of fidelity operates at many levels. If one were to apply a strict, literal sense of authenticity, then a great deal of the early operatic repertoire could not be performed today, for example due to the extinction of the castrato voice. Similarly, most audiences would take issue with a performance of Donizetti's *Lucia* that did not present the 'traditional' flute and voice cadenzas that were, in fact, composed long after the composer's death. An alternative sense of authenticity exists in the public imagination (clouded by 'tradition'), one that remains faithful to a received notion of *Lucia* that, objectively considered, is not strictly 'authentic'.

Werktreue is a strongly contested concept within musical scholarship, as is the 'work concept', which today still hangs around the neck of a period in music history when composers simply did not think of their musical creations as 'works' in the modern sense. The question of when this shift occurred has been explored in a controversial book, *The Imaginary Museum of Musical Works*,[6] by the musicologist Lydia Goehr (born 1960), who proposes that around 1800, a fundamental change occurred in how music was practised and perceived, with the notion of a 'musical work' becoming one of the central tenets for both composers and audiences. Goehr's theories have sparked much scholarly debate, which has run to many more pages than the original text. The author posits the year 1800 as a

notional line of demarcation around which composers, performers and audiences began to shift their thinking towards an integral concept of the musical work, providing an important framework, which when applied to operatic works, can illuminate how they are perceived and performed today. If Goehr is correct, our habit of looking back at works composed before around 1800 and regarding them through our 'work-based' perceptions fundamentally distorts them. The following examples may illuminate the theory and the development of 'work-based' thinking – specifically applied to opera – that Goehr describes.

Example 1: Mozart's conception of the operatic work in the late eighteenth century

The world of operatic practice in late eighteenth-century Vienna that Mozart inhabited was a commercial enterprise, where the composer was but one element in a complex process, and by no means the dominant one. Singers would be proactive in negotiating the number of arias that were assigned to their role, where they appear in the work, the range or tessitura of the part that was composed for them, with transpositions or other rewrites not infrequently being demanded.

Mozart's own manuscript of one of his operas would have consisted of a collection of individual numbers, 'a pile of unbound individual pieces, perhaps kept in paper folders for convenience or else loosely tied together'.[7] This was because 'there was no expectation at all that one production would contain the same music as the next. The converse, if anything, was true; there was a fairly strong probability that each new production would require changes.'[8] Modern usage of terms such as '"autograph", "score", "manuscript", "source" or "exemplar" ... appear to imply a single fixed object', whereas an opera score of this period was a loose pile of papers, 'resembling nothing so much as a pack of cards ready to be shuffled'.[9] That image befits the notion of an eighteenth-century opera far more than the modern reality of a fixed, hard-bound critical edition. Writings about opera of this period often refer to the composer's autograph ('initiator text'), while, in fact, at least two scores were involved in the creation of an eighteenth-century première: a 'conducting' copy, and a 'reference' copy, from which vocal scores and orchestral parts were copied. In most cases with Mozart's operas, the autograph is not the principal source.[10] The composer worked in an environment where mutability ('inescapable fluidity')[11] was operative through all phases of the preparation of his operas and continued following their premières, defining the shifting, adaptive nature of the genre.

This account of how Mozart created and developed his operas is taken from recent research by Ian Woodfield,[12] who has examined the day-to-day realities of eighteenth-century operatic practice. It firmly refutes the notion of a fixed point in time at which a Mozart opera could be considered to be definitively complete – in other words, it questions the basic assumptions of modern scholarly editions when applied to operatic works of this period. The modern idea of a 'fixed score' emerges as being alien to the world of eighteenth-century operatic practice, and Mozart's operas are revealed to be more akin to 'open works', with Woodfield

concluding that 'it would not be wrong to think of a Mozart opera as an unending stream of slightly different versions'.[13]

Woodfield's account of Mozart's working practices just over a decade before 1800 paints a very different picture from the image of him that developed over the ensuing century. By the beginning of the twentieth century, the pianist and composer Ferruccio Busoni penned a series of 'Mozart Aphorisms' (1906)[14] inspired by *Don Giovanni*, and which exemplify the nineteenth-century, deified view of the composer:

His sense of form is also supernatural.
His art is like a sculptor's masterpiece – presenting from every side a finished picture.
His proportions are outstandingly correct, but they can be measured and verified.
He stands so high that he sees further than all and sees everything, therefore, somewhat diminished.
He is the complete and round number, the perfect sum, a conclusion and no beginning.[15]

These aphorisms embody the idealised 'work-based' thinking that transformed Mozart into a deity, a genius, the creator of a legacy of perfect musical works. They also perpetuate the mindset of the nineteenth century, which idolised Mozart and endowed him with almost supernatural powers. During the late nineteenth century, when the notion of *Werktreue* conjoined with such concepts, an objective approach to a score by Mozart became an ever more illusory endeavour.

Example 2: Beethoven – the prototype work-based composer of the nineteenth century

In 1814, also in Vienna, Beethoven concluded a decade-long quest to bring his opera *Fidelio* to a final, definitive form. Following its première in 1805 (as *Leonore*), the opera was presented in a revised version in 1806, only reaching a fully resolved form in 1814. The composer's struggle with the work is evident from the revision process, which produced no fewer than four overtures (the opposite to Rossini's practice of recycling one overture several times for inclusion in other operas) and resulted in several numbers being reworked or rewritten. The composer was, on occasion, assisted in his revisions by friends, such as Josef August Röckel (1783–1870), the tenor who sang Florestan in 1806, who described the composer's rage at being pressed to make cuts and other changes. Beethoven shouted 'not a single note', against the cajoling of friends and supporters who proposed amendments to the opera, well-wishers who found themselves confronted with the idealism of a composer engaged in a never-ending struggle to refine, reshape and rework his material in pursuit of the exact form he was seeking. In Lydia Goehr's theory, the turn of the century had heralded a new position for the composer – a 'work-based' one. While Beethoven could rant and rail about 'not a single note' being changed in his score, the preconditions did not exist for

him to be able to enforce that when his opera 'left home' to find its feet in the operatic marketplace. It may seem unlikely that a work such as *Fidelio*, which today enjoys canonical status, would be just as vulnerable to the wiles of operatic practice as any other opera of the period, but the reality is that it too was subject to wide-ranging alterations and adaptations well into the twentieth century.

Example 3: Verdi and the development of authorial control

The final example of the developing *Werktreue* concept comes from Giuseppe Verdi. While his operatic career may have commenced unremarkably, each work that Verdi created was a considered step towards assuming greater authorial control over his compositions. In achieving these aims, Verdi worked closely with his publisher Giulio Ricordi, carefully supervising productions and exercising ever-increasing scrutiny over the choice of singers along with other aspects of the productions. The most formidable obstacle that Verdi faced in creating his operas in the form that he wished was probably the censor, the results of which can be still be seen in the unresolved nature of some of his works, notably *Un ballo in maschera*. During his long career, Verdi worked tirelessly to engage singers who could produce the kind of vocalism and verisimilitude that he required and who would work within his attitudes towards the primacy of the written score. Verdi lived through an extraordinary period of operatic change, and by 1871, when he was nearly 60, he was able to write to Ricordi that he was 'simply content to hear simply and exactly what is written'.[16] Verdi lived to see his works performed widely, their influence spreading onto the international stage and playing a leading role in the developing repertoire. In composing his final opera, *Falstaff*, the composer demonstrated an awareness of his place in music history, the canonical status of his corpus of operas, and the fact that he was the creator of operatic 'works', the performance of which was determined by the authorial specifications in the score.

These three examples outline three positions that were defined over a century when the idea of the operatic 'work' was being shaped, during which the position of the composer shifted considerably. Logically, it would seem that different parameters – attitudes towards *Werktreue* – might be required when performing works of differing periods today.

What follows is an account of a production of *Figaro* at The Metropolitan Opera, New York, that developed into a scandal, as notions of *Werktreue* were tested and the perceptions of all parties (including the audience) of what might be expected from the text of an eighteenth-century opera were interrogated. In the following example, the idea of substituting arias in a Mozart opera is met with outrage, even when the substitutions are the work of Mozart.

Figaro: A modern conundrum of *Werktreue*

Previous chapters have advanced an argument that popularly received versions of the Mozart's stage works that are generally performed today are based upon

agreed traditions and conventions that have taken root since the composer's death. Recent scholarship reminds us that Mozart regarded his operatic works as a series of evolving possibilities, which were halted only by the composer's early death. Today, opera lovers may understand this fluidity of form at some level, but remove a long-cherished aria from a production and the deprivation felt by both opera practitioners and audiences can erupt into the public sphere, as occurred in 1998 when the British director Jonathan Miller was engaged to direct *Figaro* at The Metropolitan Opera in New York. During the course of rehearsals, a scandal surfaced, which became amplified in the international press, bringing to light some ugly revelations of power play in the upper echelons of the Metropolitan hierarchy and some entrenched attitudes towards the operas of Mozart.

Cecilia Bartoli was engaged to sing the role of Susanna, and upon arriving for the staging rehearsals, insisted upon including the two rarely performed substitute arias composed by Mozart for her role.[17] Bartoli, at the height of her fame and enjoying full star status, pushed her preference for these alternative arias (about which the director was lukewarm), and she appears to have enlisted the support of the Metropolitan music director and conductor of the production, James Levine.[18] In protest, Miller 'left her to her own devices when it came to the dramatically redundant inserts',[19] drawing a response from Bartoli that Miller had acted in an 'ungentlemanly' fashion. 'I felt like Caesar with Brutus,'[20] she quipped at the time, a comment countered by Miller with his assessment that she was a 'rather silly, selfish girl – wilful, wayward and determined to have her own way'.[21] The matter was reported in the press shortly after opening night, and it was alleged by Miller that General Manager Joseph Volpe had confronted him, saying 'don't fuck with me', and then fired him.[22] The press initially sided with Miller, in spite of his critical and distanced attitude towards the 'glitz-loving audience'[23] of the Metropolitan.

By 2002, the issue still remained a thorn in Miller's side, in spite of the production having become extremely popular at the Metropolitan and the unfamiliar arias, which initially had been frostily received by the public, having become acceptable. Miller, in 2002, maintained that he had 'expressed [his] unease about using showy arias that are infinitely less interesting and appropriate to the drama. These [new arias] are twice as long and their words have nothing to do with the action.'[24] In response to Joseph Volpe's reported comment that Miller had agreed to the substitutions, the director replied: 'Yes, I'd agreed rather in the way that France had agreed in 1939.'[25] In an earlier interview, Miller had described the act of removing Susanna's 'Deh vieni' from Act 4 of *Figaro* as being 'like coitus interruptus'.[26]

In hindsight, it is hard to see that Bartoli, in wishing to include Mozart's alternate arias, behaved in anything but an altruistic fashion. She has been a tireless advocate and supporter of neglected repertoire, and in eschewing Susanna's 'Deh vieni' and offering something unknown, her motivations seem less than diva-like. She had the support of both the general manager and the music director of the Metropolitan. At the time of the première, critics and audiences largely sided against Bartoli and the substitutions – the critic Martin Kettle accusing her of

154 *Part III*

diva-like 'egocentricity', reporting that a disaffected audience member 'cared enough to boo. It is shocking to say it, but Bartoli deserved it.'[27] Another critic, John W. Freeman, described the Act 2 substitution as an 'ersatz ditty ... a bit of fluff that leaves a dramatic hole where "Venite, inginocchiatevi" is supposed to be'.[28]

The conservative reactions of both public and critics were evident in this incident – along with the perennial desire to fan the flames of scandal. It emphasises how the combination of *'Figaro'* and 'Mozart' sets up popular expectations, and that iconic musical numbers cannot be excised without controversy. Nevertheless, the scandal eventually resulted in a new assessment and appreciation of the two substitute arias, leading to the recognition that the insertion aria was a genre in which Mozart himself was prolific. 'The negative reactions against Bartoli's alterations were magnified because she was "tampering" with Mozart, a composer whose "vision" still possesses more clout than most.'[29] This scandal highlights the complex relationships that exist within opera houses, their creative teams and the people who are known to the public as the tastemakers in the world of opera. 'Might is right' undoubtedly plays a role here, and Miller's rhetoric about the immutable genius of Mozart begins to sound a little hollow: 'With his genius Mozart wrote the right music for *Figaro* and then, under pressure from a diva, wrote alternative arias.'[30]

The influence of 'work-based' thinking can be seen here to have persisted in operatic perceptions, where examining the classics in a new light frequently causes ructions within not just the public but also opera practitioners themselves. Operatic museums and their audiences have been slow to catch up with the more recent perception of Mozart's *Figaro*, as the composer's 'ever-mutable opera'.[31]

Manrico's struggle with an unreliable past

The following discussion concerns just one note, but a rather famous, and for some inconvenient, note. This note, furthermore, was *not* written by Giuseppe Verdi in 1853, during a period when he was beginning to exercise an increasing degree of authorial control over his music. Among those who found this note inconvenient was conductor Riccardo Muti, who in performances at La Scala, Milan, in December 2000 forbade the rising young tenor Salvatore Licitra to sing it at the conclusion of 'Di quella pira' at the end of Act 3 of *Il trovatore*. Muti's justification for his ruling was unequivocal – the note that is written in Verdi's autograph is a G, not a high C. The latter note was added in the nineteenth century by tenor Carlo Baucardé,[32] who created the role of Manrico at the work's première, though it remains uncertain whether Verdi ever heard his opera performed in this way, nor is there any evidence that he sanctioned the change. The wishes of the composer seem clear in this context, so why was it that on the occasion of this performance, the conclusion of the act was greeted by cat-calls and even an exchange between an audience member and the conductor, as a cry of 'it's the conductor's fault' erupted from the house?[33] This makes good press, particularly considering it was driven by a single (unsung) note that the composer

did not write. It might be argued that the interpolation of a C at the end of 'Di quella pira' makes excellent dramatic sense, as well as having become, over the years, an integral feature of the opera, by virtue of 'tradition', a word that is often invoked in operatic practice and criticised in purist circles. The appendix of a recent critical edition of Rossini's *Il barbiere di Siviglia* (1816)[34] includes an aria for Bartolo by Pietro Romani, a number not written by Rossini but which has been so often incorporated into the work's performance history that it was considered indispensible to the edition. It seems that in the world of Italian opera, there are both 'good' and 'bad' traditions, or 'correct' and 'incorrect' ones. Had attitudes changed so much in the intervening 37 years between the composition of *Barbiere* and *Il trovatore* that a high C not notated by Verdi can continue to cause such a scandal? Perhaps they had.

This high C, and its necessity, is something that tenors themselves do not often comment upon. If they have the note within their compass, they sing it and collect their fee. A number of tenors may in theory have the ringing C that is required, but it may be unreliable or not accessible on a night when they are not in the best form. In this case, transpositions are frequently made, meaning that rather than an unwritten high C, it may be a 'B' or even a 'B flat' that is substituted – with the public often remaining oblivious to the sleight of hand. To facilitate the high C, tenors invariably make a cut in the cabaletta, removing the repeated music, so that Verdi's score is foreshortened. Ultimately (and by no means uniquely), a tenor will be judged as suitable (or not) for the role of Manrico by their ability to produce a sound that is not notated in that character's part.

This 'case of the high C' departed from the purely musical when Jack M. Balkin (Professor of Constitutional Law at Yale University) published an article in the *Texas Law Review*, contrasting the Muti/Verdi versus Licitra/La Scala audience 'case' with an actual 1954 legal case regarding the constitutionality of segregated schools in South Carolina.[35] Balkin notes that the cases 'are both problems of performance – one in music and one in law',[36] and that in law, as in the performing arts, 'the combination of a text and an audience create distinctive problems for the performing artist'.[37] Balkin notes, in Muti's defence, that the conductor has sought to be 'scrupulous about the score', but that such a scrupulousness is 'born of the late-twentieth/early-twenty first centuries'. He finds the conductor's approach to be distanced from the realities of a provincial opera house in Italy,[38] where opera was a 'more popular entertainment' and performers adjusted to the expectations of audiences. The lawyer further suggests that it is not possible to 'understand the original public meaning of a nineteenth-century Italian opera' by the same criteria as those by which a twenty-first-century one would be considered.

Verdi expert Julian Budden is invoked as a witness, noting that Carlo Baucardé created the role of Manrico at the première of *Il trovatore*, 'a tenor whose effective range it presumably reflects'.[39] Budden relates that Verdi did not feel that Baucardé had a reliable C, and only an 'uncertain B flat'; had Verdi believed that the tenor possessed the C, he might have included it in the score – this is an argument that Balkin made from the perspective of 'hypothetical original intention'.[40] From here, accounts vary as to how the high C found its way into 'Di quella pira'.

In one version, Baucardé developed a reliable high C and started adding it to performances soon after *Il trovatore*'s première, while another asserts that tenor Enrico Tamberlick (1820–89) began to add the C in provincial theatres and eventually recounted to Verdi that this was popular with the public. Verdi evidently responded by saying: 'far be it from me to deny the public what it wants. Put in the high C if you like provided it is a good one.'[41] This recollection was passed down verbally by another tenor, Giovanni Martinelli (1885–1969), and it almost has the ring of truth. There is generally a concern in operatic practice to legitimise traditions by tracing them back to the composer, and even today in modern opera houses, conductors are known to invoke dreams, or even mysterious apparitions involving long-dead composers, who conveniently advocate the same 'traditions' that the conductor is insisting upon.

Further arguments are outlined by Balkin – for example 'it doesn't matter what Verdi intended after the fact; what matters is the score he actually wrote'; or 'original public meaning should trump original intentions'; or the judgement of one Italian critic who wrote that 'the high C, even if not written by Verdi, was a gift that the Italian people had given to Verdi'.[42] This leads to the position that 'the regular interaction of performers and audiences has authorized a tradition of performance that audiences expect and appreciate. For them, the real and true *Il trovatore* is the version with the high C.' The lawyer also presents the argument that in an artform that 'celebrates bravura display ... emotional excess and feats of artistic upmanship' by 'ordering Licitra to suppress the natural instincts of every red-blooded Italian tenor, Muti has been false to the ethos and character of a longstanding, transgenerational institution'.[43]

It is significant that the high C embargo was ordered by one of the most pre-eminent Italian conductors of the twentieth century, who was Music Director of La Scala at the time of the performance. Muti was one of the few conductors who could (in the spirit of Toscanini) order a rising young star (who had, at this time, been dubbed 'the new Pavarotti'[44]) not to sing a note that one might consider to be an indispensable career asset. Muti did not emerge completely unscathed – he was taunted by audience members during the performance and had to break off the opening of Act 4 to make a rejoinder, evoking the Verdi centennial to silence the murmurings. Given Muti's standing in the music profession, news of the scandal was hardly likely to damage his career. To an Italian audience, however, a Manrico who does not sing the C is a singer who has no high C, and the public will typically exact their revenge.

This is a complex, searching account of a troublesome note that lasts but a few seconds (or less, when Maestro Muti is in the pit). This consideration of the rights and wrongs of 'Verdi's High C' offers an intriguing perspective on an issue that will most likely never be resolved; rather, with the passing of time, it will become further clouded. It has been noted that as time passes, and the period when a work was created becomes more distant, certainty diminishes as regards that work's correct execution.[45] We discover that:

The past is a foreign country whose features are shaped by today's predilections, its strangeness domesticated by our own preservation of its vestiges. Preservation has deepened our knowledge of the past but dampened our creative use of it. ... the past, once virtually indistinguishable from the present, has become an ever more foreign realm, yet one increasingly suffused by the present.[46]

Restoring the damaged past

The volatile audiences who attended Muti's *Il trovatore* performances felt (and communicated) a sense of having been duped – robbed of something that they believed was an intrinsic part of a much-loved opera. Such reactions have also occurred in art museums when an iconic masterpiece has been the subject of restoration. The eye of an art lover who may have visited an artwork many times in its old guise is suddenly confronted with new tonal values, brighter colours, a sense of immediacy that jars against their memories of the work that they have long admired. Anger is expressed, restoration teams are accused of botched work or foul play, as the mindset of a connoisseur, approaching an artwork from a subjective (and occasionally mystical) perspective, encounters the scientific objectivity of the modern restorer, who explains that the true conception of the artist has been revealed. In the twentieth century, the catch-cry of museology has become that 'the goal of art conservation should be to present the artwork as the artist originally intended it to be seen',[47] even if it alienates the viewer.

Situations where such a jolt occurs will often spark dissent rather than gratitude, and cases of a restoration being gratefully accepted by the public have usually occurred when a work has been damaged or the subject of vandalism, such as after the attack on the Michelangelo *Pietà* in 1972[48] or the 1975 slashing of Rembrandt's *De Nachtwacht (The Night Watch)*.[49] In these cases, the efforts to ensure the survival of a work that has been defaced are viewed positively. The Rembrandt attack afforded the restoration team an opportunity to subject the painting to wide-ranging intervention that had long been considered but avoided for the above-described reasons. Following the attack, a 'full' restoration, employing state-of-the art techniques, was deemed acceptable, as it involved resuscitating a major artwork that might otherwise have been lost. The restored Rembrandt sparked new scholarship around the painting, and it was generally accepted that the restoration of the *The Night Watch* had allowed the artwork to be appreciated with greater clarity, bringing viewers closer to the artist's original conception. It is notable that many major restorations of paintings have taken place under circumstances of either crisis or subterfuge. For example, during the 1930s, a scientific department for restoration and preservation was established at the National Gallery, London by its director, Kenneth Clark.[50] After World War II broke out, the Gallery's paintings were moved to caves in Wales, where two restorers were engaged to oversee them. One of these was Helmut Ruhemann, a 'zealot of scientific restoration'.[51] The evacuation of the paintings gave Ruhemann an opportunity to apply his techniques. After the war, the paintings were returned for display

after an absence of some years, causing an outcry over the radical cleaning methods that had been used, methods that are still employed today. The Old Master paintings owned and maintained by the National Gallery would look subtly different if they were in the custodianship of another gallery, where different methods of cleaning were employed. Given the differing schools and philosophies of cleaning and restoration and their uncertain outcomes, how do we know when to trust the work of the curator/restorer?

> The restorer, unlike the orchestral conductor, is emphatically not a performer; indeed he should deliberately avoid imposing his own personality or the personality of his epoch, on the work of art in his care. The highest accolade he should aspire to is for a painting to look as though it had never been touched. In real life, however … it is possible to walk around exhibitions and classify paintings according to where they have been treated, when and even by whom.[52]

Should we trust Muti and his position regarding Manrico's high C? Was he attempting to restore a work whose parameters had been clearly laid down by the composer? Did the evidence of the autograph score form the sole criterion for his decision? Did Muti ultimately resolve and restore the work, or did he overclean it – adopting a meticulous zeal that can rob operatic works of their integral patina of age? Was the public of La Scala outraged because Muti had, in his role of cultural leader, deprived them of an operatic certainty – that Act 3 of *Il trovatore* would end with a thrilling high C? The identity of the operatic work can be challenged by power play, nostalgic attitudes and, not infrequently, confusing 'multiple authenticities'.

Notes

1. A *Harmonie* is a small ensemble of wind instruments (sometimes including a double bass) that would provide music, particularly of a background nature, during the eighteenth century, often in an aristocratic, domestic environment. Arrangements of several complete Mozart operas exist for *Harmonie*.
2. There is a further sub-genre of opera performances with puppets, with the roles usually sung by boy-sopranos from the local church; this practice can still be witnessed today in Prague, for example, but falls outside the parameters of the present study.
3. William Weber, *The Great Transformation of Musical Taste* (Cambridge: Cambridge University Press, 2008), 14–15.
4. Giuseppe Verdi, Francesco Maria Piave, Fabrizio Della Seta and Alexandre Dumas., *La traviata: Melodramma in Tre Atti (Melodramma in Three Acts)* (Chicago: University of Chicago Press; Milano: Ricordi, 1997, 1996).
5. David Lowenthal, *The Past Is a Foreign Country* (Cambridge: Cambridge University Press, 1985), inside front cover.
6. Lydia Goehr, *The Imaginary Museum of Musical Works* (Oxford: Oxford University Press, 2007).
7. Ian Woodfield, *The Vienna Don Giovanni* (Woodbridge: Boydell, 2010), xii–xiii.
8. Ibid., xii–xiii.

9 Ibid.
10 Linda B. Fairtile, 'Sources', Chapter 44 in *The Oxford Handbook of Opera*, ed. Helen M Greenwald (Oxford: Oxford University Press, 2014), 981.
11 Woodfield, *The Vienna Don Giovanni*, xi.
12 Ian Woodfield, *Mozart's Così fan tutte: A Compositional History* (Woodbridge: Boydell, 2008).
13 All quotations in this paragraph are Ibid., 2.
14 *Lokal Anzeiger*, Berlin, 1906, written for the 150th anniversary of Mozart's birth. Quoted in Ferruccio Busoni and Rosamond Ley, *The Essence of Music and Other Papers*, translated from the German by Rosamond Ley (London: Rockliff, 1957), 104–6.
15 Ibid.
16 Clive Brown, 'On Exactly What Is Written', in *Verdi in Performance*, eds. Alison Latham and Roger Parker (Oxford: Oxford University Press, 2001) 81.
17 'Un moto di gioia', which replaces 'Venite, inginocchiatevi', and 'Al desio di chi t'adora', which replaces 'Deh vieni'.
18 Kate Bassett, *In Two Minds: A Biography of Jonathan Miller* (London: Oberon Books Ltd, 2012), 284.
19 Ibid.
20 Ibid.
21 Ibid.
22 Ibid.
23 Ibid., 283.
24 Roger Parker, *Remaking the Song: Operatic Visions and Revisions from Handel to Berio* (Berkeley: University of California Press, 2006), 42–3.
25 A fuller, more colourful version of this exchange was quoted still later, in London's *Guardian* on 19 November 2004, and is quoted in Ibid., 149, fn. 2.
26 Ibid., 43.
27 Hilary Poriss, *Changing the Score: Arias, Prima Donnas and the Authority of Performance, AMS Studies in Music* (Oxford: Oxford University Press, 2009), 188.
28 Parker, *Remaking the Song: Operatic Visions and Revisions from Handel to Berio*, 50.
29 Poriss, *Changing the Score: Arias, Prima Donnas, and the Authority of Performance*, 188.
30 Parker, *Remaking the Song: Operatic Visions and Revisions from Handel to Berio*, 43.
31 Ibid., 66.
32 Jack M. Balkin, 'Verdi's High C', *Texas Law Review* 91 (2013): 1687–8.
33 Ibid.
34 Gioachino Rossini and Patricia Brauner, *Il barbiere di Siviglia* (Milano: Ricordi, 2008).
35 Balkin, 'Verdi's High C', 1689.
36 Ibid., 1690.
37 Ibid., 1692.
38 Provincial opera houses are regularly invoked in the literature to build arguments of all types in regarding operatic practice; a provincial theatre may benchmark a 'norm' in practice, or else an inferior practice, below the standards of the major centres.
39 Balkin, 'Verdi's High C', 1696.
40 Ibid.
41 Julian Budden, *The Operas of Verdi*, Vol. 2 (New York: Oxford University Press, 1978), 98–9.
42 Balkin, 'Verdi's High C', 1698.
43 Ibid., 1699.
44 Ibid.
45 Joseph Kerman, 'A few canonical variations', *Critical Enquiry* 10, no. 1, Canons (September 1983): 109.
46 Lowenthal, *The Past Is a Foreign Country*, xvii.

47 Ibid., 198.
48 www.nytimes.com/1991/09/15/world/michelangelo-s-david-is-damaged.htm, accessed 30 April 2015.
49 www.rembrandthuis.nl/en/rembrandt/belangrijkste-werken/de-nachtwacht, accessed 30 April 2015.
50 https://dictionaryofarthistorians.org/clarkk.htm, accessed 30 April 2015.
51 James Beck and Michael Daley, *Art Restoration: The Culture, the Business and the Scandal* (New York: W.W. Norton & Company, 1993), 131.
52 Sarah Walden, *The Ravished Image or, How to Ruin a Masterpiece by Restoration* (London: Weidenfeld and Nicolson, 1985), 96.

12 Rossini, Rembrandt and the *Werktreue* debate

Over- and under-supply: Rembrandt and Rossini

The apparent facility with which Rossini composed his operas has been outlined and contrasted with the deep and often lengthy struggles endured by Beethoven in resolving his works. The pairing of the two composers in music criticism, however unusual it may seem, was noted by one Raphael Georg Kiesewetter in 1834 when he declared them the two most prominent figures of the age.[1] While this may have been true, what is significant for this study is the unlikely nature of the pairing, and the enormous contrast between them in outlook and temperament, along with the fact that they each achieved a considerable degree of fame while representing quite different musical values. It would be hard to imagine Rossini clinging as uncompromisingly as Beethoven did to a particular structure or version of one of his operas, let alone a 'single note'. A more 'Rossinian' scenario was the composer's apparent failure in 1814 to recognise an aria from one of his own operas in performance, which spurred him to write out his preferred vocal embellishments etc. in full in order to prevent them 'being disfigured by the presumption and bad taste of the singers'.[2] Here, we see Rossini working within a practice rather than challenging or revolutionising it. Rossini's attitude to the musical 'work' is hard to define, and many of his preserved comments are peppered with humour and unconcern, which is hard to reconcile with the creator of a masterpiece such as *Guillaume Tell.* His operas were products that brought him fame and considerable wealth, and he had no objection to employing practices such as *pasticcio* to gain greater profit in both areas. Rossini lived during a period of wide-ranging operatic developments, which he was also influential in guiding. His decision to retire from the operatic world after the première of *Tell* has been explained in a number of ways; perhaps he sensed the changing tide in opera that was occurring, and he did not want to persist in composing only to watch his star eclipse. After the premiere of *Guillaume Tell* in 1829, Rossini's works slowly began to disappear from the stage, due not least to the declining interest in *opera seria* on the part of the public. By the later nineteenth century, the composer's stake in the opera repertoire had dwindled to one work, *Il barbiere di Siviglia*,[3] effectively casting him as a 'one-hit wonder'. Rossini's works had to wait patiently in the wings until the 1960s, when circumstances changed considerably.

Restoring Rossini

What has become known as the 'Rossini revival' began with the publication of a new edition of *Barbiere*, edited by conductor Alberto Zedda in 1969, the first critical edition of a nineteenth-century Italian opera,[4] which initiated what has since developed into the business of producing scholarly editions of operas from this period.[5] The 1969 *Barbiere* edition was initially received with some scepticism, as it effectively replaced an earlier score that had been in circulation since the late nineteenth century and had long been accepted as an authentic text.[6] In 2008, a further edition was published by Bärenreiter Verlag[7] in collaboration with the Center for Italian Opera Studies at the University of Chicago, edited by Patricia Brauner. That edition, according to the Bärenreiter website, 'makes available an edition of ... "*Il barbiere*" which meets modern demands. The editors have recently identified numerous carelessly edited places in the last critical edition by referring to additional sources.'[8] The following year, curiously, Ricordi published a further edition, which was a revision of Zedda's 1969 score, perhaps hoping to answer some of the criticisms of the Brauner edition. As a result, *Barbiere* currently exists in three critical editions published within the last six decades, each declaring its aim to be definitively representing Rossini's masterpiece. Until the late 1960s, most opera practitioners used a late nineteenth-century edition of *Barbiere*, published by Ricordi (and later reprinted by Dover edition),[9] that Philip Gossett speculates may have reflected current performance practice at La Scala around the time it was printed.[10] With rare exceptions, this was the score from which the operatic world knew and performed *Barbiere*.

The circumstances leading to the creation of Zedda's 1969 edition were unconventional. During the preceding decade, while conducting performances of *Barbiere* in the USA, the conductor was approached by some orchestral players about details in their music that seemed questionable. Unable to explain these inconsistencies, Zedda, upon returning to Italy, went to Bologna to make a direct comparison of his printed (Ricordi) score and the associated hire parts with Rossini's autograph. Zedda's unsuspecting investigations were to have far-reaching consequences, although he was not a trained musicologist, and his mindset was a practical, performance-based one. What Zedda found in the autograph was a wealth of detail that was not present in the printed Ricordi score. That edition was, in its overall structure, fundamentally complete, but it lacked the many subtle details uncovered by Zedda 'in the tissues and sinews of the opera'.[11]

The initial results of Zedda's study had something of the quality of a Rossini *farsa*. He returned the hire parts, which were annotated with the results of his labours, to Ricordi and was billed for the cost of the material. The conductor protested, and gradually Ricordi realised that Zedda had made some important discoveries that required their attention. The publishing house finally commissioned Zedda to prepare a critical edition of *Barbiere*, which was soon taken up as the most accurate performance score available and used widely, particularly after Claudio Abbado conducted that edition of the opera with a stellar cast on the first night of La Scala's 1969 season.[12] In 1971, a recording based upon these

performances appeared, accompanied by a note from Zedda explaining the ethos of his new edition.[13] It was widely considered in critical circles that a new, specifically Rossinian sound world had emerged, with comparisons being made to the cleaning of an old picture.

Given the widespread acceptance of the Zedda edition, it is notable that the prominent Italian conductor Giuseppe Patané chose to eschew using that score for his 1989 recording of *Barbiere*.[14] Publishing his justification in the recording booklet, the conductor wrote:

> My intention was to record *Barbiere* with respect for tradition, not least because I am a traditional conductor and the last thing I want to do is to start being 'modern' in my ripe old age.
>
> The latest new edition is very praiseworthy; I admire the integrity in putting it together and have taken careful account of the points it makes. Nevertheless, I have doubts as to the extent these revisions reflect Rossini's intentions.
>
> In my performance I have tried to preserve certain traditional aspects that may not be specific in the original score, but which I think the composer would have approved in agreement with the conductors of his time. It is well known that certain devices were integrated into part scores without appearing in the original [that is, the autograph] and it is rash to say that the original [autograph] is the only faithful reflection of the composer's intentions, although naturally it is the point of departure. Truth, in my opinion, is only reflected in a certain tradition which we cannot forget. Should this tradition disappear, opera as an art form would suffer as a whole and we would gradually see the disappearance of the works themselves.[15]

Patané goes on to cite specific contexts where he finds Zedda's findings to be at odds with his own judgement, concluding: 'Frankly these points are small and I only mention them because possibly undue stress is given by commentators to what edition is used.'[16]

Regarding the earlier edition in which Patané placed his trust, Zedda has stated that its readings 'even if they may have been produced and taken hold while Rossini was alive, find no confirmation in a written source'. According to Gossett, 'there is no evidence that anything resembling the Ricordi material was in use during Rossini's lifetime'[17]:

> [The] traditional *Barbiere* was a deformed version prepared long after Rossini's death, for reasons that may have seemed pressing at the time but have no validity today ... Instead of deriving from a long-standing performance tradition, the old Ricordi edition simply reflected editorial decisions in the late nineteenth century to print an easily available score of *Il barbiere*.[18]

It is significant that Patané comments dismissively upon the modern dilemma of which score to choose for performance, while deciding to remain with the

nineteenth-century one that he had grown up with, which to him represents '*Barbiere*'. Here, we see a disconnect between the deeply held convictions of the connoisseur/conductor Patané, trusting in his familiarity with an 'Old Master', and the scholarship of Gossett and Zedda, who rely on evidence provided by source-based, structured investigation, although each holds significantly differing views regarding the 'best' text of *Barbiere*.

The editor of the 2008 score is Patricia B. Brauner, and her edition claims to be a refinement of Zedda's findings rather than a criticism. She describes her task as placing *Barbiere* within a critical edition format. Why might one favour this new critical edition over Zedda's, which has served so well? The argument is a subtle one and has been clarified by David Hurwitz in a review of the more recent edition.[19] Hurwitz finds this edition to be

> the most faithful and accurate transcription yet to appear of the composer's basic text of the work, ... [it] offers a fascinating orbital constellation of planets, including: a historical preface tracing the genesis of the work ...; the complete libretto, printed with original poetic meters ... three appendices consisting of vocal variants by Rossini as well as additional music composed for subsequent revivals.[20]

Hurwitz refers to the critical commentary of some 400 pages, which considered along with the score,

> presents ... all of the material [needed] ... to prepare performances of *Il barbiere* that are both faithful to the composer's evident intentions and responsive to the requirements of real-life theatrical productions.[21]

Hurwitz emphasises that it is not the case that the 'twin goals of irreproachable scholarship and practical utility necessarily stand at odds' but rather, that 'Brauner achieves the latter through the medium of the former'.[22]

While noting that Zedda's 1969 edition represents a watershed in Rossini scholarship, Hurwitz describes it as having been produced under the 'stewardship' of Zedda, implying a subtle implying a subtle role distinction between Zedda and Brauner (described as the 'editor'). The issues of orchestral detail identified by Hurwitz are all valuable additions to Rossini scholarship and to a modern understanding of the different performance conditions pertaining in Rossini's time:

> The leader of the performance, seated at the piano, often had little more to guide him than a more elaborate first violin part with some cues written in. It was up to the players, whether solo or in sections, to play whatever was put in front of them in conditions (no orchestra pit, darkened auditorium) that allowed for a degree of direct interaction with the singers on stage that is unthinkable today.[23]

It is 'unthinkable' because of the subsequent development of the role of the conductor, who began to assume many responsibilities in performance that were left to the orchestral players in earlier times. In current operatic practice, the tacit

assumption is that the modern role of the conductor is an 'improvement' upon the past. Hurwitz notes in the readings of Zedda's score 'an overriding concern for the conductor's ability to ensure ensemble discipline within a large, modern orchestra and the notation is homogenised accordingly'.[24] In that sense, Zedda's score remains an eminently practical score for present-day performance conditions, prepared by someone who is first a conductor and second a musicologist. Hurwitz comes close to admitting this when he states that

> Rossini's conception demonstrates his desire to characterize instrumental lines even as he does the parts for his vocal soloists. The very simplicity of his accompaniments often means that he places a premium on instrumental colour and a vivid use of accent and articulation to bring the orchestra's contribution to life. And all this happens absent the presence of a single, guiding interpretive vision emanating from the conductor's podium.[25]

Today, several decades after the Rossini revival gathered force, the perspective that we have on his works has broadened enormously, many of his operas have been published in critical editions and a number have been accepted into the current operatic repertoire, although few of his *opera seria* works have found a place in the repertoires of any but the largest theatres. An issue remains, however, that today, for any conductor performing *Barbiere*, there are three editions to choose from. Significantly, the least authentic score is by far the cheapest and most easily available: the Dover Edition. As described earlier, the two later editions differ in a number of respects, and many complex arguments have been presented as to why those editions are more authentic. Given that the conductor Patané preferred the least authentic edition over the Zedda, one wonders how he would have reacted to the 2008 Brauner edition (he died before its publication). Would a conductor prefer a score edited by a conductor with musicological interests over one created by a team of musicologists? And what of audiences and listeners? Does an opera lover care which version of *Barbiere* is used, and can they discern any difference in performance? In the case of a listener who possesses a number of different recordings of *Barbiere*, which recording will they prefer? The one with the best sound, the most stylish conducting, the preferred cast or the one that presents the greatest 'authenticity'?

Rossini and hyper-authenticity

In *Faith in Fakes*,[26] Umberto Eco discusses the painstaking reconstructions that are found in wax museums, noting that 'their concern with authenticity reaches the point of reconstructive neurosis'.[27] Hurwitz has described an edition that reconstructs Rossini's score so faithfully that it has landed back in the era before the conductor had assumed the function that they exercise today. Given the parameters of the modern conductor's role in performance, perhaps the Zedda score will remain the choice of many conductors, in spite of the greater claims to authenticity of the Brauner edition. Eco continues his journey in wax museums, entering a

hall of mirrors, with figures 'duplicated by an astute play of corners, curves and perspective, until it is hard to decide which side is reality and which illusion'.[28]

Most informed opera lovers would likely judge the merits of a performance of *Barbiere* on its vocal brilliance and would be accepting of significant textual variants in different renditions. They might draw a line if, like Rossini, they found themselves confronted with ornaments that distorted the musical line beyond recognition. Few would be particularly troubled by, or able to identify, which edition was employed in such a performance. A recording (1957) of Maria Callas singing the role of Rosina (which has today returned to the preserve of the mezzo-soprano) remains in the catalogues, a much-loved classic, in spite of the use of a text whose authenticity is now in question. It is technologically conceivable that in the future it could be possible to produce an 'enhanced' version of this iconic recording, incorporating orchestral modifications to reflect the most authentic score available. Thus, in the parlance of Umberto Eco, it would be possible to create a rendition of the *Barbiere* recording that was 'hyperreal' but 'more authentic'.

In a quest to engage with the past, modern culture creates its own 'fakes'. A 1903 recording of Caruso singing to an orchestral accompaniment recorded in 2000 is patently unreal, as is the experience of walking around an art gallery in air-conditioned comfort, viewing artefacts that were produced for specific conditions that are quite foreign to the museum space (white box) that has become their home. American art museums often import entire rooms from different eras and cultures to reside within their walls. The 'genuine' room, imported from France from a 'genuine' eighteenth-century château, becomes something different in a museum when divorced from its context, and where the next room that the visitor will enter is one relocated, for example, from a nineteenth-century townhouse in Boston.

In recent decades, critical editions of operas have proliferated at a rate that could scarcely have been foreseen, producing important insights into the working methods of their composers and restoring the composer's original texts, stripping away the accretions of many decades of performance traditions. Nevertheless, Rossini wrote his *Barbiere* score for staged performances in 1816 rather than to be immurred in a critical edition, which, from a performance perspective, can only be a construct, reflecting the attitudes, concerns and neuroses of the twenty-first century. Such editions pose significant challenges for performers, many of whom do not possess the skills to engage with them fully and critically. The performance history of an opera (indeed, any musical work) can be characterised as a potentially limitless series of variations upon the work's première. Later interpreters may, at best, offer further variations. Obsession with 'authenticity' creates its own 'hyperreal' variations, contemporary responses to the complex accretions that are an ever-present element of any musical work but are particularly prevalent and complex in most operatic works.

The significance of the Chicago Rossini Edition for the reassessment of the works of the composer cannot be over-estimated. The scholarship behind the edition has given musicians new insights into the composer's working practices and Rossini's stocks have risen steadily since the edition began publication, with even

his *pasticcios* receiving attention and occasional performances. The opera repertoire has renewed itself by the acquisition of neglected works from the past, and even if certain Rossini operas remain rarities in the opera house (usually due to their scale and an under-supply of suitable singers), those works have found a niche existence in recording catalogues, where lesser-known Rossini titles are eagerly awaited by collectors.

As Rossini made his way in the world of opera, demand for his works began to outstrip supply, and, seemingly untroubled, he engaged in the recycling of earlier works that had not been a success, reusing the material in new commissions. The most famous outcome of this practice is the overture to *Barbiere*, which Rossini had already used for two previous works; it had been originally composed for a serious, rather than a comic, opera. Although it is one of the composer's most popular overtures and inextricably associated with *Barbiere*, once the slow introduction gives over to the minor key *Allegro con brio*, the atmosphere seems to breathe *opera seria* rather than *commedia*. The composer's propensity for re-using material has today spawned a veritable Rossini industry in the world of contemporary musicology, as scholars attempt to unravel the incredibly tangled web of the genesis of his works, one of the more well-known examples being the creation of *Le comte Ory* (1828) out of the ashes of *Il viaggio a Reims* (1825). Catalogues of Rossini operas have typically omitted two works which, in the later twentieth century, began to appear as an appendix to such lists – one catalogue awkwardly calls them 'Works derived from Rossini operas with the composer's participation',[29] which is a clunky way of avoiding the term *pasticcio* to (correctly) describe them. Rossini's *Ivanhoe* (1826) and *Roberto Bruce* (1846) were, in their day, much performed and admired. The twentieth century was rather less accepting of these works, which had a stigma attached to them due to the fact of Rossini having outsourced them to arrangers. In recent decades, these 'bastard' works have been performed and recorded during a period where Rossini's works are generally being reassessed and establishing a foothold on the stage of modern opera houses. This is new territory, where the discovery of Rossini's neglected works is more interesting for opera companies than supporting the work of living composers. One might almost speak of a current 'Rossini scarcity' – with supply and demand again in operation, and works of uncertain pedigree, long consigned to storage, being dragged out and considered in a new, twenty-first-century light.

Supply and demand is an integral force in the career of a composer or artist, a force that extends beyond their lifetime into their posthumous reputation. The familiar quip that Corot painted around 5000 pictures, of which 10,000 are in America, is an expression of demand outstripping supply and the willingness of unscrupulous players in the art market to profit from the situation. The case of Rembrandt illustrates a similar crisis of supply and demand, which arose during the twentieth century as it was announced that the number of authentic works by the Master had been over-estimated and that his *catalogue raisonné* needed to be revised. Arriving at an accurate assessment of the legacy of an artist or composer, in particular arriving at a position about works in which they had *some* involvement rather than sole authorship, is a complex, and at times, costly business.

The Rembrandt debate

At the start of the twentieth century, there were 'officially' around 700 acknowledged paintings by Rembrandt. That number was cut by nearly half during the course of the century, until a point was reached in the 1990s when an apologetic series of re-attributions began to increase the number again.[30] What had happened? In 1968, the Rembrandt Research Project (RRP) was instituted, operating until 2011.[31] Its object was to research the life and working practices of the artist and produce a *catalogue raisonné* of his paintings. The project was run by the art historian Ernst van de Wetering (born 1938), and its criteria and scholarly position changed so radically over the years that many major questions were raised about the attribution of works of the past, the tensions between scientific methods and connoisseurship, and the fallibility of experts, which have continued to cause waves in the art world. At the outset, the main emphasis of the RRP was upon scientifically based criteria, taking the position that scientific investigation could replace 'classic connoisseurship in the sifting out of later accretions to Rembrandt's oeuvre'.[32] As the RRP developed, however, the members found themselves becoming more and more reliant upon connoisseurship, later stating that 'faith in connoisseurship had grown to such an extent that it sometimes overruled evidence of a more objective nature'. The RRP later reported that they had begun to operate according to 'reductionist tendencies' and that 'there was a tendency to say no to paintings and that tendency was too strong.' In 2014, de Wetering made a case for the attribution of around 340 paintings to Rembrandt, including 44 works that had been previously dis-attributed by the RRP.[33] Lurking in the background are the processes of the commercial artworld, where such changes in attribution may prompt a sharp financial devaluation of works owned by leading institutions, monarchs and powerful oligarchs. Did the RRP remain completely uninfluenced by such complex forces? How were judgements made, and what influence may have been brought to bear for a project such as this – which was apparently committed to scientific principles – to change its criteria mid-way to a connoisseurship-based methodology, thereafter re-attributing works that had been deemed 'not Rembrandts'? How can art lovers make sense of such shifting designations?

Rossini defies the Met

The so-called 'Rembrandt debate' highlights many issues surrounding the attribution and identity of 'works', not to mention the extraordinary influence and faith placed in the RRP's leader, Ernst van de Wetering. Such controversies are not unknown in the world of opera, and they surface from time to time when choosing a suitable edition, from which to perform a canonical work. Like the RRP, and its position vis-à-vis Rembrandt, the Rossini Edition is an extremely influential institution, which has positioned itself as the leading repository of authenticity as regards the works of Rossini. How does it maintain that position? A recent controversy highlights the changing landscape and the rise in influence of the musicologist, who has emerged as a new stakeholder in the world

of opera. In 2011, the Metropolitan Opera asked Philip Gossett to write a program note for a new production of Rossini's *Le Comte Ory*. Gossett refused and explained very publicly that he objected to the decision of the Metropolitan to use the 1828 Troupenas edition of the opera, considering it 'a butchered edition, seemingly intended for a provincial opera house that couldn't perform the music Rossini wrote'.[34] Since 1828, the edition published by Troupenas in Paris had been the basis for all performances of the opera until the appearance of the new scholarly version, edited by Damien Colas, which is part of the Rossini Edition.[35] The new edition had been tried out in January 2011 in Zurich, raising the question of why what was good enough for Zurich was not good enough for New York.[36] The Metropolitan staff claimed that the (unpublished) edition was not made available in time; furthermore, the tenor in the Metropolitan production, Juan Diego Flórez, was resistant to the changes that the alternative edition would impose upon his role. Finally, the words of Music Director James Levine were invoked: 'with all the complex elements of mounting a new production, it can be a terrible time to try out a new version of a known opera'.[37] While New York audiences felt deprived of an edition that Zurich had enjoyed, the public stance of Mr Gossett surely brings into question the motives of an enterprise such as the Rossini Critical Edition in effectively lobbying by criticising the choice of an edition for performance in a public opera house. This is partly an issue of identity – the form in which *Le Comte Ory* takes in performance – along with the associated commercial and fiscal repercussions.

A self-portrait, not by Rembrandt

During the 1980s, Rembrandt himself suffered an identity crisis, as one of his self-portraits was declared by the RRP to be not by Rembrandt at all, producing an irony noted by Joseph Heller: 'Rembrandt did some fifty-two self-portraits that have come down to us and several of these Rembrandts are not by him. It is hard to conceive of self-portraits not conceived by the subject, but here they are.'[38] The controversy centred on a painting that became known as 'C 56',[39] also known as *Self-Portrait*, in the Gemäldegalerie, Berlin, to which the RRP in 1986 gave their verdict upon 'C' (a work definitely not by Rembrandt)[40] and renamed the work 'Govert Flinck, Bust of Rembrandt'.[41] The RRP assessment of the 'shamed' Rembrandt was not flattering, stating that the work was 'uncharacteristic and unusual for Rembrandt', suffering from 'cramped placing of the figure', displaying 'clumsy heaviness in the appearance of the figure', with a cap and feather 'not really effective in creating depth', in the chain a 'hurried manner of painting [that] is far from effective', and a colour scheme with 'no parallel in any of Rembrandt's works from these years'. The upper part of the face was 'weak [in] execution, … flat and patchy'. The 'transitions from the face to the hair are noticeably weak', while 'the somewhat primitive bravura of the brushstroke … does not always help to create clarity in the shape of the head or an effect of depth'.[42] The RRP would come to regret that judgement.

In 1992–3, an exhibition was mounted in Amsterdam, *Rembrandt: The Master and his Workshop*,[43] which brought together a number of rarely seen Rembrandt paintings from private collections as well as paintings by Flinck, a juxtaposition that allowed a rare opportunity for making direct comparisons, prompting a number of international experts[44] to note that 'the RRP has hitched its wagon load of hypotheses to horses we know something about'.[45] As a result of the exhibition, the credibility of both the RRP and the Gemäldegalerie was questioned. In 1992, de Wetering openly disputed the long-held theory that 'Rembrandt and his students never collaborated on the same paintings'.[46] This had been an RRP guideline since its inception and was now being challenged by one of its founding members.

At the XXVIII International Congress of History and Art in Berlin (where de Wetering delivered his revelations), Clauss Grimm presented his research which confirmed that Rembrandt's students 'indeed contributed to Rembrandt's paintings, cooperating with their master'[47] and advocated retaining the attribution to Rembrandt in such cases.[48] The attribution of 'C 56' was duly returned to Rembrandt by the RRP in a spectacular *volte face*: their new report on the painting praises a 'brilliant, broadly painted self-portrait ... perhaps ... a demonstration of Rembrandt's mastery of "the rough manner"' with its 'brilliantly applied brushstrokes that are left emphatically visible'.[49] Critics of the Project asked 'how that detailed, highly negative judgement from 1986 relates to the lyrical one of 2005. Indeed, not only the credibility of the Corpus but of connoisseurship itself is at stake here.'[50] The RRP, with the intention to provide more objective opinions than the older generation of Rembrandt connoisseurs, did not escape their own bias and subjectivity, and despite 'sometimes prolix verbiage',[51] their 'argumentation has proven no more inherently convincing'.[52] It did not help the RRP that de Wetering was entrenched in quantitative methodologies and did not see any value in applying biographical or psychological insights to Rembrandt's work, including the self-portraits.

This chapter has considered aspects of the artistic legacies of two iconic figures from very different disciplines and eras – Rossini and Rembrandt – raising significant questions about what may be considered real (genuine) and what may not. Rossini readily assented to the creation of *Roberto Bruce*, a *pasticcio* which incorporated music from his earlier opera *La donna del lago* (1819) as well as at least six of his other works. The composer agreed for the adaptation of his music to be undertaken by one Louis Niedermeyer but stipulated that the resulting work would be marketed under his own name. Nevertheless, these conventional procedures in operatic practice of the time are, today, still greeted with some disdain in certain circles, with the results being considered to be 'bastard' works. This is a case of a 'signed' work by Rossini having its authenticity and legitimacy questioned. What percentage of a painting needs to be completed by an artist for it to legitimately bear their name? What are the criteria for a painting to maintain an attribution to Rembrandt in light of studio practice of the time, whereby assistants would typically complete some of the less critical parts of the painting – could a 'Rembrandt' painting conceivably be the composite work of three or four artists under the overall guidance of the Master?

A panel of experts failed to arrive at a consensus about the oeuvre of Rembrandt, and reconsiderations of the RRP *catalogue raisonné* seem likely to continue, with the authorship of the artist's works continuing to shift around as staggering sums of money are potentially gained or lost by the attributions. If leading art experts cannot agree what constitutes an authentic Rembrandt painting, what chance do ordinary art lovers have? The rise in Rossini scholarship has produced three critical editions of his most famous and enduring opera since the 1960s. Which edition is the 'best'? Would a particular edition be deemed the most appropriate for use as a performance edition? Why would there be a distinction? Why do many theatres and conductors continue to use editions that have been effectively superseded, in spite of the evidence of the critical apparatus of the more recent editions?

In today's modern opera house, a general concern for authenticity is present in the musical side of performance, where the musical element has effectively been partitioned from the other aspects of an opera's identity. Such a distinction raises the following questions: does the musical element of an opera generate the drama – and if so, does that mean that a concern for musical authenticity will likely produce 'authentic' dramatic results? Why is it that modern productions of opera commonly disregard notions of authenticity in staging, ignoring the time and place of the setting, and most other elements that were laid down by the librettist?

We now consider what happens on the stage of the modern opera house, and how it may, or may not, relate to the instructions preserved within the operatic score.

Notes

1 Nicholas Mathew and Benjamin Walton, *The Invention of Beethoven and Rossini* (Cambridge: Cambridge University Press, 2013), 17.
2 Lydia Goehr, *The Imaginary Museum of Musical Works* (Oxford: Oxford University Press, 2007), 29, see also fn. 28.
3 It had remained a fixture of the repertoire since its première in 1816.
4 Philip Gossett, *Divas and Scholars: Performing Italian Opera* (Chicago: University of Chicago Press, 2006), 115.
5 As a result, the Rossini critical edition was begun in 1971 (with the first volume, *La Gazza Ladra*, appearing in 1979), and the Rossini Festival was established in Pesaro in 1980.
6 Gossett, *Divas and Scholars: Performing Italian Opera*, 114–16.
7 www.classicstoday.com/features/Barber_Critical_Edition.pdf, accessed 13 November 2014.
8 www.baerenreiter.com/en/shop/product/details/BA10506_01/, accessed 16 February 2020.
9 https://store.doverpublications.com/0486260194.html, accessed 16 March 2020.
10 Gossett, *Divas and Scholars: Performing Italian Opera*, 116.
11 Ibid., 118.
12 Ibid., 116.
13 Deutsche Grammophon 415 695–2.
14 London CD Catalog # 425520.
15 Liner notes for London 425520.

16 Ibid.
17 Gioachino Rossini, Cesare Sterbini and Alberto Zedda, *Il Barbiere Di Siviglia* (Milano: Ricordi, 1969). Commento Critico, 15. Gossett, *Divas and Scholars: Performing Italian Opera*, 116.
18 Gossett, *Divas and Scholars: Performing Italian Opera*, 116.
19 www.classicstoday.com/features/Barber_Critical_Edition.pdf, accessed 15 November 2014.
20 Ibid.
21 Ibid.
22 Ibid.
23 Ibid.
24 Ibid.
25 Ibid.
26 Umberto Eco, *Faith in Fakes: Essays* (London: Secker and Warburg, 1986), 13.
27 Ibid.
28 Ibid.
29 Richard Osborne, *Rossini* (London: J.M. Dent & Sons Ltd., 1986), 288.
30 In his survey of 1921, Wilhelm Valentiner had considered the total number of paintings to be 711; in 1935, Abraham Bredius reduced that number to 630; in 1966, Kurt Bauch reduced it further to 562; and in 1968, Horst Gerson scaled it back to 420. www.britannica.com/topic/Rembrandt-Research-Project, accessed 12 December 2014.
31 Henceforth referred to as RRP.
32 Ernst van de Wetering and Paul Broekhoff, 'New Directions in the Rembrandt Research Project, Part 1: The 1642 Self-Portrait in the Royal Collection', *The Burlington Magazine* (1996): 174.
33 http://wsj.com/articles/an-expert-cites-dozens-of-paintings-as-rembrandts-1412793706, accessed 12 November 2014.
34 www.nytimes.com/2011/04/09/arts/music/debate-surrounds-mets-debut-production-of-rossini-opera.html?pagewanted=all, accessed 14 March 2013.
35 Gioachino Rossini, Eugene Scribe ed. Damien Colas., *Le Comte Ory: Opéra En Deux Actes*, (Kassel, Bärenreiter, 2014).
36 www.nytimes.com/2011/04/09/arts/music/debate-surrounds-mets-debut-production-of-rossini-opera.html?pagewanted=all, accessed 14 March 2013.
37 Ibid.
38 Joseph Heller, *Picture This* (London: Macmillan, 1988), 59.
39 The title resembles the numbers by which prisoners are identified.
40 The original RRP group (who were responsible for volumes 1–3 of the Corpus) had adopted a peculiar grading system for attributions: 'A' stood for a genuine Rembrandt; 'C' stood for a work definitely not by Rembrandt; and 'B' indicated that the RRP could not make up its mind. This categorisation was widely criticised and subsequently discarded by de Wetering, paving the way for his later reattributions.
41 www.vadim-moroz.com/id18.html, accessed 13 November 2014.
42 Ibid. (quoting the *Corpus*, Volume 2, 671–2).
43 www.codart.com/exhibitions/details/913/, accessed 23 June 2015.
44 www.vadim-moroz.com/id18.html, accessed 13 November 2014. Led by Walter Liedtke (curator of European painting, Metropolitan Museum of Arts).
45 Ibid.
46 Ibid.
47 Ibid.
48 Ibid.
49 Ibid.
50 Ibid.
51 Ibid.
52 Ibid.

13 Dramaturgy and the dramaturge in the opera house

Mozart in a foreign land

In 1998, a new production of Mozart's *Die Entführung aus dem Serail* was given its première in Stuttgart. The director was Hans Neuenfels (born 1941), who at the time was described as 'a by now middle-aged enfant terrible of Germany's theatrical establishment',[1] from which it can be inferred that he is an exponent of *Regietheater*. Neuenfels' production, which was considered to reach a new level in directorial intervention, was described as:

> at once astonishing and dizzying, even for a spectator familiar with Mozart's Singspiel and accustomed to Neuenfels' penchant for subjecting works to relentless interpretive pressure. Some of the grounds for the spectator's disorientation are obvious: Neuenfels radically cuts much of Gottlieb Stephanie the Younger's original dialogue and adds a great deal of his own and, even more surprisingly, he doubles each of the principal roles (with the exception of Pasha Selim), splitting them into distinct roles played by a singer and an actor. Here, then, the production realizes in surplus form what the opera text otherwise constitutes as a lack: if the Pasha is normally understood (and cast) as an actor lacking a singer's voice, here each of the other principals in the opera – each one, of course, a singer – is supplemented by an actor. The actors don't do all of the talking. Indeed, they only speak roughly half of the spoken text (and the distribution varies markedly from scene to scene and from role to role); the singers, on the other hand, do all of the singing. … What is ultimately most striking about the Stuttgart *Entführung* is not the doubling of the major roles or the surgery effected upon the libretto, but the breath-taking theatrical invention that Neuenfels educes from the work. Some of this invention can be readily traced to (what's left of) the text of the work and its dramaturgy, although it is no less surprising and exciting as a result: for example, when we first encounter Osmin in act 1, scene 2, singing the lied 'Wer ein Liebchen hat gefunden' (He who has found a sweetheart), he is carefully removing and nuzzling the body parts of a woman, recently slaughtered, from an Ottoman chest.[2]

In this review, one struggles to discern remnants of the original collaboration between Mozart and his librettist, Stephanie the Younger. While the results produced by Neuenfels may have been a 'breathtaking theatrical invention', it is tempting to conclude that the primary reason for presenting *Entführung* on that occasion was the iconic status of Mozart's music, with the original libretto having been largely jettisoned and overlaid with what might, without the agency of music, have become an intriguing stage play. In effect, an historic building with heritage status has been demolished, with only the façade retained, and a postmodernist cube (complete with body parts) has been constructed behind it. Such processes are an everyday part of the world of *Regieoper* ('director's opera') and are now mostly accepted (with some low-level grumbles) by the opera-going public. The production retained Mozart's original score, but the drama revealed onstage altered the original conception beyond recognition. One might regard productions such as these as aberrations, intent upon using all kinds of posturing to attract publicity and notoriety; however, it is the case that the Stuttgart production was created in a painstaking and considered manner, developing the *Konzept* with the collaboration of one of the key figures in the theatre – the dramaturge (*Dramaturg*). The world of opera has always functioned amid a struggle for dominance among its contributors: impresario, librettist, singer, conductor and (more recently) stage director. The dramaturge has generally remained behind the scenes, although they wield considerable power in the central-European opera house, forming a key part of the curatorial team, in a similar way to which a curatorial team in an art museum will consist of a diversity of restorers, historians, exhibition makers, publicists and writers.

Entführung has proved to be a popular vehicle for radical directorial intervention, with a 2004 production from the Komische Oper in Berlin by Calixto Bieito (born 1963) removing any of the original Turkish references, as well as any of the Muslim/Christian conflict that is expressed in the original libretto. Instead, the production was set in a 'contemporary European brothel' owned and operated by Selim and Osmin. The couples, Konstanze/Belmonte and Pedrillio/Blonde, have become 'modern sex slaves'. The conclusion to the opera is a grim one, where 'Selim, Osmin and several prostitutes are killed, Konstanze commits suicide, and Belmonte becomes the new "supervisor" of the brothel'.[3] The production was a box office success, with the public presumably responding to an event that seems to have been designed to create a scandal, and a reviewer remarking that 'generosity, Mozart's nice "dizziness of tolerance," is nowadays passé'.[4] A 2003 Salzburg production of the opera by Stefan Herheim (born 1970) received a review which noted that the music was by Mozart, with added recitatives, and that a completely new plot had been grafted onto the resulting opera, meaning that *Entführung* was 'completely deconstructed', with the result that there is 'simply no real action'.[5] Do these extreme interventions serve to prolong the life of a flawed and outdated work that happens to contain the iconic music of Mozart? Has the original libretto been jettisoned to create a blank canvas, upon which the director can project their own catalogue of obsessions? It is notable that all of these productions were created in distinguished operatic institutions, with impressive resources and

well-resourced *Dramaturgie* departments. In spite of the considerable resources, research and dramaturgical scaffolding that was expended in the creation of these productions, is there any quantifiable difference between such carefully curated work and the *pasticcio* concoctions of the nineteenth century described earlier in this book? One might attribute the earlier adaptations to a lack of historical awareness. What can be the justification for these bizarre cases of genetic modification practised upon one of Mozart's canonic operatic works?

Dramaturgy in the operatic museum

The concept of 'dramaturgy' in the modern sense was articulated by Gotthold Ephraim Lessing (1729–81) in his *Hamburgische Dramaturgie*, a series of criticisms written between 1767 and 1770. Lessing drew upon the writings of Aristotle (384–322 BCE), whose *Poetics* is the earliest surviving document of the theory of drama. Ancient Greek drama has been often invoked in theoretical writings about opera, including those of the Florentine *Camerata*, through to Gluck and Wagner. Dramaturgy is the practice of studying and analysing a dramatic work, articulating the concepts, philosophies and stories that reside within it, in order to create a platform upon which to realise the drama in performance. Areas of study may include the circumstances of the creation of the work; how it relates to other works by the dramatist, as well as how the work may relate to the author's life, and the historical period in which it was written; the circumstances of the première (including documentation of the rehearsal period and staging elements), as well as significant subsequent revivals – particularly those with which the author may have been associated; linguistic style – whether written in metre or prose, use of archaic language or dialect; specific performance traditions that have accrued around the work; important editions of the text, including scholarly editions with commentaries, or alternative versions; the background to the plot – social, political and historical; significant related literature that illuminates the work and its milieu; and the psychology of the characters.

While dramaturgical principles were originally applied to spoken plays, they have increasingly come to occupy a central role in operatic practice. During the period following World War II in particular,[6] dramaturgy has become a tool for expanding the contexts of operatic works, such as setting the work in different periods and locations and allowing other new elements to be incorporated into the original libretto. The dramaturgy of opera has developed into a methodology for facilitating the practice of *Regieoper*, unlocking a new series of possibilities (at times seeming to grant *carte blanche*) to enable the stage director to graft new concepts and readings onto an existing work, whose plot may need updating in order to retain its position in the current opera repertoire. It is the growing influence of the practice of *Regieoper* that has contributed to making the role of the *Dramaturg* such an influential one in the German opera house system.[7] The practice of dramaturgy is not the exclusive domain of the *Dramaturg* – a number of functionaries within the opera house incorporate it within their practice, including conductors, répétiteurs and language coaches, who explore dramaturgical

concepts as they work with singers, building deeper layers of meaning and context into the sung musical line.

The *Dramaturg* has a wide range of responsibilities, including involvement in repertoire choice, ensuring diversity and balance over a season. They are required to be familiar with the length and breadth of the repertory, keeping abreast of new works, and following developments in research into older works which emerge from time to time as new repertoire possibilities. The *Dramaturg* works closely with the directorial team in undertaking research and identifying resource materials in order to develop the *Konzept* for a production. In preparation for the rehearsal period, the dramaturgy department will circulate relevant information to the singers, music staff and others associated with the new production. They may also write or commission articles for the programme, which they will oversee, create educational materials for younger audience members, and organise associated events in the theatre around a production, such as information evenings, lectures or recitals. It can thus be seen that in many of their functions, the *Dramaturg* corresponds to the museum curator, with their specific knowledge of the repertoire/collection, as well as expertise regarding issues of preservation, authenticity, restoration and adaptation. They each have considerable buy-in to the performative/display aspects of the opera production/exhibition and play a significant role in engaging with audiences and providing educational resources about the production/exhibition and its significance. Like museum curation, dramaturgy is a mediating force, an agency that operates between the work and its audience.

The role of the *Dramaturg* thus incorporates a considerable range of skills and areas of knowledge. Such a person will often be a polymath, and in some cases, the *Dramaturg* may occupy a hybrid role within the theatre, for example as director/*Dramaturg*, conductor/*Dramaturg* or répétiteur/*Dramaturg*. For a role that is so codified and influential in German theatres – with larger opera houses often employing a department of several *Dramaturgs* – incumbents are often astonished to discover that in other operatic cultures, such a named position simply does not exist. Theatres outside Germany consider themselves able to function perfectly well without a position that they consider to be symptomatic of the excessive funding of the German theatre system. In non-German theatres, a director will work with a chosen team of creatives who together develop the dramaturgy of the production: this may be more effective in realising the director's vision than having to work with a dramaturgy department that is in the direct employ of the theatre. Functioning effectively as director/dramaturge, the director will likely have a freer hand to lead the process. In the case of a dramaturge in the employ of a theatre working with a guest director, there can arise conflicts of allegiance. Where would the *Dramaturg*'s sympathies lie in the case of a disagreement – with the theatre management, with the director, or with some attitude of fidelity towards the operatic work in question?

While *Regieoper* has transformed the staging of operas in the post-war era, many of its processes – such as modifying or updating the fabric of the libretto by changing the plot, era or location of the work – are hardly new. It was standard practice in Verdi's Italy, for example, to submit librettos to the censor, and

often significant revisions were required. *La traviata* (1853), for example, was originally envisaged in a contemporary setting – Paris of the 1850s – which was deemed (by the censor) to be unacceptable, and the epoch was altered to 1700. Verdi was not permitted to set *Un ballo in maschera* (1859) in the era of the historical Gustav III of Sweden, whose assassination had occurred six decades prior to the opera's composition. Today, it is usual to recreate Verdi's preferred setting, with *Ballo* moved to the Sweden of Gustav III (1792) rather than the city of Boston, thus avoiding the unlikely situation of 'masked balls in a Puritan stronghold in the United States at the end of the seventeenth century'.[8]

Today, it is recognised that *La traviata*, both musically and socially, reflects the world of mid-nineteenth-century Paris, and this is the point of departure when creating a new production. In the nineteenth century, however, once the locale and era had been agreed by the censor and published in the libretto or score, they became fixed, and productions adhered to what was stipulated. In the case of modern *Regietheater*, a work can be reinvented according to a director's *Konzept*, which allows the most far-reaching alterations to be made to the sinews of the libretto. Interestingly, museum director Suzanne Pagé describes the role of the *Ausstellungsmacher* (modern art curator) as someone 'who carries his own museum of obsessions in his head',[9] which well describes the modern director.

The sung text of the libretto may be updated or altered to bring it in line with the *Konzept*, and changes may extend further to the musical score itself. Often, these shifts are quite subtle: would Verdi's *Ballo* sound somehow different if it were set in Boston, or Stockholm? Would the music for Ulrica be interpreted differently if her character were the historical Swedish fortune teller Madame Arvidson, rather than Ulrica, 'a fortune teller of negroid race'?[10] The impact of changes to the libretto upon the musical score fall into the area of *musical dramaturgy*, a term which raises a number of fundamental questions about the nature of operatic works. The following is an example of *Regieoper* calling upon musical dramaturgy to make a significant change to an iconic opera.

The opening scene of *La traviata* is a large tableau, set at a ball, where the orchestral accompaniment is punctuated by that of an offstage *banda*. Towards the end of the scene, Violetta and Alfredo hurry to leave the stage (to the strains of 'Addio'), where their conversation has been accompanied by the offstage *banda*. Their words of farewell prompt the pit orchestra to resume, with two bars of *tremolo* and *crescendo* that lead into the *stretta*, which concludes the scene.[11] In Germany, it is not unusual to find *La traviata* transposed into the era of Mussolini, although the visual world of that period creates a disconnect with Verdi's music that some find jarring. One production the author witnessed in Germany had the music break off at this important moment of transition, interrupted by an air raid siren, which sounded for about 10 seconds (during the performances, some audience members thought an actual fire alarm was being sounded and began to leave their seats), after which the music recommenced. A long, loud, 'unmusical' intervention has been made in the score, not envisaged by the composer or librettist, placing the composer's conception 'on hold' while a conceptual device is introduced. In this example, the score has been tampered with, the musical fabric has

been torn, and the composer's notation of dramatic pacing and timing has been all but destroyed. This was all legitimised by a *Konzept* that was imposed onto a musical work in the service of *Regieoper*.

The 'musical dramaturgy' of opera

In Chapter 1, an issue was raised: 'how to identify the elements that generate drama in an opera',[12] and it was suggested that the 'operatic work' might be represented by the composer's score. The creation of an operatic work involves, first and foremost, a collaborative negotiation between the librettist and the composer. The combination of text and music raises the issue of where the drama resides and how it is transmitted in performance. In the dramaturgy of spoken drama, there is a division of opinion, the more recent being that 'the text (whether words alone or words and music) already constitutes a "drama," which is then realized on stage as "theater," whereas the original meaning was that only as theater did the text become a drama rather than merely a draft for one.'[13] Furthermore, it is recognised that 'the primary constituent of an opera *as a drama* is the music'.[14] Philip Gossett echoes this notion of the primacy of the music in relation to the dramaturgy of opera when he writes: 'and, yes, I believe that the composer *is* the "creator" of such a work, not the singers, not the librettists, not the directors – no matter how significant their impact might be upon the final outcome'.[15] Joseph Kerman, in his *Opera as Drama*, also regards the musical score as the generating force of the drama.[16] Laurel Zeiss identifies three elements that create the 'multivalent' nature of opera – the dramatic/literary, vocal/instrumental and the visual/plastic arts – and asks how 'these diverse modes of expression interact with one another'. She further asks whether the libretto is the 'primary purveyor of narrative and form' or if the music is 'the chief dramatic and structural agent'. She questions exactly what it is that makes an operatic work 'cohere', and further asks whether we should actually be 'concerned with formal coherence at all'.[17]

Damien Colas concisely defines *operatic dramaturgy* as 'the elements that generate drama in an opera',[18] while admitting that identifying these elements is 'not so obvious', stating that this is the outcome of an 'inconclusive debate that has recurred throughout the history of music'.[19] Colas defines *musical dramaturgy* as the 'production ... of theatrical action ... through music'.[20] The unresolved nature of this conundrum is implicit in Richard Strauss's valedictory *Capriccio* (1942),[21] which quotes the title of the opera composed by Antonio Salieri and the Abbé de Casti – *Prima la musica e poi le parole* (1786) – although Strauss, in his introduction to the score of *Capriccio*, misquotes it as *Prima le parole, dopo la musica*. In spite of this slip,[22] the work concludes with the poet/composer debate left hanging in the air. That was Strauss's last word on opera, and the relative positions of influence of the librettist and composer continue to shift around in a tension which remains one of the generating forces of opera.

The poet Metastasio was, in his day, a leading force in shaping the structure of opera, effectively delineating his requirements, via his librettos, to the composer. Gluck, in his score of *Alceste* (1769), published an introduction that outlined his

philosophical position regarding the relation between the words and music – it was actually written for him by his librettist, Ranieri de' Calzabigi, but Gluck signed it as his own, leaving uncertainty around who was the main driving force behind their collaborations.[23] Musicologist Tim Carter has suggested that it would be possible to 'write a history of opera on the basis of not its composers but, instead, of its librettists. Arguably, they were the driving force behind many of the genre's developments in subject matter, plot and even structure.'[24] He has also written about the inherent 'messiness' of opera, equating 'messiness' with plural multiplicities which have 'become the liberating norm in this postmodern age, and, as had always been the case with opera, it might even be viewed as cause for celebration'.[25] While the argument remains an open one, in current operatic practice, the librettist has undoubtedly been relegated to a subservient position, below not only the composer but also the stage director, perhaps even, in some cases, the dramaturge. While Gossett confidently positions the composer as the 'creator' of an operatic work, there is in all of the most significant operatic collaborations a sense of tension, of creative negotiation in the dealings between librettist and composer, that has helped spark the outstanding works of the operatic literature.

Mozart challenged Lorenzo Da Ponte's judgement on a number of occasions. In *Così fan tutte*, the composer devised a quintet from a text that Da Ponte had originally designed as recitative.[26] In *Don Giovanni*, the opening aria for Donna Elvira[27] has interpolations from Leporello and the Don which were added by Mozart, effectively prefiguring the following *secco* recitative, altering and extending the structure of the aria to create an open musical form. On occasion, composers could be sloppy, as in the case of Richard Strauss, who famously mistook a stage direction by his librettist, Hugo von Hofmannsthal, and composed it as sung text for Baron Ochs.[28] There are also rare cases where the composer defines the musical dramaturgy by creating an absence of music. Operas by Mozart (*Entführung*) and Richard Strauss (*Ariadne auf Naxos*) include characters who only speak. As we have seen, *Entführung* includes dialogue for all of the characters, but the Pasha Selim is unique in speaking but not singing, which places him on a slightly different plane to the other characters, allowing him to appear as a symbol of the Enlightenment. The *Haushofmeister* in *Ariadne auf Naxos* is a masterly portrait of an influential functionary, the major-domo to the richest man in Vienna, who possesses considerable influence, representing his master in most household matters, irrespective of his knowledge of them. The *Haushofmeister* only speaks, indicating that he is entirely unmusical: the orchestra remains silent while he makes his pronouncements about the premières of two operatic works, one comic and one serious, which he mandates must be performed simultaneously, to allow the fireworks (it is New Year's Eve) to occur on the dot of midnight. Musical dramaturgy operates in stage plays, such as those of Shakespeare, where not only music, but also other sound effects, such as cannons or the cries of advancing armies etc., were employed on, behind or around the stage area. Opera, however, incorporates text within a musical fabric – arias become monologues, soliloquies, repositories of private reflection and self-revelation which operate

outside of real time, usually slowed down artificially by the tempo and figurations of the orchestra.

In the third act of *Le nozze di Figaro*, a *secco* recitative occurs between Barbarina and Cherubino.[29] As they leave the stage, this 'half music'[30] concludes with a cadence played by the continuo. The Countess appears on stage and picks up the thread of the recitative: 'E Susanna non vien!' ('and Susanna has not come'), a prosaic utterance that is answered by the orchestra with an unexpected syncopated figure that also shifts into a new key, bringing the realisation that the Countess is embarking on a deeply personal moment of soliloquy as she recalls the plot that she has hatched with Susanna in order to exact revenge upon her faithless husband. The subterfuge worked out between the Countess and Susanna has the flavour of a childish game, the telling of which is interrupted by moments of self-revelation, as she speaks of her husband's impetuousness and jealousy (*geloso*), underscored by the orchestra in a change of gear from *Andante* into a threatening *Allegretto*, replying with impulsive, ascending figurations. The Countess continues to elaborate the details of the plan in an attempt to convince herself that all will be well, the orchestra replying with assuring, mellifluous figurations – she asks 'Ma che mal c'e?' – ('but what could be the harm?'). Finally, she can no longer conceal the humiliation and hurt which afflict her, and bursts out, imploring the heavens ('o cielo'), accompanied by sharply accented chords from the strings.

Secco recitative is generally delivered in 'real time' – approximately at the speed of speech – and *Figaro* provides particularly rich examples of not only *secco* but also orchestral recitative. In working to realise these passages in performance, a dramaturgical analysis of the characters may assist; for example, Don Curzio is often stopped in his tracks by an inconvenient stammer; the gardener, Antonio, often drunk and none too sharp at the best of times, may deliver his recitative more slowly than other characters, or with significant pauses between lines; at the opening of the opera, the first characters that we meet are the betrothed couple, Figaro and Susanna, and the musical context suggests their relationship subtly, but unequivocally, making it clear that Susanna is the dominant force, the strategist and the smarter of the pair.

In the orchestral recitative under consideration, the Countess alternates between lines which are delivered in the 'real time' of speech and more histrionic moments where time is stretched, when she expresses pain, or falters, changing into an 'arioso' style of delivery. *Forte-piano* explosions in the orchestra[31] echo her husband's earlier recitative and aria from the same act,[32] where his seething anger is expressed by the same orchestral device. The recitative examines not only the relationship between both the Count and Countess but also that between the latter and Susanna. Significantly, during the opera, they cultivate a friendship of almost sisterly intensity, at least on the surface, as though the distinction of class between the two dissolves. This, however, is an illusion, and in the last bars of the recitative, we see the pride of the Countess fully revealed when she says that she was first loved by her husband, then offended, and finally betrayed, as Baroque-style figurations in the orchestra lead to an uncomfortable dissonance, to which the

Contessa sings with disdain of being forced to seek the help of a servant. Those two bars define the relationship between the two women, of different classes, who can never be equals. The recitative ends on what we assume is the dominant chord of E major, and one would expect a *lamentoso*-style aria to follow, in the key of A minor. Instead, we are transported into C major, another realm, indicating that the Countess has lost herself and slipped into the haven of an aria where she can express her existential crisis. In a short space of time, the opera has moved from *secco* recitative, to a soliloquy with orchestral recitative, to an aria in *Andante*, which presents an exquisitely crafted portrayal of bereavement, in time slowed down. We have moved from the public world into an intensely private one that is rarely revealed, an aristocratic one. This scene encapsulates Mozart's mastery of musical dramaturgy, achieved through the text of Da Ponte, who provides the composer with the depth that he requires. The three Da Ponte collaborations are all rich in scenes of similar complexity and profound dramatic truth.

The singer has a certain licence to add to the musical dramaturgy by the use of ornamentation, particularly *appoggiature*. At the line 'fammi or cercar' ('forcing me to seek'), the orchestra arrives on a remote chord, emphasising that in seeking Susanna's assistance, the Countess has distanced herself from her own social class. On the word 'aita' ('assistance'), Mozart has written two Bs at the conclusion of the phrase. This would be a typical place to add an *appoggiatura*, for which the singer might consider a couple of possibilities. In this context, an upper note (C–B) *appoggiatura* adds a particular spice to the harmony, and appearing on 'aita', underlining the sense of humiliation that the Countess feels in seeking help from Susanna. It also evokes, in a single dissonance, uneasily resolved, the irreconcilable distance of class between the two women. *Appoggiature* can often take on a dramaturgical significance in contexts such as these, becoming more than mere decorations that soften the musical line; rather, they add layers of meaning to the dimensions of the characters and the dramatic situations they find themselves in.

A much later example of musical dramaturgy can be found in Debussy's *Pelléas et Mélisande* (1902), which recounts an almost invisible tale of love as originally articulated by Maurice Maeterlinck's symbolist drama. Recent scholarship has highlighted the influence of Wagner upon the work, notably *Tristan und Isolde* (1859).[33] It is possible to read *Pelléas* as a kind of photographic negative of *Tristan*, with its tumultuous erotic music replaced by blank silences. Maeterlinck's much quoted comment about 'les grands silences d'amour' relates particularly to the (anti)climax of Debussy's opera in Act 4 Scene 4, where the pair declare their love for one another. This takes place in a musical void – silence – with the orchestra torn away as Pelléas kisses Mélisande. To Pelléas' unoperatic confession of 'Je t'aime', Mélisande responds slowly and deliberately, almost in a whisper (*à voix basse*) on a monotone low C, almost spoken ('Je t'aime aussi …'), delivered in what resembles a funeral rhythm. In this passage of unaccompanied recitative, their declaration of love seems to be outside the 'music' of the opera, and Debussy's interest in the aesthetic of Maeterlinck becomes clear: here was

the escape hatch through which Debussy escaped the thrall of Wagner, exorcising what he later called the 'ghost of old Klingsor'.

The following chapter will look at the dramaturgy of paintings, as latent 'operas without music', and examine how a portrayal of a significant historical event might devolve into an operatic chorus. The case of the works of Wagner is also considered in light of musical dramaturgy. As a prelude, spare a thought for the plight of the conductor who enters the pit to conduct a performance of the *Vorabend* to the Ring, *Das Rheingold*. The conductor will typically have studied Wagner's score assiduously, including all of his staging directions: they enter the pit, and see the following text printed in their score:

> The banks of the Rhine. Greenish twilight, above lighter, below, somewhat deeper. The upper part of the scene is filled with surging water which moves, wave-like, left to right. Towards the bottom of the scene, the waters resolve themselves into a fine mist, so that the space, to the height of a man above the stage, seems free from water which floats like a train of clouds over the gloomy depths. Everywhere are steep points of rock jutting up from the depths and enclosing the while stage; all the ground is broken up into a wild confusion of jagged pieces, so that there is no level place, while on all sides darkness indicates other deeper fissures.[34]

In opera theatres today, as the curtain rises, it is a virtual certainty that the conductor will not see anything that resembles these instructions. Nevertheless, they must intuit a tempo for the orchestra that equates with Wagner's written instruction, *Ruhig heitere Bewegung* (calm, serene movement), and generally obey all of the notations in the score as precisely as they can. Wagner ceased writing metronome markings for his operas after *Tannhäuser*, preferring to write subjective descriptors in the vernacular that allow the conductor to follow their instincts, which, in part, will be informed by what the conductor sees onstage. How can the conductor hope to recreate Wagner's musical wishes when the stage bears no resemblance to his textual stipulations? That question is considered in Chapter 15.

Notes

1 David J. Levin, *Unsettling Opera: Staging Mozart, Verdi, Wagner and Zemlinsky* (Chicago: University of Chicago Press, 2007), 104.
2 Ibid.
3 Ulrich Müller, 'Regietheater/Director's Theater', in *The Oxford Handbook of Opera*, ed. Helen M. Greenwald (Oxford: Oxford University Press, 2014), 586–7.
4 Ibid., 599. Original text 'Mozarts schöner Humanitätsdusel am Schluss, ist in heutiger Welt passé.' 'Humanitätsdusel' would be best translated as - 'humanitarianism'.
5 Ibid., 587. (Originally from: *Mostly Opera*, 2008. "Stefan Herheim Abducts the Abduction" mostlyopera.blogspot.com/2008/08/Stefan-herheim-abducts-abduction.html)
6 John Rosselli, 'Dramaturg', in *Grove Music Online*, accessed 31 August 2011.
7 Daniel Meyer-Dinkgräfe, '*Regieoper* und *Werktreue*', has explored these two apparently interlocked forces in the practice of opera curation inside the operatic museum.

8 Philip Gossett, 'Writing the History of Opera', ch. 49 in *The Oxford Handbook of Opera*, ed. Helen M. Greenwald (Oxford: Oxford University Press, 2014),1041.
9 Hans Ulrich Obrist, *A Brief History of Curating* (Zurich: Jrp Ringier, 2008), 238.
10 See also: Gossett, 'Writing the History of Opera', 1036.
11 Giuseppe Verdi, *La traviata* (Milano: G. Ricordi & C., 1944) (plate number 42314), 151–2.
12 Damien Colas, *Musical Dramaturgy*, ch. 8 in *The Oxford Handbook of Opera*, 177.
13 Dalhaus, *The Dramaturgy of Italian Opera*, in Bianconi and Pestelli, *Opera in theory and practice, image and myth* (Chicago: The University of Chicago Press, 2003), 74.
14 Ibid., 73.
15 Gossett, 'Writing the History of Opera', 1034.
16 Joseph Kerman, *Opera as Drama* (Berkeley: University of California Press, 1988).
17 All quotes from Lauren E. Zeiss, 'The Dramaturgy of Opera', in *The Cambridge Companion to Opera Studies*, ed. Nicholas Till (Cambridge: Cambridge University Press, 2012), 179.
18 Colas, *Musical Dramaturgy*, 177.
19 Ibid., quoting Di Benedetto, *Poetiche e polemiche*, 1988, 177.
20 Ibid.
21 Clemens Krauss and Richard Strauss, *Capriccio* (London: Boosey & Hawkes, 1942), 1.
22 Discussed in more detail in Lydia Goehr, 'The Concept of Opera', in *The Oxford Handbook of Opera* ed. Helen M. Greenwald (Oxford: Oxford University Press, 2014), 94.
23 Tim Carter, 'What is Opera', ch. 1 in *The Oxford Handbook of Opera*, ed. Helen M. Greenwald (Oxford: Oxford University Press, 2014), 28.
24 Tim Carter, *Monteverdi's Musical Theatre* (Hartford, CT: Yale University Press, 1982), 47.
25 Carter, 'What is Opera', 16.
26 Act 1, 'Di scrivermi ogni giorno', No. 8a – the Bärenreiter edition describes it as a 'Recitativo'.
27 Act 1, 'Ah, chi mi dice mai', No. 3.
28 Act 1, Fig. 263, bars 1–2. The direction is '*discret vertraulich*' – discreetly confidential.
29 Act 3, scene VII.
30 A term coined by Dalhaus for *secco* recitative in relation to the dramaturgy of opera.
31 No. 18, bars 14 and 15, for example.
32 No. 17, bars 3, 35 and 36.
33 Carolyn Abbate, 'Tristan in the Composition of Pelléas', *19th-Century Music* 5, no. 2 (Autumn, 1981): 117–41.
34 Adapted from Frederick Jameson's translation of Wagner's *Das Rheingold* (Mainz: B Schott's Söhne, 1899).

14 The dramaturgy of murder and madness

Framing a murder

Jacques-Louis David's painting *The Death of Marat* (*La mort de Marat*, 1793)[1] captures a moment in time just after the murder of an important figure in French history. The work may capture the exact moment of Marat's death, or perhaps he remains unconscious, clinging to the last threads of life, his heart faltering? Perhaps he has been dead for some time – there is no sign of the assassin. They may be still lurking in the room, somewhere beyond the borders of the painting, or they may have already fled. At the moment depicted by David, how far away might they be? Of course, the artist was not about to include the perpetrator of the deed in the painting, which is both a political and personal statement, a threnody to Marat, who was also a friend of the artist. The moment depicted invites the viewer to speculate about the past as well as the future, to consider what led to this moment and what might follow. David's achievement is measured not least in his choice of the exact moment which, for him, represents the essence of the event. His choice can be explored by making a comparison with a number of less iconic paintings that were subsequently created in response to the murder. Guillaume Joseph Rocques (1754–1847)[2] painted the same scene in 1793, from a slightly different angle and using essentially the same 'props', although the gaudy Tricolor has been added in the background. As the nineteenth century wore on, Marat's assassin, Charlotte Corday, begins to appear in depictions of the scene, as in *The Assassination of Marat, Charlotte Corday* (1860)[3] by Paul-Jacques-Aimé Baudry (1828–86) where the woman's presence dominates the picture. By 1875, Santiago Rebull (1829–1902)[4] captures the moment of the murder, rather than the moment of death, with both the wounded Marat and the figure of Corday shown. By 1880, we steer perilously close to the world of melodrama, where Joseph Weerts' (1847–1927) *The Assassination of Marat*[5] presents a crowded space, showing a dying Marat, Corday holding the murder weapon and a group of revolutionaries forcing their way in through the door, not unlike an intervening opera chorus. Unlike David's work, these later paintings focus upon the deed – the assassination – rather than the aftermath, where the victim, either dead or dying, becomes the focus of attention. Following the murder, the perpetrator of the crime, Corday,

was also painted in her own right in a number of settings, including awaiting her death by guillotine; she eventually became more celebrated than her victim. In contrast, David's painting portrays only the victim, evoking an ominous silence, which encourages reflection upon the tragedy of the event.

How might the murder of Marat have been portrayed in an opera? A messenger might run onto the stage to inform a gathering of what has occurred or, in a duet, two characters might discuss what they have learned of the recent tragedy, while a funeral march playing in the distance, offstage, would allow the audience to imagine a passing cortège. Alternatively, an empty stage might spring to life as a woman enters, hurriedly closing a door behind her, and then in a monologue delivers a mad scene, perhaps slowly reciting the contents of the letter she has left behind, before fleeing to escape arrest.

Committing an operatic murder

The opening scene of Mozart's *Don Giovanni* portrays in 'composed' time the events leading up to a murder, raising the question of which moment an artist would choose to capture in painting 'The Death of the Commendatore'. Following the overture, the curtain rises to reveal a comic scene, essentially an aria of disgruntlement, sung by a servant who no longer wants to serve but rather wishes to emulate his master. As the futility of his complaints becomes apparent, the orchestra takes the lead and gears up into a tumult as a mysterious figure is seen to escape from Donna Anna's chamber, only to be waylaid by her father, the Commendatore. A duel is fought between the mysterious perpetrator and the father, leading to the *coup de grâce*, the fatal wounding of the Commendatore, a moment that is suspended by a frozen diminished chord, hanging luridly in the air. In the following passage, time shifts into another, 'slowed down' dimension – defined by the orchestra – with each character expressing their personal reaction to the fatal outcome of the duel, accompanied by ghostly, pizzicato triplets that accompany the death struggle of the stricken Commendatore. As the Commendatore sings his last words, the stage instructions tell us that he dies. Exactly where does his death occur? Does death follow on from his last utterance? In which case, the lamenting, descending wind figures that follow function as an epilogue for him. Those same wind figures, however, could also musically represent the gradual extinction of life from the Commendatore's body, with the exact moment of death occurring slightly later, where the scene dovetails into the next.[6] The end of the scene is thus masked, the music vacillates and the death of the Commendatore remains an unresolved wound that drives the remainder of the opera: it will not be avenged until towards the end of the opera's final act. The scene dissolves into the 'half music' of recitative, in this case an uneasy, absurdist exchange worthy of a Beckett play. After the lengthy passage of expanded time that follows the stabbing, 'real' time is gradually re-established. Out of the darkness, we slowly recognise the perpetrator and his servant, who engage in a fragmentary, black comic exchange, with Leporello asking if it is his master who is dead or the Commendatore.[7] We realise that only two characters remain on stage, beside a lifeless corpse, and the dialogue

becomes recognisable as a *secco* recitative, which revives into the style of opera *buffo* – suggesting the Don's cursory dismissal of the gravity of the situation and the heinous crime he has committed. One has the impression that this is not the first time Giovanni's antics have led to murder; there is something 'practised' in the exchanges between master and servant.

Operatic deaths (murders or suicides) can be staged in a variety of ways. For example, in Berg's *Wozzeck*, the main protagonist drowns,[8] a means of death not often portrayed in the operatic literature.[9] At the point in Act 3[10] where Wozzeck enters the waters of the pond, he is clinically mad – a diagnosis that has been made (by the orchestra) in the interlude between Scenes 2 and 3. Therefore, the question of whether it is a death or a suicide that follows is likely to be an open verdict. In his final words, Wozzeck confuses the water with blood ('Ich wasche mich mit Blut – das Wasser ist Blut'), at which point the music that effectively drowns him begins to rise,[11] a particularly graphic passage in which the orchestra becomes the pond, creating through sound the effect of the waters rising to receive the protagonist and the reeds far beneath the surface beginning to wrap around his feet, dragging him inexorably downwards. Wozzeck gradually disappears beneath the surface of the pond, his life extinguished, leaving only the distant sounds of nature, represented by croaking toads. As is the case in David's and Mozart's examples, the exact moment of Wozzeck's death is open to interpretation, but what follows the conclusion of the scene is Berg's musical analogue of David's painting: a Mahlerian threnody, a meditation and reflection (through musical flash-backs) on a life cut short. David's frozen moment, in Berg's opera, lasts around three minutes.

Wozzeck's death carries a sense of him disappearing not only into the pond but into the orchestra, who are playing below the stage, as he drowns in their sound. In Richard Strauss's *Elektra* (1909), Klytemnestra's death occurs offstage, with the orchestra evoking what the audience cannot see. Orest accompanied by his tutor, enters the palace, leaving Elektra waiting outside to receive confirmation of Klytemnestra's murder. The orchestra reflects Elektra's intense anxiety, with repetitions of the axe motif in the orchestra reminding her that she has forgotten to give her brother the weapon with which he is to commit the murder.[12] The orchestra writhes about, indicating both Elektra's near-insanity and also the hushed passage of Orest through the palace in search of his victim.[13] Next, two blood-curdling cries are heard, one over the orchestra, then the final one in complete silence, indicating the moment of Klytemnestra's murder, which is confirmed by the reaction of Chrysothemus and the Maids.[14]

An even more gruesome murder occurs in Strauss's *Salome* (1905), when the executioner enters the cistern to decapitate Jochanaan. Salome expresses her free-floating anxiety in a passage that is usually sung 'around' the written pitches, in something approaching *Sprechgesang*.[15] From the double bass section of the orchestra, a strange, whimpering sound is heard, played first by a solo double bass, then a group of four, sounding a high B flat,[16] an eerie effect not usually associated with that instrument. The unearthly sound may represent the fear that

Jochanaan feels when confronted by the executioner, with the powerful bass-baritone timbre associated with his character having been transposed into a high whimper, his authentic voice and nerve failing him in his last moments. It is an unearthly and somewhat irritating sound, which, through repetition, further winds up the tension as Salome waits helplessly to discover if her macabre demand has been carried out. The music of this scene gives the audience little clue as to what is happening in the cistern, which remains musically 'dark', undefined. Suddenly, the timpani hammers (literally: the instruction to the player is '*hämmernd*') out a motif with wooden sticks, as the notion of 'music' deconstructs and we are left with noise; a bass drum, also 'beaten' with wooden drum sticks, builds in volume to the moment when the severed head of the prophet becomes visible to Salome and the audience.[17]

In these examples, the audience do not witness the deed; rather, they experience the anxiety-ridden expectation of the murder (or some other disaster), portrayed by the orchestra, and are presented after the fact with the consequences. Many significant, often violent operatic events happen offstage and are experienced only as sound, without visual representation, such as the torture of Cavaradossi in Act 2 of *Tosca* (1900). In the first act finale of *Don Giovanni*, musical and dramatic complexity are achieved through the use of three onstage orchestras, a justly famous passage where different dance styles, representing the different strata of society, are combined, effectively creating a subterfuge for Giovanni's antics.[18] Amid the musical multi-layeredness, Giovanni seizes his chance to abduct Zerlina while Leporello is distracting Masetto. Suddenly, from offstage, we hear Zerlina's cries for help ('Gente aiuto'), which silences the three onstage orchestras and prompts the pit orchestra to instigate an *Allegro assai*[19] tumult as the protagonists attempt to rescue Zerlina. The Don appears, with a bearing of feigned calm (*Andante maestoso*)[20] as he attempts to pass Leporello off as the culprit. As the play of the maskers disintegrates, revealing Elvira, Donna Anna and Ottavio, the music again speeds along as Giovanni, also finding himself unmasked, struggles to maintain his composure against those who, previously only suspicious, are increasingly certain of his guilt. The curtain falls on a scene of confusion and conflicting emotions and reactions that resembles the tableau of a painting.

Musical dramaturgy in the twentieth century

The operas of Alban Berg provide examples of extreme authorial control, which demonstrate an extremely detailed and individual approach to musical dramaturgy. Berg adapted his own librettos from plays by Georg Büchner (1813–37) and Frank Wedekind (1864–1918), making his operas conform to the genre of *Literaturoper*, allowing himself the Wagnerian privilege of uniting the dramaturgy of both the musical and the textual elements in one creator.

For his first opera, *Wozzeck*, Berg drew on Büchner's fragmentary, incomplete text (*Woyzeck*, 1836) that was unknown until its publication in the 1870s and not staged until 1913. Berg developed the skeletal text into a libretto, finding the

seeds of musical structures in lines such as the palindromic 'Langsam, Wozzeck, langsam'. The text provided the composer with an opportunity to develop highly integrated forms in his score, creating a sense of balance that was 'denied him by Büchner's forceful but unstructured text'.[21] Berg also wrote extremely detailed stage directions for his operatic realisation, which had been largely absent from the original play. These extend to cues for gestures, entrances and exits etc., directed to occur at very specific moments in the music. This practice of tight integration, where even tiny gestures are finely coordinated with the orchestral fabric, is typical of many twentieth-century operas, and the techniques employed in Berg's score became enormously influential upon the work of many subsequent opera composers. One might almost say that in composing *Wozzeck*, Berg has definitively staged the opera, and the prescriptive nature of the instructions has not generally inspired a response of literal fidelity among stage directors. Some of the more notable examples of Berg's approach include the 'staging' of the curtain, which, for example, in Act 2[22] is directed to rise during a long upwards harp glissando, which occurs in a specified time frame (and tempo). Berg's careful instructions for the curtain was a response to new technologies, by which the speed with which it moved could be determined mechanically.

In the tavern scene of Act 2, a stage band appears, including a bombardon,[23] which is unceremoniously muted during a sermon delivered by the drunken First Apprentice.[24] The Apprentice speaks about God having bestowed upon man the need to shoot and kill, and at the moment where 'shoot dead' is declaimed, the onstage band rises in volume to a *sffz*.[25] The sound coming from the bombardon is loud enough to drown out the rest of the band, and the score specifies that its sound must immediately be reduced to *pianissimo* after the *sffz* outburst. This is achieved not by the player, but by a singer, the Second Apprentice, who is directed to pick up a tuba mute (a rather large device) and place it in the bombardon at just that moment in order to affect the sudden reduction in sound. This is a kind of musical joke, or conceit, which occurs in the surrealistic atmosphere of the tavern scene, where Mozart, Weber and Richard Strauss are also subject to parody by quotation.

Along with such requirements for action to occur on specific musical cues, Berg also 'composes' silence, with *four* bars of silence (two bars with pauses and two bars 'in tempo') occurring at the conclusion of Act 2. As Act 3 follows, Berg notates *two* silent bars[26]: one bar equating with the two bars that concluded Act 2 and one pause bar, which is also equal in duration to the two pause bars that closed the previous act. In this way, although notated very differently (looking very different on the page), the duration of silence that ended Act 2 should equate exactly with that which begins Act 3. These silences 'accompany' the fall and subsequent rise of the curtain, which occurs during the 'in tempo' bars of the close of Act 2 and the opening of Act 3 and hence needs to be timed exactly to the (silent) tempo notated. The silences that close Act 2 and open Act 3 form, by virtue of their precise notation, a palindrome, a device which held considerable significance for Berg, both musically and personally. While one might find this to be a case of extreme authorial control, the conductor of the première of *Wozzeck*,[27]

Erich Kleiber, dutifully conducted all of these silent bars, a practice which has been generally maintained by subsequent conductors of the work.

Berg was no less prescriptive in the composition of his second opera *Lulu* (1937), which contains similar examples of staging instructions that are to be exactly synchronised with musical cues. Characters are often directed to make gestures or entrances/exits on specific musical cues or motifs,[28] with arrows in the score indicating the exact point where these are to occur. A sense of anxiety on the part of the composer can be discerned here, and it seems that Berg was concerned that the correspondence between stage and orchestra must be meticulously maintained. While this may have been useful, even necessary, in mounting early productions, in most modern interpretations, Berg's exacting instructions are more likely to be taken as suggestions than mandatory requirements, and they are on occasion ignored completely.

During the first act of the opera we are introduced to the character of Schigolch,[29] whom we quickly discover is an asthmatic. His short, broken phrases, relieved by rests, are 'composed-in', veristically highlighting the nature of his affliction; Berg goes even further and at certain moments stipulates exactly where his asthmatic wheezes should occur, and whether they should be inwards or outwards.[30] Characters are directed to dance during particular passages in the score, again on specific cues. Taking further advantage of new technologies, Berg composes music for a silent film, which over 66 bars outlines the year that Lulu spent in prison – an instance of time being considerably sped up, in music that proceeds to a mid-point and then retreats in reverse – another palindrome.[31] The overwhelming impression of the score is one of rigorous, meticulous control, which is understandable considering Berg's position as a pupil of Arnold Schoenberg and a member of his circle, as well as his (at least partial) embracing of the rigours of composition using the 12-tone system.

In his one-act opera *Die glückliche Hand* (1910–13), Schoenberg indicates stage directions with a similar exactitude according to a special system of symbols that he devised. He goes as far as to notate specific lighting states (brown, dirty green, blue-grey, violet, dark red, blood-red etc.) that are also specified to change on very precise musical cues[32] and are unlikely to be taken literally in productions today, representing an extreme and somewhat naïve case of overall control of the parameters of an operatic work. Schoenberg remains an important composer, rather than a lighting designer, though he was a prolific painter, with a particular interest in colour. It was not just the growing complexity of the musical score of the works of Berg and Schoenberg that caused their composers to engage in wide-ranging authorial control. They were also heirs to the Wagnerian *Gesamtkunstwerk* aesthetic, in which all the parameters of the operatic work – textual, musical and staged – co-existing in a perfect balance, which, just as Wagner had sought to demonstrate, could best be achieved by all disciplines being under the control of one person – who would, of course, be the composer.

In the face of this trend towards ever greater authorial control, the extensive use of *Sprechgesang* by Schoenberg and Berg in their dramatic vocal works seems a curious device to employ. While not invented by Schoenberg,[33] *Sprechgesang*

was famously articulated by the composer in his *Pierrot Lunaire* (1912) score and adopted by Berg in both of his operas. The instructions created by Schoenberg for performing *Sprechgesang*[34] are significant in terms of what they do and don't specify – in fact, it has been suggested that there is no exact mid-point between speech and song but 'rather a haze of alternatives'.[35] In the musical notation, certain notes have crosses placed on their stems, and the singer is instructed that these notes are 'not to be sung' (*nicht zum Singen bestimmt*) but to be delivered as a 'spoken-melody' (*Sprechmelodie*) while 'taking into account the pitch of the notes' (*der vorgezeichneten Tonhöhen*). It is the last part of these instructions where confusion emerges. Clearly, a form of declamation is required, whereby the speaking voice is lifted into a higher position, in what might be termed a 'melodramatic', even 'sing-song' type of speech. It is not quite clear how the notated pitches should inform this process, though it is often understood that the shape formed by the higher and lower tones should be followed by the voice. A variety of approaches can be heard in different performances and recordings, and exactly what Berg and his teacher meant (and expected) remains a matter of debate. *Sprechgesang* is often employed as a transition between sung passages and spoken ones. It is also used to highlight the mental state of a character – for example, at the opening of Act 3 of *Wozzeck*, where Marie is sitting with her child reciting a passage from the Bible. The text leads her into a reverie, to a place far removed from the harsh reality of her daily existence. In this context, the Biblical text is delivered in *Sprechgesang*, conveying a dissociated state,[36] whereas harsh reality is expressed by fully sung outbursts.[37] The use of *Sprechgesang* becomes doubly problematic because the pitches of both Schoenberg's and Berg's works are rigorously organised, which the introduction of *Sprechgesang* threatens to undermine. To further complicate the issue, Berg adopted a further, 'in-between' type of declamation in *Lulu*, 'half-sung' – something between *Sprechgesang* and singing. Finding solutions for the delivery of the *Sprechgesang* in these works remains challenging, and although there are recordings supervised by Schoenberg where *Sprechgesang* is employed,[38] these are today generally regarded as historical curiosities rather than workable examples of the effect required. Performances and recordings of Berg's operas by leading conductors such as Claudio Abbado and Pierre Boulez have been criticised for veering from the notation, while the notation itself seems to indicate that some sense of freedom and spontaneity towards the specified pitches is implied. Used within works that are highly organised from the perspective of pitch, *Sprechgesang* emerges as a kind of red herring, an imaginary point on uncharted terrain between recitative and singing. It remains an important element in the musical dramaturgy of these works, where the performer is provided with an additional (though ambiguous) tool through which to project the psychology of the character and situations they are portraying.

Notes

1 www.khanacademy.org/humanities/renaissance-reformation/rococo-neoclassicism/neo-classicism/a/david-and-the-death-of-marat, accessed 10 February 2020.

2 www.augustins.org/en/les-collections/peintures/xviiie/panorama-des-oeuvres/-/oeuvre/50677, accessed 10 February 2020.
3 https://artsandculture.google.com/asset/charlotte-corday-paul-jacques-aime-baudry-1828-1886-nantes-mus%C3%A9e-d-arts/SgGO70kMNlmOIQ?hl=en, accessed 10 February 2020.
4 https://commons.wikimedia.org/wiki/File:Rebull_-_La_muerte_de_Marat.jpg, accessed 10 February 2020.
5 https://fineartamerica.com/featured/the-assassination-of-marat-jean-joseph-weerts.html, accessed 10 February 2020.
6 Bar 194 of the Bärenreiter score, which is also numbered bar 1 of the *Recitativo*, highlighting the dovetailing.
7 'Chi è morto, voi, o il vecchio'.
8 Alban Berg, Georg Büchners Wozzeck. Oper in 3 Akten (15 Szenen) ... Op. 7. Partitur. Nach Den Hinterlassenen Endgültigen Korrekturen Des Komponisten Revidiert von H. E. Apostel (1955). English Translation by Eric Blackall and Vida Harford (Wien, etc: Universal Edition, 1955). In Act 3, scene 4.
9 A double drowning occurs in the final scene of Shostakovitch's *Lady Macbeth of Mtsensk*, where Katerina pushes Sonyetka to her death in the river, then throws herself in after her, committing suicide. At the conclusion of Britten's *Peter Grimes*, Grimes sails out to sea in order to drown himself.
10 Bar 274 of the score.
11 Bar 284 of the score.
12 Fig. 186a–189a of the score.
13 Fig. 190a–191a of the score.
14 Commencing at three bars before Fig. 194a.
15 *Sprechgesang* is discussed at the end of this chapter.
16 B flat 1 (Helmholz).
17 Fig. 314.
18 Act 1 finale, bars 406–67.
19 Ibid., bar 468.
20 Ibid., bar 499.
21 Tim Carter, 'What Is Opera', ch. 1 in *The Oxford Handbook of Opera*, ed. Helen M. Greenwald (Oxford: Oxford University Press, 2014), 26.
22 Act 2, bar 170.
23 The 'bombardon' is a vernacular name for the lowest of the tubas, also known as a 'double B flat tuba', and is identical with Wagner's 'Kontrabass Tuba'. Source: Norman Del Mar, *Anatomy of the Orchestra* (London; Boston: Faber and Faber, 1983), 280.
24 Act 2, bar 625.
25 Act 2, bars 815–18.
26 Act 3, bars 1 and 2.
27 Staatsoper, Berlin, 1925.
28 For example, Act 1, bars 453–62 (Lulu/Schigolch).
29 Act 1, Scene 3, bar 463.
30 For example Act 1, Scene 3, bars 486–8.
31 Act 2, Scene 1, bars 655–721.
32 Schoenberg, *Die glückliche Hand*, Universal Edition, UE 13613, ND.
33 It was first used by Englebert Humperdinck in his *Königskinder* (1st version) of 1897, probably having its origins in popular music.
34 As given in the score of *Wozzeck*.
35 Stanley Sadie, *The New Grove Dictionary of Opera*, 4 vols (London: Macmillan, 1992), iv, 488.
36 e.g. Act 3, bars 5–6.
37 e.g. Act 3, bars 7–9.
38 Notably the recording of *Pierrot Lunaire* conducted by the composer with Erika Steidry-Wagner singing, from 1940.

15 'Deeds of music made visible'

The vision of Richard Wagner

The previous chapters have explored the workings of musical dramaturgy, an area of operatic practice that is indebted to the works of Richard Wagner, whose legacy has been more influential than any other in determining the course of opera production during the twentieth century. The operas of Berg reveal their debt to Wagner in a number of ways, including the use of *Leitmotif*, and in the close and precise relationship between what is heard in the orchestra and what which is enacted on the stage. This was a fundamental tenet of Wagner's directorial approach for the 1876 *Ring* cycle at Bayreuth, where he insisted that the onstage drama should correspond to the music (which generates it) and not work in counterpoint with it. It was the literalism of this approach (which Berg adopted) that Wagner reconsidered in his later reflections upon the success of the 1876 Festival, and which subsequently created a loophole by which the correspondences between the pit ('mystical abyss') and stage were loosened to allow a wider field of interpretation of the relationship between the musical score and the libretto's stage directions.

In his art, as in his life, Wagner was a revolutionary, whose achievement in creating a temple to his own canon of works, establishing the conditions where he could present his progeny in the way he had imagined, is all the more extraordinary when his humble musical origins are considered. Wagner began his career as a *Kapellmeister* in provincial theatres, where he came face to face with the limitations of the conditions of opera production that existed at that time in Germany. As a result, in 1839, Wagner turned towards the operatic mecca of Europe – Paris. He remained there for three years: an unhappy and humiliating experience which left him hugely disillusioned by the city, the Opéra and some of its leading musical figures such as Giacomo Meyerbeer, whose *Robert le diable* had been produced in 1831, establishing the grand opera style. It must have been a bitter blow for Wagner to find himself in the city with the best equipped opera house in the world, boasting all of the resources and apparatuses that the composer had longed for in order to make possible the works that filled his mind, only to find all doors closed to him. Finally accepting rejection, Wagner, a master of self-belief and self-publicity, resolved to create in Germany the conditions where he could realise the works that he had planned during his Paris sojourn. These were *Der*

fliegende Holländer (1841–43) and *Tannhäuser* (1843–5), with *Lohengrin* following after his return to Germany (1845–50).

While Wagner's works are performed today under lavish conditions in the largest theatres of the world, it is important to remember that the composer struggled for many years to create the conditions he required to produce his operas to his satisfaction. Of the three early works mentioned, none exists in a single, composer-approved version, the result of artistic aspiration and theatrical reality failing to align. Late in life, having been unable to produce a definitive *Tannhäuser* at Bayreuth, the composer commented to his wife Cosima that he still 'owed the world'[1] that work, which is generally performed today in a conflation of the two versions he left unresolved, which Cosima created after the composer's death. While the mythology that Wagner wove around his final work, *Parsifal* (1882), was influential in creating a sense of canonicity for his oeuvre (it has been noted that *Parsifal* became a part of the operatic canon before it became a part of the repertoire), this sense of the inviolable work, requiring rarefied, specialist conditions in order to realise the composer's vision, is an idealised construct that only applies to his final work. It does not reflect the realities encountered in the creation of all of the composer's works up until *Parsifal* and the many compromises that were not only required but readily agreed to by the composer in securing performances for his works. Wagner was undoubtedly concerned with his legacy, and while he cultivated a cult-like, quasi-religious atmosphere in Bayreuth, the musical pragmatist was never far away, and the showman within was not averse to granting performances of his works under less than ideal conditions so they would at least receive exposure before the eyes of the public.

Wagnerians are often surprised to learn that extensive cuts were condoned by the composer himself, not only in the earlier operas but also in the later music-dramas. *Tristan und Isolde*, for example, was performed with cuts agreed by the composer, including the excision of 103 bars in Act 2, Scene 2,[2] along with a cut of 11 bars to Act 3, Scene 1,[3] as well as smaller cuts,[4] and the provision of lower variants for Tristan's taxing vocal lines. In the case of that work, Wagner continued to consider further cuts until the end of his life, reportedly telling Cosima that it demanded too much of audiences and performers, and that he would make cuts to the second and third acts that could be performed everywhere except Bayreuth. Hermann Levi, who conducted *Tristan* in Munich in 1880, expressed his reservations about the cuts proposed by the composer, who responded: 'Nonsense – don't be so sentimental – those passages should be omitted once and for all.'[5] Not only Wagner but also his heirs were prepared to make cuts, with Gutrune's entire scene in *Götterdämmerung*, for example, being cut at Bayreuth by Wieland Wagner, who found it 'boring'. Today, these cuts are regularly made, even at Bayreuth, not least to ensure the role of Tristan is singable, a convention that audiences are often oblivious to. Today, over 160 years after its composition, *Tristan* remains a work that taxes singers to their limit.

Wagner also gave permission for the *Ring* to be taken on tour and approved wide-ranging cuts for seasons given by Angelo Neumann, who created the touring company that presented Wagner's works outside Bayreuth. Wagner had

witnessed at first hand the difficulty of realising certain parts of the *Ring* at Bayreuth – for example the Norns scene that opens *Gotterdämmerung*, as well as the scene with Brünnhilde and Waldtraute,[6] which the composer had at one point considered cutting entirely, fearing even worse failures in an 'ordinary theatre'.[7] Neumann, an enterprising impresario, took the *Ring* on the road across Europe, and as far as London, giving that work alongside 'monster Wagner concerts'. Performances of the tetralogy often required modification while on tour, as theatres of widely varying technical capacities were encountered, and last minute excisions were often required, as well as encores of popular moments.[8] Neumann's 'Richard Wagner Opera Company' has been described as more of a 'travelling circus than a temple of the arts'[9] – there was certainly something of Barnum and Bailey about the enterprise – though it took place with the full agreement of Wagner, a reminder that the composer himself almost undertook a similar tour to the US. Bayreuth was Wagner's most grandiose vision, one that he realised in relative old age. Rather earlier in his career, he had imagined a quite different outcome for what became the *Ring* cycle. In 1850, while he was working on *Siegfrieds Tod* (the composer's initial conception of what later became the Ring), Wagner expressed the desire to create a theatre 'made of planks' and assemble a hand-picked cast, along with other required forces, to achieve the best realisation of his opera, which would be given three performances (free to the public), after which 'the theatre would then be demolished and the whole affair be over and done with'.[10] Wagner, the grandee of Bayreuth, also possessed an innate understanding of the essentially ephemeral nature of opera.

Wagner's 'Theatre of Illusion' – The 1876 *Ring* cycle

The construction of the theatre at Bayreuth gave Wagner the opportunity to initiate a number of theatrical innovations that included the creation of the 'mystic abyss' – the orchestra pit that was formed by the addition of a second arch in front of the proscenium, 'on the line of the curved shell concealing the sunken orchestral pit',[11] creating two proscenium arches that placed a further distance between the audience and the 'dreamlike vision', separating 'reality' (the public) from 'ideality' (the stage), while the 'spectral music' rose up 'like vapours' from the 'mystic abyss'.[12] It was Wagner's intention to create a 'theatre of total illusion'(*Illusionsbühne*),[13] an immersive environment into which his audience could be magically drawn. In this sense, Wagner's creation of idealised worlds can be seen to relate to the Universal Exhibitions and World Fairs of the nineteenth century, which aspired 'to present a miniature version of the world that was as true to scale as possible',[14] recalling the 'microcosms of the world' of the *Wunderkammer*. To allow the audience to immerse themselves in a 'vision of a dream',[15] the auditorium lights were to be dimmed, a practice that dates back as far as the seventeenth century and which Wagner had previously employed in Munich for *Das Rheingold* in 1869. The completely darkened auditorium that is often referred to was in fact the product of a technical hitch that occurred at the first performance

of *Das Rheingold* in the *Festspielhaus*, when the auditorium was accidentally blacked out, a fault later rectified so that the house lights would be dimmed but not extinguished.[16] In creating his world of illusion, Wagner drew upon the most recent technologies available to him, including electric lighting; magic-lantern projections created the illusion of the *Walküre* maidens riding through the air; and a hand-operated machine allowed the Rhine daughters to appear swimming in the opening scene of *Rheingold*, as well as a 'big-dipper' slide for Alberich to escape down after he has stolen the gold.[17] Two locomotive boilers were employed to create steam, which was useful in masking some of the more approximate (and less successful) stage effects. A dragon, created by a firm in London, was greeted by audiences with 'mirth and derision' that flummoxed the composer.[18]

Wagner did not conduct the *Ring* cycle at Bayreuth in 1876; rather, he appointed Hans Richter to the task of carrying out his musical demands. He also engaged a technical director, Carlo Brandt, and a movement coach, Richard Fricke, a former ballet-master, both of whom assisted him in bringing the entire enterprise together. Wagner worked with his hand-picked singers as a stage director might work with actors, coaching them in their roles and ensuring that they fully understood the psychology and motivation of their characters, working in detail on declamation, phrasing, dynamics and above all, revealing the emotions of the characters.[19] One of Wagner's assistants, Heinrich Porges, noted that he could 'as if by magic, assume at a stroke any role in any situation – indeed in the rehearsals of the *Ring* he demonstrated these powers so fully it was as though he himself were the "total actor" (*Gesamtschauspieler*) of the entire drama'.[20] In his work realising the characters, Wagner was at pains to maintain spontaneity and an element of improvisation in the process. Not infrequently, he would contradict himself, negating comments that he had made days earlier, as he sought, through a variety of means, to release the inner life of the characters. A similar spirit informs his remark made in 1871 about the theatrical art being 'born from the spirit of free improvisation'.[21] It is also reflected in a comment that the composer made to future interpreters of the *Ring* – 'Kinder! macht *Neues*! *Neues*! und abermals *Neues*!'[22] – which may also convey the frustration and ultimate sense of failure the composer felt as he attempted to release his inner vision of his works in the Bayreuth productions, something that continued to elude him in the reslisation of the visual elements. The qualities of authorial invention and experiment were lost after Wagner's death. His widow, Cosima, took to quoting *Der Meister* at length, seeing it as her role to reproduce as exactly as possible what the composer had stipulated in his own productions, effectively 'embalming the "artwork of the future" in the formaldehyde of the past'.[23] In the 1876 *Ring*, Wagner established a production style in which stage movements and gestures, along with entrances, exits etc., would correspond with the music, not work in counterpoint with it. Wagner believed that the production was already implicit with the music, and that it was through the music that the dramatic action found its form. This was a position that he was to revise when he came to produce *Parsifal* in 1882.

The aftermath of the 1876 *Ring* cycle

That Wagner's 1876 *Ring* production met with considerable criticism, was no surprise to the composer, who was only too keenly aware of where his attempts to literally realise the effects specified in his stage directions had fallen short, partly due to technical limitations. The magic lantern portrayal of the *Walküre* ride had aroused audible mirth, as had Fafner the dragon, while the Rainbow Bridge at the conclusion of *Das Rhinegold* had been simply disappointing. The *Gesamtschauspieler* Wagner remained troubled by the discrepancy between what had been realised onstage and what was imprinted upon his mind's eye, his own inner vision of the work.

The 1882 première of *Parsifal* at the Festspielhaus was more successful from the composer's point of view, and the production continued to be revived in Bayreuth until 1933, essentially unchanged. Between the 1876 *Ring* production and *Parsifal*, Wagner modified his views regarding the position of the music in relation to the drama and began to view the visible action as 'but a threshold to the hidden essence revealed in the music'.[24] He distanced himself from the notion of *Gesamtkunstwerk*, and coined a new term: 'deeds of music made visible': 'The music sounds, and what it sounds you may see in the stage before you. ... I would almost like to call my dramas "ersichtlich gewordene Taten der Music"'.[25] Wagner was still struggling to find a workable visual language for his operas, and this new position raised the question of how these musical deeds could be 'made visible'. This dilemma remained unresolved at the time of the composer's death, and his artistic (and familial) heirs have continued to search for a resolution to it.

Following Wagner's death, his widow Cosima assumed the artistic direction of the Festival, in which position she has been generally regarded as a zealous custodian rather than an innovator, but nevertheless a remarkably loyal and dedicated one. Cosima produced versions of the earlier operas, opening the cuts in *Lohengrin*, creating a composite version of *Tannhäuser* and moulding *Der fliegende Holländer* into a one-act structure that brought it closer to the form of a music–drama. Bayreuth essentially became a museum, with Cosima as its chief curator, dedicated entirely to the staging of the established canon of Wagner's works and maintaining the Festspielhaus as a museum of 'authentic performance' of the works of *Der Meister*.

Bayreuth after Wagner

As the twentieth century unfolded, Bayreuth continued with its conservative, historicist position regarding the staging of Wagner's works. The composer's son Siegfried, succeeded his mother as director of the Festival in 1906. His work was carried out under the watchful eye of his mother, however, and his position was a fairly passive one. Nevertheless, at Siegfried's instigation, the Bayreuth production style shifted towards a more symbolic style of representation during the 1920s, with a reduction of scenery to the bare essentials and the use of more sophisticated lighting to create dramatic effect, and it is here that the influence

of Adolphe Appia (1862–1928) was significant. Appia had embraced Wagner's later, Schopenhauer-influenced conception of opera as 'deeds of music made visible', recognising music as the driving force in productions. He spoke of the 'musicalisation' of the stage, involving a reduction of scenic elements to simple symbolic shapes that were animated by the use of lighting – allowing the notion of suggestion to replace literal description. In instituting these innovations, however, Siegfried was heavily criticised by powerful conservative forces that regarded Bayreuth as an unalterable monument to the composer, which should in no way be tampered with.

Beyond Bayreuth, more radical directions in staging Wagner's works had been long underway. As early as 1903, at the Hofoper in Vienna, Gustav Mahler created a new production of *Tristan und Isolde* in collaboration with the designer Alfred Roller. Mahler and Roller were also influenced by Appia, who, in 1899, had written that the 'Illusionsbühne' of Wagner needed to be replaced with an 'Andeutungsbühne'[26] – a stage where the drama was implied or suggested rather than literally shown. Mahler was *Direktor* of the Hofoper, a position in which he was responsible for both directing the staging of the operas as well as the musical direction, which included conducting performances. His role was very similar to that created by Wagner for himself in 1876, with the proviso that Mahler also conducted the performances. Alfred Roller functioned as the staging designer and technical director – creating sets and also using lighting in a new way – 'painting with light' rather than using painted set pieces. The 1903 production of *Tristan* was a landmark of stage production. It established a methodology distinct from that upheld in Bayreuth, based upon going directly back to Wagner's text ('Alles steht in der Partitur')[27]. In developing new concepts and methodologies towards the libretto, Mahler and Roller advanced the principle that 'fidelity to the protean, evanescent spirit of a dramatist's work is more artistically fruitful than fidelity to the letter of his intentions. The right to interrogate a work of genius and come up with answers undreamt of by its creator was established once and for all.'[28] As an alternative to the literalist approach of Bayreuth, this idea – that the composer and librettist effectively provide a blueprint that forms a creative point of discussion and negotiation – proved to be a radical departure from tradition, the implications of which continued to resonate for a century and beyond.

Following the end of World War II, with Germany in ruins, the role of culture within society was subject to revaluation and reassessment. The position that Wagner's works had occupied in the Nazi ideology created a complex situation that was further muddied by the role that Festival director Winifred Wagner (Siegfried's widow) had played during the war with the Nazi leadership, in particular her close personal friendship with Hitler. Bayreuth had suffered bomb damage and post-war looting, and following her denazification, Winifred was banned from leading the Festival. This responsibility passed to her sons Wieland (1917–66) and Wolfgang (1919–2010), who were not only able to distance Bayreuth from its Nazi past but also succeeded in establishing an entirely new production aesthetic – symbolic and abstract – that successfully enabled a depoliticisation of the works that proved troublesome in the post-war era, notably *Meistersinger* and

Lohengrin. Wieland created a masterly synthesis, building upon the ideas of both Appia and Roller, introducing light as the major element in his productions, along with shapes and forms that were abstract and symbolic – in so doing, he replaced the 'theatre of illusion' with a 'theatre of the mind'. No longer were the audience simply drawn into what lay beyond the proscenium; rather, the abstract forms and deep lighting states that they encountered worked upon their subconscious imagination. The unsolved problems of realising some of the more 'pantomime-like effects' that the composer had been unable to resolve, such as the rainbow bridge, the dragon or the *Walküre* ride, had been replaced by a stark, almost empty stage that seemed to reflect Jung's archetypes, through which the audience could become active participants, imagining and creating the drama for themselves. Wieland saw his grandfather as a precursor of Freud and Jung, with the orchestra being the means by which the thoughts and motivations of the characters and their interactions were explored. The stage became a space of psychological states: 'the modern equivalent of the folk-tale, the saga, religion'.[29] Wieland wrote in 1951 that 'the works of Richard Wagner tolerate no change. Like all elemental works of art, they remain inviolable and sufficient unto themselves. ... The actual staging – and it alone – is subject to change. To avoid change is to transform the virtue of fidelity into the vice of rigidity.'[30] The productions of Wieland, along with his writings about his aims, redefine the notion of *Werktreue*, which in this new conception is achieved through the interrogation of the musical work, searching for new directions and processes that the original creator may never have conceived of. Just as in Wagner's role as the *Gesamtschauspieler* of the 1876 *Ring*, the crucial aspect of this work is that the interrogation should be a creative one, which may produce no single answer, but a range of possibilities. Wieland was also of the opinion that the music was the generating force of opera, as he wrote in the *Festspielbuch* of 1951:

> It is music which transmits Wagner's visions in so expressive a language that it is well-nigh impossible to duplicate those visions for the eye. The watcher will invariably fall behind the listener, however happily the scenic problems may have been solved.[31]

Wieland possessed the intense visual intuition that his grandfather had failed to realise, as he worked to distance his grandfather's operatic creations from time and place, echoing the words of Guernemanz – 'zum Raum wird hier die Zeit'.[32] Wieland combined an extraordinarily sensitive eye, which could detect the most subtle changes in lighting states, with considerable expertise as a musician. He would on occasion play the scores on the piano during the intense, painstaking work of lighting rehearsals in order to allow the sound of the score and the lighting states to fuse. Wieland possessed a knowledge of both music and lighting that surpassed that of most opera directors. His ultimate aim was to abstract and depoliticise his grandfather's works, and these aspirations extended to the interpretation of the music: in relation to *Parsifal*, Wieland told the Bayreuth chorus

director, Wilhelm Pitz: 'No unnecessary crescendos and decrescendos, no marcatos, everything mystical, but not German and not Christian Democratic'.[33]

The rise of *Regieoper*

In the new East Germany, formed at the end of the war, work was also underway to achieve a depoliticisation and rehabilitation of Wagner. The Komische Oper had been founded in 1947 in East Berlin, where the director Walter Felsenstein (1901–75) established a so-called *Musiktheater* aesthetic that was heavily focused upon production values. Felsenstein aimed to demystify opera and concentrate upon dramatic concerns within the musical context so that 'the first and most important stage director is the composer'.[34] The demystification process included accessible ticket prices and operas being sung in the (German) vernacular. Felsenstein developed many ideas which originated in Otto Klemperer's Kroll Opera (1927–31), which enjoyed a short period of renown during the Weimar Republic, presenting many radical, cutting-edge productions.[35] Felsenstein chose to focus upon a small number of operatic works, in which he found elements not only of realism but also of universal meaning and significance. In developing this repertoire and bringing it to the stage, Felsenstein was also rehabilitating cultural artefacts, bestowing upon them new meaning and relevance in the post-Nazi era. The Komische Oper provide Felsenstein with a wealth of resources to achieve his aims. Large numbers of rehearsals, by the standards of other theatres, were *de rigueur*, and the director exercised ongoing control over his productions. A performance of *La traviata* at the Komische was on one occasion cancelled because the Annina was indisposed, and no other singer could be found who had been part of Felsenstein's rehearsal process. Such a situation could never have occurred outside of this unique *milieu* – the cancellation of a mainstage performance due to the indisposition of a minor role is inconceivable in the world of commercially driven opera.

Felsenstein's practice of *Musiktheater* was developed further by his disciples Joachim Herz (1924–2013), Harry Kupfer (1935–2019) and Götz Friedrich (1930–2000). From the 1970s, their staging practices and philosophy became known as *Regieoper* (literally director's opera), a style and a term that developed within the German-speaking opera world. The word has broadly two meanings. One suggests that the *Regie* (and possibly, by extension, the director) is as important as the text and the music. In a way, this reverts to Wagner's earlier position of the 'total work of art', which implies an equality between those three disciplines. The other, more disparaging connotation of the term is where the *Regie* 'seeks to dominate the drama, to deconstruct it, to question it, even to transform the story and/or interpret it in a new way'.[36]

Regietheater has become an imprecise term that is often evoked when a production is perceived to diverge from the popularly accepted parameters of the librettist's conception. Today, the term embraces both accepted practitioners of the form as well as the work of the international celebrity stage director, who apparently operates independently, without being subject to the dramaturgical

processes of *Regietheater*. The imperative with modern productions is to connect with current situations and contemporary audiences at all costs. Some of the techniques for creating productions have already been discussed:

- updating the time and location of a work into the present day, or at least more recent times
- making modifications to the libretto in order to accommodate those changes of time and location
- the use of abstraction in set designs, and blended styles in the approach to costuming – often mixing periods and locales
- an emphasis upon sexuality and the exploration of gender issues
- exploring questions of race, gender and class-based oppression
- presenting visual elements and characterisations that contradict or play against the style of the music (creating a kind of harsh counterpoint) and generally ignoring the original stage directions

Jürgen Kühnel (1944–2018) divided the categories of *Regietheater* into four types:

1) symbolic or allegorical settings, exemplified by those of Wieland Wagner
2) *Musiktheater*-based stagings, such as those of Felsenstein and Herz
3) productions that move the story into the period of the author(s) or into the present time
4) the staging not of the story, but of the mental reflexes and reactions of the director[37]

We have seen the music–dramas of Wagner pass through the directorial hands of their creator, in the course of which he attempted to realise them on the stage through the inner vision of his mind's eye – a process which was far from successful. Following Wagner's death, music–dramas were left in a textually complete state, but the task of realising them in the theatre remained in its formative stages. The composer's productions were effectively set in aspic by his heirs in Bayreuth, immune to change. However, beyond that realm, new technologies and concepts of staging were fermenting and developing, often in response to the challenges posed by the works themselves. Following World War II, Wagner's works, exceptionally, were fairly quickly repatriated, and productions of his operas became an important element in post-war cultural recovery. The turn-around in the composer's reputation was heavily influenced by his grandson, Wieland, who was able to synthesise many strands of philosophy, psychology, art and new staging possibilities to depoliticise, mythologise and abstract his forebear's work, establishing a central place for it in German post-war culture and the international operatic canon.

Not only Wagner's music but also his conception of theatre left an indelible mark upon subsequent generations of composers and theatre practitioners. The work of Wieland Wagner pointed the way forward not just for his grandfather's work but for opera generally. The idea that staging a work might involve

interpreting and critiquing the score, that fidelity in relation to a work could mean towards the *spirit* of the work, and that such a process could potentially produce results that the original authors could not have envisaged, all arose from the ambition to make Wagner's 'deeds of music visible' on the operatic stage and were present in the practice of Mahler and Roller as far back as 1903. These notions are the direct precursors of the style of opera production that developed in Germany in the decades following 1945, based upon the examples of Wieland Wagner, Felsenstein and their followers. During a long period of heavily state-funded operatic activity in Germany, the cult of the director has developed and been imitated internationally. Countless productions have been decried as scandalous, only to be replaced by even more extreme conceptualisations. In Germany, it has become almost a rite of passage that a new production be loudly 'booed' at its première, a counter-intuitive sign of success. It is hard to judge what lies in store for the future of opera production. It cannot be denied that the current convention of director's opera has all too often taken the process of interrogating a work to an absurd position. Perhaps the opera repertoire has become an over-used commodity, something that society is fundamentally bored with, able to find nothing else to do but to parody it and overlay it with a plethora of meanings and devices that threaten to engulf it. Nevertheless, the major developments in opera production, and the evolving relationship between text, music and stage over the last 120 years, are inextricably bound up with the theatre of Richard Wagner.

Notes

1 Geoffrey Skelton, *Wieland Wagner: The Positive Sceptic* (London: Victor Gollancz Ltd., 1971), 123.
2 Bars 933–1036.
3 Bars 698–839.
4 Such as bars 350–418 of Act 3.
5 Richard Wagner, *Sämtliche Werke*, Band 8, III. *Tristan und Isolde* (Mainz: B Schott's Söhne, 1993), ix.
6 Act 1, Scene 3.
7 Patrick Carnegy, *Wagner and the Art of the Theatre* (New Haven: Yale University Press, 2006), 101, 123.
8 In Rome, a performance of *Die Walküre* was interrupted by the arrival of the King and Queen, necessitating a performance of a royal march before the performance resumed. (Carnegy, *Wagner and the Art of the Theatre*, 128.)
9 Ibid., 127.
10 Ibid., 70.
11 Ibid., 73.
12 Ibid., 73–5.
13 Ibid., 72–3.
14 See: https://brewminate.com/worlds-fairs-of-the-19th-century/, accessed 10 October 2019.
15 Carnegy, *Wagner and the Art of the Theatre*, 75.
16 Ibid., 76.
17 Ibid., 87.
18 Ibid., 89.
19 Ibid., 93.

20 Ibid., 92.
21 Ibid., 131. See fn. 65: '*Über die Bestimmung der Oper*' SSD IX, 142 (PW V, 143).
22 Ibid., 130.
23 Ibid., 136.
24 Ibid., 118.
25 Ibid. See fn. 29: 'Über die Benennung 'Musikdrama', SSD IX, 305–6 (PW VI, 302–3).
26 Ibid., 164.
27 Ibid.
28 Ibid., 172–3.
29 Ibid., 295 and see fn. 109.
30 Skelton, *Wieland Wagner, the Positive Sceptic*, 94.
31 Ibid., 95–6.
32 *Parsifal*, Act 1.
33 Carnegy, *Wagner and the Art of the Theatre*, 309, see fn. 150.
34 Peter Paul Fuchs, *The Music Theatre of Walter Felsenstein* (London: Quartet Encounters, 1991), xxii.
35 See: Carnegy, *Wagner and the Art of the Theatre*, ch. 8 – 'Travail and Truth: Klemperer and the Kroll Opera'.
36 Müller, 'Regietheater/Director's Theater', in *The Oxford Handbook of Opera*, ed. Helen M. Greenwald (Oxford: Oxford University Press, 2014), 582.
37 Ibid., quoting Jürgen Kühnel, 2007. 'Regietheater. Konzeption und Praxis am Beispiel Mozarts. Versuch einer Typologie', 13–30.

16 Conclusion

One of the fundamental themes of this study has been the examination of how humans relate to and work with the past, particularly artefacts that have been preserved and accorded a place in the museum, becoming part of the Pantheon of the fruits of human civilisation. The human preoccupation with the past has proved to be a troublesome one, at times ridden with anxiety. There was a time when an opera consisted of a loose collection of musical numbers, readily adapted, altered or reconfigured, with the potential existing for a multiplicity of versions, which could proliferate without the agency of the composer. Today, most opera goers and specialists retain a view of such operas as 'works'– entities – and those involved in the world of opera continue to struggle with the notion that, of all the classic operas that survive in the opera repertoire, only a small number exist in a single, definitive version. Much of the effort that goes into creating a new production of an opera involves reassessing the musical score and rendering it as closely as possible to the known intentions of the composer. While the score is curated according to these principles, the libretto and the staged elements of the opera are liberally reinvented, employing all kinds of posturing, in order to keep the notion of repertoire alive – to retain certain works as performable and saleable to the opera going public. Operas have to compete with the new visual worlds that have been opened up by film and the related genre of the musical. For all that the singers, orchestra and other musical forces strive for authenticity, the function of the staging is to provide a visual world that brings alive the drama for contemporary audiences. In their quest to do so, the technical staff of an opera house may devise and emulate the kinds of fantastical effects first seen on Baroque-era stages: now, as then, people still wish to be transported to other worlds. In that sense, modern opera house practice represents an attempt to achieve the 'best of both worlds' – maintaining a sense of historical musical fidelity, while creating a much more negotiable zone on the stage, where downright 'un-museum'-like offering old works a new lease of life, maintaining them as 'immortal classics', defying time, rather like Elina Makropulos in Janáček's final opera. This split or apparent disjunction between pit and stage may actually be part of the artform's enduring charm, though whether it has an everlasting life is more questionable. If

current parameters of authenticity were applied equally to the music and the stage (some historical reconstructions of early productions have occurred in recent decades) in modern opera productions, then it is a certainty that the artform would devolve into a museum curiosity and cease to exist in its current form.

In the sphere of the visual arts, it may seem that working with notions of authenticity, particularly in matters of restoration and preservation, is a more straightforward matter, as today the most sophisticated scientific techniques are available to forensically establish a painting's authorship, provenance and structural history. The scientific-based investigations of the Rembrandt Research Project (RRP), however, have shown that although much can be learned from the gathering of scientific data, the old values of connoisseurship, a specialised blend of human knowledge, observation and instinct that has long been a principal guiding force in the curatorial practices of the art museum, still has a place and a relevance in museology. Between 'objective' science and 'subjective' judgement, there is a tension which continues to create dissention and unrest in the art world. Today the authoritative six-volume opus produced by the Rembrandt Research Project, *A Corpus of Rembrandt Paintings* (1982–2014),[1] may be the latest articulation of the painter's authentic oeuvre, but it will certainly not be the last. Works that we presently regard as indisputable Rembrandts, will fall from grace in the future, and the trust of art lovers in museums will be eroded, causing them to question what is dished up for them by even the most prestigious institutions. Similarly, it is not hard to imagine that the current authoritative-looking critical editions of iconic operas will be reconsidered and superseded in future decades.

In the art world, the discovery of a forgery holds a certain morbid fascination, partly fuelled by a sense of anxiety: what other forgeries may be out there, lurking undiscovered, and what happens when our sense of security and certainty about the past is eroded? We long to feel secure in our position in the continuum of history but all too often the works of the past intrude, reminding us of their fragility, their mutability, and in turn reflecting back to us the uncertain and ephemeral nature of our own existence. Forgeries become threats to our personal identity, as the past turns around and mocks us. How do we respond to assertions that there are other 'Mona Lisa' paintings in existence, which may potentially claim greater authenticity than the 'original' in the Louvre? Did Shakespeare actually write the works attributed to him, and if not, who did? Did Monteverdi actually compose *L'incoronazione di Poppea* – it has been established that he did not write all of it, so exactly how much was penned by him? We search for recognisable names among those who have produced lasting works of cultural value. Works that are 'anonymous' are not popular: a work by Giotto is more easily appreciated than one by 'The Master of the Vaulting of St Francis',[2] a designation that disconnects the art lover from any sense of a person with a name, a birthplace and a biography. Many facts are known about the life of Monteverdi, who makes a personable subject for a biography. It is possible for an interested music lover to 'get to know' Monteverdi by reading about him, and while there remains a haze around the authorship of his final opera, this becomes an intriguing mystery to be solved. One can trawl back through history, hoping to draw closer to the past, while, in the

words of Walter Benjamin, the object of interest retains 'a unique manifestation of a remoteness, however close it may be'.[3]

As a consolation, our culture has created the reproduction, a kind of 'authentic' fake, which may be seen, admired and even purchased in the ubiquitous art-museum shop. A visitor to such a museum may acquire a reproduction of a work from the collection, which may come to represent the work in their mind, facilitating a 'fake experience'. In disseminating a potentially unlimited number of iconic images of significant works, the apparent interchangeability of the real and the reproduction becomes disturbing. Benjamin describes the phenomenon thus: 'getting closer to things' in both spatial and human terms is every bit as passionate a concern of today's masses as their tendency to surmount the uniqueness of each circumstance by seeing it in reproduction.[4] A more cynical view was expressed by Theodor Adorno, who described the opera repertoire as 'a limited store of works, which have long since sunk into the living-room treasure chests of the petite bourgeoisie, like Raphael's paintings, abused through innumerable reproductions'.[5] This leads us to the phenomenon of hyperreality.[6]

The *Albertina Museum* in Vienna holds a famous drawing by Albrecht Dürer, *Young Hare* (1502), which is rarely displayed. 'After a maximum of three months, *Young Hare* needs five years in dark storage with a humidity level of less than 50 percent for the paper to adequately rest.'[7] In order to maintain a semblance of accessibility to this elusive jewel of the *Albertina* collection, as mandated by the original owners (the Habsburg royal family), there is a facsimile that can be viewed more readily. A Google Cultural Institute Gigapixel image of the *Hare* is readily available online – 'the better to see the reflections in the bunny's eyes with'.[8] Dürer's iconic work has become both widely available and strangely reclusive in recent times, the 'authentic' work substituted by a very accessible reproduction with a commentary that calls into question the value of experiencing the work of art in its original form (Google is nearly as good, in some ways better). Today, we can all enter the great art museums of the world from the comfort of our living rooms, just as we can invite operatic museums into our homes courtesy of live broadcasts. A cinema ticket to a 'live' Met broadcast can be purchased for a fraction of the cost of a ticket to a live performance at the Met – surely the 'reproduction' is the sensible, accessible solution? But perhaps it nevertheless lacks something? Walter Benjamin also speaks of an 'aura',[9] a peculiar quality that emanates from artworks, something that is innate to the 'work' which remains immutable through its journey in time, even while the work's function, meaning and state of preservation may alter considerably. It is this essence of a 'work' that cannot be reproduced: 'even the most perfect reproduction of a work of art is lacking in one element: its presence in time and space, its unique existence at the place where it happens to be'.[10] This is a concept that causes our modern civilisation considerable unrest, resulting in a prurient interest in, even fetishisation of, works of the past.

Perhaps the continued fascination with Han van Meergeren and his forgeries is the result of our own fears that we may be 'getting it wrong', that works that we hold to be authentic, or genuine are, unbeknownst to us, forgeries, reproductions,

copies (possibly inept ones) or misattributions, and that our perceptions are inevitably limited by our particular place in time and the continuum of history. We look back at what passed for a Vermeer in the 1930s and 1940s and are horrified – how did they get it so wrong? What would we do if we came to prefer a reproduction over the original? How would we deal with our shame if we mistook a forgery for an authentic work? Perhaps it is not such a bad thing that we tread with more care today and recognise that we are less certain of our relationship to the past than we would care to admit. This may save us from some of the many errors of judgement with which history is littered:

> It is very pleasant to walk the streets here. Over almost every door is an antique statue or basso-relievo, more or less good though all much broken, so that you are in a perfect gallery of marbles in these lands. Some we steal, some we buy ... We have just breakfasted and are meditating a walk to the citadel, where our Greek attendant is gone to meet the workmen and is, I hope, hammering down the Centaurs and Lapiths [from the frieze of the Parthenon] ... Nothing like making hay when the sun shines and when the commandant has felt the pleasure of having our sequins for a few days, I think we shall bargain for a good deal of the old temple.[11]

The author of this account, John Morritt, undoubtedly felt himself to be performing a useful, even noble, deed. He saw himself as a curator, a custodian whose job it was to appropriate treasures from distant lands and bring them to the safe repository of a museum within the British Empire. Curator Susanna Kearsley has written:

> In the years that I worked in museums ... one of the primary lessons I learned was this: History is shaped by the people who seek to preserve it. We, of the present, decide what to keep, what to put on display, what to put into storage, and what to discard. These choices can be made unconsciously, or they can serve (or subvert) an unspoken agenda.[12]

As much as we attempt to understand the past, using our knowledge to help us reimagine and preserve the works that survive from the past, what can we ever actually know – how close can we come? One of the most well-known, haunting images of Mozart is an unfinished portrait, painted by his brother-in-law, Joseph Lange.[13] The sombre hues of the work, along with its unfinished state, seem to encapsulate the melancholy of the last months of the composer's life: a creative life cut tragically short. It is a much-reproduced work, and one of the few images of Mozart from which we might imagine we are gaining some semblance of private, personal insight into the man, beyond the music. The portrait presents a likeness that is somehow 'knowable'. In fact, little is known for certain about the portrait other than that Mozart is the subject, Lange was the painter, and the picture was left unfinished, which conveniently evokes Mozart's incomplete late works that his premature death has denied us. In recent times, however, even the

question of the work's unfinished state has been challenged, and attempts made to date the portrait have been inconclusive. The year 1791 (which would be most biographically appropriate) has been proposed, while some scholars have preferred an earlier date of 1782. An investigation by Michael Lorenz[14] has led to an alternate hypothesis that the painting is the companion work to a portrait of Constanze Mozart (1782).[15] This small (18 cm × 13 cm) portrait has been shown to be attached to a larger (32.3 cm × 24.8 cm) canvas and reworked. A photograph taken of the portrait of Wolfgang in a pre-restoration state in 1946 shows very similar characteristics to those of the Constanze likeness – a miniature portrait, irregular in shape, turned a few degrees and attached to a larger canvas. Lorenz makes the claim that 'the Mozart portrait by Joseph Lange is not an unfinished painting of "Mozart at the Piano", but an unfinished enlargement of an original miniature of Mozart's head'. In this case, a portrait that seemed to convey a very private, introspective, late image of the composer, potentially allowing us some kind of visual entry point to the final period of his life, has been found not to be what it seems; it remains a private, intimate portrait of a composer whose music we know almost too well, but for whose 'aura' we are still searching.

Operatic works vividly reflect the times in which they were created. Enjoyment of them is inseparable from the social, historic and political contexts that produced them. This wider sense of an opera's history and influence is something that fascinates and enriches opera lovers, and that makes the artform an ideal aesthetic space in which to play with the past and develop a dialogue with the present. The physical opera house is, however, a more unruly environment, difficult to tame or to pin down. Within it reside highly complex musical works, the products of some of the most iconic composers of the Western canon, alongside other works which are popular, lighter, even plain 'worthy' – nonetheless they occupy a significant place in the repertoire of the opera house and often receive more performances than canonic masterpieces. Other operas may contain sublime music – but have proven to be too long for modern tastes or simply not quite stage worthy by the standards of today, their plots having dated. Each kind of work requires a different approach to its curation. 'Worthy' and 'not quite stage worthy' require more invasive approaches, requiring a new scaffold or support. The 'masterpiece' requires caution, perhaps the practice of *Werktreue* or some similar construct, allowing it to be 'authentically' realised. Authenticity has been selectively incorporated into the musical practices of the opera house, with conductors, music staff and – with their assistance – singers increasingly preparing performances according to some of the criteria of HIP.[16] In Mozart recitatives, singers no longer need to use their instincts; they can look at the editorial suggestions printed in the critical editions of his works to discover where *appoggiature* should be interpolated.[17] In contexts where a singer would typically extemporise a cadenza, it is more usual to search for one that has been used by a famous singer of the past (a 'genuine fake'), which will provide some sense of historical veracity, than to create a new version or even spontaneously improvise one. Hyperreality is no stranger to the opera house.

However carefully considered, the practice of curation does not always 'get it right', but what is notable is the sense of resilience that characterises the central operatic repertoire, which is able to survive power-hungry functionaries, ego-driven artists, directors and conductors who, from within their own backgrounds and disciplines, often bring polarised points of view towards the treatment of these works. Ultimately however, operatic productions are tangible objects, as are the artworks in a museum. People are fascinated by things, relics from the past, we try to make sense of them, we hope they may be able to give us some clues about the human condition and where civilisation is heading. Both art and operatic museums preserve and present the past to people who are hungry to learn more about their origins. The curatorial processes that are employed to carry out these tasks are central to an understanding and appreciation of our world.

Afterword, July 2020

This book was completed in Sydney, Australia, during a lockdown, which commenced on 31 March in New South Wales, as a response to the COVID-19 virus. The worldwide pandemic has changed life as we know it, and no one can be sure what the 'other side' will look like, when, or even if it might be reached. The opera industry in Australia has long been heavily reliant on the services and skills of singers, conductors and directors from beyond these shores for their operations. Live operatic performance in Australia has been effectively silenced for the foreseeable future. Local artists, including orchestral musicians and chorus singers contemplate long-term unemployment. As time continues to pass, speculation grows as to whether the opera industry as it previously existed may ever shift back towards what was once 'normal'.

During the course of this year we have witnessed many events that we had perhaps never contemplated. Public art galleries have closed, images have circulated widely of artworks wrapped in funereal black cloths. Reports of the staff of these institutions being made redundant, leaving cavernous buildings, populated only by inanimate objects have been confirmed. The creative spirit has not been idle – some galleries have taken the opportunity to practise conservation and restoration on iconic works that are otherwise difficult to remove from public display.[18] Art lovers have busied themselves making pastiches of, and reimagining favourite art works, posting images of their creations online, paying homage to and attempting to somehow engage with what they have been deprived of.

Opera houses worldwide have gone dark. While the scores and publications that represent the opera repertoire remain safely preserved, those who animate these works are facing a bleak and uncertain future. Central-European countries continue to subsidise opera workers during these times, with most singers, instrumentalists and other functionaries of theatres receiving income relief, whereas in other places where opera funding necessitates a more hand-to-mouth existence, salaried staff are furloughed and many freelance performers have been left in a dire situation, deprived of their incomes, and unsure if or when their occupation may resume. What happens to a singer or an instrumentalist who does not perform

for two years? How will they pick up the threads of their career? COVID-19 has highlighted the fragile human fabric of the operatic museum, and the fact that while opera consists of 'works', instantiated by physical scores and productions, opera as an artform is defined and animated by the human spirit.

Arts companies have been busy maintaining some semblance of activity: posting archival footage of past performances, or creating and sharing podcasts of individual instrumentalists or singers performing to an empty hall, attempting to maintain the notion of live performance, albeit virtually. In other times, under different circumstances, these 'virtual' performances might be dubbed 'fake' experiences, reproductions that are hyperreal – but at the present time, they are a lifeline that has managed to give some sense of presence to an ailing industry that would otherwise be invisible. Poetic and beautifully curated events have been crafted in response to the crisis, notably a performance of Puccini's *Crisantemi* for string quartet, which was performed at the Gran Teatre del Liceu in Barcelona to a live audience of 2292 indoor plants.[19] Such considered responses only intensify our awareness of the fragility of the world around us, and the transitory nature of what we hold dear. Opera, in its generally acknowledged form, is just over 400 years old. There is no guarantee it will survive in a recognisable form for another 100. In *The Museum of Lost Art*, Noah Charney reminds us that many well-known artworks by great artists may not, in fact, be their greatest works but 'just the ones that happen to survive, winning the historical roll of the dice'.[20] We await the next roll of the dice to learn how the future of opera will be curated.

Notes

1 http://rembrandtdatabase.org/literature/corpus, accessed 18 March 2020.
2 Galienne Francastel and Pierre Tisné, *Italian Painting, Byzantine to Renaissance*, trans. M.J. Strachan (London: A. Zwemmer Ltd, 1956).
3 Walter Benjamin and J.A. Underwood, *The Work of Art in the Age of Mechanical Reproduction* (translated from the German) (London: Penguin, 2008), 9.
4 Ibid.
5 Theodor W. Adorno, 'Bourgeois Opera' (1955) in *Opera Through Other Eyes*, ed. David Levin (Stanford: Stanford University Press, 1993), quoted in Heather Wiebe, 'The Rake's Progress as Opera Museum', *Opera Quarterly* 25, no. 1–2 (Winter–Spring 2009): 8.
6 Eco, *Faith in Fakes: Essays*, (London: Secker and Warburg, 1986), 1–58.
7 www.bbc.com/culture/story/20150123-7-masterpieces-you-cant-see, accessed 30 April 2015.
8 Ibid.
9 Miriam Bratu Hansen, 'Benjamin's Aura', *Critical Inquiry* 34, no. 2 (2008): 336–75, accessed April 10 2020.
10 Ibid.
11 John Bacon Sawry Morritt, c1798, in Edward Hollis, *The Secret Lives of Buildings: From the Ruins of the Parthenon to the Vegas Strip in Thirteen Stories*, 1st ed. (New York: Metropolitan Books, 2009), 30.
12 http://news.nationalpost.com/arts/susanna-kearsley-curating-canlit, accessed 3 March 2017.
13 Joseph Lange (1751–1831), amateur painter and brother in law of Mozart.

14 http://michaelorenz.blogspot.com.au/2012/09/joseph-langes-mozart-portrait.html, accessed 28 January 2020.
15 www.huntsearch.gla.ac.uk/cgi-bin/foxweb/huntsearch/DetailedResults.fwx?collection=art&searchTerm=43746, accessed 30 January 2020.
16 Historically Informed Performance practice.
17 All of the Italian operas of Mozart published by Bärenreiter contain (mostly in the recitatives) editorial additions of suggested *appoggiaturas*.
18 For example, Jackson Pollock's 'Blue Poles' in the National Gallery of Australia, Canberra, Australia.
19 https://observer.com/2020/06/barcelona-plant-opera-eugenio-ampudia/, accessed 20 July 2020.
20 Noah Charney, *The Museum of Lost Art* (London: Phaidon Press Limited, 2018), 14.

Bibliography

Abbate, Carolyn and Roger Parker. *A History of Opera: The Last Four Hundred Years* (London: Allen Lane, 2012).
Abbate, Carolyn. 'Tristan in the Composition of Pelléas', *19th-Century Music* 5, no. 2 (Autumn, 1981): 117–41.
Abert, Hermann and Peter Gellhorn. *Mozart's 'Don Giovanni'* (London: Eulenburg Books, 1976).
Adorno, Theodor W. 'Bourgeois Opera' (1955), in *Opera Through Other Eyes* (Stanford: Stanford University Press, 1993), quoted in: Heather Wiebe. 'The Rake's Progress as Opera Museum', *Opera Quarterly* 25, no. 1–2 (Winter–Spring 2009): 8.
Arnold, Ken. *Cabinets for the Curious* (Aldershot: Ashgate Publishing Limited, 2006).
Atkinson, Paul. *Everyday Arias: An Operatic Ethnography* (Lanham: AltaMira Press, 2006).
Baker, Evan. *From the Score to the Stage: An Illustrated History of Continental Opera Production and Staging* (Chicago: University of Chicago Press, Ltd., 2013).
Balkin, Jack M. 'Verdi's High C', *Texas Law Review* 91 (2013): 1687–8.
Balzer, David. *Curationism* (Toronto: Coach House Books, 2014).
Bassett, Kate. *In Two Minds: A Biography of Jonathan Miller* (London: Oberon Books Ltd, 2012).
Bauman, Thomas. *W.A. Mozart, Die Entführung aus dem Serail, Cambridge Opera Handbooks* (Cambridge: Cambridge University Press, 1987).
Beck, James and Michael Daley. *Art Restoration: The Culture, the Business and the Scandal* (New York: W.W. Norton & Company, 1993).
Benjamin, Walter and J. A. Underwood. *The Work of Art in the Age of Mechanical Reproduction*, Translated from the German (London: Penguin, 2008).
Bereson, Ruth. *The Operatic State, Cultural Policy and the Opera House* (London: Routledge, 2002).
Berlioz, Hector and Elizabeth Csicsery-Rónay. *The Art of Music and Other Essays (a Travers Chants)* (Bloomington: Indiana University Press, 1994).
Berlioz, Hector. *Gluck and His Operas; With an Account of Their Relation to Musical Art* (Westport: Greenwood Press, 1973).
Bianconi, Lorenzo and Giorgio Pestelli, eds. *Opera in Theory and Practice, Image and Myth* (London: The University of Chicago Press, 2003).
Bloom, Peter, ed. *Berlioz Studies* (Cambridge: Cambridge University Press, 1992).
Böhm, Karl. *Ich Erinnere Mich Ganz Genau: Autobiographie* (Wien: F. Molden, 1974).
Bourdieu, Pierre. *The Rules of Art: Genesis and Structure of the Literary Field*, Translated by Susan Emanuel (Cambridge: Polity Press, 1996).

Bibliography

Bourdieu, Pierre and Randal Johnson. *The Field of Cultural Production: Essays on Art and Literature* (Cambridge: Polity, 1993).

Branscombe, Peter. *W.A. Mozart, Die Zauberflöte, Cambridge Opera Handbooks* (Cambridge: Cambridge University Press, 1991).

Brenson, Michael. 'The Curator's Moment: Trends in the Field of International Contemporary Art Exhibitions', *Art Journal* 57, no. 4 (Winter 1998): 16–27.

Brown, Bruce Alan. *W.A. Mozart, Così fan Tutte, Cambridge Opera Handbooks* (Cambridge: Cambridge University Press, 1995).

Budden, Julian. *The Operas of Verdi*, Vol. 2 (New York: Oxford University Press, 1978).

Busoni, Ferruccio. *The Essence of Music and Other Papers*, Translated by Rosamond Ley (London: Rockliff, 1957).

Carnegy, Patrick. *Wagner and the Art of the Theatre* (New Haven: Yale University Press, 2006).

Carter, Tim. *Monteverdi's Musical Theatre* (Hartford, CT: Yale University Press, 1982).

Carter, Tim. *Mozart's Le nozze di Figaro* (Cambridge: Cambridge University Press, 1987).

Chailley, Jacques. 'The Magic Flute Unveiled: Esoteric Symbolism in Mozart's Masonic Opera, 1992'.

Charney, Noah. *The Museum of Lost Art* (London: Phaidon Press Limited, 2018).

Cook, Nicholas. *Beyond the Score: Music as Performance* (New York: Oxford University Press, 2014).

Cowgill, Rachel et al. *Art and Ideology in European Opera: Essays in Honour of Julian Rushton* (Woodbridge: Boydell, 2010).

Danto, Arthur. 'The Artworld', *Journal of Philosophy* 62, no 19 (1964): 571–84.

Del Mar, Norman. *Anatomy of the Orchestra* (London: Faber and Faber, 1983).

Dent, Edward J. *Mozart's Operas, a Critical Study*, 2nd ed. Oxford Paperbacks (London: Oxford University Press, 1960).

Dizikies, John. *Opera in America* (New Haven: Yale University Press, 1993).

Donington, Robert. *The Rise of Opera* (London: Faber, 1981).

Dykstra, Steven W. 'The Artist's Intention and the Intentional Fallacy in Fine Arts Conservation', *Journal of the American Institute for Conservation* 35, no 3 (1996): 197.

Eco, Umberto. *The Infinity of Lists* (London: MacLehose, 2009).

Eco, Umberto, trans. *The Open Work* (London: Hutchinson Radius, 1989).

Einstein, Alfred. *Gluck*, 1st ed. Reprinted with revisions. Ed: Dent. (Farrar Straus and Cudahy, 1964).

Einstein, Alfred. *Mozart: His Character, His Work* (London: Cassell, 1946).

Ellis, Katharine. 'Rewriting *Don Giovanni* or "the Thieving Magpies"', *Journal of the Royal Musical Association* 119, no. 2 (1994): 213.

Everist, Mark. *Mozart's Ghosts, Haunting the Halls of Musical Culture* (Oxford: Oxford University Press, 2012).

Everist, Mark. 'Enshrining Mozart: *Don Giovanni* and the Viardot Circle', *19th-Century Music* 24, no. 2–3 (Fall/Spring 2001–02): 165–89.

Fiorani, Francesca. 'Reviewing Bredecamp' (1995), *Renaissance Quarterly* 51, no. 1 (Spring 1998): 268–70.

Francastel, Galienne and Pierre Tisné. *Italian Painting, Byzantine to Renaissance*, Translated by M.J. Strachan (London: A. Zwemmer Ltd, 1956).

Fuchs, Peter Paul. *The Music Theatre of Walter Felsenstein* (London: Quartet Encounters, 1991).

Bibliography 213

Geddie, William, ed. *Chambers' Twentieth Century Dictionary* (Edinburgh: London: W. & R. Chambers, Ltd., 1959).
Gibbons, William. *Building the Operatic Museum: Eighteenth-Century Opera in Fin-De-Siècle Paris* (Rochester: University of Rochester Press; Woodbridge: Boydell and Brewer Limited, 2013).
Goehr, Lydia. *The Imaginary Museum of Musical Works* (Oxford: Oxford University Press, 2007).
Gossett, Philip. *Divas and Scholars: Performing Italian Opera* (Chicago: University of Chicago Press, 2006).
Greenwald, Helen M., ed. *The Oxford Handbook of Opera* (Oxford: Oxford University Press, 2014).
Gruber, Gernot. *Mozart and Posterity* (Boston: Northeastern University Press, 1994).
Hahn, Reynaldo. 'Notes', *Journal d'un Musicien* (Paris, 1933).
Hansen, Miriam Bratu. 'Benjamin's Aura', *Critical Inquiry* 34, no. 2 (2008): 336–75.
Harnoncourt, Nikolaus. *Mozart-Dialoge* (Kassel: Bärenreiter Verlag, 2009).
Hartmann, Rudolf. *Handbuch des Korrepetierens (Zur Psychologie und Methodik des Partienstudiums)* (Berlin: Max Hesses Verlag, 1926).
Headington, Christopher, Roy Westbrook and Terry Barfoot. *Opera: A History* (London: Arrow Books, 1991).
Heesen, Anke te. *Theorien des Museums* (Hamburg: Junius Verlag, 2012).
Heller, Joseph. *Picture This* (London: Macmillan, 1988).
Hollis, Edward. *The Memory Palace: A Book of Lost Interiors* (London: Portobello Books, 2013).
Howard, Patricia. *C.W. von Gluck, Orfeo* (Cambridge: Cambridge University Press, 1981).
Hunter, Michael Cyril William, Alison Walker and Arthur MacGregor. *From Books to Bezoars: Sir Hans Sloane and His Collections* (London: British Library, 2012).
Impey, R. and Arthur MacGregor. *The Origins of Museums: The Cabinet of Curiosities in Sixteenth and Seventeenth Century Europe* (New York: Clarendon Press; Oxford: Oxford University, 1985).
Kerman, Joseph. *Opera as Drama* (Berkeley: University of California Press, 1988).
Kerman, Joseph. 'A Few Canonical Variations', *Critical Enquiry* 10, no. 1 (Sep 1983).
Kersten, Fred. *Galileo and the "Invention" of Opera: A Study in the Phenomenology of Consciousness* (Dordrecht: Kluwer Academic, 1997).
Kirkendale, Warren. 'The Myth of the "Birth of Opera" in the Florentine Camera Debunked by Emilio de' Cavalieri: A Commemorative Lecture', *The Opera Quarterly* 19, no. 4 (Autumn 2003), (Oxford University Press).
Kloiber, Rudolf. *Handbuch Der Oper* (Regensburg: Gustav Bosse Verlag, 1952).
Kloiber, Rudolf, Wulf Konold and Robert Maschka. *Handbuch Der Oper, 9., erw., neubearbeitete Aufl., gemeinschaftliche Originalausg. ed.* (München Kassel: Deutscher Taschenbuch Verlag; New York: Bärenreiter, 2002).
Kobbé et al. *The New Kobbé's Opera Book* (London: Ebury Press, 1997).
Kobbé, Gustav and George H.H.L. Harewood. *The Definitive Kobbé's Opera Book*, 1st American ed. (New York: Putnam, 1987).
Kobbé, Gustav and George H.H.L. Harewood. *Kobbé's Complete Opera Book*, 8th ed. (London: Putnam, 1969).
Kobbé, Gustav. *The Complete Opera Book* (London: Putnam, 1922).
Konold, Wulf and Inter Nationes. *German Opera, Then and Now: Reflections and Investigations on the History and Present State of the German Musical Theatre* (Basel: Bärenreiter Kassel, 1980).

Krehbiel, Henry Edward. *More Chapters of Opera; Being Historical and Critical Observations and Records Concerning the Lyric Drama in New York from 1908 to 1918* (New York: Henry Holt and Company, 1919).

La Grange, Henri-Louis de. *Gustav Mahler*, Vol 2. (Oxford: Oxford University Press, 1995).

Latham, Alison and Roger Parker. *Verdi in Performance* (Oxford: Oxford University Press, 2001).

Leinsdorf, Erich. *Erich Leinsdorf on Music* (Portland: Amadeus Press, 1997).

Levin, David J., ed. *Opera Through Other Eyes* (Stanford: Stanford University Press, 1993).

Levin, David J. *Unsettling Opera: Staging Mozart, Verdi, Wagner and Zemlinsky* (Chicago: The University of Chicago Press, 2007).

Loewenberg, Alfred. *Annals of Opera, 1597–1940* (New Jersey: Rowman and Littlefield, 1978).

Lowenthal, David. *The Past is a Foreign Country* (Cambridge: Cambridge University Press, 1985).

Lubar, Steven. *Inside the Lost Museum* (Cambridge, MA: Harvard University Press, 2017).

Lynch, Christopher. '*Die Zauberflöte* at the Metropolitan Opera House in 1941: The Mozart Revival, Broadway and Exile', *Music Quarterly* 100 (2017): 33–84.

Marvin, Roberta Montemorra and Downing A. Thomas. *Operatic Migrations: Transforming Works and Crossing Boundaries* (Aldershot: Ashgate, 2006).

Mathew, Nicholas and Benjamin Walton. *The Invention of Beethoven and Rossini* (Cambridge: Cambridge University Press, 2013).

Mauriès, Patrick. *Cabinets of Curiosities* (London: Thames and Hudson, 2002).

Meyer-Dinkgräfe, Daniel. '*Regieoper* und *Werktreue*', in *Music on Stage*, ed. Fiona Schopf (Newcastle: Cambridge Scholars Publishing, 2015).

Moss, Hugh. *The Art of Understanding Art* (London: Profile Books Ltd, 2015).

Munari, Bruno. *Design as Art* (London: Penguin Books, 1971).

Niemetschek, Franz Xaver. *Life of Mozart (Leben Des K.K. Kapellmeisters Wolfgang Gottlieb Mozart)* (1798), Hyperion reprint ed. (Westport: Hyperion Press, 1979).

Obrist, Hans Ulrich. *A Brief History of Curating* (Zurich: Jrp Ringier, 2008).

Obrist, Hans Ulrich. *Everything You Always Wanted to Know About Curating*: *but Were Afraid to Ask*, Edited by April Elizabeth Lamm (Berlin: Sternberg Press, 2007).

O'Neill, Paul. *The Culture of Curating and the Curating of Culture(s)* (Cambridge, MA: MIT Press, 2012).

Osborne, Richard. *Rossini* (London: J.M. Dent & Sons Ltd., 1986) 288.

Parker, Roger. *Remaking the Song: Operatic Visions and Revisions from Handel to Berio* (Berkeley: University of California Press, 2006).

Paul, Carole, ed. *The First Modern Museums of Art* (Los Angeles: The J. Paul Getty Museum, 2012).

Poriss, Hilary. *Changing the Score: Arias, Prima Donnas and the Authority of Performance, Ams Studies in Music* (Oxford: Oxford University Press, 2009).

Quinn, Malcolm., David Beech, Michael Lehnert, Carol Tulloch and Stephen Wilson, eds. *The Persistence of Taste Art, Museums and Everyday Life after Bourdieu* (London: Routledge, 2018).

Reece, Frederick. 'Composing Authority in Six Forged "Haydn" Sonatas', *The Journal of Musicology* 35, no. 1 (2018): 104–43.

Rice, Edward J. *W.A. Mozart, La clemenza di Tito, Cambridge Opera Handbooks* (Cambridge: Cambridge University Press, 1991).

Roberts, Warren. *Rossini and Post-Napoleonic Europe* (Rochester: University of Rochester Press, 2015).
Rosand, Ellen. *Opera in Seventeenth-Century Venice: The Creation of a Genre* (Berkeley: University of California Press, 1991).
Rosenthal, Harold. *Two Centuries of Opera at Covent Garden* (London: Putnam, 1958).
Rosselli, John. *Music and Musicians in Nineteenth-Century Italy* (London: Batsford, 1991).
Rosselli, John. *The Opera Industry in Italy from Cimarosa to Verdi* (Cambridge: Cambridge University Press, 1984).
Rugg, Judith and Michele Sedgwick. *Issues in Curating Contemporary Art and Performance* (Bristol: Intellect Books, 2007).
Rushton, Julian. *W.A. Mozart, Idomeneo* (Cambridge: Cambridge University Press, 1983).
Rushton, Julian. *W.A. Mozart, Don Giovanni* (Cambridge: Cambridge University Press, 1981).
Sadie, Stanley. *The New Grove Dictionary of Opera*, 4 vols (London: Macmillan, 1992).
Saïd, Edward W. *On Late Style: Music and Literature against the Grain* (New York: Pantheon Books, 2006).
Saint-Saëns, Camille and Roger Nichols. *Camille Saint-Saëns on Music and Musicians* (Oxford: Oxford University Press, 2008), 169.
Saint-Saëns, Camille. *Portraits Et Souvenirs, L'art et les Artistes* (Paris: Société d'édition artistique, 1900).
Sawallisch, Wolfgang. *Im Interesse der Deutlichkeit: Mein Leben mit der Musik* (Hamburg: Hoffmann and Campe, 1988).
Senici, Emanuele. 'Adapted to the Modern Stage: *La clemenza di Tito* in London', *Cambridge Opera Journal* 7, no. 1 (1995): 1–22.
Serafin, Tulio. *Stile, traditione, e convenzioni del melodrama italiano* (Milano: Ricordi, 1958).
Skelton, Geoffrey. *Wieland Wagner: The Positive Sceptic* (London: Victor Gollancz Ltd., 1971).
Snowman, Daniel. *The Gilded Stage: The Social History of Opera* (London: Atlantic, 2009).
Stanislavsky, Constantin. *My Life in Art* (Boston: Little Brown & Co., 1924).
Sternfeld, Frederick Wilhelm. *The Birth of Opera* (Oxford: Clarendon Press, 1993).
Strunk, Oliver et al. *Source Readings in Music History*, Vol 5 (London: Faber and Faber, 1952).
Süskind, Patrick. *Der Kontrabass* (Zürich: Diogenes, 1984).
Taruskin, Richard. *Music in the Nineteenth Century* (Oxford: Oxford University Press, 2010).
Taruskin, Richard. *Music in the Seventeenth and Eighteenth Centuries* (Oxford: Oxford University Press, 2010).
Thielemann, Christian. *My Life with Wagner* (Great Britain: Weidenfeld & Nicolson, 2015).
Thompson, Don. *The Curious Economics of Contemporary Art* (London: Aurum Press Ltd., 2008).
Till, Nicholas, ed. *The Cambridge Companion to Opera Studies* (Cambridge: Cambridge University Press, 2012).
Walden, Sarah. *The Ravished Image or, How to Ruin a Masterpiece by Restoration* (London: Weidenfeld and Nicolson, 1985).
Weber, William. *The Great Transformation of Musical Taste* (Cambridge: Cambridge University Press, 2008).

Weber, William. *The Rise of Musical Classics in Eighteenth-Century England: A Study in Canon, Ritual and Ideology* (New York: Clarendon Press; Oxford: Oxford University Press, 1992).
Wetering, Ernst van de and Paul Broekhoff. 'New Directions in the Rembrandt Research Project, Part 1: The 1642 Self-Portrait in the Royal Collection', *The Burlington Magazine* (1996).
Whitehead, Christopher. *Museums and the Construction of Disciplines* (London: Gerald Duckworth & Co. Ltd., 2009).
Wiebe, Heather. 'The Rake's Progress as Opera Museum', *Opera Quarterly* 25, no. 1–2 (Winter–Spring 2009): 8.
Woodfield, Ian. *The Vienna Don Giovanni* (Woodbridge: Boydell, 2010).
Woodfield, Ian. *Mozart's Così fan Tutte: A Compositional History* (Woodbridge: Boydell Press, 2008).

Scores consulted

Berg, Alban, Hans Erich Apostel, Vida Harford and Eric A Blackall. *Georg Büchners Wozzeck. Oper in 3 Akten (15 Szenen)* ... Op. 7. Partitur. Nach Den Hinterlassenen Endgültigen Korrekturen Des Komponisten Revidiert von H. E. Apostel (1955). English Translation by Eric Blackall and Vida Harford. (Wien: Universal Edition, 1955).
Berg, Alban. *Lulu* (3-act version) Universal Edition, Vienna (vocal score) 10745A, 1964.
Britten, Benjamin. *Owen Wingrave* (television opera) Faber Music, Full Score, 1995.
Britten, Benjamin. *Billy Budd*, revised version (London: Boosey & Hawkes, 1961).
Britten, Benjamin. *Peter Grimes* (London: Boosey & Hawkes, 1945).
Cavalli, Francesco and Jennifer Williams Brown, ed. *La Calisto* (Wisconsin: A-R Editions, Inc., 2007).
Debussy, Claude. *Pelléas et Mélisande*, vocal score (Paris: Durand, 1907).
Francesco, Cavalli, Álvaro Torrente and Nicola Badolato, ed. *La Calisto* (Kassel: Bärenreiter Verlag, 2013).
Gluck, Christoph Willibald Ritter von and Hermann Abert. *Orfeo Ed Euridice*. Originalpartitur Der Wiener Fassung Von 1762 (Graz: Akad. Druck- u. Verl., 1960).
Gluck, Christoph Willibald Ritter von and Alfred Dörffel. *Orpheus, Opera in 3 Acts* [in German, French and Italian text]. (Leipzig: C. F. Peters, n.d.).
Henry, R. Bishop ed. Christina Fuhrmann. *Mozart's the Marriage of Figaro: Adapted for Covent Garden, 1819* (Middleton: A-R Editions, 2012).
Monteverdi, Claudio and Alan Curtis, ed. *L'incoronazione di Poppea* (London: Novello, 1989).
Mozart, Wolfgang Amadeus and Vittorio Gui, ed. *Idomeneo* (Milano: Edizioni Suvini Zerboni, 1947).
Mozart, Wolfgang Amadeus and Alexander Zemlinsky. *Die Zauberflöte*, für Klavier zu 4 Händen, UE708A. (Vienna: Universal Edition, ca. 1906).
Mozart, Wolfgang Amadeus et al. *La clemenza di Tito*, Bärenreiter score TP 321 (Kassel: Bärenreiter, 1997).
Mozart, Wolfgang Amadeus et al. *Così fan tutte*, Bärenreiter score BA 4606 (Kassel: Bärenreiter, 1991).
Mozart, Wolfgang Amadeus et al. *Die Entführung aus dem Serail*, Bärenreiter score BA 4591 (Kassel: Bärenreiter, 1982).

Mozart, Wolfgang Amadeus et al. *Don Giovanni*, Bärenreiter score BA 4550 (Kassel: Bärenreiter, 1979).
Mozart, Wolfgang Amadeus et al. *Le nozze di Figaro*, TP 320 (Kassel: Bärenreiter, 1973, 2011).
Mozart, Wolfgang Amadeus et al. *Idomeneo: [Dramma Per Musica in Tre Atti]* BA 4562 (Kassel: Bärenreiter, 1972).
Mozart, Wolfgang Amadeus et al. *Die Zauberflöte*, Bärenreiter score BA 4553 (Kassel: Bärenreiter, 1970).
Mozart, Wolfgang Amadeus, J. Pittman and Arthur Sullivan. *Il Flauto Magico. Opera in Two Acts, with Italian and English Words*, Edited by Arthur Sullivan and J. Pittman (London: Boosey and Co, 1871).
Mozart, Wolfgang Amadeus, J. Wrey Mould and W.S. Rockstro. *Die Zauberflöte* (London: T. Boosey & Co., 1850).
Mozart, Wolfgang Amadeus, J. Wrey Mould and W. S. Rockstro. *Jon Juan: or the Libertine Punished. (Il Don Giovanni) Ossia (Il Dissoluto Punito)*. Founded on the Spanish Tale of L. Tirso de Molina by the Abbé da Ponte (London: T Boosey and Co., 1850).
Rossini, Gioachino Cesare Sterbini and Alberto Zedda. *Il Barbiere di Siviglia* (Milano: Ricordi, 1969).
Rossini, Gioachino and Patricia Brauner. *Il barbiere di Siviglia* (Milano: Ricordi, 2008).
Schoenberg, Arnold. *Die glückliche Hand*, UE13613, (Vienna: Universal Edition, N.D.).
Shostakovitch, Dmitri. *Lady Macbeth von Mtsensk*, vocal score (Hamburg: Hans Sikorski Verlag, 1979).
Strauss, Richard and Clemens Krauss. *Capriccio* (London: Boosey & Hawkes, 1942).
Strauss, Richard and Hugo von Hofmannsthal. *Ariadne auf Naxos* (Berlin: Adolph Fürstner, 1916).
Strauss, Richard and Hugo von Hofmannsthal. *Die Frau ohne Schatten* (Berlin: Adolph Fürstner, 1919).
Strauss, Richard and Hugo von Hofmannsthal. *Elektra* (Berlin: Adolph Fürstner, 1908).
Strauss, Richard and Hugo von Hofmannsthal. *Salome* (Berlin: Adolph Fürstner, 1905).
Stravinsky, Igor. *The Rake's Progress: An Opera in Three Acts*, Full Score (London: Boosey and Hawkes, 1962).
Verdi, Giuseppe et al. *La traviata: Melodramma in Tre Atti (Melodramma in Three Acts)* (Chicago: University of Chicago Press; Milano: Ricordi, 1997, 1996).
Verdi, Giuseppe. *La traviata* (Milano: G. Ricordi & C., 1944) (plate number 42314).
Wagner, Richard and Felix Mottl, ed. *Die Walküre* (Frankfurt: C.F. Peters, 1914), Nr. 3404.
Wagner, Richard. *Sämtliche Werke, Band 8, III. Tristan und Isolde* (Mainz: B Schott's Söhne, 1993).
Wagner, Richard. *Das Rheingold*, vocal score (Mainz: B Schott's Söhne, 1899).

Index

Abbado, Claudio 172, 189
Abbate, Carolyn 51, 53, 116, 121
Adorno, Theodor 205
Albertina Museum, Vienna 205
Alloway, Lawrence 42
Altes Museuem, Berlin 38–9
Angiolini, Gasparo 72
Appia, Adolphe 197–8
Arcadian Academy, Rome 65
architecture: in art museums 1–2, 14–20, 36–40; in theatres 15–17, 58, 63, 194–5
Aristotle: *Poetics* 175
Ashmolean Museum, Oxford 40
Atkinson, Paul 29
Attwood, Thomas 90, 104
Auber, Daniel 92, 97, 123; *Fra Diavolo* 123; *Gustave III* 92
audience(s), behaviour and reactions 5, 15, 16, 30, 90, 91, 94, 133, 150, 153–7, 169, 177, 195; expectations and prejudices 6, 13, 20, 26, 57, 58, 66, 124, 133, 149, 153–7, 169, 187, 194, 198–9; of indoor plants 209
Auersperg Palace, Vienna 102
Ausstellung (exhibition) 19, 24, 25; *Ausstellungsmacher* (curator) 1, 7, 12, 19, 42, 44, 177

Bach, Carl Philipp Emmanuel 4
Bach, Johann Christian 74
Bach, Johann Sebastian 62, 75, 93
Balkin, Jack M.: arguing Verdi's intentions 155–6
Ballet/dance 35, 51, 55, 61, 64, 76, 92, 103, 104, 107, 108, 135, 141, 189; *Opéra-ballet* 55
Barbedette, Hippolyte 119
Barry, Robert 43

Bartoli, Cecilia 153–4
Basle Theatre (Theater Basel) 45
Baucardé, Carlo 154–6
Baudry, Paul-Jacques-Aimé 184
Bavarian State Opera *see* Bayerische Staatsoper
Bayerische Staatsoper (Bavarian State Opera), Munich 24, 102, 141
Bayreuth Festival 8, 17, 25, 27, 33, 124, 193–9, 200; Festspielhaus Theatre as museum 195–6
Beckett, Samuel 185
Beethoven, Ludwig van 25, 114, 122, 141, 151–2, 161; authorial control 151–2; compared with Rossini 114; *Fidelio* 151–2; Symphony No.9 25
Bellini, Vincenzo 108, 113, 115–17
Belvedere Palace, Vienna 37–8
Benedict, Julius 105
Benjamin, Walter 205
Bereson, Ruth 29
Berg, Alban 19, 136, 142, 186–90, 192; *Les Troyens* 96; *Lulu* 188–90; *Wozzeck* 186–8, 190
Berlioz, Hector 68, 76–9, 90, 93, 95, 96, 101, 119; co-editor of *Orphée et Eurydice* 76–9; recitatives for *Der Freischütz* 77
Bernabei, Giuseppe Antonio 63
Bernard, Paul 96
Bertinotti-Radicati, Teresa 109
Bertoni, Fernando 77–8
Betterton, Thomas 61
Bieito, Calixto 174
Bildung (cultural formation) 37, 140
Bishop, Henry 93, 105
Bizet, Georges 52, 115; *Les pêcheurs des perles* 52

Blow, John: *Venus and Adonis* 61
Böhm, Karl 81–2
Boito, Arrigo 16, 28
Bontempi, Giovanni Andrea 63
Boretti, Giovanni Antonio 54
Boulez, Pierre 20, 190
Bourdieu, Pierre: theory applied to opera companies 130–42; theory of cultural power dynamics 29, 129–30, 142
Brandt, Carlo 195
Brenson, Michael 43
British Museum, London 40
Britten, Benjamin 28, 44, 133; *Billy Budd* 28; *Owen Wingrave* 28, 44
Broadway 20, 44
Bruckner, Anton 141
Büchner, Georg 187
Budden, Julian 155
Buonaiuti, Serafino 107–8
Burney, Charles 73
Busoni, Ferruccio 151

cadenza 27, 77–8, 149, 207; Lucia's mad scene 27, 149; Viardot singing Eurydice 77–8
Callas, Maria 166
Calzabigi, Ranier de' 72–3, 78
Camerata, Florentine 51–4, 57
Campi, Antonia 89
Canon, foundation and development of 52, 56, 67, 68, 80–5, 113–24, 152, 192–3, 196, 200, 207
Capitoline Museums, Rome 35
Carré, Albert 97
Carter, Tim 105, 179
Caruso, Enrico 121, 166
Carvalho, Léon 76
Castil-Blaze, François-Henri-Joseph 91–3
Castrato 58, 62, 73, 76, 79, 107, 149
Catalani, Alfredo 117
Catalani, Angela 104, 108
Cavalieri, Emilio de': *Rappresentatione di Anima e di Corpo* 52
Cavalli, Francesco 53, 54–5, 58; *La Calisto* 58
Chantavoine, Jean 97
Charles II of England 61
Charney, Noah 209
Chédeville, Etienne Morel de 89
Chorus director *see* opera house
Christov-Bakargiev, Carolyn 12
Clark, Kenneth 157
Code Rossini 114

Colas, Damien 169, 178
coloratura 89
Comédie Française 55
Commedia dell'arte 51, 64
copyright in musical/operatic scores 71, 116, 117, 124
Corday, Charlotte 184
Costa, Michael 93
Covent Garden Theatre, London (later the Royal Opera House) 28, 75, 93, 105
Covid–19 virus 208
curtain (rising/falling), (parting/closing) 13, 16, 93, 131, 182, 185, 187, 188

David, Jacques-Louis: *La mort de Marat* 184–5
Debussy, Claude: *Pelléas et Mélisande* 181–2
Delacroix, Eugène 95
Delibes, Léo: *Lakmé* 52
Dent, Edward (E.J.) 106
Diderot, Jacques 67
director *see* stage director
Dodo, thrown into moat 34
Donington, Robert 53–4
Donizetti, Gaetano 27–8, 108, 113, 115, 117, 119, 121, 123, 136, 149; *Lucia di Lammermoor* 27–8, 115, 123, 149
Dorner, Alexander 42
dramaturgy/dramaturg(e) 6, 8, 20, 27–8, 90, 173–82, 184–90
drowning, death by 186
Dryden, John 61
Duchamp, Marcel 18, 41; museums as 'morgues of art' 18
Dukas, Paul 96
Durazzo, Giacomo 72
Dürer, Albrecht: *Young Hare* 205

Eco, Umberto 120, 165, 166
Edgcumbe, Richard 107
Einstein, Alfred 73, 106
England, English opera 61–4, 90, 93, 105
Everist, Mark 95–6

Farquharson, Alex 11
Faustini, Giovanni 54
Felsenstein, Walter 199
Ferrier, Kathleen 75
film 20, 28, 57, 133, 189, 204; film directors as stage directors 20; opera on film 28
Fischer, Ludwig 102

Fischer-Dieskau, Dietrich 79
Fontana, Lucio 42
France, French opera 38, 55–7, 59, 61, 62, 64, 67, 74, 75–80, 89, 91, 93, 95–7, 118–19; French Revolution 38, 67, 89, 184–5; nationalism 38, 96, 119
Fricke, Richard 195
Friedrich, Götz 199

Galileo Galilei 58
Gamerra, Giovanni de 90
Gardiner, John Eliot 75, 79
Gay, John: *The Beggar's Opera* 62
Gemäldegalerie Berlin 169–70
Gemäldegalerie Dresden 36
Gemäldegalerie Düsseldorf 36
Gershwin, George: *Porgy and Bess* 43
Gesamtkunstwerk 37, 54, 55, 189, 192–6
Gibbons, William 96
Giotto di Bondone 204
Glass, Philip: *Einstein on the Beach* 43
Gluck, Christoph Willibald von 16, 19, 52, 54, 62, 67, 68, 72–80, 90, 95, 96, 119, 120, 175, 178, 179; *Alceste* 96, 178; *Iphigénie en Aulide* 74, 96; *Le feste d'Apollo* 73; operatic reform 52, 54, 67, 72–5; *Orfeo ed Euridice/Orphée et Eurydice* 62, 68, 72–80, 90, 95, 120; perspective of Berlioz 78
Glyndebourne, napkins at 121
Goehr, Lydia 51, 149–50
Goldberg, Rose Lee 12
Gold Rushes, Californian and Australian 124
Google Cultural Institute 205
Gossett, Philip 116
Göttingen International Handel Festival 63
Grabu, Luis: *Albion and Albanius* 61
Grand Tour 34–5, 62
Gran Teatre del Liceu, Barcelona 209
Graun, Carl Heinrich 64
Guadagni, Gaetano 73–4
Guardasoni, Domenico 108
Guarienti, Pietro Maria 36

Habermas, Jürgen 36
Habsburg dynasty 34, 37, 72
Hagen, Oskar 63
Hahn, Reynaldo 77, 96
Halévy, Fromental 2, 92, 119; *La Juive* 92
Hamilton, Richard 42
Handel, George Frideric (Händel) 62–4, 75, 93; *Rinaldo* 62

Haneke, Michael 20
Harnoncourt, Nikolaus 85
Hasse, Johann Adolph 64
Haute-contre 76, 79
Haydn, Joseph, faked sonatas of 3–4
Herheim, Stefan 174
Herz, Joachim 199
Herzog, Werner 20
Hirt, Aloys 39
historically informed performance (HIP) 5, 14, 79–80, 149
Hockney, David 20
Hoffmann, Ernst Theodor Amadeus (E.T.A.) 91, 92
Hofgartengalerie, Munich 38
House, The (BBC documentary series) 28–9
Hultén, Pontus 42
Hurwitz, David 164–5

impresario 24, 36, 55, 62, 71, 174, 193–4
Institute of Contemporary Arts (ICA), London 42
Intermedi 33, 35, 51, 57
Intermezzi 66
Italy, Italian opera 17, 19, 24, 64–7, 113–18, 123–4, 132, 155, 162–7; *bel canto* 5, 115, 134; birthplace of opera 51–2; censorship 152, 176–7; repertoire formation 51–5, 113–14, 123–4; unpopularity of Mozart's operas 100, 103, 108–9

Jahn, Otto 106
Janáček, Leoš 142; *The Makropulos Case* 203

Kaprow, Allan 42
Karsch, Joseph 36
Kasperltheater 64
Kearsley, Susanna 206
Keiser, Reinhard 64
Kelly, Michael 104
Kentridge, William 20
Kerll, Johann Caspar 63
Kerman, Joseph 178
Kiesewetter, Raphael Georg 161
Kiesler, Frederick 41
King's Theatre, London 104, 108
Kleiber, Erich 189
Klein, Yves 42
Kloiber, Rudolf: *Handbuch der Oper* 80–1

Kobbé, Gustav: *Complete Opera Book* 80–2, 121
Komische Oper, Berlin 24, 174, 199; Felsenstein's directorship of 199
Komödienhaus, Dresden 63
Konold, Wulf 120, 121
Kooning, Willem de 19
Krahe, Wilhelm Lambert 36
Kramer, Christian 101
Krehbiel, Henry: *Chapters of Opera* 80–82, 121
Kreisler Fritz 3
Kroll Opera, Berlin 199
Kühnel, Jürgen 200
Kunsthaus, Vienna 41
Kunsthistorisches Museum, Vienna 37
Kunstkammer see Wunderkammer
Kupfer, Harry 199

Lachnith, Ludwig Wenzel 89–90, 93
Landesmuseum Hannover 41, 42
Landon, H.C. Robbins 3–4
Lange, Joseph 206–7
language coach *see* opera house
Leinsdorf, Erich 94
Lessing, Gotthold Ephraim: *Hamburgische Dramaturgie* 175
Levi, Hermann 97, 110, 193; as conductor of *Tristan und Isolde* 193
Levine, James 153, 169
Lévi-Strauss, Claude 31
librettist(s) 4–6, 12, 15, 16, 27, 28, 54, 55, 59, 65–7, 70, 72–3, 78, 88, 90, 93, 101, 110, 171, 174, 187–8, 192, 197, 199
libretto 8, 12, 15, 16, 20, 27, 65–7, 68, 73, 78, 88, 90, 92, 101–2, 106, 107, 108, 109, 145, 164, 173–7, 178–9, 197, 200, 203; metastasian 59, 65–7, 106, 178; revisions and substitute texts 68, 88–9
Licitra, Salvatore 154–6
lighting 189, 196–7, 198; Schoenberg and lighting 189
Lind, Jenny 124
Lissitzky, Lazar Markovich (El) 41
Literaturoper 187
Loewenberg, Alfred: *Annals of Opera* 120
Lorenz, Michael 207
Lorrain, Claude 95
Lortzing, Albert 23, 64, 121–2; *Zar und Zimmermann* 23
Louis XIV 55

Louvre Museum, Paris 1, 38, 96, 118–19, 204
Lubar, Steven 40, 134
Lully, Jean-Baptiste 15, 55–6, 59, 61, 63, 67, 96, 118; *Atys* 56

mad scenes 27–8, 185, 186
Mahler, Gustav 71, 80, 110, 141, 197, 201; revolutionary staging of *Tristan* 197
Malraux, André 43
Mannlich, Johann Christian von 38
Marat, Jean-Paul: his death in paintings 184–5
Maria Theresa of Austria 37
Martinelli, Giovanni 156
masque 61–2
Mechel, Christian von 37
Meegeren, Han van 3, 205
Meijers Debora 38
Meisl, Karl 88
Melba, Nellie: adapting Donizetti's Lucia 27
Menotti, Gian Carlo: *Amahl and the Night Visitors* 43
meta-opera, Straussian 30, 142
Metastasio, Pietro 59, 65–7, 73, 106–8, 178
Metropolitan Opera, New York 24, 44, 121, 152–4, 168–9
Meyerbeer, Giacomo 1, 16, 96, 117, 119, 193; *Les Huguenots* 96; *Robert le diable* 193
Michelangelo Buonarotti: *Pietà* 157
Miller, Jonathan 153–4
Millöcker, Carl: *Gasparone* 23
Moderna Museet, Stockholm 42
modern/modernist opera 19, 174, 186–90, 199–201
Molière 91, 96
monologue 185
Monteverdi, Claudio 52–4, 57, 65, 120, 204; *Arianna* 53; *L'incoronazione di Poppea* 53, 204; *L'Orfeo* 52, 54, 57, 120
Moreno (pseudonym of Henri Heugel) 96
Morritt, John 206
Mould, J. Wrey 93
Mozart, Constanze 106, 207
Mozart, Wolfgang Amadeus 4–5, 13, 16, 25, 64, 68, 70–1, 80–5, 88–97, 100–10, 113, 114, 119–22, 136–7, 146, 148–54, 173–5, 179, 181, 185, 186, 206–7; *Così fan tutte* 13, 26, 30, 82, 97, 100, 104, 105, 106, 108–10, 179; critical editions of 71–2, 82–5, 101, 110; deification

of 95–7; *Der Schauspieldirektor* 82; *Die Entführung aus dem Serail* 64, 68, 80, 82, 120–1; adaptations of 100–2; modern stagings of 173–4; *Die Zauberflöte* 19, 64, 136; adaptations of 88–91; Mahler's production of 102; Masonic symbolism in 91; *Don Giovanni* 5, 30, 90, 96, 103, 104, 108, 151; adaptations of 91–4; manuscript as holy relic 95–6; Prague and Vienna versions 94–5; *Idomeneo* 82, 92, 102–3, 106; *La clemenza di Tito* 82, 85, 90, 136; adaptations of 106–8; *La finta giardiniera* 82, 85; *Le nozze di Figaro* 90, 93, 109; adaptations of 103–5; modern attitudes to 152–4; recitative in 180–1; *Lucio Silla* 85; missing chord in 71–2; operas as 'open works' 150–1; portrait of 206–7; 'Raphael of music' 109, 119
Munari, Bruno 40
Munich 24, 35, 38, 63, 80, 88, 97, 102, 110, 129, 137, 141, 193–4; Mozart in Munich 102, 110, 137
Münster, Robert 102
murders (operatic)/death scenes 184–7
Musée du Louvre *see* Louvre Museum
Muti, Riccardo: fidelity to Verdi's scores 154–6, 158

Naples, Neapolitan opera 13, 26, 54, 59, 62, 64–6, 106, 108, 116
Napoleon Bonaparte 38, 40, 89, 114–15, 119; compared with Rossini 114
National Gallery, London 157
Neuenfels, Hans 173–4
Neumann, Angelo 193–4
Nicolini (Nicolo Grimaldi) 62
Niedermeyer, Louis 170
Niemetschek, Franz Xaver 106
Norrington, Roger 94
Nourrit, Adolphe 92

Obrist, Hans Ulrich 12, 20, 33, 43, 44; *Il tempo del Postino* 20, 44; referring to artworks as scores 43
Offenbach, Jacques 76, 91; *Orphée aux enfers* 76
offstage music and drama 28, 131, 177, 185–7
Oiticica, Hélio 42
Oldenburg, Claes 42

Old Vic Theatre, London 105
O'Neill, Paul 42
Opéra–ballet 55
Opera buffa 67, 91–7, 103–5, 108–10, 180–1, 186
Opéra-Comique, Paris 97
'Opera crisis' 6–7, 18–20, 124
Opéra de Paris 1, 24, 57, 58, 73, 96, 118–19, 193
opera house, key positions in: backstage/offstage conductor 131, 135, 136; chorus director/assistant chorus director 139, 198; dramaturg(e) *see* dramaturgy, Intendant 141–2; Kapellmeister (first and second) 137–8, 141, 193; language coach 133–5; music director (Generalmusikdirektor) 138–42; prompter 17, 30, 131–3; Répétiteur (Solorepetitor, Korrepetitor) 129, 133–6, 137–8, 140; Studienleiter (head of music staff) 139–40; surtitle operator 133
opera 'reform' 54, 65, 67, 72, 73, 74, 75, 76, 79; *Orfeo ed Euridice*, impact of 73–9
Opera seria 52, 64–6, 73, 74, 85, 102–3, 106–7, 162, 165, 167
operetta/grand operetta 24, 76, 104, 135, 138, 141
Opernhaus am Salvatorplatz, Munich 63
ornamentation/extemporization 26, 89, 166, 181, 207

Pagé, Suzanne 177
Paisiello, Giovanni: *Socrate immaginario* 76
Pantheon theatre, London 104
Paraklias, James A. 120
Paris Opéra *see* Opéra de Paris
Paris, Parisian opera 1, 19, 38, 57, 58, 67, 73–9, 89, 90, 91, 93, 94, 96, 101, 103, 106, 118–19, 177, 192–3; *Don Giovanni* as Parisian grand opera 91
Parker, Roger 51, 53, 116, 121
Pasticcio 62, 68, 85, 91–5, 101, 103–5, 107, 109, 145, 161, 167, 170, 175
Patanè, Giuseppe 163–4
Pavarotti, Luciano 156
Peranda, Marco Giuseppe 63
Pergolesi, Giovanni Battista: *Il prigioniero superbo*; *La serva padrona* 66–7, 114

Peri, Jacopo: *Dafne*; *Euridice* 52
Pitz, Wilhelm 198
Planché, James 105
Ponchielli, Amilcare 117
Porges, Heinrich 195
Possart, Ernst 97, 110, 137
Prague 34, 94, 106, 108; version of *Don Giovanni* 94
'Prima la musica, dopo le parole' 54, 178
prompter *see* opera house
publishers, rising influence of 116, 117, 146
Puccini, Giacomo 15, 19, 23, 115–18, 121, 131, 132, 187, 209; *Crisantemi* 209; *Gianni Schicchi* 132; *La bohème* 15, 23; *Madama Butterfly* 19, 131; *Tosca* 131, 187; *Turandot* 19, 121
Purcell, Henry 61–3; *Dido and Aeneas* 62

Querelle des Bouffons 67
Quiccheberg, Samuel 35

Rameau, Jean-Phillipe 56–7, 58, 67, 74; *Castor et Pollux* 57; *Dardanus* 58; development of the orchestra 56–7
Rauschenberg, Robert 19
Rebull, Santiago 184
recitative (secco/accompagnato) 27, 28, 55, 57, 66, 77, 89, 90, 93, 96, 101, 103, 105, 106, 107, 108, 110, 136–7, 174, 179, 180–1, 186–7, 190, 207; adaptation/elimination of Mozartian recitative 101–10; *Figaro* recitatives 180–1; the répétiteur as continuo player 136; Richard Strauss playing recitative 137
recordings 17, 25–6, 52, 75, 79, 80, 94, 121, 123, 135, 136, 162–3, 166, 167, 190
Regietheater (*Regieoper*) 8, 20, 174–8, 199–201
Rembrandt Research Project 3, 168–71, 204
Rembrandt van Rijn 2–3, 96, 157, 167–8, 169–71; *The Night Watch* 157
repertoire system 23–4
Répétiteur *see* Opera house
Retuschen (re-orchestration) 146
Richter, Hans 195
Ricordi, music publishers 114, 117, 118, 123, 162, 163; editions of *Il barbiere di Siviglia* 162–5; Giovannni Ricordi 114; Giulio Ricordi 117, 152
Roller, Alfred 197–8, 201
Romani, Pietro 155
Roques, Guillaume-Joseph 184
Rosand, Ellen 52, 57
Rosselli, John 117
Rossini, Gioachino 4, 19, 95, 105, 107, 108, 113–17, 119, 122–3, 136, 151, 155, 161–7, 168–9, 170–1; compared with Beethoven 114–15, 151; depression 115; genuflecting before *Don Giovanni* 95; *Guillaume Tell* 96, 161; *Il barbiere di Siviglia* 19, 105, 108, 115, 136, 155, 161, 166, 167; critical editions of 162–5; *Il viaggio a Reims* 167; *Ivanhoe* 167; *Le comte Ory* 167, 169; ornamentation in 155; *Roberto Bruce* 167, 170; *Semiramide* 122–3; Stendhal on Rossini 114
Rousseau, Jean-Jacques 67
Royal Opera House *see* Covent Garden

Saint-Saëns, Camille: as co-editor of *Orphée* 76–9
Salieri, Antonio 82, 178
Salzburg Festival 25, 174
Sammlung (collection) 19, 25, 37
Sandberg, Willem 42
Sarti, Giuseppe 103
Sartorio, Antonio 54
Sawallisch, Wolfgang 137, 141–2
Scala, La *see* Teatro alla Scala
Scarlatti, Alessandro 59, 64–5
Scarlatti, Domenico 4
Schikaneder, Emanuel 84, 88–9
Schinkel, Heinrich 39
Schoenberg, Arnold 189–90
Schütz, Heinrich 63
Senici, Emanuele 107
Serafin, Tullio 160
Shakespeare, William 28, 109; *Othello* 28
Sibelius Jean 141
Siegelaub, Seth 42
silence 181, 185, 186, 188
Singspiel 63–4, 90, 100, 173
Snowman, Daniel 121
Soler, Antonio 103, 104
Sondheim, Stephen: *Sweeney Todd* 43
speaking roles (*Die Entführung/Ariadne auf Naxos*) 105, 179

224 Index

Spieloper 23, 64, 141
Sprechgesang 186, 189–90
stage director 6, 8, 13, 16, 20, 24, 27, 45, 64, 101, 102, 130, 135, 137, 142, 153, 173–9, 188, 198–201
Stagione system 24–5
Stanislavsky, Constantin 131
Statuario Publico, Venice 35
Stedelijk Museum, Amsterdam 42
Stendhal (Marie-Henri Beyle) 114
Storace, Nancy 104
Storace, Stephen 104
Strauss, Richard 16, 30, 79, 80, 82, 97, 103, 110, 120, 131, 136, 137, 178, 179, 186–7; *Ariadne auf Naxos* 30, 136, 142, 189; *Capriccio* 30, 178; *Der Rosenkavalier* 120, 134; *Die Frau ohne Schatten* 131; *Elektra* 131, 136, 186; as Mozart conductor 137; *Salome* 186–7
Stravinsky, Igor: *The Rake's Progress* 30–1
Studienleiter *see* Opera house
surtitles/supertitles 6, 10, 133; surtitle operator *see* opera house
Süskind, Patrick: *Der Kontrabaß* 139
Szeeman, Harald 12, 20

Taruskin, Richard 67
Teatro alla Scala, Milan 24, 117, 132, 154–8, 162
Teatro Regio, Parma 24
Teatro San Cassiano, Venice 54
tenor 26, 79, 91, 102, 107, 109, 139, 154–7; unwritten top notes 26, 154–7
Theater am Gänsemarkt, Hamburg 63
Theater an der Wien, Vienna 24
Theater auf der Wieden, Vienna 88
Théâtre de la Monnaie, Brussels 133
Théâtre du Châtelet, Paris 79
Théâtre-Lyrique, Paris 76
Theile, Johann 64
Thielemann, Christian 137
Toscanini, Arturo 156
Tragédie lyrique (*Tragédie en musique*) 55–6, 61, 67, 74
Tramezzani, Diomiro 104, 110
Treitschke, Georg Friedrich 109

Uffizi Gallery, Florence 35

Venice, Venetian opera 52–5, 57, 62, 65, 66

Verdi, Giuseppe 16, 28, 116–19, 122, 123, 146–7, 149, 132, 152, 154–7, 177–8; and the censor 177; collaboration with Boito 28; *Falstaff* 132, 152; *Il trovatore*, Manrico's high C in 154–7; *La traviata*, editorial discrepancies in 146–7; *Otello*, invention of Iago's 'Credo' in 28; partnership with Ricordi 117, 152; *Regietheater* approaches to 177–8; textual fidelity to 146–7, 149, 154–7; *Un ballo in maschera* 152, 177
Vermeer, Johannes 3, 206
Viardot, Pauline 76–9, 95–6; co-editor of *Orphée et Eurydice* 76–9; keeper of the Mozartian flame 95–6
Vienna Hofoper *see* Vienna Staatsoper
Vienna Staatsoper (Vienna State Opera, formerly Vienna Hofoper) 20, 24, 45, 71, 82, 106, 110, 197

Wagner, Cosima 193–6
Wagner, Richard 8, 16, 17, 25–6, 27, 33, 54, 108, 110, 137, 181–2, 189, 192–9; after-life of his operas 196–9; and *Così fan tutte* 108; *Der fliegende Holländer* 192, 196; *Der Ring des Nibelungen* 30, 33, 182, 193–6, 198; as director of *Parsifal* 193; as director of the *Ring* 195–6; as *Gesamtschauspieler* (celebrity curator) 8, 194; influence on Debussy 181; *Lohengrin* 23, 132, 193, 196, 198; and Paris 192–3; *Parsifal* 8, 25, 123, 193, 196, 198; *Siegfrieds Tod* 194; *Tannhäuser* 182, 193, 196; and the 'theatre of illusion' 33, 194–5; *Tristan und Isolde* 181, 193, 197
Wagner, Siegfried 25, 196–7
Wagner, Wieland 17, 193, 197–9, 200–1; revolutionary stagings of Wagner 197–9
Wagner, Winifred 197
Wagner, Wolfgang 197
Weber, Carl Maria von 77, 96, 121, 188; *Der Freischütz* 77, 96, 121
Weber, William 105
Wedekind, Frank 187
Weerts, Joseph 184
Werktreue (authenticity) 13, 93, 110, 145–58, 161–9, 198–9
Whitehead, Christopher 29, 134
Wiener Hofoper *see* Vienna Staatsoper
Wiener Staatsoper *see* Vienna Staatsoper

Wolf-Ferrari, Ermanno 103
world fairs/expositions 40, 95, 119, 194
Wunderkammer (*Kunstkammer*, *Wunderkabinett*) 7, 30, 33–5, 37–9, 44, 57–8, 120, 194

Zeiss, Laurel 178
Zemlinsky, Alexander von 71
Zeno, Apostolo 65

Printed in the United States
By Bookmasters